TREASURES OF ASIAN ART
FROM
THE IDEMITSU COLLECTION

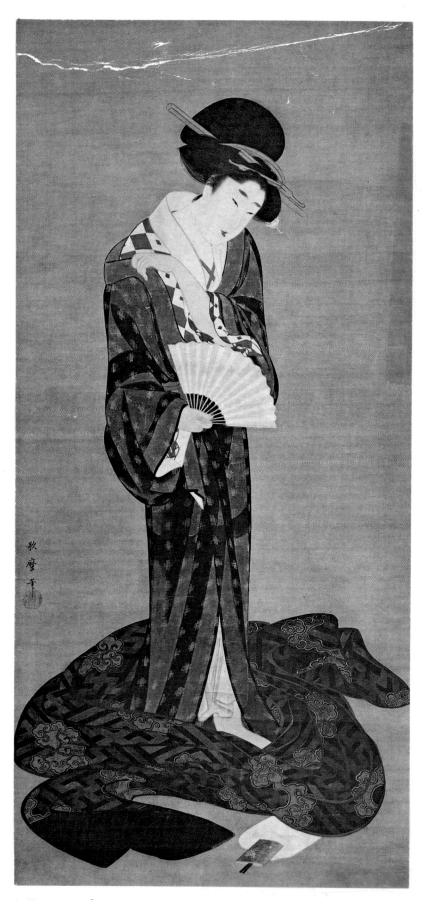

A Beauty Changing Clothes
Kitagawa Utamaro (1753–1806)
(Catalogue no. 89)

TREASURES OF ASIAN ART
FROM
THE IDEMITSU COLLECTION

By

Henry Trubner and Tsugio Mikami
in collaboration with
William J. Rathbun
and
The Idemitsu Museum of Arts

assisted by Amy Newland

SEATTLE ART MUSEUM

The Project is supported by:
The Idemitsu Museum of Arts and
The Participating Institutions in the United States
The Agency for Cultural Affairs (Bunka-chō), Tokyo
and by grants from:
The National Endowment for the Arts in Washington, D.C., a federal agency
The Japan-United States Friendship Commission, Washington, D.C.
The Japan Foundation, Tokyo

Copyright 1981 by the Seattle Art Museum, Seattle, Washington
All right reserved
Library of Congress Catalogue card No. 81–52557
ISBN 0-932216-06-4
Designed by: Tadanori Yuba, Idemitsu Museum of Arts, Tokyo
Printed by: Bunka Insatsu Co., Ltd., Tokyo

Itinerary

Seattle Art Museum
Seattle, Washington
 August 27, 1981 to October 25, 1981
Kimbell Art Museum
Fort Worth, Texas
 November 18, 1981 to January 3, 1982
Japan House Gallery
New York, New York
 January 27, 1982 to March 14, 1982
Denver Art Museum
Denver, Colorado
 April 10, 1982 to May 23, 1982

Cover Illustration:
Two Peaks Embraced by Clouds
Uragami Gyokudō (1745–1820)
(Catalogue no. 92)

Contents

Foreword

Since its founding in 1933, the Seattle Art Museum has enjoyed a particularly close relationship with Japan, its museums, both public and private, and the ministries and government agencies that oversee the arts in Japan. As a result of the museum's keen interest in Japan and its art, witnessed by its renowned collection of Japanese art, a series of major traveling exhibitions from Japan have been presented at the Seattle Art Museum over the last quarter century. Foremost among these exhibitions were "Japanese Painting and Sculpture" (1953), "Ceramic Art of Japan: One Hundred Masterpieces from Japanese Collections" (1972), "Shinto Art" (1976), "Chinese Ceramics from Japanese Collections" (1977), and "Masters of Japanese Realism: The Maruyama-Shijō School of Painting, 1750–1850" (1980). The two exhibitions of Japanese and Chinese ceramics, and the exhibition of the Maruyama-Shijō School of painting were jointly organized by the Seattle Art Museum, working in close harmony with the Agency for Cultural Affairs of the Government of Japan, co-sponsor of the exhibitions, and the participating institutions in the United States. This museum has, in turn, been a frequent lender to major exhibitions in Japan, including the exhibition of art of the Rimpa School, held at the Tokyo National Museum on the occasion of its one hundredth anniversary (1972), and more recently, the Tokyo National Museum's special exhibition "Art of the Tea Ceremony" (1980). The Seattle Art Museum's close working relationship with major museums and collectors in Japan and with the Agency for Cultural Affairs and other agencies of the Japanese government has been instrumental in bringing to the American people a better understanding and appreciation of Japanese art and of Japan's ancient culture.

Plans for the present exhibition "Treasures of Asian Art from the Idemitsu Collection" first came into being when Professor Tsugio Mikami, a member of the Board of Directors and an Advisor to the Idemitsu Museum of Arts, extended an invitation to the undersigned to organize an exhibition drawn from the Idemitsu Museum's noted collection of Asian art. The exhibition was to be shown in four museums in the United States during the 1981–1982 season in celebration of the fifteenth anniversary of the opening of the Idemitsu Museum of Arts in Tokyo on October 29, 1966. It was agreed that the exhibition would be jointly sponsored by the Idemitsu Museum of Arts and the Seattle Art Museum, together with the participating institutions in the United States. Organizational responsibility for the exhibition and its American tour was left to the writer, who was to be guest director of the exhibition working closely with the Board of Directors and the staff of the Idemitsu Museum. Our sincere appreciation is expressed to the Board of Directors and the staff of the Idemitsu Museum of Arts and to the participating museums for their unwavering support in this undertaking and for helping to bring about the successful conclusion of this project.

We would like to thank in particular Professor Tsugio Mikami who first proposed the project and who subsequently exercised his considerable influence at the Idemitsu Museum of Arts to make certain that many of its finest

and most important examples of the Japanese, Chinese, Korean, and Southeast Asian holdings would be included. Special thanks are also extended to Takashi Eto, the Idemitsu Museum's Curatorial Manager, who assisted in many ways with the organization of the exhibition and publication of the catalogue, and who devoted long hours to resolving the many logistical problems associated with an international exhibition of such magnitude and complexity. Ryosuke Suematsu, Acting Director of the Idemitsu Museum, at all times gave his full support to ensure the smooth progress of the project, including certain financial and administrative commitments for which we are most grateful.

The exhibition includes a number of objects of major importance, each designated by the Japanese Government as an 'Important Cultural Property' or an 'Important Art Object.' These works of art are so marked in the catalogue. We are greatly indebted and would like to express our thanks to the Agency for Cultural Affairs (Bunka-chō) of the Government of Japan, which generously approved the exhibition concept and, as required by law in Japan, gave permission for all of the registered objects to leave the country for exhibition in the United States.

The exhibition and catalogue are supported by a number of grants. A very generous grant from the National Endowment for the Arts in Washington, D.C., a federal agency, provided broad financial assistance for the project, including publication of the catalogue. We are deeply grateful to the Endowment for this support and would like to thank in particular Tom Freudenheim, Director, Museum Program, the National Endowment for the Arts. The Japan-United States Friendship Commission in Washington, D.C. approved a generous grant underwriting the costs of the Japanese curators who will accompany the exhibition in the United States. We greatly appreciate the interest of the Friendship Commission in the project and extend our special thanks and appreciation to Francis B. Tenny, Executive Director of the Japan-United States Friendship Commission for his enthusiastic support of the project.

On the other side of the Pacific, the Japan Foundation awarded a much appreciated grant supporting the publication of the catalogue. The catalogue, which has been printed in Japan, was further assisted by financial support from the Idemitsu Museum of Arts. All exhibition expenses incurred in Japan, including those for assembling, crating, and packing of the objects as well as the unpacking upon their return, all costs for photographs and color transparencies required for the catalogue, for press releases and other exhibition purposes were also covered by the Idemitsu Museum of Arts. We would like to thank this institution for the generous financial support provided throughout the project, and for the encouragement and aid it has consistently extended towards the exhibition.

We also extend our thanks and our appreciation for their interest and support to the participating museums in this country and to their staff. The late Richard F. Brown, then Director of the Kimbell Art Museum in Fort Worth, Texas, and a close friend and colleague, was one of the first to endorse our exhibition plans enthusiastically and to commit his museum to active participation. Unfortunately, he was unable to witness its realization, but Edmund P. Pillsbury, who succeeded Dr. Brown as Director, David Robb, Chief Curator, and Emily Sano, Curator of Asian Art, maintained the Kimbell Art Museum's

keen interest and participation in the exhibition. We would also like to thank, for their support and participation, Rand Castile, Director of Japan House Gallery, New York, Maryell Semal, Assistant Director and Registrar, Margot Paul, Assistant Director and Editor, and Hisa Ota, Assistant to the Director. The Denver Art Museum is the fourth participant and our thanks go to Thomas Maytham, Director, and to Ronald Otsuka, Curator of Asian Art, for their keen interest in the exhibition and their enthusiastic participation. To each and everyone of the participants and to their staff we extend our thanks for their wholehearted support and their generous cooperation.

The staff of the Seattle Art Museum has been heavily involved in sharing responsibility for the organization and successful realization of the exhibition. We express our sincere thanks and appreciation to each one of them, but the following staff members in particular deserve special praise for a job well done. William J. Rathbun, Curator of Japanese Art, Barbara Satori, Curatorial Assistant in the Asian Department, her successor in the same post, Michael Knight, and MaryAnn Dosch, Assistant to the Associate Director, all provided invaluable help and assistance with the catalogue production and other important aspects of the exhibition. Amy Newland, Catalogue Research Assistant, and Nancy Savage, Clerical Assistant in the Asian Department, also gave generously of their time and knowledge. The exhibition could not have been successfully concluded without the wholehearted support and commitment of the museum's Department of Asian Art, for which the writer is deeply grateful.

Pamela Diedrichs, formerly the editor of the museum's Publication Department, performed admirably as editor of the catalogue. Her diligent and conscientious editorial work has been a most valuable contribution to the catalogue.

A heavy work load also fell on the museum's Register, Gail Joice-McKeown, and her department, who not only had to deal with shipping, security requirements, and logistics at the Seattle Art Museum, but with arrangements for the ongoing tour to the other participating institutions. We thank not only Gail Joice-McKeown but her entire staff, including Dale Rollins, Evelyn Klebanoff, and Paula Wolf, as well as William J. Lahr, Shipping Supervisor, and his staff. All of them were faced with difficult tasks in successfully and efficiently handling their respective responsibilities. Annie Searle, the museum's Public Relations Officer, and Steve Davolt, Assistant Manager, contributed much of their time and energy towards the success of the project. Aside from the exhibition catalogue, which was designed and printed in Japan, all printing and graphic design requirements pertaining to the exhibition were ably handled by Richard Hess, Publications Coordinator.

One of the most challenging tasks of any exhibition is usually the installation, and Mike McCafferty, museum Designer and Head Preparator, aided by his skilled staff, notably Chris Manojlovic, Bob Meyer, and Wes Pulka, could be depended upon to produce an artistically exciting and novel installation apropriate to the subject and the occasion. We would like to thank Mike McCafferty and his staff for their imaginative solution to many difficult installation problems, which they resolved with success and great skill. Our profound thanks, moreover, go to the entire museum staff, including all those not specifically mentioned here, for their many contributions and generous

support of the project.

Last, but not least, the undersigned would like to express his thanks and appreciation to Arnold Jolles, Director of the Seattle Art Museum, for his enthusiastic and wholehearted support of this project.

The Seattle Art Museum is very proud and greatly honored to present this major exhibition "Treasures of Asian Art from the Idemitsu Collection". It is our hope and expectation that this selection of great masterpieces of Asian art will come as a revelation to museum goers in the United States. It is a most important and unique collection of Asian art, assembled by a noted Japanese collector, the late Sazo Idemitsu, and the distinguished staff of the museum. The major portion of the exhibition is devoted to the arts of Japan, particularly ceramics, paintings, and lacquer ware; the balance features important aspects of the arts of China, and a small, but select, group of Korean and Southeast Asian ceramics. The Idemitsu Museum of Arts is today one of the world's great treasure houses of Asian art, and the organizers of this exhibition consider it a great privilege to present this renowned collection to the American public for the first time on the occasion of the fifteenth anniversary of the opening of the Idemitsu Museum of Arts. The exhibition opens another significant chapter in the continuing cultural and artistic communion between Japan and the United States and is certain to strengthen the close bonds of friendship between our two countries.

Henry Trubner

Associate Director
Seattle Art Museum
May 1981

Chinese and Japanese Art

THE ARTS OF CHINA

In the Neolithic period, ceramic art in China began its original development with the production of painted pottery, as well as polished black and white pottery in various shapes and designs. Recent studies tell us that simple but well-balanced jades were already in production by that time. The rapid progress of a stabilized community setting resulted in the emergence of the first civilization in the latter half of the Shang period (1523–1028 B.C.) and consequently Chinese crafts in general achieved a remarkable development. In ceramic art, intentional glaze was used for the first time. The lapidary's craft advanced both in technique and variety, and the advent of bronze metallurgy, and ivory and bone carving fell also in this period. It is known that lacquer wares existed already and that silk was being woven. Among these various achievements, the art of the bronze caster was of primary importance, followed by the lapidary's craft.

Bronzes appeared for the first time in the first half of the second millennium B.C. as food containers and wine vessels for ritual use. They display an archaic naiveté and crudeness, but the thin bodies and simple designs tell us that they were still in the first stages of development. After the removal of the capital to An-yang in Honan Province, bronze metallurgy made miraculous advances. The bronzes can be classified into various categories such as food containers, wine vessels, drinking vessels, musical instruments, weapons, and chariot and harness ornaments. The first two can be seen in various shapes according to their diversified uses in their society. All were made by casting and reveal shapes that are both symmetrical and sublime. They appear static but at the same time harmonize with their elaborate designs and their superior casting of decorative motifs, such as the *t'ao-t'ieh*, dragons, other animals and birds, and in rare cases, human figures. They reveal to us the aesthetic consciousness and religious thoughts of the Shang and Chou people. Bronzes of this period, with their elaborate forms and designs, could be classified as the world's finest products of ancient times. The bronze metallurgy of that time was accomplished to perfection. The bronzes were made for the ruling class and were used to worship their deities and the departed souls of their ancestors. They were also used as symbols of power and prestige, and quite naturally were discovered at ancestral ritual sites and tombs. Many of the bronzes were, moreover, inscribed and these inscriptions, some of which are quite long, throw new light on ancient history and the various institutions that existed in those days. The finest bronzes were made in the latter half of the Shang (1300–1028 B.C.) and during the Western Chou (1027–771 B.C.) periods.

In the Eastern Chou period (771–256 B.C.), the production of ritual bronzes was still in its prime. In the period of the Warring States (481–221 B.C.), their shapes and designs, in contrast to the Shang and Western Chou bronzes, show great linear beauty and fluidity. The political, economic, and cultural upheavals occuring at various times, however, changed the values and concepts of the people. New techniques of gold, silver and jade inlay were adopted. Casting

of bronzes continued until the Ch'in (221–206 B.C.) and Han (206 B.C.–A.D. 220) periods, but in the Han period the shapes became much simpler and decorative designs were rare. This was the end of the extensive production of ritual bronzes.

Bronze mirrors with exquisite designs came to be made in the Period of the Warring States, and continued to be produced until the Six Dynasties period (220–589). In the Sui (589–618) and T'ang (618–906) periods, bronze mirrors became less archaic and symbolic in concept and their elaborate designs reflect the superb techniques employed in the elaborate gold and silver works of the time.

Jades and bronzes were the two primary products among the arts and crafts of the Shang and Western Chou periods. Among the jades, blue, yellow and white jades, which were imported from Khotan in Chinese Turkestan were highly praised as the finest. Ritual and ornamental jades in various shapes and designs were made with a texture like the tender warm skin of a baby. The lapidary craft was so skilled as to give the products an air of nobility and people greatly treasured these objects. Like the bronzes, the best jades were produced in the Shang and Chou periods. In the Period of the Warring States, they began to show great linear beauty. Jade carvings continued to be produced well into the Han dynasty. The recent excavation of an ivory oblong cup from the Fu-hao tomb at An-yang, dating from the Shang dynasty attests to the high technique of the arts in that period.

Lacquer, too, appeared for the first time in the Shang period, but it was not until the Period of the Warring States that it reached a high technical level which led to the production of many excellent examples in Honan Province. Utensils for daily use, such as bowls, stem-cups, covered-boxes and jars, musical instruments, horse trappings, ornaments and burial utensils, such as coffins, were made in lacquer. The designs—clouds, dragons, t'ao-t'ieh, and geometric patterns—were executed in colored lacquer with curvilinear patterns on a black lacquer ground. The products were already in those days regarded as superior works of art peculiar to China. In the following Han dynasty, lacquer art developed further and many vessels and utensils with elaborate bodies and exquisite designs were produced. After this period the quality previously achieved declined and we must wait almost a thousand years to witness another great period of lacquer art.

It is a well-known fact that fabrics, especially fine silks, have been a Chinese speciality since ancient times. Superb relics of the silk products of that time were found in Mongolia, Turkestan, and more recently in the Ma-wang Tui tomb in Honan Province.

As we have seen, all the noble arts and crafts of ancient China, such as bronzes, jades, ivories, lacquers and textiles which had all attained superior achievements, came to a temporary halt in the Han dynasty and in turn the art of ceramics started to make a very rapid advance. Since the middle of the Shang period ash-glazed brown wares and stonewares of similar quality were already in production for about one thousand years. During the Ch'in and Han dynasties, pottery making as well as glazing and firing techniques made gradual progress, and ash-glazed brown or greenish-brown vessels such as jars, vases, bowls and so-called *tou* (bowls on high stems) were produced in fine quality

and shape. In the later Han period, with the further development of techniques, archaic celadons were produced for the first time in Chekiang Province. The province subsequently remained the center of celadon production for centuries.

In the Han dynasty, gray pottery jars, bowls, stem-cups, and painted terracotta sculptures were made as *ming-ch'i* (funerary objects). The lead glazed green and brown wares were made for the same purpose and it is believed that they had some technical connection with contemporary lead glazed wares from the Roman Empire.

The Chekiang kilns produced an enormous amount of celadons during the Six Dynasties period. These celadons were yellowish green in color and included such shapes as jars, vases, bowls, and urns, referred to in China as *shên-t'ing* (pavilion of the souls), as well as other objects in the shape of animals (tigers, lions, sheep, birds, and frogs). The so-called chicken-headed ewer, with its spout in the form of a chicken head, appeared in this period. In the latter part of the Six Dynasties period, the shapes were limited to jars, plates and bowls, with some of them having decorations of lotus petals which clearly show the influence of Buddhist art. Though minor in number, black wares were also produced.

The manufacture of fine white porcelaneous wares, the use of Persian motifs on pottery, and the appearance of the so-called Northern Celadons with yellowish or bluish green glazes are important forerunners in the development of the ceramic art in Northern China in the following periods. The arts and crafts of the Sui and T'ang dynasties reflect the cosmopolitan nature of the political and social environment of the time, which had adopted many elements from other Asian countries. The ceramic art was not an exception. In Northern China, political center of the Empire, a new kind of pottery was introduced, namely the T'ang three-color glazed ware. The decorations were executed on a white ground with lead glazes in green, yellowish brown, and dark blue which gave the ware a bright, colorful and distinctive character. The shapes, as well as the designs, reflect the extent of Persian and Indian influences that were in exotic harmony with the colors. White and black wares were produced in large quantities in Northern China. The Huang-tao and Lu-shan kilns gave birth to suffused black and grayish white glazed wares which are extremely fascinating and in a way suggest the nature of modern abstract art. In Southern China celadons were the main product and in the Five Dynasties period (907–960) the potters were successful in producing beautiful olive green celadons. One of the new and representative kilns was Ch'ang-sha, in Hunan Province, which produced jars, pitchers, and bowls decorated with realistic human figures, birds, animals, flowers and letters in brown or green colors under a transparent yellow glaze. It is an important aspect of Chinese ceramic history that such wares with realistic designs were produced in the ninth century.

In the Sung dynasty (960–1279), following the unsettled conditions prevailing during the Five Dynasties period, an absolute monarchy was established which resulted in a stabilization of the social system and produced an industrial development, which in turn, gave birth to one of the most highly advanced civilizations of all times. Correspondingly, the arts and crafts attained an even higher level of development and as a result the art of ceramics improved greatly both in the quality and in the quantity of wares produced.

In Northern China, the Ting yao kilns (*yao* meaning 'ware') produced white porcelains for the palace and for governmental use, while the Tz'u-chou kilns produced wares suitable for the daily needs of the people. Tz'u-chou wares comprise a variety of types and include simple white wares, those with flowers or fish-and-water-plant designs that are carved or painted, and black or caramel brown wares. The decorative designs on Tz'u-chou ceramic pillows take on various forms and are very interesting. By this time fine celadons had also begun to be made in Northern China. Besides the Kuan celadons, various kilns such as Yao-chou yao, Lin-yu yao, and Chün yao produced celadons for daily use. Southern China meanwhile became the center of celadon and white porcelain production. The potters of the traditional celadons of the Chekiang kilns were successful in producing the famous celadon ware referred to as having the color of clear blue sky after the rain. Flower vases, incense burners, jars, pots, bowls, and cups are all distinguished by clear and distinct profiles and well-balanced proportion. At the same time the wares have a calm and restrained appearance. Lung-ch'üan was the center of their production. The Ching-tê-chên kilns in Kiangsi Province produced fine quality porcelains, such as white porcelain and *ch'ing-pai* (bluish white or clear white), also known as *ying-ch'ing* (shadowy blue), to support the demands of the court and nobility. Among Southern Chinese kilns, Shui-chi yao in Fukien (*temmoku* or Chien ware), Yung-ho yao in Kiangsi (black ware) and Chi-chou yao (black painted on white ground ware) were well known.

It is not only in ceramic art that fine pieces were produced at this time, but bronze and jade production also made a remarkable comeback, as did lacquers. The textile industry in particular showed the most remarkable development and produced such high quality goods as satin and satin damask.

In the Yüan dynasty (1280–1368) under Mongol control, the ceramic art of China underwent a tremendous change in style. The appearance of multi-colored ware such as blue-and-white, underglaze red, as well as black painted designs under a peacock green glaze, exemplify the new style and technical advances. During this period designs became more complex when compared to the former simple flower and fish designs. Not only the combination of several motifs were used but also narrative scenes, sometimes taken from literature or classic drama were adopted.

In the Ming dynasty (1368–1644) the tendency toward polychrome ceramics became more conspicuous, especially among the overglaze enameled wares. In the latter half of the Ming period, *wu-ts'ai* (five-color ware), *tsa-ts'ai* (overglaze yellow, overglaze red, etc.) and *fa-hua* (cloisonné style enamel ware) were in production. These wares constituted the main stream of Chinese ceramics and thus resulted in the decline of production of the monochromatic celadons and white porcelains while multi-colored, blue-and-white and enameled wares dominated the output. Ching-tê-chên continued as the center of ceramic manufacture.

It was not only in the art of ceramics that people wanted variety and splendor, but this demand was also felt in the other arts and crafts. In the Yüan dynasty, various techniques such as carved cinnabar or black lacquers and the *ch'iang-chin* (etched gold) techniques were introduced and subsequently, in the Ming dynasty, they developed into highly popular wares. The intricate

mechanism of Ming society gave birth to manifold measures of value and as a result people demanded very diversified and complicated styles.

In the Ch'ing dynasty (1644–1912) such tendencies towards increased complexity and variety intensified even further. Porcelains produced for the Ch'ing imperial court are good examples of such phenomena. These ceramics were produced with unparalleled skill and meticulous care. The new range of enamel colors introduced at this time from Europe were applied and they are know as *yang-ts'ai* (foreign colors). Similar concepts also dominated other aspects of the arts and crafts of the time.

THE DEVELOPMENT OF JAPANESE CERAMICS

In earlier times, Chinese culture and civilization had always been far more advanced than in any of the other East Asian countries, and when Chinese techniques in the field of the arts and crafts had been transmitted to these neighboring countries, they provided a stimulus to their own native techniques and inspired developments that gave new birth to their own originality. The art of ceramics was no exception. Korean, Japanese, Vietnamese, and Thai ceramics were all deeply influenced by Chinese prototypes. I would like to look into the process of assimilation and achievement of a uniquely Japanese creation that emerged in the history of Japanese ceramics.

Already in the neolithic period, the Japanese people had a deep interest in ceramics and were capable of making their own original vessels. Jōmon ware with its wide variety of shapes and decorations, which are full of expression, testifies to this. In the Yayoi period (c. 200 B.C.–A.D. 250), stimulated by the Korean red clay wares, utilitarian vessels such as jars, bowls, and stem-cups were produced. These reddish brown wares were called Yayoi pottery and this type of ware was also similar to its Korean counterparts in the baking process. Yayoi pottery was produced in Japan over a long period of time. Haji ware (*hajiki*) appeared in the Kofun period (c. 250–552) and spread throughout the country. It is one of the types of Japanese ceramics that is devoid of decoration, relying solely on the form and color of the clay for its natural beauty.

Contemporaneously with Haji ware, a better quality of hard pottery appeared. It is called Sue ware (*sueki*). Both of these wares were high-fired, unglazed pottery and were made by Korean immigrants. They were continuously produced throughout the Nara (645–794) and Heian (794–1185) periods to satisfy the taste of the aristocracy and the court. In the meantime Nara *sansai* (three-color) ware was produced in imitation of the T'ang three-color glazes and green glazed wares were copied after the Yüeh-chou celadons of the Five Dynasties (907–960) and Northern Sung (960–1127) periods. Both types appeared respectively in the Nara and Heian periods. In the cases of Sue and Haji wares, many jars and vases similar in shape to those of the T'ang and Sung dynasties were made in these periods.

In the Heian period, the Sanage kilns in Owari, east of modern Nagoya, produced jars, vases, vessels with handles and spouts, bowls, and ink slabs, which were similar to Chinese prototypes, with fine off-white bodies covered with a light brown ash glaze. These are the earliest ash glaze kilns that appeared in Japan.

In the Kamakura period, the Seto kilns in Owari started to produce Ko Seto wares, which were covered with amber, greenish-blue, and caramel brown ash glazes. The freely incised flower designs and stamped decorations that adorn the ware clearly show the influence of Sung celadons, but the difference of Seto kiln construction and paste were obstacles in achieving the clear celadon color of Northern Sung celadons. On the other hand the attempt to copy Chien ware was successful and resulted in a black or amber color which is referred to as Seto *temmoku.* This was the beginning of the rapid Japanization of ceramic art. The simple, yet dynamic high-fired stonewares, covered with a natural glaze appeared in the Kamakura period and were continuously produced right through the Muromachi period, and are particularly Japanese in character. Tokoname, Atsumi, Echizen, Shigaraki, Tamba, and Bizen kilns were the principal kilns producing such wares. These ceramic centers produced jars in various sizes and roughly potted vessels for rustic daily use, many of which impart an inherent quality of beauty. In the Kamakura period (1185–1333) the fashion of drinking tea was introduced, and in the Momoyama period (1568–1615) it became the vogue of the day. Initially, the ceramics used in the tea ceremony were Chinese ceramics such as celadons and white porcelains, but by the end of the sixteenth century, Japanese and Korean ceramics came to be adapted for that purpose. The tea ceremony provided the impetus for a sudden development of Japanese style glazed wares, and the centers producing them were Seto and the southeastern part of Mino Province. It was here that Black Seto *temmoku,* Ki Seto, Shino (mainly a white ware, but with many variants), and Oribe with bluish green and yellowish glazes, flourished. Among them Shino and Oribe are distinctively Japanese with their novel, often abstract designs.

The production of lightweight Raku ware originated in Kyoto, made solely for use in the tea ceremony. At the same time the Iga, Shigaraki, Tamba, and Bizen kilns started to produce tea bowls, flower vases, and ewers for the tea ceremony.

The Momoyama period might be referred to as the Renaissance of Japanese art, not only for its achievements in ceramic art but also in the other arts and crafts, such as lacquers, textiles and metal works, which saw the production of many excellent pieces.

Concurrently with the Mino and Raku wares, groups of kilns for glazed and high-fired stonewares for use in the tea ceremony made their appearance in Western Japan: Hagi in Yamaguchi Prefecture, Agano in Oita, Takatori in Fukuoka, Karatsu in Saga, Shōdai in Kumamoto, Ryūmon-ji in Kagoshima. The glazes, mainly brown, are full of variety and the decorations of designs taken from nature, painted in iron black, are impressive and highly appreciated as tea ceremony utensils. All of these kilns were originated by Korean immigrant potters at the end of the sixteenth century.

The next major step in the history of Japanese ceramics was the discovery of porcelain clay at Arita early in the seventeenth century. In Arita, white porcelain and blue-and-white decorated porcelain were in production in the early stage of development, and it was in the middle of the seventeenth century that over-glaze enamel wares began to be produced. They were exported to Southeast Asia, West Asia, and Europe from the nearby port of Imari, hence the generic term Imari ware. The feudal lords of Nabeshima had special kilns under

their direct control, where porcelains with underglaze blue and overglaze enamels of extraordinary quality and with highly original designs were produced. This ware, accordingly, was called Nabeshima ware.

The heavy demand of Europe for quality as well as for specialized shapes and decorations, accelerated the development of Arita overglaze enamel wares, and distinctive types such as Ko Imari with baroque designs, and Kakiemon porcelain with rococo-style decoration were established. These export wares were not only in great demand, having become very famous in Europe, but they also acted as stimulus for imitators in Germany, France, and England.

On the other hand, porcelain production, with underglaze blue-and-white or overglaze enamel decoration, spread to Himetani in Okayama and Kutani in Kanazawa Himetani wares have decorative designs that may be described as delicate, whereas Kutani porcelain, in contract, is roughly made with bold and vigorous designs. In Kyoto, with a highly advanced cultural tradition, the production of *Kyō-yaki* (Kyoto wares) originated. These wares are distinguished by the use of overglaze enamels and decorative designs derived from native traditions formulated by Nara and Heian period aristocratic court taste. It was in the eighteenth century in Kyoto that many artist potters appeared in succession, namely Nonomura Ninsei (active mid-seventeenth century), Ogata Kenzan (1663–1743), Okuda Eisen (1753–1811), Aoki Mokubei (1767–1833), Ninami Dōhachi (1783–1856), and Eiraku Hozen (1795–1854). The copying of Chinese overglaze enamel designs was predominent in the ceramics of the late Edo period in Kyoto.

Tsugio Mikami

*Member of Board of Directors
and Adviser
Idemitsu Museum of Arts
May 1981*

The Japanese Painting Collection of
The Idemitsu Museum of Arts

Since the opening of the country in the Meiji era, the Japanese people have been deeply interested in and have paid deep respect to the study of Western cultural and artistic developments, making strenuous efforts to learn and digest them. Thanks to these efforts, within just a century, the remarkable and characteristic Japanese culture has been formed, the result of an unusual harmony between the distinctive traditional culture of a small island with a long history in the Far East and the universal culture which is leading the modern era.

This Japanizing ability can be counted as one of the most splendid natural dispositions of the Japanese. First we try to understand the highly advanced foreign culture in a humble way, then transform it and adapt it to our own constitution and sensibility. Looking back upon the history of Japanese art confirms this basic fact.

I

The beginning of the history of Japanese painting can be traced back to the middle of the sixth century, when Buddhism was officially introduced to Japan from the Korean Peninsula. Since then, Japan has been the recipient of intermittent waves of influence of Chinese-style painting transmitted to the island nation, where these foreign styles were imitated and ultimately transformed through gradual refinement. This process of Japanizing Chinese painting styles was repeated over the next 1300 years until the Meiji Restoration.

The influence of Chinese paintings from the period of the Six Dynasties (220–589) through the Sui dynasty (581–618) made itself felt in the Asuka period (552–645). Paintings of the T'ang dynasty (618–906) were transmitted during the Nara (645–794) and the beginning of the Heian (794–1185) periods. Ancient Chinese paintings of these periods were transformed into the graceful and elegant *Yamato-e* (Japanese picture) style during the period from the tenth to the twelfth centuries, when diplomatic relations between the two countries were severed with the fall of the T'ang dynasty.

From the beginning of the Kamakura to the end of the Muromachi period (1185–1568), the samurai class replaced the emperor and the court nobles in holding the reins of government. In this medieval period a new style of painting, principally based on *suiboku-ga* (ink painting) of the Sung (960–1279) and Yüan (1279–1368) dynasties was eagerly studied by the Zen priest-painters as a part of Zen culture. This new style of painting was called *kan-ga* (Chinese paintings) and was greatly appreciated by such intellectuals as the Zen priests and members of the warrior class.

Kan-ga was finally blended and unified with the traditional *Yamato-e,* bringing about the second stage of Japanization. The credit for this may be given to the great masters of the Momoyama era (1568–1615), especially the painters

of the Kanō school. The Kanō school was the most influential school of art under the patronage of the shogunal family and daimyo (feudal lords) throughout the country during the Edo period (1615–1868) of the Tokugawa government. While respecting the Sung and Yüan paintings as having achieved the highest classical standards, the Kanō school transformed these into *wa-ga* (Japanese painting) whose style was simple and direct, representative of the Japanese sense of beauty.

It was after the middle of the Edo era, in the latter part of the eighteenth century, that the painting styles of the Ming (1368–1644) and Ch'ing (1644–1912) dynasties came to be studied on a regular basis. This influence of the Kanō school at the same time began to decline. *Bunjin-ga* (which aimed at expressing the personal feelings of the artists in their paintings) attracted the new groups of intellectuals (many of whom were poets as well as masters of calligraphy) who became conscious of themselves as individuals in their own right. In addition, realistic paintings which reproduced flowers and birds just as they appeared in the natural world, strongly appealed to the rising bourgeoisie, steeped in the spirit of positivism. Thus, the paintings of the Ming and Ch'ing dynasties, upon which the non-academic painters concentrated their attention during the last century of the Edo period, became the framework of the *Nihon-ga* (Japanese painting) after the Meiji era (1868–1912). Finally, Japanese painting developed into present-day *Nihon-ga* which is founded upon the traditions of the past.

In the first stage of development Japanese painting, inspired by paintings of the T'ang dynasty, developed into *Yamato-e*; in the second stage, in medieval times, *kan-ga*, imitating the paintings of Sung and Yüan, developed into *wa-ga*; and in recent times the painting styles of Ming and Ch'ing were added to the preceding styles. The history of Japanese painting was long and complex, but altogether the self-renewal and metamorphosis which invariably followed the influx of Chinese ideals and concepts were repeated three times in the development of Japanese painting.

II

This year (1981) the Idemitsu Museum of Arts celebrates its fifteenth anniversary. Although this is a private museum and has not been in existence very long, it is regarded as one of the finest museums in Japan and the world. Thanks to the keen judgment and the perceptive eye for beauty of Mr. Sazo Idemitsu, the museum's founder who died earlier this year, its collections, which are primarily composed of Asian works of art and crafts, are preeminent in their quality, breadth and variety. Japanese paintings and Far Eastern ceramics form the nucleus of the collection and it is impossible to exhaust the list of masterpieces which should be singled out for special mention. The present essay will therefore simply survey the collection of Japanese paintings, laying stress on the works which are displayed in this exhibition.

The painting entitled *A Poetry Party at the Imperial Court* (no. 77) is an important example of *Yamato-e*. This picture scroll depicts a night party dedicated to the composing of poetry and playing of music held at the Imperial palace in the fall of 1218. Each man's name and age appear beside him, and the emperor and all the court nobles are painted with life-like realism and

meticulous attention to individual details. The original—said to have been painted by Fujiwara Nobuzane, the master of *nise-e* (portrait painting) in the Kamakura era—was lost and this Muromachi period copy remains as a reminder of the original masterpiece. The technique of *hakubyō-ga* (white painting), the monochrome delineation in fine, even lines in ink without color, was quite unique even in the field of *Yamato-e*, but the artistic inclination of the Japanese is clearly expressed here in the grasp of distinct forms and pure beauty.

Other examples of *Yamato-e* in the Idemitsu collection include such important works as the eighth century *Illustrated Sutra of Past Causes and Present Effects*, the *Transcription of Old Sutra on Illustrated Paper*, the *Portraits of the Poets Hitomaro and Henjō* from the series of *Portraits of the Thirty-six Poets*, and the *Tales of Petition Presented by Tachibana Naomoto*. All of these, including the *Poetry Party*, are registered by the Government of Japan. As for works of the *Rimpa* school (a term derived from the last syllable of the name of the painter Kōrin, combined with the character for school) which revived the gorgeous and decorative classical *Yamato-e* in the seventeenth-eighteenth centuries, such fine examples as *Autumnal Flowers* by Tawaraya Sōtatsu (active 1600–1640) and *Rose Mallow Flowers* by Ogata Kōrin (1658–1716) were added to the collection in recent years.

III

The developing process of *kan-ga* from the fourteenth to the sixteenth centuries is clearly shown by three examples.

Kannon, Goddess of Mercy (no. 78) is an ink painting by the eminent priest Sōen Osei (active 1340–1375), who went to China in the middle of the fourteenth century to study Zen. Since the work is on the theme of Kannon, Goddess of Mercy, and painted as the pastime of the priest-painter, it can be regarded as a typical Japanese picture of an early stage of development under Chinese Zen influences.

The *Landscape* (no. 79) illustrates the academic style flourishing about one century later. It is said to be by Shūbun (active 1414–1463), a professional priest-painter (a Zen priest, primarily engaged in painting for the temple) who played an active part in Sōkoku-ji, an important Zen temple in Kyoto. The landscape is distinguished by the abrupt transition from foreground to distance, showing a lack in spacial integration, undoubtedly caused by simple copying and only partial adaptation of the techniques of the Sung and Yüan masters.

In contrast, the six-fold screen of *Flowers and Birds of the Four Seasons* (no. 80), with the signature of Sesshū (1420–1506), illustrates the development of painting after Shūbun. The work belongs to the series of "Flowers and Birds in Sesshū Style," which depicts the flowers and birds of the four seasons. Originally there is likely to have been another screen on the left, balancing the screen on the right. The artist aimed at emphasizing the dynamic movement to the left rather than depth in space, by gathering the objects prominently in the foreground, producing powerful and massive forms. This arrangement must have been influenced by the new painting style of the Ming dynasty. Moreover, the dramatic presentation of the progressive cycle of seasons forcefully expresses the sensibility peculiar to Japan. We know from this work that the classical style

of *kan-ga* established by Shūbun was intentionally modified and the groping for new direction had already begun. In the Idemitsu collection there is another painting entitled *Flowers and Birds of the Four Seasons* (a pair of small six-panel screens) attributed to Sesshū and another entitled *Eight Views of Hsiao-hsiang*, by Soga Chokuan, which is a masterpiece of *suiboku-ga* of the Momoyama period when the further Japanization of *kan-ga* was dominant.

IV

The Idemitsu collection is limited in the field of large gilded pictures of flowers and birds in colors and gold, which were prevalent before and after the Momoyama period. In this turbulent age of civil wars, warlords such as Oda Nobunaga (1534–1582) and Toyotomi Hideyoshi (1536–1598) rose rapidly to high positions by believing in their own powers. At this time Europeans came to Japan while Japanese merchants in turn went to various places in Southeast Asia to trade. The age was filled with an open and enterprising spirit and people preferred brightly colored pictures with thickly applied color on gold ground to the monochrome *suiboku-ga*. They also preferred the vital style of flower-and-bird pictures to the meditative spirit of landscape paintings. Moreover, genre paintings which depicted the life and customs of society were preferred over narrative pictures and portraits of historical persons which required a certain education to be fully appreciated.

Although the Idemitsu collection is limited in the number of large flower-and-bird pictures, it includes many masterpieces of other types of genre painting. The *Gion Festival* (no. 83) is particularly well-known as one of the oldest and most splendid examples of the festival type of genre painting. The Gion festival was the principal celebration of the Yasaka Shinto shrine in Kyoto and is still held today. The grand spectacle of the procession with *mikoshi* (shrine palanquins) and *yamaboko* (processional carts colorfully draped and decorated) carried and pulled through the streets reflected the wealth, power and the aesthetic sensibility of the merchant class of this ancient city. The emotional release and lifting of the spirit on the occasion of the annual festival is effectively conveyed by these screens.

The screen of *Okuni Kabuki* (no. 82), depicting an early form of Kabuki, said to have been originated by a shrine maiden named Okuni, and the *Namban Byōbu* (no. 81) which expresses the sense of curiosity of seeing Western people for the first time, are two of the most valuable genre paintings of this era. In the Idemitsu collection there are in addition a few other Kabuki genre paintings of early date and a pair of six-panel screens of *Namban Byōbu* which depicts a large sailing ship which has just landed and Westerners from the ship proceeding through the city streets en route from the port to the Christian church.

V

Fūzoku-ga (genre painting), a new field of painting, flourished in the Momoyama period and remained in fashion until after the beginning of the Edo period. The themes, however, became gradually more limited, focusing increasingly on particular customs and manners in the entertainment quarters rather than on the normal life of the people. As a result of this tendency, there appeared at the end of the seventeenth century the popular genre painting called

ukiyo-e (Pictures of the Floating World, or paintings of the life of the pleasure quarters). The most popular form of expression was in the form of wood-block prints, but a number of ukiyo-e artists concentrated on painting, yet many famous woodblock artists displayed their skills in paintings as well. Examples of the former are *A Beauty* (no. 85) by Kaigetsudō Ando (active 1704–1714) and *A Beauty* (no. 86) by Miyagawa Chōsun (1682–1752). Examples of the latter type are *A Beauty Changing Clothes* (no. 89) by Kitagawa Utamaro (1753–1806), *A Beauty* (no. 87) by Nishikawa Sukenobu (1671–1750), and *Three Beauties Under the Cherry Blossoms* (no. 88) by Katsukawa Shunshō (1726–1792). Utamaro is particularly noted for his ukiyo-e prints, but also produced paintings and this work vividly depicts with erotic overtones a woman, relaxed, changing clothes on a hot summer day. The Idemitsu Museum of Arts has a very extensive ukiyo-e collection, including such famous works as the genre scenes known as the *Shiki Himachi Zukan* by Hanabusa Itchō (1652-1724) and *A Beauty Having a Smoke* by Utagawa Toyokuni (1769–1825).

Iwasa Katsumochi, better known as Matabei (1578–1650), the painter of the *Thirty-six Master Poets* (no. 84), is according to tradition the originator of ukiyo-e painting. The Idemitsu Museum of Arts has taken great interest in this peculiar artist for a long time. The collection includes his *Scroll of Various Professions* which is of particular interest in studying the relationship between Matabei and gentre painting. The museum has a good and representative collection of Matabei and his school.

VI

After the middle of the eighteenth century the various revolutionary movements took on added significance. The most noteworthy event was the transmittal to Japan of the ideals and painting style of Chinese *bunjin-ga* (painting in the literati style). This style was advocated by Ikeno Taiga (1723–1776) and Yosa Buson (1716–1783). Their subjective and independent attitudes which sought the creative motive in the artist himself and did not seek the understanding and sympathy of others, except of their intimate friends, were quite new to the Japanese, although a few priest-painters working in the earlier *sui-boku-ga* had already promoted such attitudes. The intellectuals, well grounded in Chinese literature and poetry, learned of such ideas mostly from Chinese theory books about painting. The style was imperfectly learned from the albums of woodcuts, books about Chinese art and from inferior pictures occasionally imported. Thus, from the beginning, there were elements in Japanese *bunjin-ga* which were different from those of Chinese *bunjin-ga* and depending on the individual character of the artists, the free and sometimes arbitrary development of their own style was permitted. The following are good examples of the unique achievements of Japanese *bunjin-ga*: *Solitary Deer in the Deserted Winter Forest* (no. 91) by Yosa Buson, which is conspicuous by its reflection of Northern rather than the Southern mode of Chinese painting; *Spider and Sparrow* (no. 97) by Watanabe Kazan (1793–1841); *Two Peaks Embraced by Clouds* (no. 92) by Uragami Gyokudō (1745–1820), a player of the ancient *koto*, expressing a desolate mental image in a picture distinguished by the presence of his own free and unrestrained spirit.

The first *bunjin-ga* collection of the late Sazo Idemitsu was centered around Tanomura Chikuden (1777–1835), the ancient sage in Kyushu where Mr. Idemitsu was born. His collection of paintings by Chikuden is therefore very large and includes *Kōban-zu (Utopia) and Calligraphy* (no. 94), displayed in this exhibition, and many works by students of Chikuden such as Takahashi Sōhei (1804–1835) (no. 96). Striving hard to penetrate the essence of Chinese Southern-style painting, Chikuden never neglected the observation of nature and examination of his inner self, thus avoiding the easy outward imitation of Chinese painting. He was a typical *bunjin-ga* artist, combining poetry, calligraphy, and painting and thus realizing the noble poetic ideal.

Yamamoto Baiitsu (1783–1856) who was active at the end of the Edo period in Nagoya often painted large-scale works, an unusual practice for a *bunjin-ga* artist. *Flowers and Birds* (no. 98), painted in 1845, represents the fullest expression of his superb descriptive techniques and is regarded as one of his masterpieces.

Other examples in the *bunjin-ga* collection worthy of special mention include *Mountain Robed in Fresh Verdure in the Rain* by Aoki Mokubei (1767–1833), a potter (see no. 64) who painted poetic landscapes as a hobby.

VII

In introducing the Idemitsu collection of painting, we cannot omit the witty and buoyant caricature of the Zen priest Sengai (1750–1837), active in the latter part of the Edo period. He expressed in plain poems and pictures the quintessence of Zen so that the Zen spirit might be easily understood even by uneducated people. Sazo Idemitsu, when still in his youth, was atracted by the humor and simplicity of *Hotei Singing* (no. 100) and went on to collect more than one thousand Sengai works. Hotei looking up at the moon and dancing with children is innocent and happy, reminding us of Sengai himself.

This survey will hopefully convey an idea of the extent of the Idemitsu collection of painting, even though fewer than thirty works are included in the exhibition. The collection is the fruit of sincere collecting efforts which always sought the noble spirit and pure beauty, while at the same time maintaining a familiarity with the popular culture. As a natural result the collection has a wide range of schools and types of painting and is outstanding in its quality.

Tadashi Kobayashi

Associate Curator
Tokyo National Museum
May, 1981

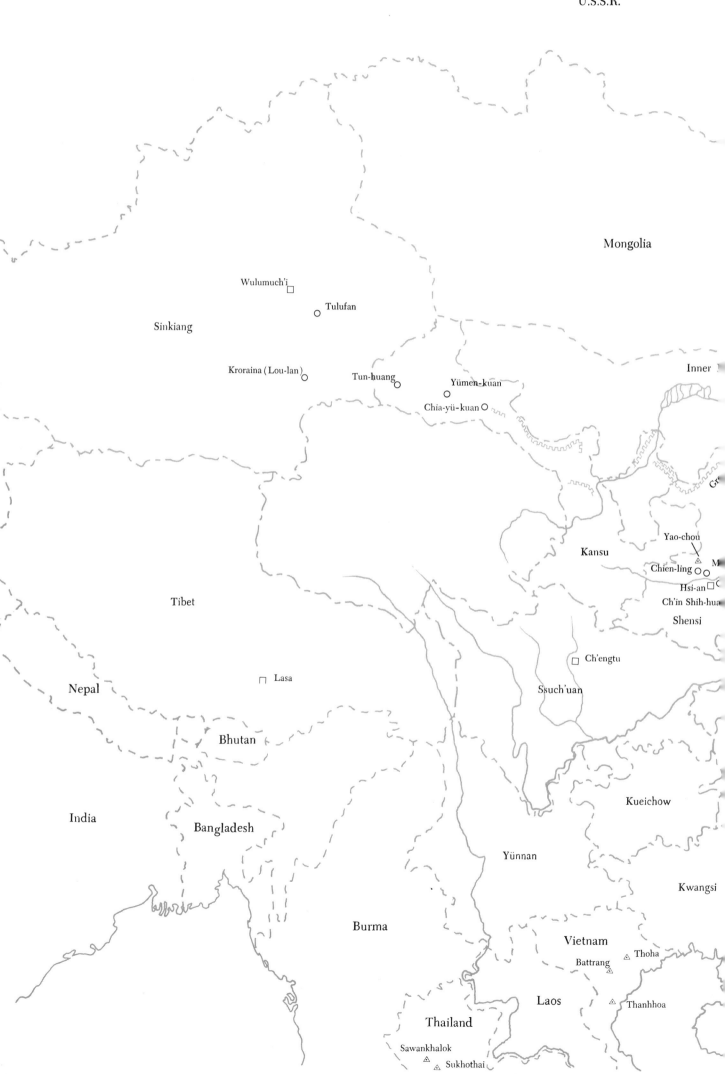

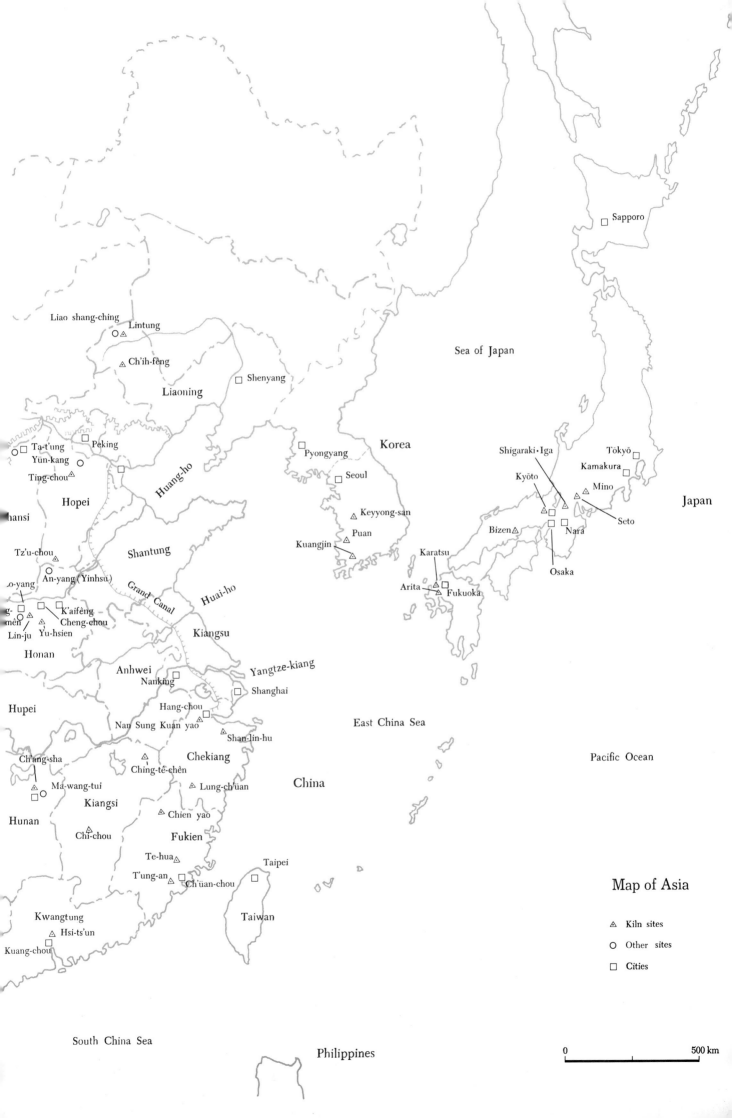

Liao shang-ching

Lintung

Ch'ih-fêng

Liaoning

Shenyang

Sea of Japan

Sapporo

Korea

Ta-t'ung
Yün-kang
Ting-chou

Peking

Shigaraki·Iga

Tōkyō
Kamakura

hansi

Hopei

Huang-ho

Pyongyang

Seoul

Kyōto

Mino

Japan

Tz'u-chou

Shantung

Keyyong-san

Bizen

Nara

Seto

o-yang An-yang (Yinhsu)

Grand Canal

Puan

g-
mên
Lin-ju

K'aifêng
Cheng-chou
Yu-hsien

Huai-ho

Kuangjin

Karatsu

Osaka

Honan

Kiangsu

Arita

Fukuoka

Anhwei
Nanking

Yangtze-kiang

Shanghai

East China Sea

Hupei

Hang-chou

Nan Sung Kuan yao

Shan-lin-hu

Pacific Ocean

Ch'ang-sha

Chekiang

Ching-tê-chên

China

Ma-wang-tui

Lung-ch'üan

Kiangsi

Chien yao

Hunan

Chi-chou

Fukien

Te-hua

Taipei

T'ung-an

Ch'üan-chou

Map of Asia

Kwangtung

Hsi-ts'un

Taiwan

△ Kiln sites

Kuang-chou

○ Other sites

□ Cities

South China Sea

Philippines

0

500 km

Chronology

CHINA

NEOLITHIC c. 3500–1500 B.C.
SHANG DYNASTY 1523–1028 B.C. An-yang period, 1300–1028 B.C.
CHOU DYNASTY 1027–250 B.C. Western Chou dynasty, 1027–771 B.C.
 Eastern Chou dynasty, 771–256 B.C.
 Period of the Spring and Autumn
 Annals, 722–481 B.C.
 Period of the Warring States, 481–221 B.C.

CH'IN DYNASTY 221–206 B.C.
HAN DYNASTY 206 B.C.–A.D. 220 Former (or Western) Han dynasty, 206 B.C.–A.D. 9
 Later (or Eastern) Han dynasty, 25–220

THREE KINGDOMS 220–280
SIX DYNASTIES 220–589 Northern Dynasties, 317–589
 Northern Wei dynasty, 386–534
 Northern Ch'i dynasty, 550–577
 Northern Chou dynasty, 557–581
 Southern dynasties, 420–589

SUI DYNASTY 581–618
T'ANG DYNASTY 618–906 Important rulers:
 T'ai-tsung, 627–649
 Empress Wu, 674–705
 Hsüan-tsung (Ming Huang), 712–755

FIVE DYNASTIES 907–960 Liao Kingdom (in Manchuria), 916–1124
SUNG DYNASTY 960–1279 Northern Sung dynasty, 960–1127
 Important rulers:
 Hui-tsung, 1101–1125
 Southern Sung dynasty, 1127–1270

YUAN DYNASTY 1280–1368
MING DYNASTY 1368–1644 Important rulers:
 Yung-lo, 1403–1424
 Hsüan-tê, 1426–1435
 Ch'êng-hua, 1465–1487
 Chêng-tê, 1506–1521
 Chia-ching, 1522–1566
 Wan-li, 1573–1619

CH'ING DYNASTY 1644–1912 Important rulers:
 K'ang-hsi, 1662–1722
 Yung-chêng, 1723–1735
 Ch'ien-lung, 1736–1795
 Chia-ch'ing, 1796–1820

JAPAN

JOMON PERIOD c. 4500–c. 200 B.C.
YAYOI PERIOD c. 200 B.C.–A.D. 250
KOFUN (TUMULUS) PERIOD c. 250–552
ASUKA (SUIKO) PERIOD 552–645 Important rulers:
 Empress Suiko, 593–628
 Prince Shōtoku, Regent, 593–622

NARA PERIOD 645–794 Early Nara, or Hakuhō, 645–710
 Late Nara, or Tempyō, 710–794
 Important rulers:
 Shōmu, 724–749
 Empress Kōken, 749–758

HEIAN PERIOD 794–1185 Early Heian or Jōgan (Kōnin), 794–897
 Late Heian, or Fujiwara, 897–1185

KAMAKURA PERIOD 1185–1333 Important rulers:
 Minamoto Yoritomo, Shogun, 1192–1199

NAMBOKUCHO PERIOD 1333–1392
(NORTHERN AND SOUTHERN COURTS)
MUROMACHI (ASHIKAGA) PERIOD 1392–1568 Important rulers:
 Ashikaga Yoshimitsu, Shogun, 1368–1394
 Ashikaga Yoshimasa, Shogun, 1449–1473

MOMOYAMA PERIOD 1568–1615 Important rulers:
 Oda Nobunaga, 1573–1582
 Toyotomi Hideyoshi, 1586–1598
 Tokugawa Ieyasu, 1600–1616

EDO (TOKUGAWA) PERIOD 1615–1868 Important eras:
 Genna-Kanei, 1615–1643
 Genroku, 1688–1703
 Bunka-Bunsei, 1804–1829

MEIJI PERIOD 1868–1912

KOREA

THREE KINGDOMS PERIOD 57 B.C.–A.D. 668 Kokuryo Dynasty, 37 B.C.–A.D. 668
 Paekche Dynasty, 18 B.C.–A.D. 663
 Old Silla Dynasty, 57 B.C.–A.D. 668

UNITED SILLA KINGDOM 668–936
KORYO PERIOD 918–1392
YI DYNASTY 1392–1910

Catalogue and Plates

An asterisk after the object number, e.g. 3*, indicates
that the object is illustrated in color in the catalogue.

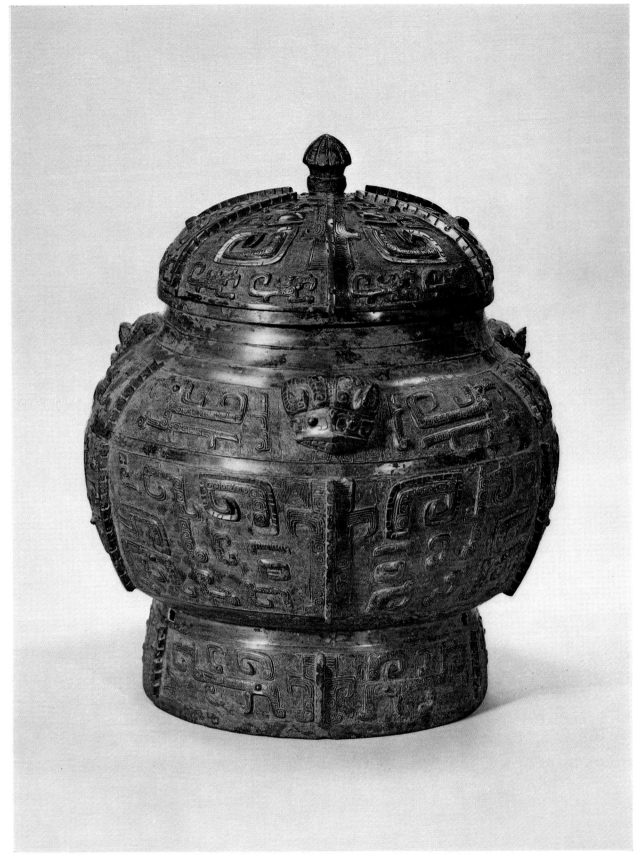

Catalogue no. 3 *P'ou* (ceremonial wine or water vessel)

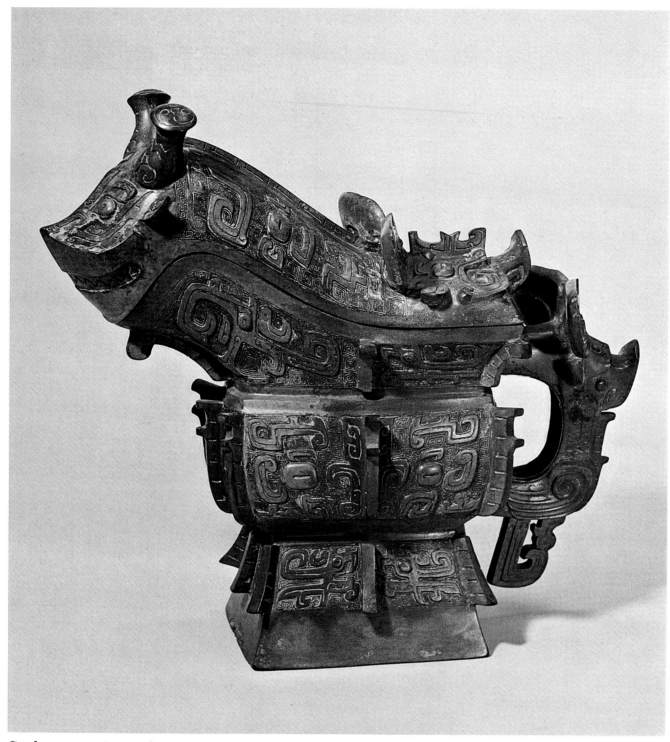

Catalogue no. 7 *Ssu-kuang* (ceremonial wine vessel)

Catalogue no. 14 Globular Jar

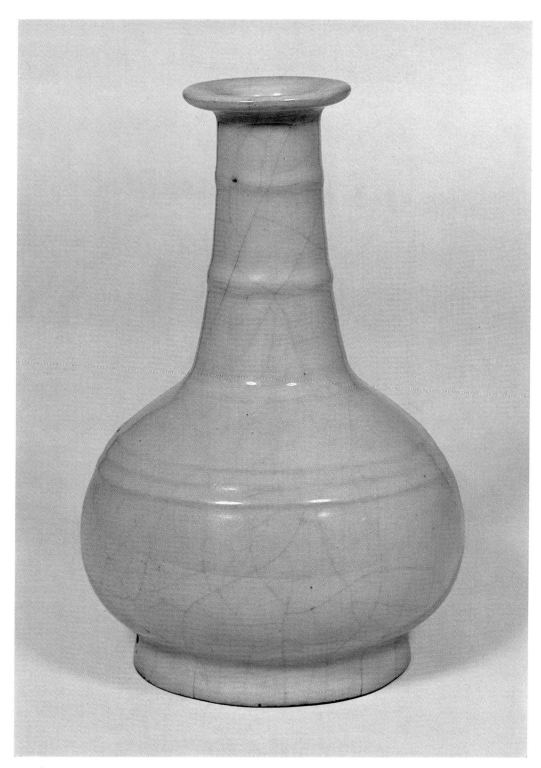

Catalogue no. 20 Vase

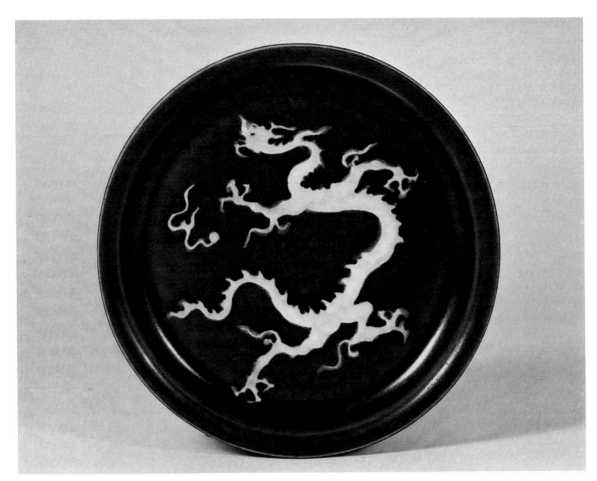

Catalogue no. 22 Dish with Design of Dragon Chasing Flaming Pearl

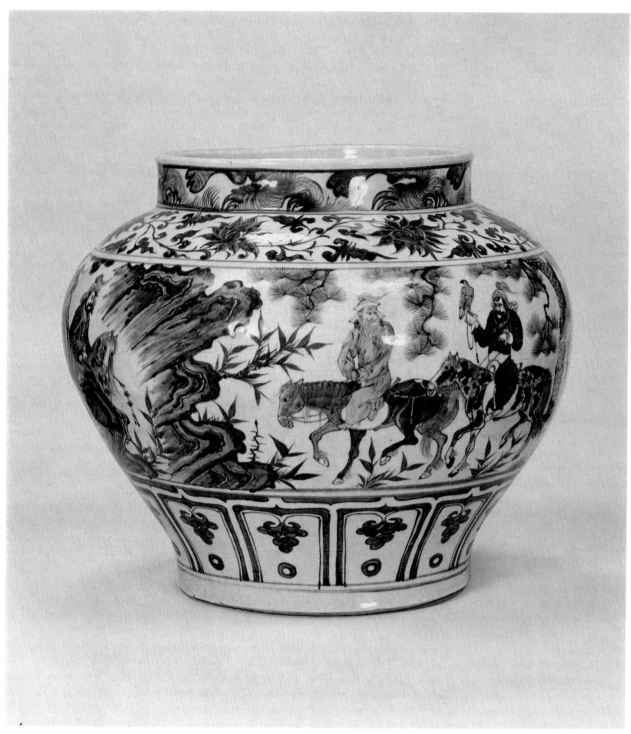

Catalogue no. 23 Jar with Design of Figures on Horseback

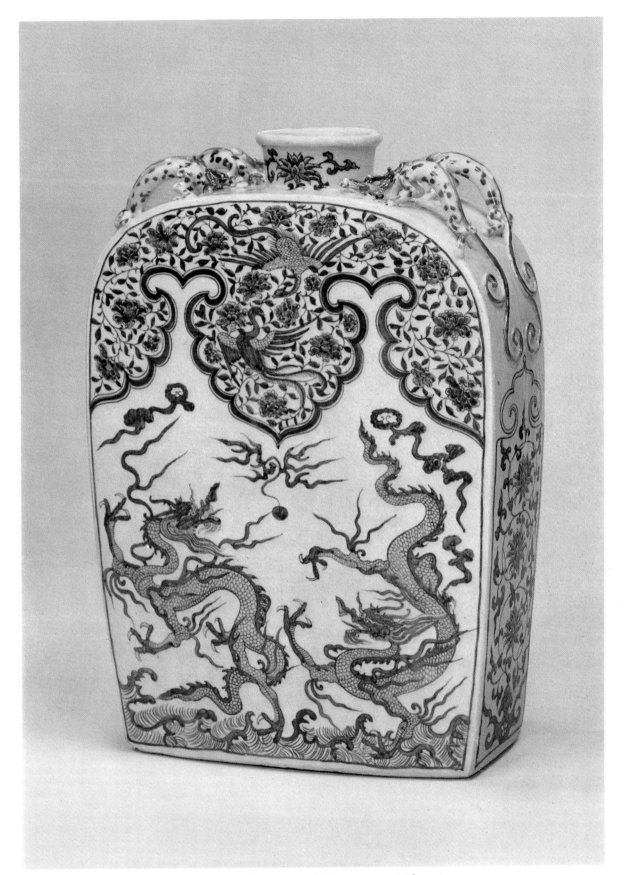

Catalogue no. 24 Pilgrim Bottle with Design of Dragons and Phoenixes

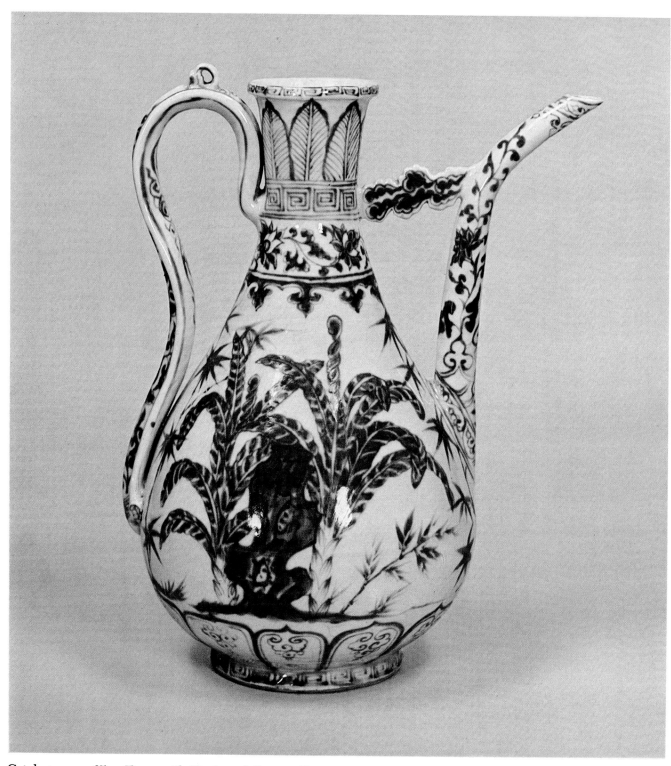

Catalogue no. 25 Ewer with Design of Banana Trees

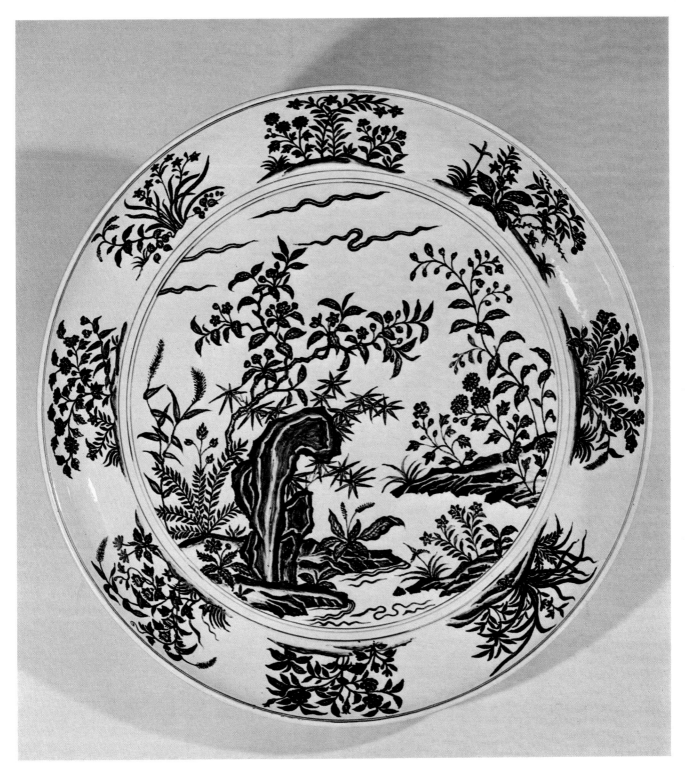

Catalogue no. 27 Large Dish with Design of Flowers and Rocks

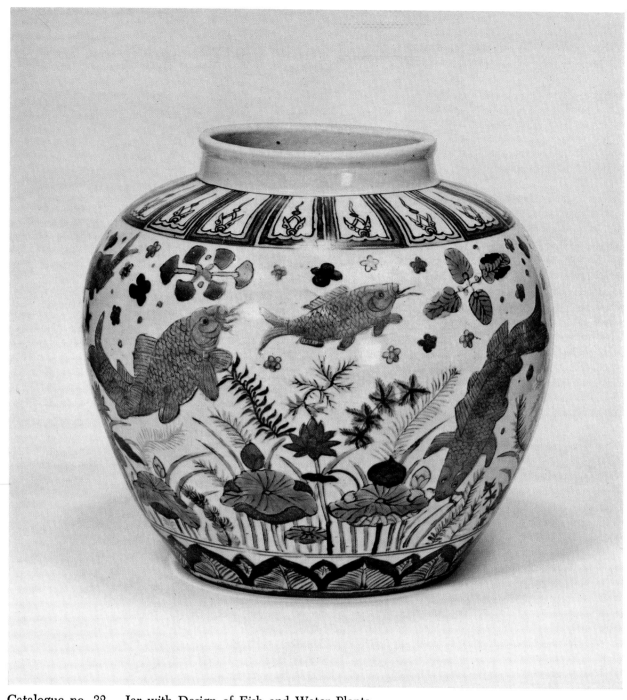

Catalogue no. 32 Jar with Design of Fish and Water Plants

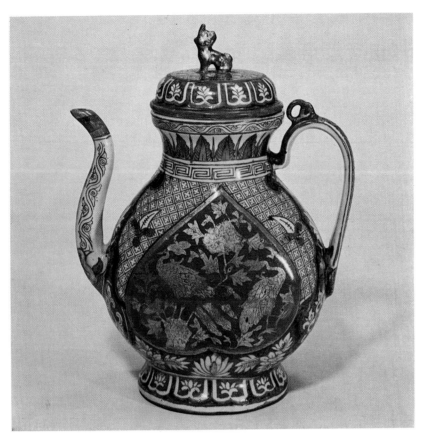

Catalogue no. 30 Ewer with Design of Peacock and Peonies

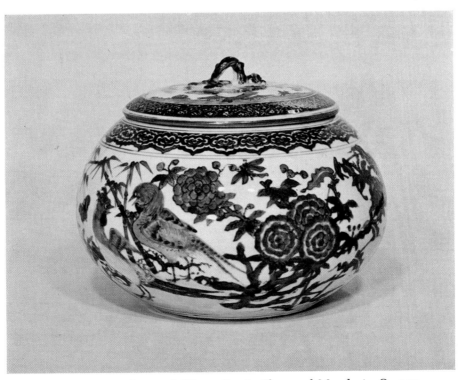

Catalogue no. 34 Covered Water Jar in Shape of Mandarin Orange
with Design of Flowers and Birds

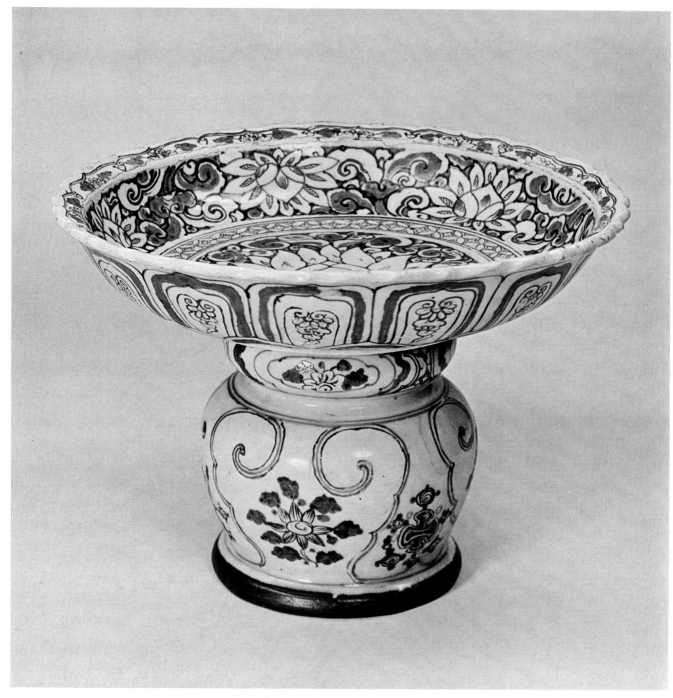

Catalogue no. 38 Footed Dish with Design of Flowers

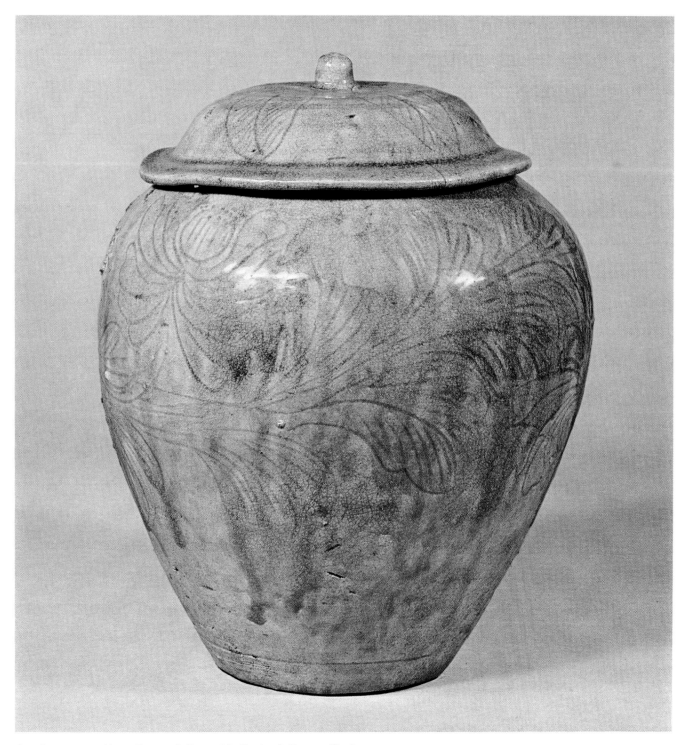

Catalogue no. 41 Covered Jar with Incised Peony Design

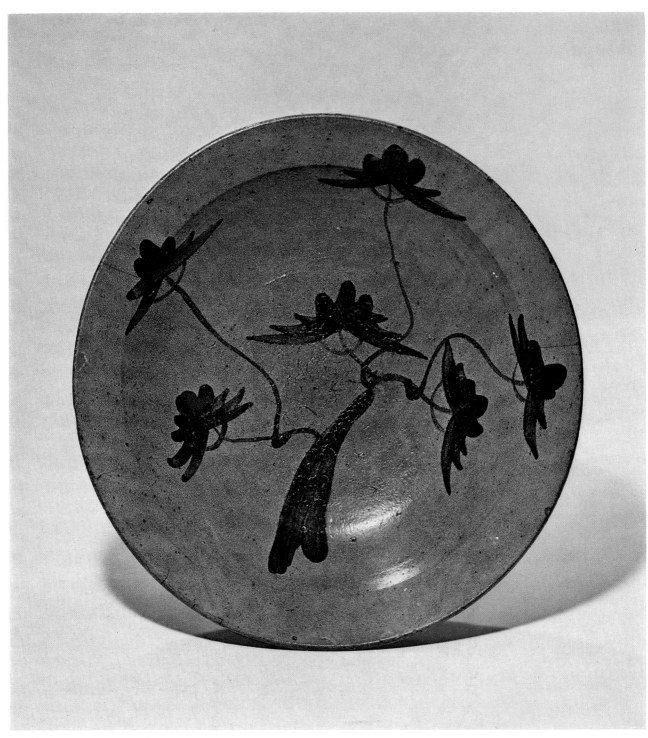

Catalogue no. 49 Dish with Design of Pine Trees

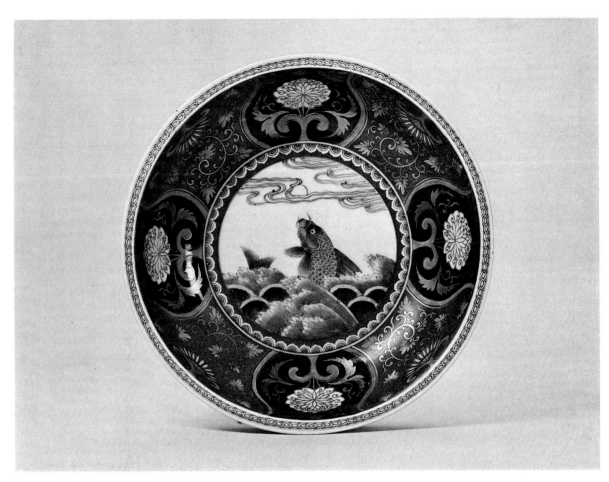

Catalogue no. 53 Bowl with Carp Design

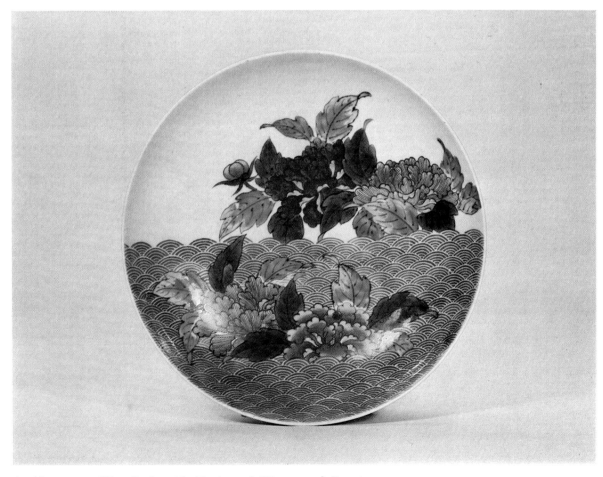

Catalogue no. 57 Dish with Design of Waves and Peonies

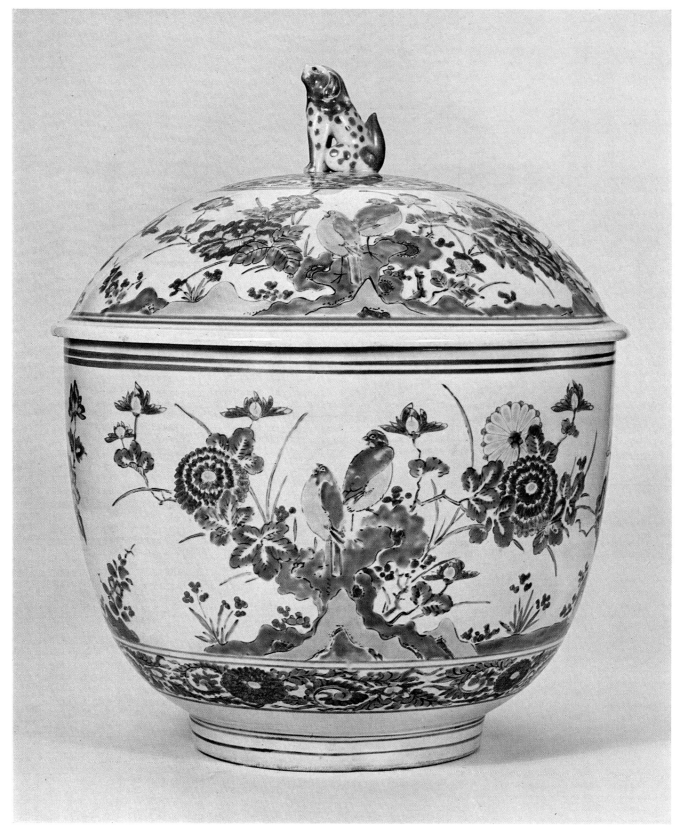

Catalogue no. 56 Large Covered Bowl with Flower-and-Bird Design

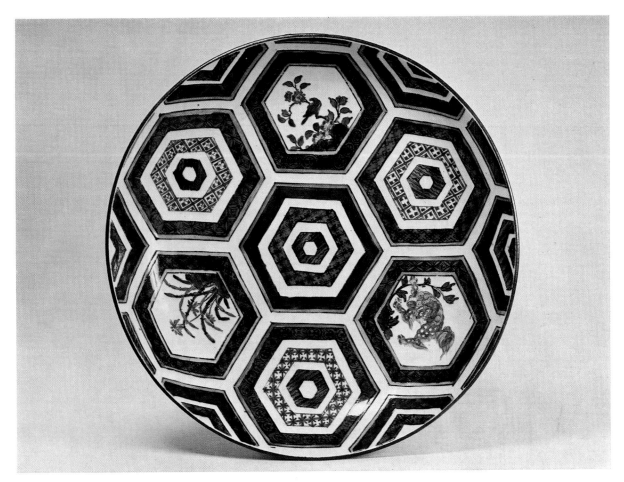

Catalogue no. 58 Dish with Hexagonal Medallions

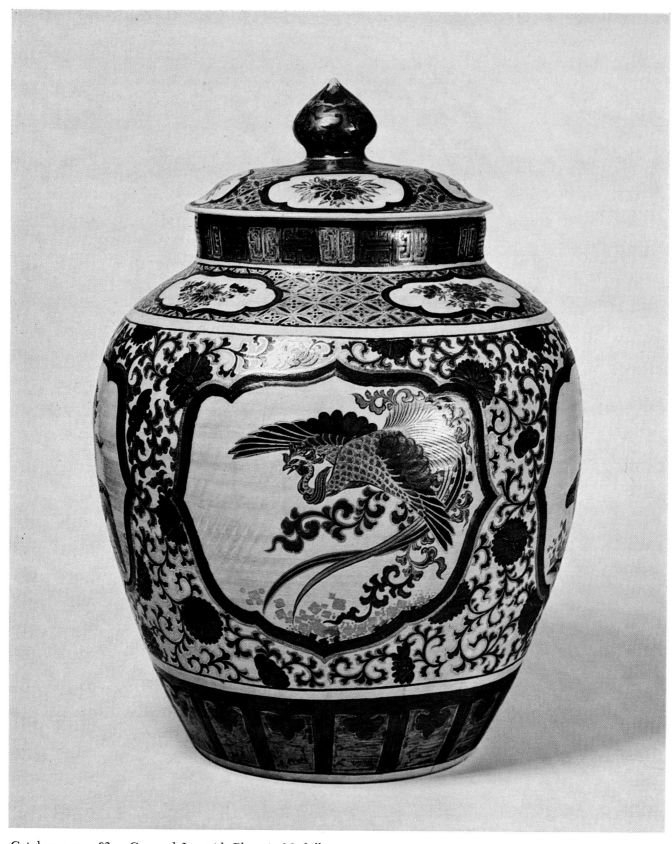

Catalogue no. 62 Covered Jar with Phoenix Medallions

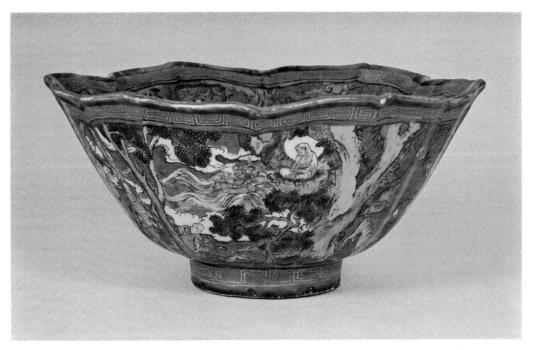

Catalogue no. 64 Flower-Shaped Bowl with Design of Lohans

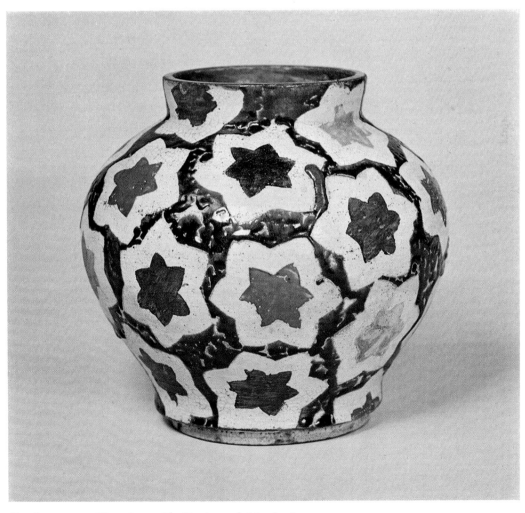

Catalogue no. 63 Jar with Design of Maple Leaves

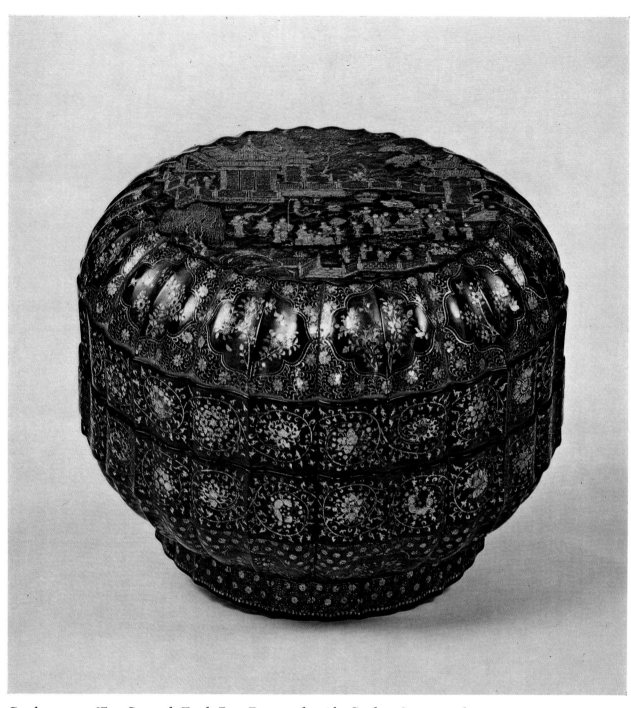

Catalogue no. 67 Covered Food Box Decorated with Garden Scenes and
 Floral Scrolls

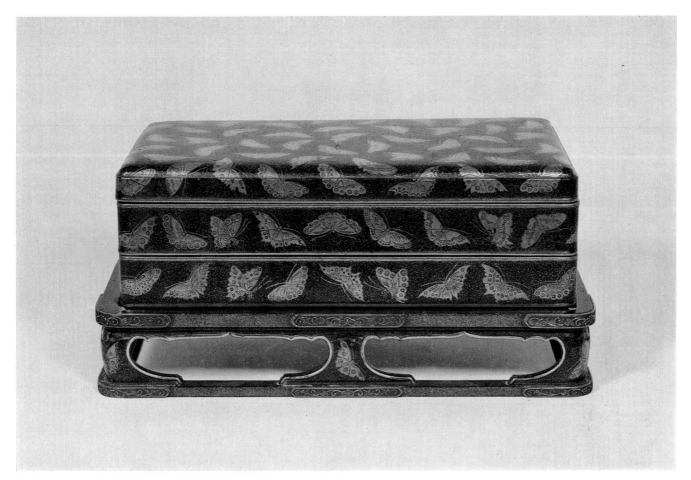

Catalogue no. 71 Sutra Box with Butterfly Design

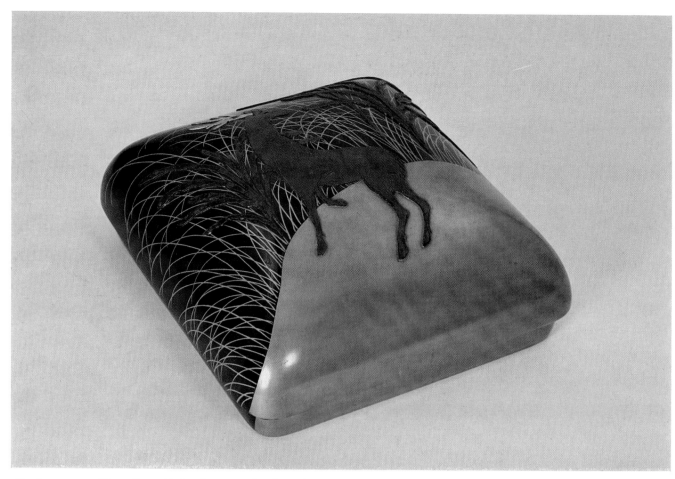

Catalogue no. 73 *Suzuribako* (writing box) with Deer Design

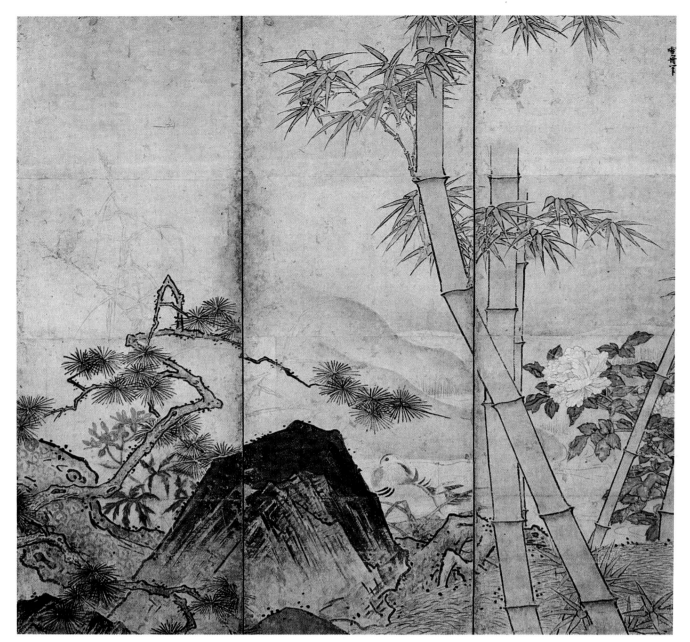

Catalogue no. 80 Flowers and Birds of the Four Seasons (detail)

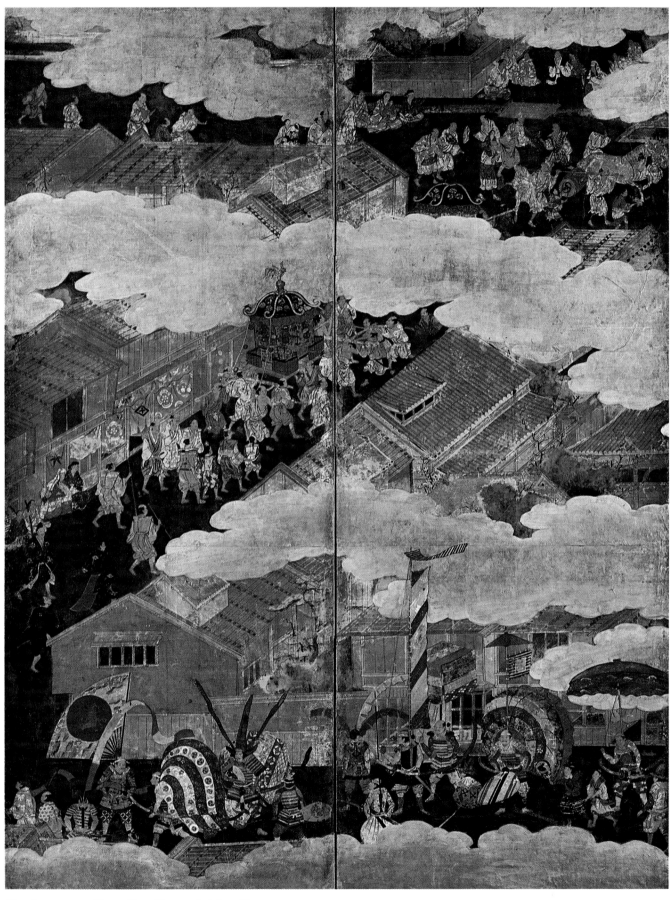

Catalogue no. 83 Gion Festival (detail)

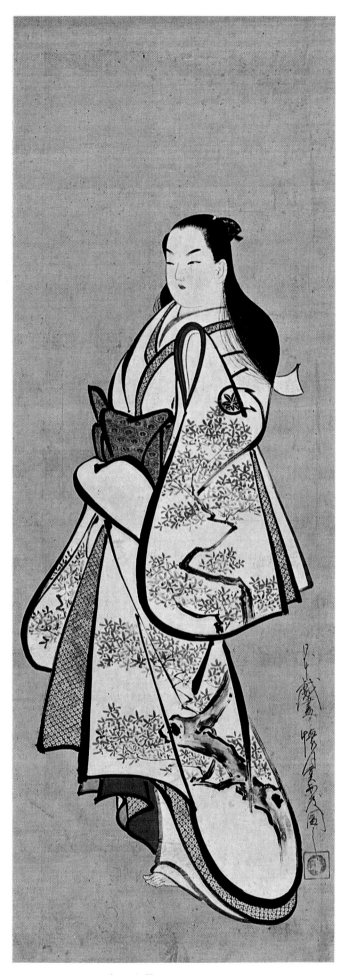

Catalogue no. 85 A Beauty

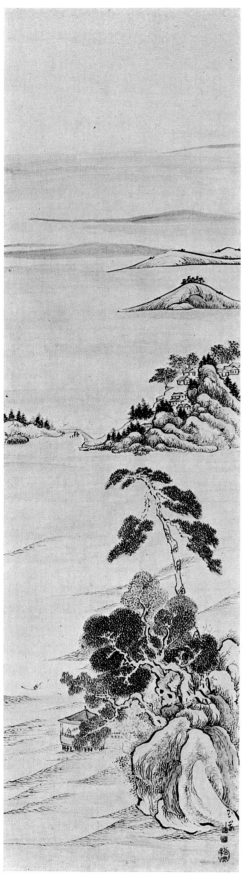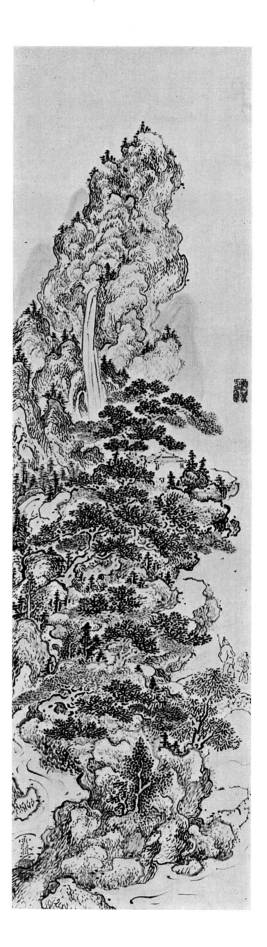

Catalogue no. 90 Two Landscapes

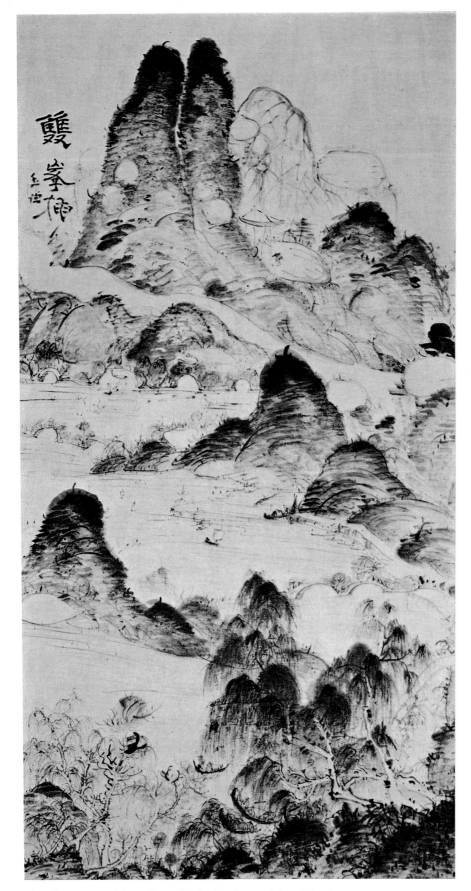

Catalogue no. 92 Two Peaks Embraced by Clouds

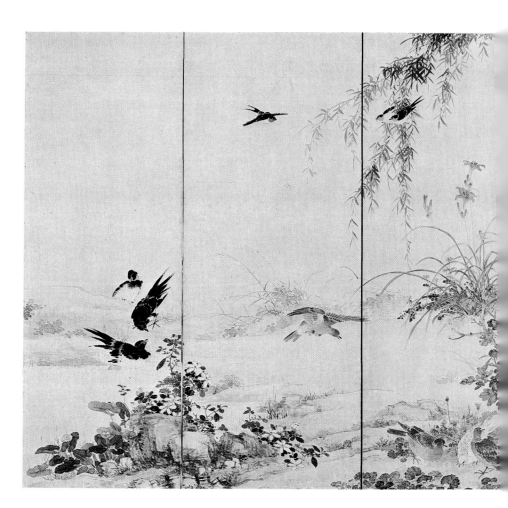

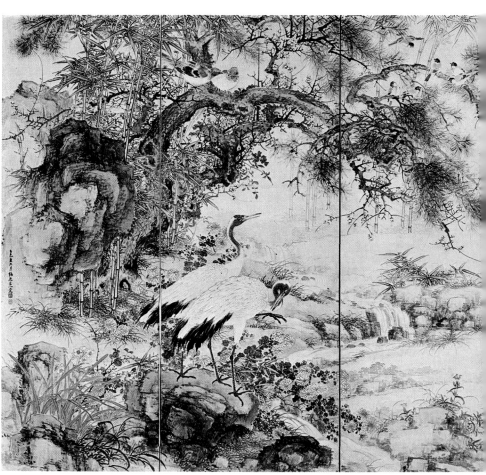

Catalogue no. 98 Flowers and Birds

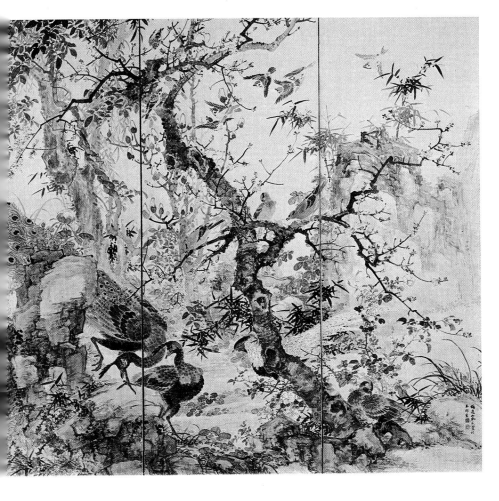

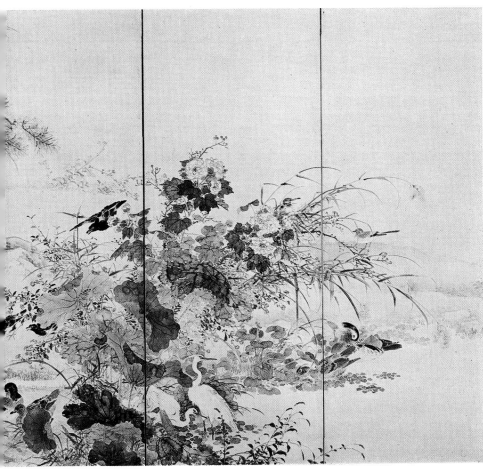

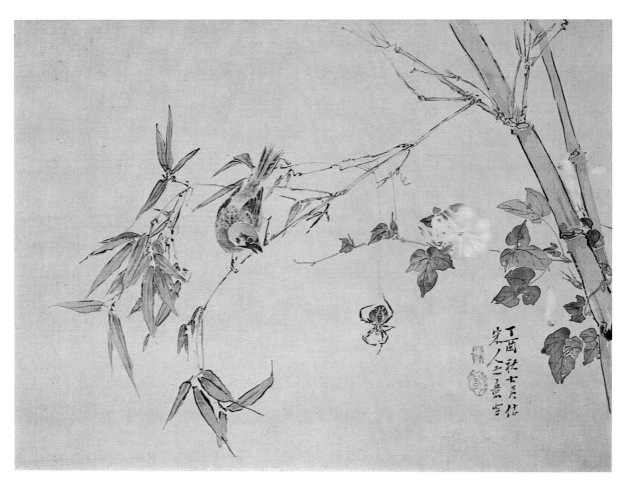

Catalogue no. 97 Spider and Sparrow

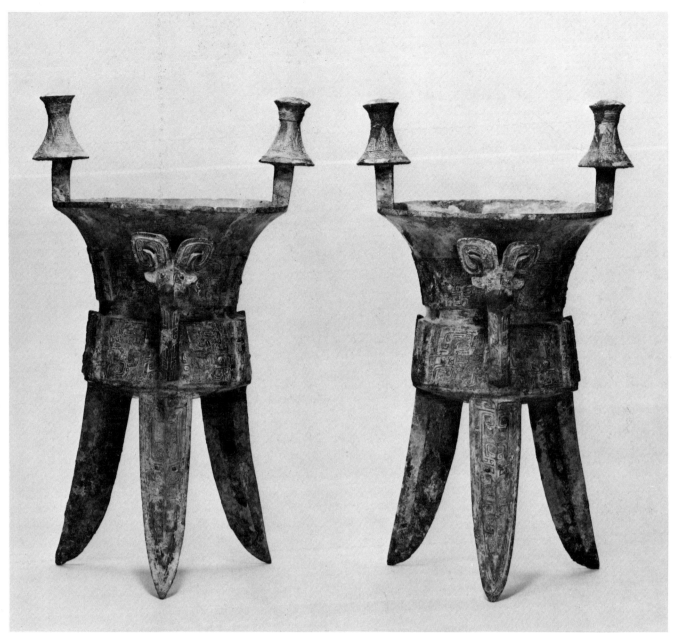

CHINESE BRONZES

1
Pair of *Chia* (ceremonial wine vessels)

China, Shang dynasty, An-yang period
(fourteenth-eleventh centuries B.C.)
Bronze
Height: 48.6 cm.
Important Art Object

The *Chia* is a vessel used to heat wine during the sacrificial ceremonies forming part of the ancestor worship during the Shang (1523–1028 B.C.) and early Chou (1027–771 B.C.) dynasties. The pair of inscribed *Chia* in the exhibition are among the most important examples of the ancient Chinese bronzes in the Idemitsu Collection. The two *Chia* were reportedly excavated at An-yang, the Shang capital during its latter years, c. 1300–1028 B.C.

Each vessel has a deep bowl with an elegantly flar-ing rim, a broad base, and convex bottoms supported on three, slightly curving, triangular legs with pointed ends. Two rectangular uprights with tall flaring caps are mounted on the lip, and a strap handle with ani-mal head, displaying curved, C-shaped horns is attach-ed to the side of each vessel, directly above one leg. The upright projections are diametric to each other on the rim, and at right angles to the handles, which are lined up vertically with one of the outward-curved, triangular-shaped legs. The placing of the upright posts across the diameter of the mouth rim, and the elegant silhouette of the vessels differs from the earlier form of the *Chia*, prevalent in what Max Loehr refers to as Shang, style I and Shang, style II (*Ritual Vessels of Bronze Age China*. The Asia Society, New York, 1968).

Vertical flanges divide both the two main registers of the *Chia* and the *t'ao-t'ieh* that decorate them. A finely delineated, pendant blade with *t'ao-t'ieh* and *lei-wên* pattern design decorates the outer face of each

leg. The caps projecting from the lip have a triangular design and *lei-wên* pattern; abstract scroll designs decorate the handles. The bold animal heads with prominent, round horns form an integral part of the handles, and give the appearance of literally holding the curved handles in their mouths.

Inside the bottom of each vessel there is a single-character inscription.

Published
Hakutsuru Fine Art Museum. *Masterpieces of the Idemitsu Collection.* (Kobe, 1976). pl. 73.
Idemitsu Museum of Arts. *Ancient Chinese Works of Art.* (Tokyo, 1978). pl. 48.
Idemitsu Museum of Arts. *Special Exhibition Commemorating the Tenth Anniversary of the Idemitsu Collection.* (Tokyo, 1976). pl. 62.
Umehara, Sueji. *Kanan anyō ihō.* (Kyoto, 1940). pl. 49.

References
Loehr, Max. *Ritual Vessels of Bronze Age China.* (New York, 1968). cf. cat. nos. 4, 8, and 14.
Sugimura, Yūzō. *Chūgoku Ko-dōki.* Idemitsu Art Gallery Series, Vol. 3. (Toyo, 1966). pp. 98–105, cat. no. 8, for inscription, see p. 98.

Fig. 1. Inscription inside vessel (no. 1)

2
Tsun (ceremonial wine vessel)

China, Shang dynasty, An-yang period
(fourteenth-eleventh centuries B.C.)
Bronze
Height: 32.5 cm

The bronze wine vessel known as a *Tsun* held an important place in the ceremonies accompanying ancestral worship. It is associated primarily with bronze production of the Shang dynasty (1523–1028 B.C.) and the type soon disappeared in early Western Chou, if not earlier.

The Idemitsu *Tsun*, like other vessels of this type, is built up in three horizontal sections. The vessel has a high conical base with slightly convex sides. The body is considerably wider than the foot and rises toward the shoulder where it angles sharply inward, rising toward the neck. The bases of the neck and the body have roughly the same diameter. The neck itself rises rather steeply, then flares out sharply to form a wide trumpet-shaped mouth.

The neck is plain and undecorated, except for three slightly raised lines, or 'strings.' On the shoulder a narrow band with *t'ao-t'ieh* is divided by flanges, bordered above and below by rows of raised circlets. The body is decorated with a wide band of *t'ao-t'ieh* masks bordered by rows of circlets and divided vertically by notched flanges. Another band of *t'ao-t'ieh* encircles the truncated base just above the foot, below a plain zone with raised lines similar to those on the neck. The base also features three holes required to secure molds in the casting process. A two-character inscription is cast on the inside of the base.

Three buffalo heads in relief are placed at the juncture of the shoulder and body. The animal heads resemble those on a *Tsun* in the Museum für Ostasiatische Kunst in Cologne, Germany, illustrated by Max Loehr in *Ritual Vessels of Bronze Age China.* The proportions and outline of the Idemitsu *Tsun*, in fact, correspond to those of the *Tsun* in Cologne, both vessels having a narrow foot, a wide body which juts out over the foot, and a flaring trumpet-shaped neck. Stylistically, this would relate the Idemitsu *Tsun* to what Loehr referred to as Shang, style IV, associated with the time when An-yang was the Shang capital.

The close-knit linear design that distinguishes the Idemitsu vessel is cast in intaglio, or sunken relief, in a thread-like technique. Only the eyes of the *t'ao-t'ieh*, and the animal heads on the shoulder and flanges are raised above the surface of the vessel. This design, which lacks the usual *lei-wên* spiral background, corresponds most closely to Loehr's Shang, style III. An early An-yang date is therefore suggested for the Idemitsu *Tsun*, pre-dating some of the other, stylistically more advanced bronze vessels in the exhibition.

Published
Idemitsu Museum of Arts. *Ancient Chinese Works of Art.* (Tokyo, 1978). pl. 36.

References
Loehr, Max. *Ritual Vessels of Bronze Age China.* (New York, 1968). cf. cat. nos. 12, 14, and 30.
Sugimura, Yūzō. *Chūgoku Ko-dōki.* Idemitsu Art Gallery Series, Vol. 3. (Tokyo, 1966). pp. 134–137.

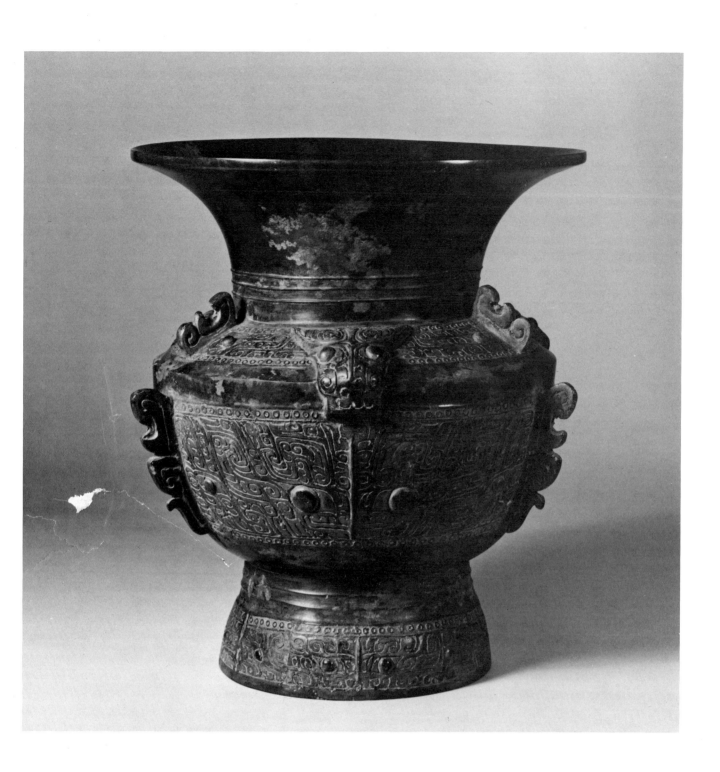

3*

P'ou (ceremonial wine or water vessel)

China, Shang dynasty, An-yang period
(fourteenth-eleventh centuries B.C.)
Bronze
Height: 48.0 cm. Diameter at mouth: 24.0 cm.

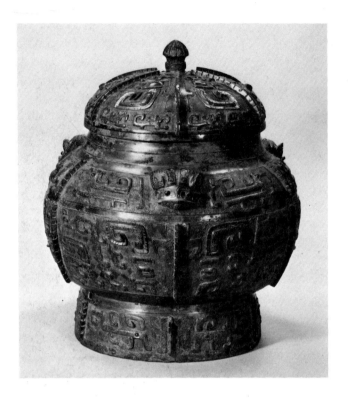

The *P'ou* in the Idemitsu Collection is one of the largest and finest examples of its type, complete with its original cover. It is distinguished by an unusually bold and vigorous design that covers the entire vessel. Three of the most prominent and frequently occurring motifs of Chinese bronze decor are found on the Idemitsu *P'ou*: dragons, invariably shown in profile; the *t'ao-t'ieh*, or monster mask, always shown full face and in low relief, with prominent staring eyes, eyebrows, and horns, but as a rule without a lower jaw; and the spiral pattern or *lei-wên* (thunder pattern), either round or squared. Three large *t'ao-t'ieh* masks flanked by vertical *K'uei* dragons on *lei-wên* ground form the principal design.

Vertical flanges divide the cover and body of the vessel into six segments. The cover has a conical knob and is decorated with a *ch'an wên* (cicada) pattern. A horizontal band around the shoulder of the vessel has three horned animal heads in relief, and confronted pairs of *K'uei* dragons separated by flanges. Three plain grooves encircle the neck of the vessel. The *t'ao-t'ieh* are divided and separated from each other by vertical flanges, and separated from the shoulder band by a horizontal groove.

The high circular foot is also divided into six sections with confronted *K'uei* dragons on *lei-wên* ground and vertical flanges. A plain horizontal band pierced by three small holes separates the foot from the body. The inside of the cover contains an inscription of flowing flower petals.

Many different types of dragons appear on Shang and early Chou bronzes, but the term *K'uei* is often prefixed to the word 'dragon' to describe specific beasts that appear singly or in pairs, or in a continuous line, neatly arranged in horizontal bands, as on the cover of the Idemitsu *P'ou*. Stylized-designs of birds, cicada patterns, and a variety of other motifs were frequently added to the basic decor by the Chinese bronze casters of the Shang and early Chou periods.

A similar, but slightly smaller *P'ou* of Shang-early Chou date (twelfth-eleventh centuries B.C.) is in the Freer Gallery of Art, Washington, D.C. The Idemitsu *P'ou* also relates to a famous, even larger example (height: 62.4 cm.) in the Nezu Collection, Tokyo, and to a large *P'ou* (height: 36.2 cm.) in the Sumitomo Collection, Kyoto. Other important examples can be found in the University Museum, Philadelphia, and the Metropolitan Museum of Art. The University Museum example measures 48.2 centimeters in height, virtually the same as the Idemitsu piece, and the Metropolitan Museum's *P'ou* 4 centimeters

All of these examples are large, and similar, decorated with vertical divisions of flanges and decorative motifs of *t'ao-t'ieh* and dragons in low relief on a *lei-wên* ground of spirals. The University and the Sumitomo example are identical in design and of almost the same size. The Idemitsu example, one of the largest, is generally recognized as one of the greatest treasures in the Idemitsu Collection.

Published
Asahi Shinbunsha. *Asiatic Art in Japanese Collections: Bronze.* (Tokyo, 1968). pl. 16.
Hakutsuru Fine Art Museum. *Masterpieces of the Idemitsu Collection.* (Kobe, 1976). pl. 74.
Mizuno, Seiichi. *Bronzes and Jades of Ancient China.* Translated by J.O. Gauntlett. (Tokyo, 1959). color pl. 8 and pl. 65B.
Sugimura, Yūzō. *Chūgoku Ko-dōki.* Idemitsu Art Gallery Series, Vol. 3. (Tokyo, 1966). pl. 18.

References
Idemitsu Museum of Arts. *Special Exhibition Commemorating the Tenth Anniversary of the Idemitsu Collection.* (Tokyo, 1976).
Okudo, Naoshige et al. *Selected Masterpieces from the Collection of the Nezu Institute of Fine Arts.* Translated by Shigetaka Kaneko. (Tokyo, 1978). pl. 193, cf. pl. 634.
Pope, John et al. *The Freer Chinese Bronzes*, Vol. 1. The Freer Gallery of Art Oriental Studies, no. 7. (Washington, D.C., 1967). cf. pl. 2.
Umehara, Sueji. *Shin-shū sen-oku sei-shō*, Vol. 2. (Kyoto, 1971). cf. pl. 40.
Umehara, Sueji. *Shina Kodō seika.* part. I, Vol. II. (Osaka, 1933). cf. pls. 127, 128.

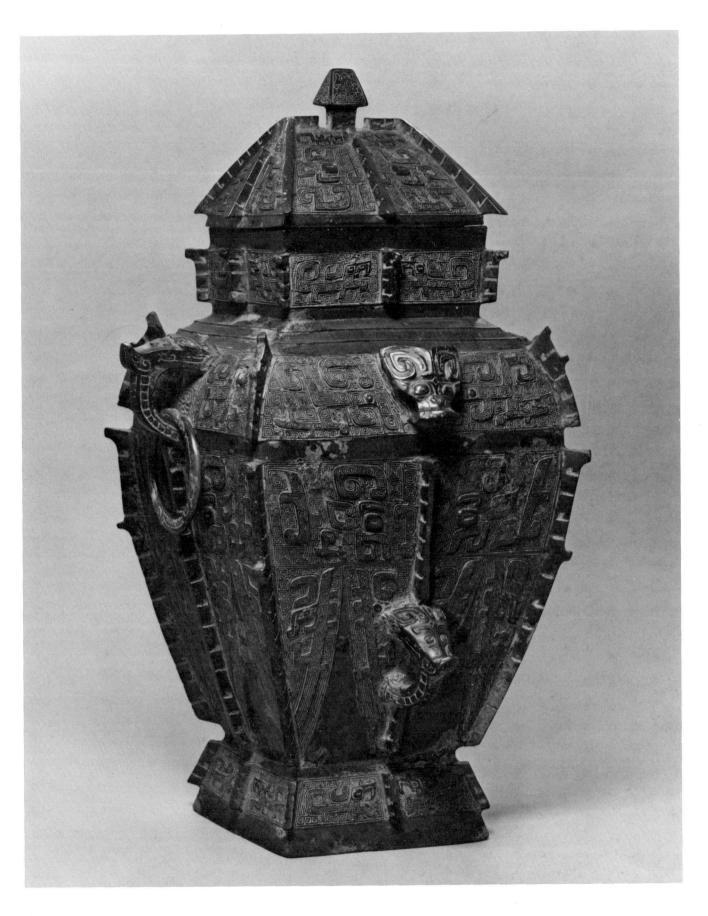

4

Fang-lei (ceremonial wine vessel)

*China, Shang dynasty, An-yang period
(fourteenth-eleventh centuries B.C.)
Bronze
Height: 45.0 cm. Diameter at mouth: 13.5 cm.*

This tall, monumental vessel is square in shape with a rounded shoulder and a straight neck. It rests on a pyramidal foot, and has a roof-shaped cover with a central post surmounted by a knob. The cover, neck, body, and foot have flanges running from the ridge of the lid down to the four corners and down the sides of

the vessel. Two ring-handles are surmounted by an animal head on the shoulder and two additional ring-handles, each supporting an animal head with C-shaped horns, are mounted on the lower side of the body. Two additional animal heads, without ring-handles, sit on the shoulder on each side of the vessel.

The decoration, which covers the entire surface of the vessel consists of t'ao-t'ieh masks on the lid and upper body, and pairs of confronted dragons on the neck, shoulder, and around the foot. The lower part of the body, below the t'ao-t'ieh masks, is decorated with hanging blades, each consisting of two vertical dragons. The blades are divided by the corner and central flanges. The entire background is filled with a design of lei-wên spirals.

A Fang-lei in the Saint Louis Art Museum, although similar to the Idemitsu Fang-lei, displays some striking differences, which suggest a somewhat later date. The most notable changes, when compared to the Idemitsu piece, are the prominent flanges with hooks and spikes at varying intervals, the animal heads with five-pronged antlers in full relief which surmount the handles, and the double t'ao-t'ieh masks on the sides of the vessel. According to Max Loehr, it is difficult to associate the heavily undercut flanges with the Shang date; he therefore attributes the Saint Louis example to the early Western Chou period (late eleventh-early tenth centuries B.C.), despite the Shang date assigned to the piece by other scholars. The Idemitsu example, however, with its regular flanges and usual t'ao-t'ieh and dragon designs on lei-wên ground, is less baroque, less sculptural in concept, and points to an earlier date in the Shang dynasty.

Published
Idemitsu Museum of Arts. *Ancient Chinese Works of Art.* (Tokyo, 1978). pl. 41.

References
Loehr, Max. *Ritual Vessels of Bronze Age China.* (New York, 1968). pl. 102, cf. cat. no. 43.
Umehara, Sueji. *Nihon shūcho Shina Kodō seika*, Vol. 3. (Osaka, 1964).

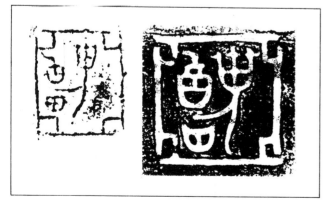

Fig. 2. Inscription inside cover and vessel (no. 4)

5

Large *Ting* (ceremonial food vessel)

From Lo-yang, Honan Province
China, Shang dynasty, late An-yang period
(twelfth-eleventh centuries B.C.)
Bronze
Height: 55.2 cm.

The *Ting* is a cooking vessel used in ceremonies associated with ancestor worship. The vessel was produced throughout the Bronze Age, although modified during middle and late Chou periods in both form and decoration. The *Ting* usually occurs as a round vessel with three legs, but numerous examples can be found of the *Ting* as a rectangular vessel supported on four legs. The rectangular *Ting*, however, is found only in Shang and early Chou (late eleventh-early tenth centuries B.C.), whereas the round type persisted throughout the Chou and into the post-Han period (206 B.C.–A.D. 221) when it was eventually transformed into a three-legged incense burner. The *Ting* was later adapted to ceramic usage and, under the influence of archaism prevailing at the Sung court (960–1279) sometimes occurs as a tripod incense burner in *Lung-ch'üan* celadons and in *Kuan* ware of the period. The *Ting* tripod continued as a type in ceramic products of the Yüan (1288–1368), Ming (1368–1644), and Ch'ing (1644–1912) dynasties.

The Idemitsu bronze has a deep round body supported on three solid, slightly convex legs. Two upright loop handles rise vertically from the rim, placed diagonally and at right angles to the frontal flange and t'ao-t'ieh, and at right angles to the third, or rear leg. The *Ting* is decorated with a single horizontal band below the rim with six t'ao-t'ieh in low relief divided by vertical flanges. The background is filled with square and rounded lei-wên spirals and meander pattern. A t'ao-t'ieh divided by a flange is placed on the upper segment of each leg, just below the point where the leg joins the circular bowl. Two characters are inscribed on the inside of the bowl, below the rim.

The Idemitsu bronze, with its prominent, slightly raised design of t'ao-t'ieh on lei-wên ground belongs stylistically to the products of the late Shang–early Western Chou periods (1100–950 B.C.), just before the transition to bolder, more sculptural designs in high relief. In the later phase of the early Western Chou style, the Shang zoomorphic images were often transformed into linear ribbon-like designs of birds.

Published
Asahi Shinbunsha. *Asiatic Art in Japanese Collections: Bronze.* (Tokyo, 1968). pl. 2.
Idemitsu Museum of Arts. *Special Exhibition Commemorating the Tenth Anniversary of the Idemitsu Collection.* (Tokyo, 1976). pl. 61.
Idemitsu Museum of Arts. *Ancient Chinese Works of Art.* (Tokyo, 1978). pl. 14.
Mizuno, Seiichi. *Bronzes and Jades of Ancient China.* Translated by J.O. Gauntlett. (Tokyo, 1959). p. 75, fig. 74,

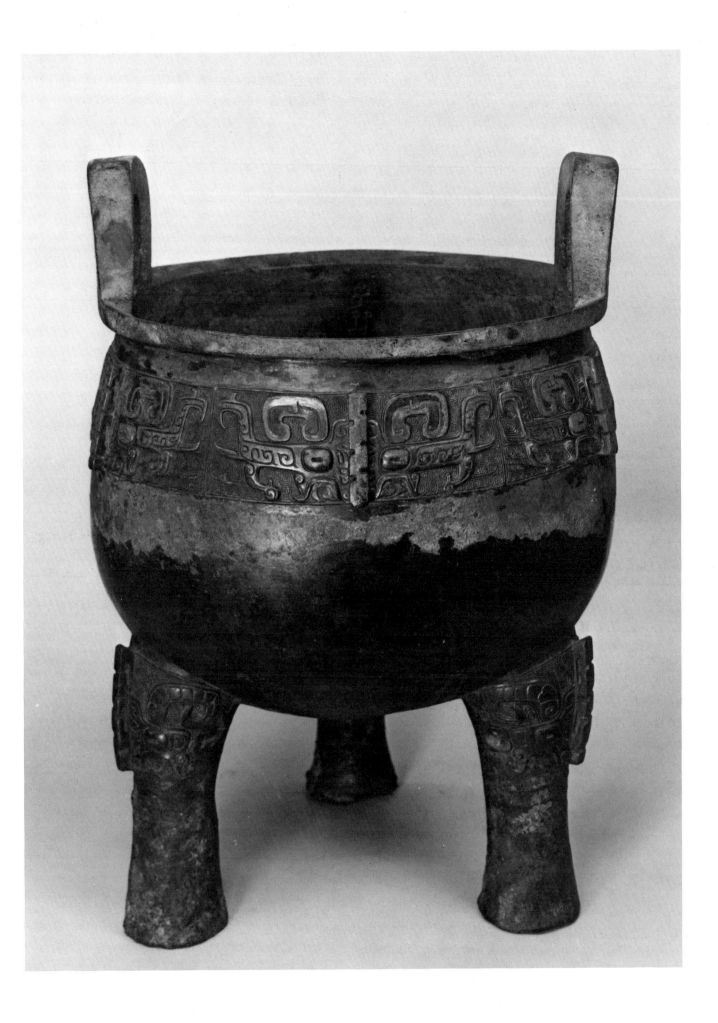

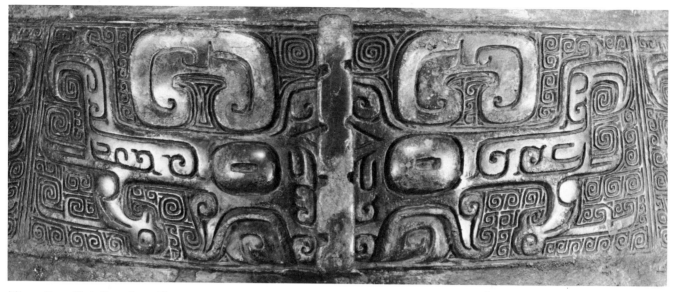

Fig. 3.　Detail　(no. 5)

pl. 66.
Sugimura, Yūzō. *Chūgoku Ko-dōki*. Idemitsu Art Gallery Series, Vol. 3. (Tokyo, 1966). no. 2.
The Tokyo National Museum. *Exhibition of Eastern Art Celebrating the Opening of the Gallery of Eastern Antiquities*. (Tokyo, 1968). pl. 226.

References
Expo Museum of Fine Arts. *Catalogue of Expo Museum of Fine Arts*. (Osaka, 1970). pp. 1–52.
Loehr, Max. *Ritual Vessels of Bronze Age China*. (New York, 1968). pls. 49, 51, and 52.
Mizuno, Seiichi. *Bronzes and Jades of Ancient China*. Translated by J.O. Gauntlett. (Tokyo, 1959).
Sugimura, Yūzō. *Chūgoku Ko-dōki*. Idemitsu Art Gallery Series, Vol. 3. (Tokyo, 1966).

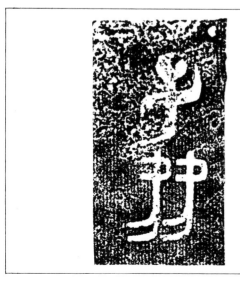

Fig. 4.　Inscription inside vessel　(no. 5)

6

Yu (ceremonial wine vessel)

China, Shang dynasty, late An-yang period
(twelfth-eleventh centuries B.C.)
Bronze
Height:　32.4 cm.

The *Yu* is a covered wine container with bail handle. It has a swelling concave body, ovoid in horizontal section and supported on a high foot, and a domed cover with high collar that fits over the neck of the vessel. The body and cover are divided vertically into four sections by prominent, sharply segmented flanges. The bail handle terminates in two feline animal heads with round bottle horns.

The body and cover are decorated with *t'ao-t'ieh* and dragon designs on *lei-wên* ground arranged in three distinct horizontal bands on the body, and a horizontal band encircling the collar of the cover.

The cover with its central knob is decorated with inverted *t'ao-t'ieh* in relief above a band of proboscidean dragons around the collar. A band of similar dragons encircles the neck of the vessel. The principal decoration on the body consists of two large *t'ao-t'ieh* masks with C-shaped horns, and large eyes in relief. The *t'ao-t'ieh* are divided bilaterally by the flanges, as are the similar but inverted *t'ao-t'ieh* masks on the cover. The oblong foot is decorated with a band of dragons. *Lei-wên* scrolls fill the background of the cover, body, and foot. A single character-like inscription is cast in relief inside the cover, and in intaglio on the interior of the body.

The *Yu* was a common form of bronze vessel used in the Shang (1523–1028 B.C.) and early Western Chou (1027–771 B.C.) dynasties to store or carry the wine used in the ceremonial worship of the royal ancestors. The Idemitsu Yu—with clearly defined *t'ao-t'ieh* masks in relief, profile dragons in horizontal bands, and *lei-wên* pattern filling the ground—conforms stylistically to the

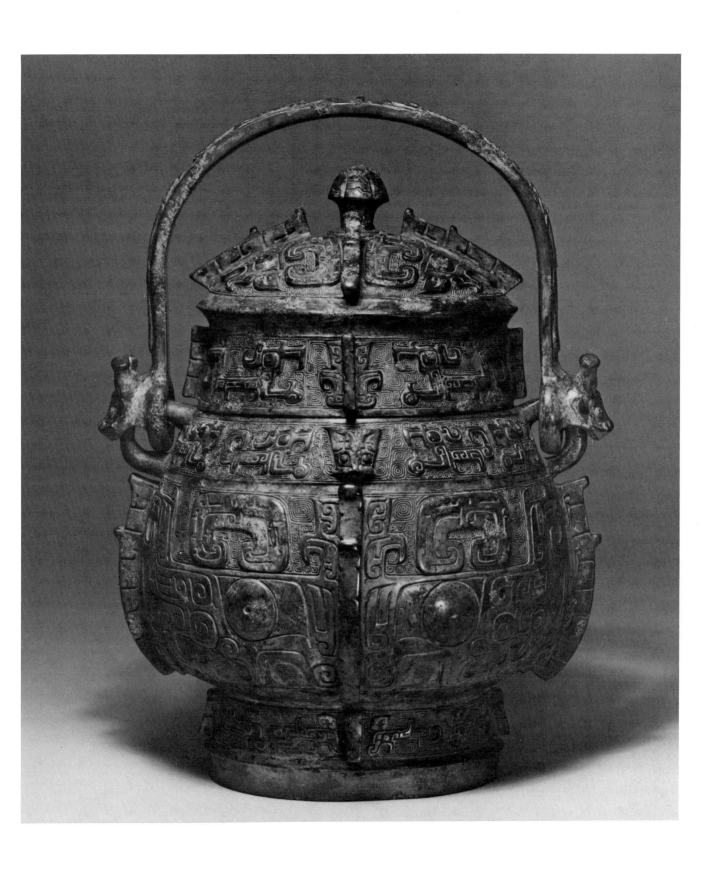

late An-yang phase of production. It represents the Shang style at the height of its evolution, before it gave way to a more baroque and sculptural style of early Chou.

References
Idemitsu Museum of Arts. *Ancient Chinese Works of Art.* (Tokyo, 1978).
Karlgren, Bernhard. *A Catalogue of the Chinese Bronzes in the Alfred F. Pillsbury Collection.* (Minneapolis, 1952). cf. cat. no. 14, pls. 18 and 19; no. 15, pls. 20 and 21.
Loehr, Max. *Ritual Vessels of Bronze Age China.* (New York, 1968). no. 41.
Pope, John et al. *The Freer Chinese Bronzes,* Vol. 1. The Freer Gallery of Art Oriental Studies, no. 7. (Washington D.C., 1967). pls. 49 (late An-yang) and 50 (early Chou).

7*

Ssu-kuang (ceremonial wine vessel)

China, late Shang to early Western Chou dynasties (eleventh-tenth centuries B.C.)
Bronze
Height: 31.5 cm.

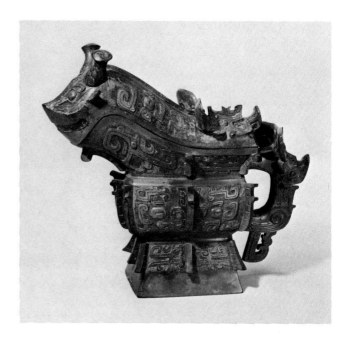

The *Ssu-kuang* is a wine vessel, found only in the Shang and Early Western Chou periods. It is usually rectangular in section, with a boat-shaped body and cover in the form of an animal head and back, the jaws sitting directly over the spout, and a projecting, upward-curving flange sitting in back above the handle.

The *Ssu-kuang* in the Idemitsu Collection has a foot in the shape of a truncated pyramid which is distinctly plain at the base, a feature found in similar pieces. A *Kuang* in the collection of the Art Museum, Princeton, is referred to as "Pre-dynastic Chou, coeval with Shang, style V," which, in Loehr's system of dating would put it in the An-yang period, c. 1300–1028 B.C.

The lid of the Idemitsu *Kuang* takes the form of the back of a monstrous animal; a central flange divides the lid like a spine, extending from the big monster head over the spout to the animal head at the opposite end. The monster head resembles a *t'ao-t'ieh* with bulging eyes but, unlike the *t'ao-t'ieh*, it has round bottle-shaped horns and an open mouth revealing ferocious-looking teeth. The monster mask at the opposite end is in the form of a *t'ao-t'ieh*, but with large c-shaped horns, prominent central flange, and a tongue-like projection at the end that may have been used to lift the lid. A dissolved *t'ao-t'ieh* mask in low relief on *lei-wên* ground is placed on top of the lid between the two principal monster heads, its jaws adjacent to the bottle horns.

The body of the vessel is decorated with *lei-wên* spiral ground and horizontal bands of *K'uei* dragons

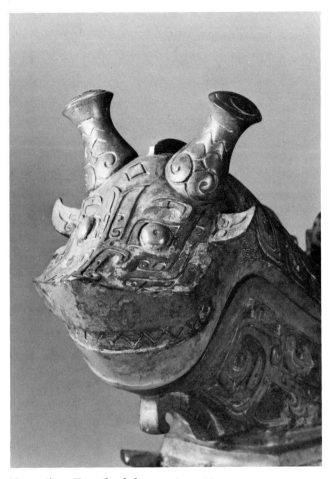

Fig. 5. Detail of front (no. 7)

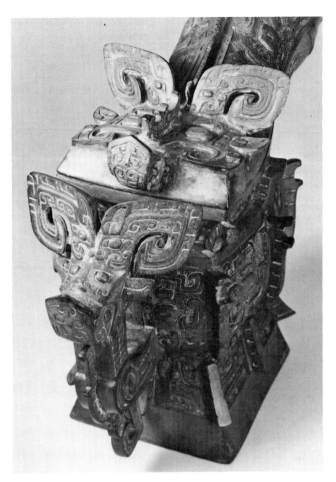

Fig. 6. Detail of handle (no. 7)

with elongated upper jaws or beaks, a central band of *t'ao-t'ieh*, and horned dragons with hooked beaks in the band above the foot. Vertical flanges divide the decorative bands. The loop handle is shaped like a monster head with bared teeth and large ears. The head literally emerges from the jaws of a *t'ao-t'ieh* with prominent, round, c-shaped horns. From the jaws of the monster head, which forms the handle, there emerges yet another animal. It has an upturned snout, a scaled body, seen on the side of the handle, and spiral-like wings above a hook-like projection near the base. In profile, the handle suggests the form of a bird with spread wings and clawed feet.

A similar form of the bird handle is illustrated by an early Chou *Kuang* in the Freer Gallery of Art, Washington, D.C. The bird's head is held in the mouth of a monster, as in the Idemitsu *Kuang*. A more developed form of the bird handle is illustrated by a second *Kuang* in the Freer Gallery, where the top of the bird head held in the mouth of a monster is easily recognizable. The body and wings of the bird are also readily identified, although the legs rest on the feet of a human.

A flange vertically divides the bird-like creature of the Idemitsu *Kuang* to form the outer median line of the handle. A lengthy inscription arranged in two vertical columns is cast in intaglio inside the cover, and the same inscription, with the two lines and the character reversed and in raised relief, is repeated inside the vessel on the bottom.

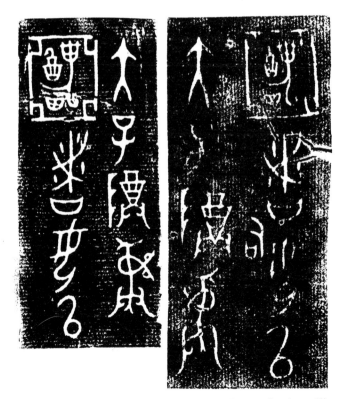

Fig. 7. Inscription inside cover and vessel (no. 7)

Published

Expo Museum of Fine Arts. *Catalogue of Expo Museum of Fine Arts.* (Osaka, 1970). pp. 1–58.

Idemitsu Museum of Arts. *Ancient Chinese Works of Art.* (Tokyo, 1978). pl. 43.

Idemitsu Museum of Arts. *Special Exhibition Commemorating the Tenth Anniversary of the Idemitsu Collection.* (Tokyo, 1976). pl. 57.

Mizuno, Seiichi. *Bronzes and Jades of Ancient China.* Translated by J.O. Gauntlett. (Tokyo, 1959), pl. 81.

Nihon Keizai Shimbunsha. *Exhibition of Select Works of Ancient Chinese Art.* (Tokyo, 1973). pl. 6.

Sugimura, Yūzō. *Chūgoku Ko-dōki.* Idemitsu Art Gallery Series, vol. 3. (Tokyo, 1966). cat. no. 1.

The Tokyo National Museum. *Exhibition of Eastern Art Celebrating the Opening of the Gallery of Eastern Antiquities.* (Tokyo, 1968). pl. 1.

References

Loehr, Max. *Ritual Vessels of Bronze Age China.* (New York, 1968). cat. no. 50.

Pope, John et al. *The Freer Chinese Bronzes,* vol. 1. The Freer Gallery of Art Oriental Studies, no. 7. (Washington, D.C., 1967). cf. pls. 44 and 45.

Sugimura, Yūzō. *Chūgoku Ko-dōki.* Idemitsu Art Gallery Series, vol. 3. (Tokyo, 1966). p. 64 (rubbing) and pp. 72, 73.

Umehara, Sueji. *Nihon shūcho Shina Kodō seika,* vol. 3. (Osaka, 1964).

8

Hu (ceremonial wine vessel)

China, early-middle Western Chou dynasty (eleventh-ninth centuries B.C.)
Bronze
Height: 49.0 cm. Diameter at mouth: 20.5 cm.

The *Hu* is of large size, its body oval in cross section, its wide sides flattened, and its corners rounded. It is supported on a conical foot from which it projects sharply outward, gently tapering off in a slightly concave line towards the top where it flares out slightly.

The bold design differs from the dense, tightly controlled ornament of the Shang dynasty (1523–1028 B.C.) and suggests and early to middle Western Chou date (c. eleventh-ninth centuries B.C.). A continuous wavy band surrounds the upper part of the neck above a band of crested birds, their heads turned back. The main body of the vessel is decorated with two huge *t'ao-t'ieh* made up of disintegrated dragon and bird forms and a filling of simple raised lines. The *t'ao-t'ieh* are rendered by broad flat lines, curves, and hooks on a ground of *lei-wên* and meander pattern. The same ground pattern extends to the horizontal bands at the top and bottom of the vessel. The spreading foot is decorated with a stylized pattern of triangles and large circles, suggesting disintegrated dragon forms. Two separately cast handles surmounted by bird forms project from the neck at the level of the band with crested birds.

The vessel is stylistically related to a *Hu* in the Freer Gallery of Art, ascribed to the early-middle Western Chou dynasty (ninth century B.C.). The Freer bronze has similar large *t'ao-t'ieh* made up of dissolved dragon and bird forms on the sides, and has a design of wavy bands around the neck. However, it lacks the band of crested birds and the unusual handle motifs, both distinguishing features of the Idemitsu vessel.

Published

Idemitsu Museum of Arts. *Ancient Chinese Works of Art.* (Tokyo, 1978). pl. 47.

Idemitsu Museum of Arts. *Special Exhibition Commemorating the Tenth Anniversary of the Idemitsu Collection.* (Tokyo, 1976). pl. 63.

References

Pope John et al. *The Freer Chinese Bronzes,* vol. 1. The Freer Gallery of Art Oriental Studies, no. 7. (Washington, D.C., 1967). cf. pl. 76.

Sugimura, Yūzō, *Chūgoku Ko-dōki.* Idemitsu Art Gallery Series, vol. 3. (Tokyo, 1966). pp. 163–167.

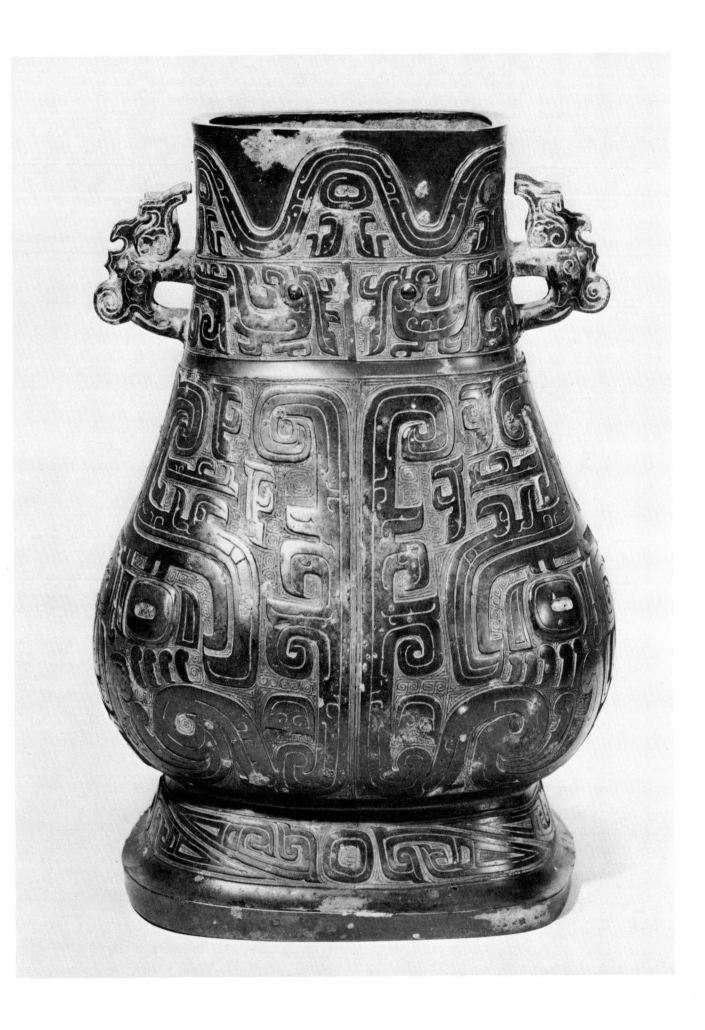

9

Hu (ceremonial wine vessel)

China, Eastern Chou dynasty, Warring States period
(fourth-third centuries B.C.)
Bronze with copper-inlaid design
Height: 30.0 cm. Diameter at mouth: 10.0 cm.

The *Hu* is supported on a low circular foot. The round, swelling body curves inward toward the shoulder, then curves slightly outward again at the neck. The vessel has a low, slightly dome-shaped cover to which two free-swinging handles are attached. Two additional ring-handles are suspended from the mouths of two small *t'ao-t'ieh* masks mounted on the shoulder.

The body is divided into eighteen compartments by vertical and horizontal bands, their surface decorated with a simple hatched design that gives the appearance of a braided cord. The compartments themselves are decorated in inlaid copper with hunting scenes and figures carrying bows. Three scenes are visible in the illustration (pl. 9): in the upper section, a figure is taking aim at two animals; in the midlde zone, a figure wrestles with an animal by holding its horns, and another figure, a bird, and an animal complete the design; the bottom register depicts four dancing figures holding bows in their hands.

The *Hu* is an important example illustrating the use of a brownish inlay, probably copper, for pictorial design. The technique is commonly associated with the Warring States period and there is little doubt that the vessel dates from the early part of the period. This dating can be reinforced by a *Hu* excavated in 1965 in Ch'eng-tu, Szechwan, which was included in the exhibition "Treasures from the Bronze Age of China," which toured the United States during 1980–1981. The excavated *Hu* is similar in shape, with a slightly dome-shaped cover, ring-handles, and a body divided into three horizontal registers decorated with inlaid designs, including hunting scenes, an archery contest, a battle scene, animals, and freely disposed figures. The vessel is dated sixth-fifth century B.C. and a similar date is probable for the Idemitsu *Hu*.

It is also likely that the inlaid technique of the Idemitsu bronze corresponds to the *Hu* excavated in Ch'eng-tu, and a *Tou* in the same exhibition—with copper-inlaid design of animals and human figures—in 1923 at Liyu, Hunyan, in Shensi Province. The piece is now in the Shanghai Museum. According to the exhibition catalogue, and based on x-ray studies of the inlaid technique by Pieter Meyers of the research laboratory at the Metropolitan Museum of Art, the inlay was applied during the casting process. This technique was apparently restricted to copper-inlaid decoration of animals and other pictorial designs and does not seem to have been used for inlays of gold, silver, or copper in geometric designs. Such inlays were apparently applied by hammering the metals into existing depressions in the cold bronze surface. A *Hu* of simi-lar type with an inlaid design of birds, rather than humans and animals, is illustrated by Seiichi Mizuno in *Bronzes and Jades of Ancient China*.

Published
Mizuno, Seiichi. *Bronzes and Jades of Ancient China.* Translated by J.O. Gauntlett. (Tokyo, 1959). pl. 142.
Uehara, Sueji. *Nihon sūcho Shina Kodō seika*, vol. 5. (Osaka, 1964). pl. 393.

References
Fong, Wen, editor. *The Great Bronze Age of China.* (New York, 1980). cf. cat. no. 70, pp. 268, 269, fig. 97; cf. cat. no. 91, pp. 316, 317, fig. 107.
Idemitsu Museum of Arts. *Ancient Chinese Works of Art.* (Tokyo, 1978). cat. no. 75.
Mizuno, Seiichi. *Bronzes and Jades of Ancient China.* Translated by J.O. Gauntlett. (Tokyo, 1959). pl. 143.

Fig. 8. Detail (no. 9)

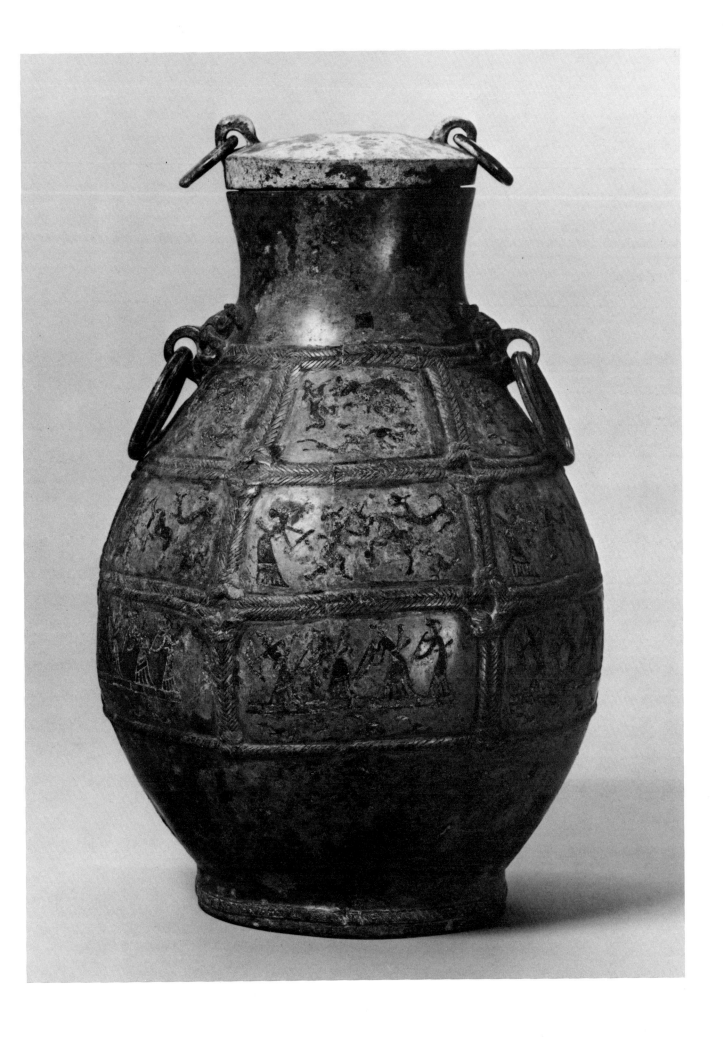

47

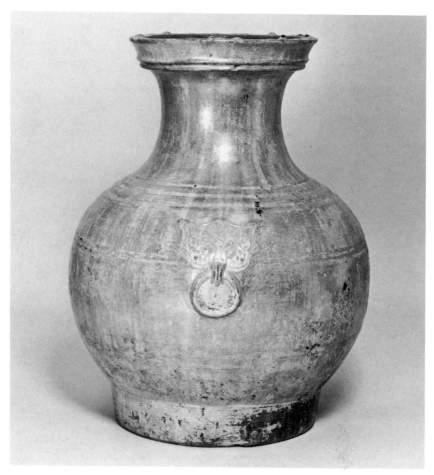

CHINESE CERAMICS

10
Jar with Animal Rings

China, Han dynasty (206 B.C.–A.D. 220)
Pottery with green lead glaze
Height: 40.0 cm.

The Han dynasty ranks as one of the most illustrious of the early Chinese epochs and was marked by periods of national unification and expansion. The Han dynasty, divided into the Former or Western Han (206 B.C.–A.D. 9) and the Later or Eastern Han (A.D. 25–220), extended its boundaries to the north, northwest, and south, and strengthened its contact with foreign countries through the silk trade. As a result, during this period China experienced an influx of foreign ideas and products.

The arts under the Western and Eastern Han dynasties prospered. The former practice of burying various artifacts with the dead continued, and throughout China tombs were repositories for *ming-ch'i* (funerary objects), to be used by the deceased and others. This Idemitsu *ming-ch'i* may have been used for the ritual offerings of food or wine.

During the late Chou dynasty (1027–256 B.C.) or early Han dynasty, glazes composed of a lead oxide fluxing agent and copper green coloring were introduced. The origin of lead glazes, the type used on this piece, is unclear; they may have come from the Near East or may have been a native development. Lead oxide, capable of being suspended in water, facilitated application by either dipping or brushing on the glaze on unfired green ware. The pieces were then fired at low temperatures of around 1,100°c. to an earthenware hardness, and the glazes vitrified to a grayish to olive green color. After a long period of burial, the lead glazes took on a silvery iridescence, a quality that counteracts and softens the otherwise metallic green tone of the glaze.

Han ceramics borrowed their forms from contemporary bronzes; this bulbous jar recalls the shape of the bronze *Hu*. The handles are joined to the shoulder of the jar by zoomorphic escutcheons that are reminiscent of the *t'ao t'ieh* (monster mask) on contemporary bronze pieces. Encircling the shoulder areas are incised lines, and the everted neck flares slightly.

The predominant production centers in the Western and Eastern Han dynasties are thought to have been in the regions of Ch'ang-an, the capital city during the Western Han dynasty and Lo-yang, the Eastern Han dynasty capital.

References
Medley, Margaret. *The Chinese Potter: A Practical History of Chinese Ceramics.* (New York, 1976).
Valenstein, Suzanne G. *A Handbook of Chinese Ceramics.* (New York, 1975).
Watson, William. "On T'ang Soft-glazed Pottery." *Pottery and Metalwork in T'ang China: Their Chronology and External Relations.* Colloquies on Art and Archaeology in Asia No. 1. (London, 1971). pp. 35–43.

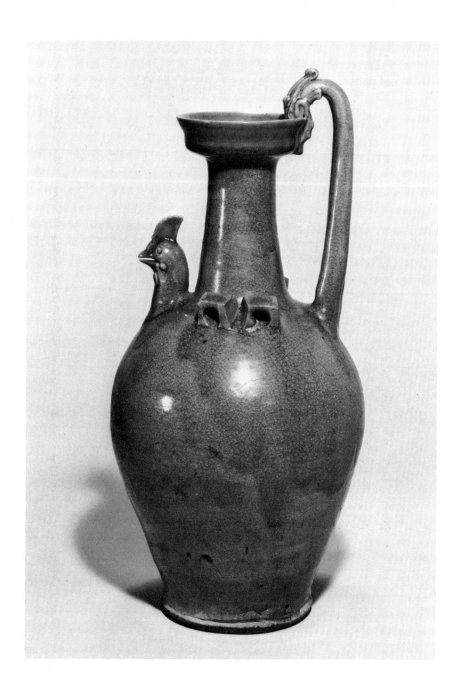

11
Chicken-headed Ewer

China, Six Dynasties period (220–589)
Proto-Yüeh ware, stoneware with celadon glaze
Height: 47.2 cm.

The stability of the Han dynasty (206 B.C.–A.D. 220) was followed by political turmoil, incessant wars, and barbarian invasions during the Six Dynasties period (220–589). Despite the political discord, substantial cultural growth occurred; ceramics broke from total dependence on bronze prototypes (cf. no. 10) and gradually came into their own with the production of green-glazed ware, more commonly known as celadon. Formerly these celadons were referred to as Yüeh, because they were first thought by scholars to have primarily been produced at Yu-chou in Chekiang Province. However, specialists are increasingly referring to the same

celadon wares as Proto-Yüeh, since the appellation, Yüeh is not believed to have been used until the T'ang dynasty (618–906).

Proto-Yüeh wares represent the initial stages of celadon development; they have a pale gray stoneware body which, when exposed to the heat of the kiln, fires to a reddish brown. The piece is then covered by a thin semi-translucent greenish feldspathic glaze. During the Six Dynasties period, Proto-Yüeh continued its evolution as a celadon ware. The clay bodies were improved and the surface decoration was minimized, as in this piece, as the quality of the celadon glaze was perfected. In addition, the down-draught kiln, in use since the Shang (Yin) dynasty (1523–1028 B.C.), continued to be refined by local potters. The resulting wares were characterized by a conscious attempt at uniformity in shape and color and heralded the future refinement of Chinese celadons as they are known today.

Among the popular forms of these early celadons are bulbous ewers with short spouts terminating in the shape

of a chicken's head, called *t'ien-chi-hu*. These chicken-headed ewers are generally ornamental and served no practical purpose, which signifies that they may have been principally made as tomb ware. By the fourth century, these forms became taller and more elongated. The handles began to be embellished with ornamental dragon heads, as in this example, at the junction of the rim and handle. Small squared lugs, luted onto the shoulder of the piece, seem to have been used for passage of a cord.

Published
Hakutsuru Fine Art Museum. *Masterpieces of the Idemitsu Collection*. (Kobe, 1976). pl. 2.
Idemitsu Museum of Arts. *Special Exhibition Commemorating the Tenth Anniversary of the Idemitsu Collection*. (Tokyo, 1976). pl. 83.
Koyama, Fujio. *Seiji*. Tōji Taikei, Vol. 36. (Tokyo, 1978). pl. 33.
Satō, Masahiko. *Chūgoku no Tōjiki*. (Tokyo, 1977). p. 15.
The Tokyo National Museum. *Exhibition of Far Eastern Ceramics*. (Tokyo, 1970). pl. 7.

References
Hayashiya, Seizō and Trubner, Henry et al. *Chinese Ceramics from Japanese Collections: T'ang Through Ming Dynasties*. (New York, 1977).
Medley, Margaret. *The Chinese Potter: A Practical History of Chinese Ceramics*. (New York, 1976).
Valenstein, Suzanne G. *A Handbook of Chinese Ceramics*. (New York, 1975).

12
Censer, *Po-shan Hsiang-lu*

China, Sui dynasty (581–618)
Pottery with green glaze
Height: 28.4 cm.

As early as the reign of Ch'in Shih-huang-ti, the First Emperor of the Ch'in dynasty (221–206 B.C.) there existed the Taoist legend that Chinese Immortals inhabited the Three Isles of the Immortals in the Eastern Sea. The emperor Ch'in Shih-huang-ti (ruled 221-210 B.C.) is said to have sent an expedition under the guidance of the Taoist mystic Hsü-shih to one of the Isles, the fabulous P'êng-lai-shan, in search of the elixir of immortality. The expedition never returned.

This ceramic incense burner, or *Po-shan Hsiang-lu*, is a rendering of this Taoist theme, and the subject is translated into clay from the bronze and lacquer prototypes of the Han dynasty (206 B.C.–A.D. 220). The cone-shaped cover, decorated with abstract curvilinear and beadlike patterns suggestive of the gold inlay on bronze work, rests on an open lotus form that is supported by entwined dragons. The lotus, the Buddhist symbol of purity, was probably introduced to China together with Buddhism during the Six Dynasties period (220–589). Supporting the imaginary Isles of the Immortals are two fierce dragons, whose serpentine tails are coiled around the stem of the burner. The dragon,

an important symbol in China, was the chief of the reptilian world and emblem of sovereign power; as the Blue Dragon of the East, it is also one of the divinities of the four directions. The other divinities are the White Tiger of the West, the Red Phoenix of the South, and the Black Snake-Tortoise of the North. Although the shape is based on a Taoist motif, the function of the censer is solely Buddhist in origin.

This piece is thought to have been made during the Sui dynasty (581–618) when China was united by a general of the Northern Chou dynasty (557–581). Although frequently grouped with either late Six Dynasties period or early T'ang dynasty (618–906) ware, the pottery of the Sui dynasty is important in that it formed a bridge between the two periods. Recent archaeological finds show that the Sui dynasty potters covered their earthenware pieces with yellow and green glazes that were a forerunner of later T'ang dynasty wares.

Published
Asano, Kiyoshi et al. *Sekai Kōkogaku Taikei*, Vol. 7. (Tokyo, 1959). pl. 4.
Osaka Municipal Museum of Fine Arts. *Chūgoku Bijutsu 5000 nen Ten*. (Osaka, 1966). pl. 4, 21.
Osaka Municipal Museum of Fine Arts. *Zui, Tō no Bijutsu*. (Osaka, 1978). pl. 11.

References
Fong, Wen, editor. *The Great Bronze Age of China: An Exhibition from the People's Republic of China*. (New York, 1980). cf. pl. 95, p. 190.
Medley, Margaret. *The Chinese Potter: A Practical History of Chinese Ceramics*. (New York, 1976).
Mizuno, Seiichi. *Tō san sai*. Tōji Taikei, Vol. 35. (Tokyo, 1977). cf. figs. 12, 13, p. 94.
Osaka Municipal Museum of Fine Arts. *Zui, Tō no Bijutsu Ten*. (Osaka, 1976).
Satō, Masahiko. *Hakuji*. Tōji Taikei, Vol. 37. (Tokyo, 1975). cf. pl. 33.
Wenley, A. G. "The Question of the Po-shan Hsiang-lu." *Archives of the Chinese Art Society of America*, no. III. (New York, 1948–1949). pp. 5–12.
Williams, C. A. S. *Outlines of Chinese Symbolism and Art Motives*. (Rutland, Tokyo, 1974).

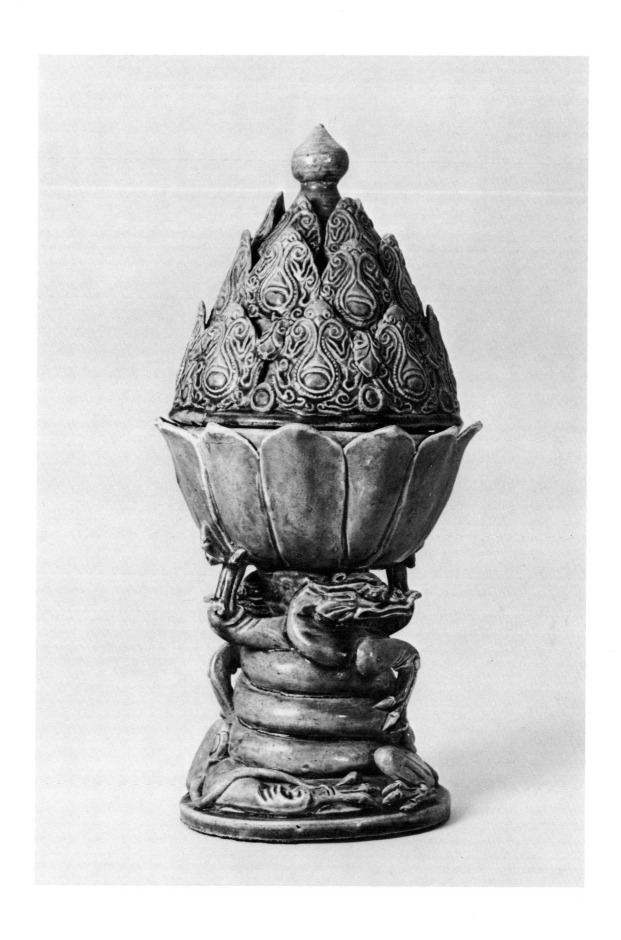

13
Amphora

China, T'ang dynasty (618–906)
Porcelaneous white ware
Height: 60.8 cm.

The evolution from the white porcelaneous stonewares to what is considered true porcelain was a gradual process of trial and error by the T'ang dynasty (618-906) potters. The hard, resonant, white translucent clay body characteristic of these early porcelaneous wares was a successful amalgamation of plastic *kaolin* (china clay), with the appropriate balance of feldspathic and flint material. These wares were fired at high temperatures of about 1,250°C for proper vitrification, higher than any of their stoneware or earthenware predecessors.

It is clear to many specialists that true porcelain was produced during the T'ang dynasty; however, the problems of the origin and the exact physical composition of these early wares are still unresolved. White wares are believed to have been produced in the northern and southern regions of China, and those wares typical of northern China tend to be more varied in the body composition. From the sixth century, the northern wares became whiter and gradually harder as the firing conditions improved and high temperatures were attained. The pieces were frequently covered with a slip both on the inside and outside and were covered with a transparent glaze that would mature to either a pale green or straw yellow. In some cases, the glaze would turn a pale blue or muted ivory color. The glaze would be applied by dipping the piece or by pouring the glaze over the piece. The latter technique is recognizable by the drips or uneven glaze line on the shoulder of the piece, and by the wavy line of the slip above the foot.

This amphora—from the Greek, *amphi* (two sides) and *phoreus* (bearer)—has two curved handles that are joined to the vessel by dragon heads biting the rim. Two palmettes in applied relief are on the shoulder at the base of the handles. This particular form of an amphora with biting dragon heads is not an indigenous Chinese motif but a form borrowed from western Asian models. The shape and style appeared in the work of the earlier Six Dynasties period (220–589) (cf. no. 11) and resembles both Roman vases and their Syrian sources.

Published
Idemitsu Museum of Arts. *Special Exhibition Commemorating the Tenth Anniversary of the Idemitsu Collection.* (Tokyo, 1976). pl. 86.
Koyama, Fujio. *Chūgoku Tōji,* Vol. I. Idemitsu Art Gallery Series 2. (Tokyo, 1970). pl. 11, p. 146.
Satō, Masahiko; Hasebe, Gakuji and the Zauho Press. *Sui, Tō.* Sekai Tōji Zenshu, Vol. 11. (Tokyo, 1979). pl. 14–16. pp. 28–29.

References
Beurdeley, Cécile and Michel. *A Connoisseur's Guide to Chinese Ceramics.* Translated by Katherine Watson. (New York, 1974).
Mino, Yutaka. *Pre-Sung Dynasty Chinese Stonewares in the Royal Ontario Museum.* (Toronto, 1974). cf. pls. 25–27.
Satō, Masahiko. *Hakuji.* Tōji Taikei, Vol. 37. (Tokyo 1975).
Valenstein, Suzanne G. *A Handbook of Chinese Ceramics.* (New York, 1975). cf. pl. 17, p. 45.

Fig. 9. Detail of handle (no. 13)

Fig. 10. Detail of animal head on shoulder (no. 13)

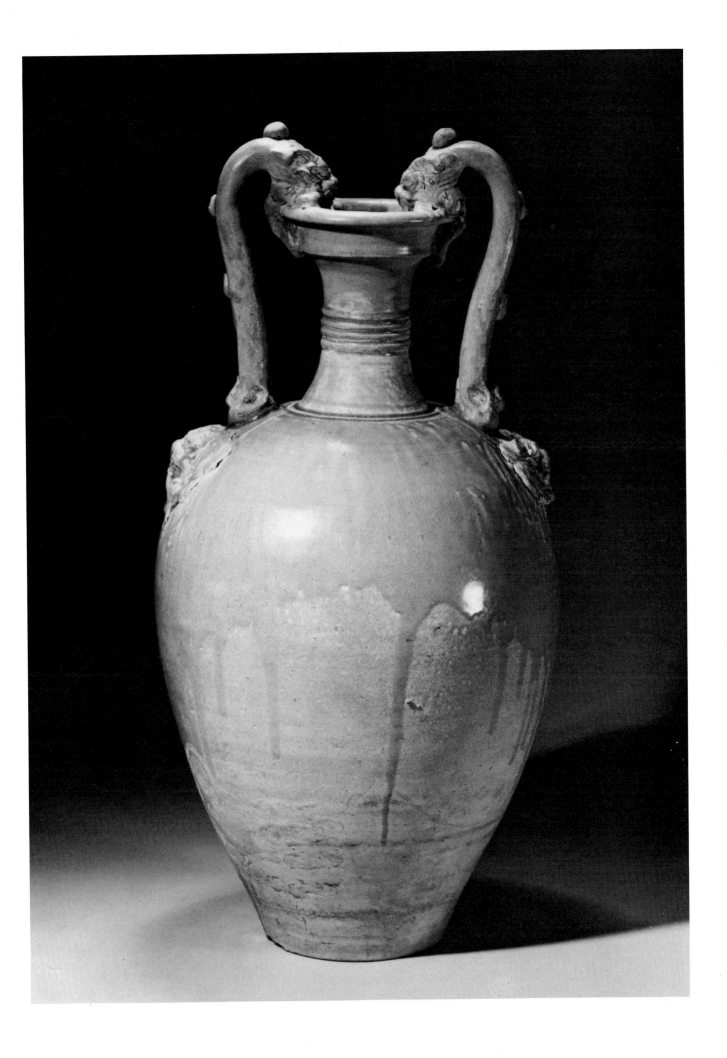

14*

Globular Jar

China, T'ang dynasty (618–906)
Pottery with san-ts'ai (three color) glaze
Height: 24.0 cm.

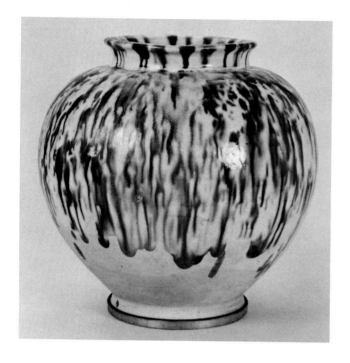

Following the unification under the brief Sui dynasty (581–618), China, under the succeeding T'ang dynasty (618–906), entered into an age of prosperity and power. The influence of T'ang culture reached beyond its geographic boundaries into Central and Southeast Asia and at the same time, absorbed and adapted to Chinese taste the foreign artistic and cultural influences. As a result of this cultural florescence, the arts flourished and the development of ceramics underwent many changes. The production of lead-glazed wares still principally used for *ming-ch'i* (funerary objects) continued; yet, the T'ang dynasty potter assimilated new ideas along with the glaze techniques formerly practiced by Sui dynasty potters. With the introduction of cobalt from the Near East in the eighth century, the repertory of colored glazes was expanded: cobalt blue was added to the iron browns and yellow, and the copper greens. By the first decade of the eighth century, opulent polychrome wares were being produced, and these wares are frequently referred to as *san-t'ai* (three-color wares) even though they appear in a wide range of colors and hues.

The multi-colored glazes were applied in overlapping patterns over a coat of white slip. The application of the white slip aided in lightening the ground color and preventing the ferruginous nature of the clay from spotting, and thus spoiling the color of the glazes. As the glazes vitrified at low temperatures of about 600–800°C, they were able to flow freely over the surface of the pieces to form splashed and running glaze patterns, as seen on the Idemitsu jar.

Although important as a ceramic style and influential on later Japanese pottery, *san-ts'ai* wares were relatively short-lived. They only remained in vogue between the late seventh century and the first half of the eighth century. After this time, production apparently ceased, indicating to some scholars that for some unknown reason *san-ts'ai* ware witnessed a rapid decline. Historical research is further clouded by the difficulty in locating the the predominant *san-ts'ai* kiln sites. It is believed that *san-ts'ai* kilns were most active near the bustling center of Ch'ang-an, in Shansi, and at Lo-yang in Honan Province. In 1956, the only verified T'ang *san-ts'ai* kilns were unearthed east of Lo-yang at Kung-hsien.

References
Beurdeley, Cécile and Michel. *A Connoisseur's Guide to Chinese Ceramics.* Translated by Katherine Watson. (New York, 1974).
Medley, Margaret. *The Chinese Potter: A Practical History of Chinese Ceramics.* (New York, 1976).
Mizuno, Seiichi. *Tō san sai.* Tōji Taikei, Vol. 35. (Tokyo, 1977).
Valenstein, Suzanne G. *A Handbook of Chinese Ceramics.* (New York, 1975).
Watson, William. "On T'ang Soft-glazed Pottery." *Pottery and Metalwork in T'ang China: Their Chronology and External Relations.* Colloquies on Art and Archaeology in Asia No. 1. (London, 1970). pp. 35–43.

15

Ewer

China, Northern Sung dynasty (960–1127)
Ch'ing-pai ware, white porcelain
Height: 19.7 cm.

During the Northern Sung dynasty (960–1127), while the kilns that were producing white Ting ware (no. 16) and green-glazed celadons were active in northern China, a porcelain ware known as *ch'ing-pai* also appeared. The principal center for the production of *ch'ing-pai* (bluish white or clear white) ware was located at Ching-tê-chên in Kiangsi Province. Other sites have also been excavated in Fukien Province. The Ching-tê-chên kilns are believed to have been in use since the pre-T'ang period (fifth or sixth century); however, during this time ceramic production was still subordinate to the agricultural demands of farmers who controlled the kilns. By the late tenth or early eleventh century, the kilns began production on a regular basis with skilled craftsmen who replaced the former part-time farmer potters. As a result, a highly developed group of potters formed, and by the eleventh century a myriad of shapes ranging from ewers—such as the Idemitsu example—to vases, lamps, incense burners, and bowls of various sizes appeared. *Ch'ing-pai* manufacture, which was apparently not an imperial ware, is believed to have continued uninterrupted until the fourteenth century. Its products not only supplied the domestic market but were also shipped to Japan and reached many parts of

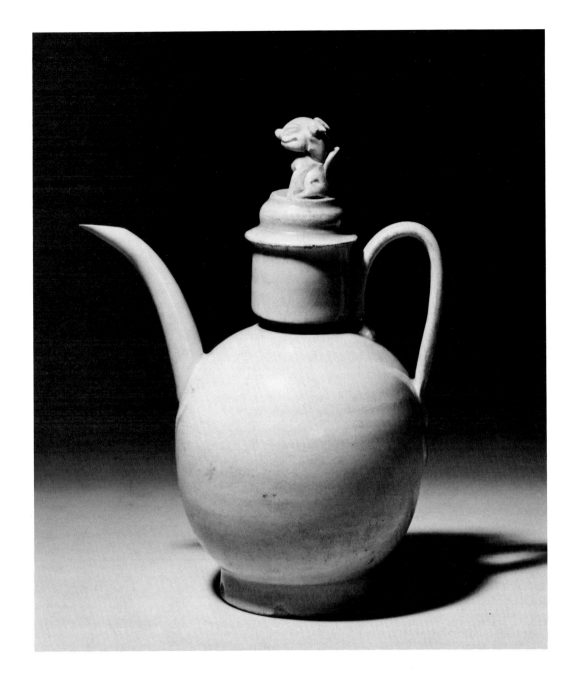

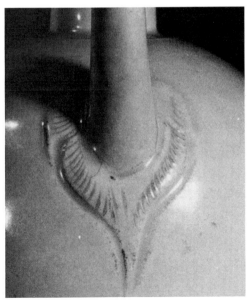

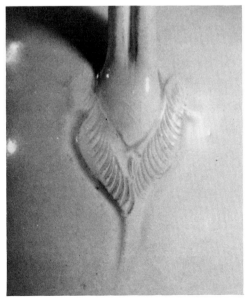

Fig. 11. Detail of underside of spout
(no. 15)

Fig. 12. Detail of underside of handle
(no. 15)

Asia, including the Philippines, Southeast Asia, Indonesia, and the Near East. *Ch'ing-pai* ware was exported in large numbers to Japan, some examples reaching Japan as early as the twelfth century, as witnessed by pieces recovered from twelfth-century sutra mounds. (Hayashiya, Seizō and Trubner, Henry et al. *Chinese Ceramics from Japanese Collections: T'ang through Ming Dynasties.* [New York, 1977]. cf. cat. nos. 9, 10, 14, 15.)

Ch'ing-pai is derived from the thin transparent glaze used on a whitish porcelain paste composed of *kaolin* and *pai-tun-tzu*, also referred to as *petuntse*, a white feldspathic material. Both *kaolin* and *pai-tun-tzu* were found in Kiangsi Province. The preparation of *ch'ing-pai* glazes is explained by Margaret Medley in her book, *The Chinese Potter: A Practical History of Chinese Ceramics*, as a combination of fritted re-crushed *pai-tun-tzu* with layers of brushwood and leaves. The fritted materials were ground and mixed, and afterwards applied to the unfired or green body. *Ch'ing-pai* glazes generally have a bluish color, as do most pieces from southern China during this period, and consequently these wares have been referred to in modern times as *ying-ch'ing* (shadowy-blue). The bluish cast is due to the iron in the glaze material; it was not until later that the Chinese potters consciously tried to produce a pure white body covered by a clear transparent glaze.

This piece is believed to have been produced during the Northern Sung dynasty, possibly in the eleventh century, at the Ching-tê-chên kilns. It is undecorated except for the molded *ch'i-lin* (Chinese lion) on the lid and the incised band around the spout. According to Jan Wirgin, a noted authority on Chinese ceramics, the lion is rarely seen on Sung ceramics, although its appearance predates the Sung period as a design motif on Sui and T'ang mirrors, on examples of silver, and on stone carvings. Furthermore, the lion is not a traditional Chinese motif; it was, according to Wirgin, adapted from Western Asia, where it was a significant Manichaean symbol and from India, where it was associated with Buddhism. The rare examples of the lion found on ceramics are believed to be of a type specific to China and having definite associations with Buddhism.

Published

Hasebe, Gakuji and the Zauho Press. *Sō.* Sekai Toji Zenshu, Vol. 12. (Tokyo, 1977). pl. 26.

Idemitsu Museum of Arts. *Special Exhibition Commemorating the Tenth Anniversary of the Idemitsu Collection.* (Tokyo, 1976). pl. 91.

Koyama, Fujio. *Chūgoku Tōji*, Vol. 1. Idemitsu Art Gallery Series 2. (Tokyo, 1970). pl. 37, p. 212.

16
Deep Bowl with Incised Design of Peony Scrolls

China, Northern Sung dynasty (960–1127)
Ting ware, white porcelain
Diameter: 26.5 cm.

The culture of the Sung dynasty (960–1279), unlike that of the T'ang dynasty (618–906), which was receptive to the influx of western ideas, turned away from foreign influences and looked inward for artistic and cultural inspiration. One of the classic wares produced during the Northern Sung (960–1127), the Chin (1115–1234) and the Southern Sung (1127–1279) dynasties was the elegant and polished porcelain ware known as Ting. Early Ting ware was principally limited to flat pieces such as bowls, basins, dishes and plates, the flat surface of which encouraged simple decoration applied by hand. The pieces were generally wheel-thrown, and while still damp, carved and incised by skilled craftsmen. These early wares were primarily decorated with simple naturalistic compositions, such as the peony spray on this bowl, a popular design during the Sung dynasty.

In the early twelfth century, stoneware molds were introduced. Designs, which would be applied to the pieces, were carved onto the convex surface of the mold. The introduction of molds eliminated the work required for individual pieces. As a result, the design compositions that were reproduced on the molds became increasingly elaborate, and the index of motifs was expanded to include phoenixes, floral patterns, children, and landscapes. Much of the inspiration for these later themes was influenced by the contemporary repoussé metalwork and embroidered textiles.

Fig. 13. Detail of foot (no. 16)

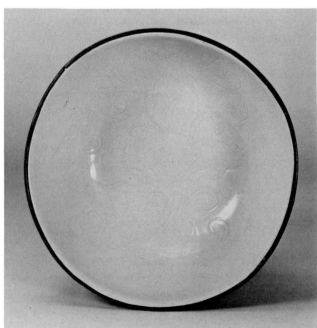

Fig. 14. Detail of inside (no. 16)

Ting wares were glazed with an ivory white translucent glaze, and except for the rim, the entire piece was glazed. Inside the kiln, the wares were stacked in an inverted fashion inside larger pieces placed on saggers. These porcelain wares were fired to extremely high temperatures (1,260–1,300°c.). Firing Ting wares on their rims proved economical for production—more pieces could be fired simultaneously in one kiln—and by positioning the piece on the rim, warping was reduced during the initial drying-out period within the kiln. The only disadvantage of this method of firing was that the rim was left unglazed; therefore, it was necessary for the potters to cut copper alloy strips for each piece.

In 1941, the Ting kiln sites were excavated by Fujio Koyama at Ch'ien-tz'u-ts'un and at Yen-shan-ts'un. It is now believed that these kilns were already active during the late T'ang dynasty; these later T'ang wares served as a foundation for the Ting wares produced in the Sung dynasty. The Ting wares, acclaimed at the Sung court, continued to be produced during the eleventh and twelfth centuries. After the Mongol invasion in the thirteenth century and the subsequent formation of the Yüan dynasty (1280–1368), operation of the kilns declined and the quality of Ting wares degenerated.

Published
Hakutsuru Fine Art Museum. *Masterpieces of the Idemitsu Collection.* (Kobe, 1976). pl. 14.
Idemitsu Museum of Arts. *Special Exhibition Commemorating the Tenth Anniversary of the Idemitsu Collection.* (Tokyo, 1976). pl. 90.
Osaka Municipal Museum of Fine Arts. *Sō, Gen no Bijutsu.* (Osaka, 1980). pl. 122.

References
Medley, Margaret. *The Chinese Potter: A Practical History of Chinese Ceramics.* (New York, 1976).
Satō, Masahiko. *Hakuji.* Tōji Taikei, Vol. 37. (Tokyo, 1975). cf. pls. 71–72.
——. *Chūgoku no Tōjiki.* (Tokyo, 1977). p. 38.

17
Flower Pot

China, Northern Sung dynasty (960–1127)
Chün ware, stoneware with iron and copper ash glaze
Height: 18.6 cm.

With the cultural introspection of the Sung dynasty developed an increasing interest in nature, and as a result, gardens were cultivated by the upper classes, and texts on fruits and herbs were written by the literati. To satisfy this interest in the natural world, Chün ware was commissioned by the court to be used as flower pots.

Flower pots, such as this example, are but one type of Chün ware produced in China. The advent of Chün production is unclear; yet, scholars believe that it began sometime during the Northern Sung dynasty (960–1127), and a large quantity of kilns have been unearthed near the Northern Sung capital of K'ai-feng (modern P'ien-liang) with sites in modern Yu-chou in Yu-hsien in east Honan Province. The demand for imperial or non-imperial Chün ware resulted in kiln sites scattered throughout China.

Chün flower pots are distinguished by an opalescent purplish crimson glaze outside and a lavender blue glaze inside. The opacity of glaze, unique to Chün wares, is caused by what is referred to as 'kiln mutations' and is due to the combination of phosphate in the glaze and *kaolin* (china clay). During the firing process, the phosphate decomposes and causes a gas pore in the glaze, which appears as a bubble under the glaze. If the phosphate gas pore is diffused during the firing it leaves a pitted area, and the affected glaze takes on an opalescent appearance. An additional kiln mutation of Chün is 'earthworm tracks', the small fissures that appear during the firing and are filled with running glaze. The results, as seen on this piece, are small curvilinear marks

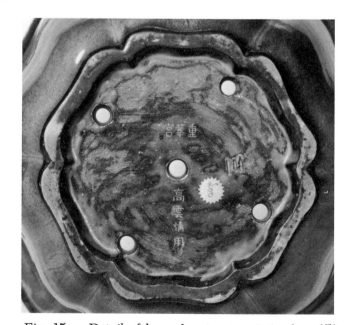

Fig. 15.　Detail of base showing inscription (no. 17)

that resemble the tracks left by earthworms.

Chün pieces were fired twice; first, they were coated with a ferruginous slip and biscuited at low temperatures. Ash glazes were generously applied before the second firing, which reached a temperature of about 1,400°c. The primary ingredient for the ash glaze was rice straw, which was found in abundance in the rice-producing areas south of Honan Province. Coloring agents in the glaze were iron, which was found locally and produced a lavender blue glaze, and copper. Copper is believed to have been imported from southern China and yields red-purplish and crimson hues.

It has been suggested that copper was not used on Chün wares until the twelfth century. Initially it appeared as splashes of color over the blue glaze, and later it was lavishly applied to pieces such as this flower pot, narcissus bowls, and pot stands. The dating of pieces such as this one poses a problem because the generous use of the crimson glaze does not reflect the style of earlier wares, and therefore these pieces are sometimes dated anywhere from the Northern Sung to to Yüan and early Ming periods.

Chün flower pots are frequently numbered from one to ten and consequently are called 'numbered wares.' The numbers indicate the size of the piece—the higher the number, the greater the size—and the numbers were either impressed or incised on the base. For example, this Chün pot carries the number three, which indicates that its size is approximately 18.6 cm. This system of numbering facilitated ordering by individual patrons and introduced a certain degree of industrialization to Chün ceramic production.

Some pieces also carry an engraved designation on their bases that was added later. The characters inscribed on the base of this piece are *Ch'ung Hua Kung* and *Kao Yun Ch'ing Yung*. *Ch'ung Hua Kung* was the name of a Ch'ing dynasty palace and *Kao Yun Ch'ing Yung* possibly refers to the user of the piece whose name was perhaps, Kao Yun-ch'ing.

Published
Idemitsu Museum of Arts. *Special Exhibition Commemorating the Tenth Anniversary of the Idemitsu Collection.* (Tokyo, 1976). pl. 99.

References
the Oriental Ceramics Society. (London, 1945–1946). Lee, George F. "Numbered Chün Ware." *Transactions of* pp. 53–62.
Legeza, I.L. "A New Appraisal of Chün Ware." *Oriental Art,* Vol. XVIII, no. 3. (Surrey, England, 1972). pp. 267–275.
Medley, Margaret. *The Chinese Potter: A Practical History of Chinese Ceramics.* (New York, 1976). cf. fig. 84, p. 121.
Valenstein, Suzanne G. *A Handbook of Chinese Ceramics.* (New York, 1975).
The Tokyo National Museum. *Tōyo no Tōji; Tōyō Tōji Kinen Zuroku.* (Tokyo, 1971). cf. pl. 55, p. 243.

18
Jar with Peony Design

China, Northern Sung dynasty (960–1127)
Tz'u-chou ware, stoneware with underglaze iron oxide decoration
Height: 22.0 cm.

The interest in the natural world that typified the Sung dynasty (960–1279) was already developed by the time of the Northern Sung (960–1127) and reached its peak during the Southern Sung (1127–1279). This appreciation of the natural world not only extended to the classic art forms created for the educated classes but was also transmitted to the popular art used by the common people, such as merchants. These popular wares formed a large and diversified group of stonewares called Tz'u-chou wares. The term Tz'u-chou is taken from the district of the same name, modern Tz'u-hsien in Hopei Province, a major Tz'u-chou production center by the eleventh century. By the middle or end of the eleventh century there were other centers in Mi-hsien, Têng-fêng, Tang-yang and Yu-hsien in Honan Province, and other sites in Shansi. Tz'u-chou ware continued production relatively uninterrupted through the Chin dynasty (1115–1234) and apparently continued operation until the fourteenth century, with particular styles persisting until the beginning of the Ming dynasty (1368–1644) in the fifteenth century.

The decorative techniques and the designs employed on Tz'u-chou wares were profuse. The Idemitsu vase, a tuncated version of the *mei-p'ing* shape called *tou-lou-p'ing* and a shape rarely found among other wares, is included within the large group of Tz'u-chou wares that are slip-painted and decorated with a freely drawn design in dark brown or black slip. Such pieces were covered with a transparent glaze and fired to stoneware temperatures of about 1,200°c. The freely drawn designs, such as the peony sprays on this piece, were boldly executed with great skill and spontaneity; they are the first actual attempts at free painting under a glaze. Incised lines, moreover, delineate the petals and veined leaves. The technique was further developed during the Yüan dynasty (1280–1368).

Motifs taken from nature and the animal world were the main subjects of Sung Tz'u-chou ware. However, the ubiquitous appearance of natural motifs was not only due to their appeal as attractive design motifs but more importantly to their symbolic nature. Flowers and trees were often chosen because of their symbolic meaning, which was easily comprehended by the ordinary person, and held deeper literary associations for the educated.

As an ornamental flower, the peony did not emerge as a popular design motif until the end of the T'ang dynasty when the *mu-tan* (tree peony) was introduced. Its earliest appearance on ceramics was probably on Yüeh wares. Stylistically, it evolved from being depicted as a conventionalized pattern to freely drawn sprays, as on the present example, and by the end of the eleventh

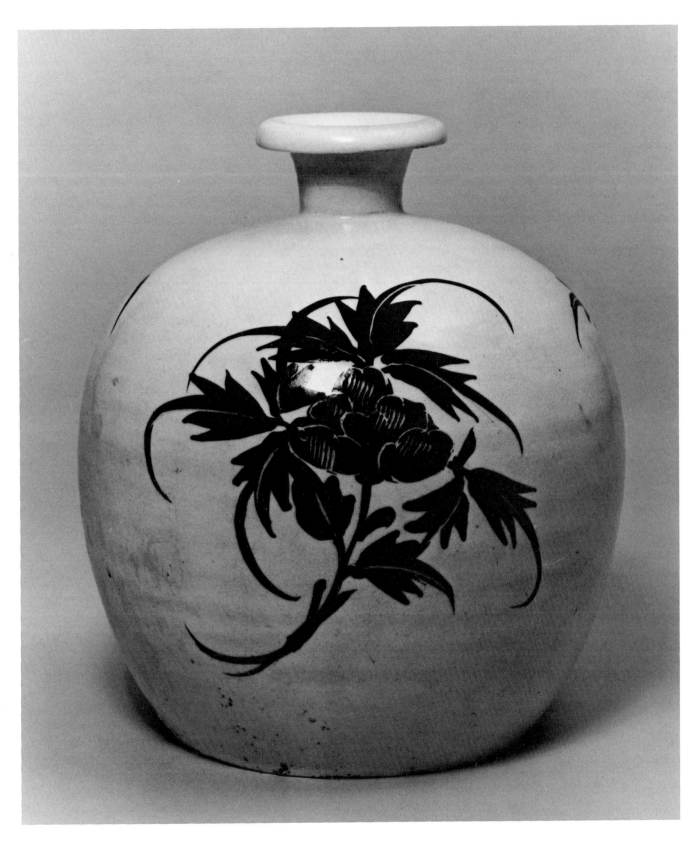

century the peony motif was fully developed as a decorative design. During the Sung dynasty, the widespread use of the peony extended to ceramics, bronze mirrors, paintings, and stone carvings. Tree peonies, also known as *Pai Liang Chin* (A Hundred Ounces of Gold), and *Fu Kuei Hua* (Flower of Wealth and Rank), were considered by the Chinese to be the king of flowers and one of the four seasonal flowers, Spring. The peony also referred to honor and happiness, and served as a symbol of love and feminine beauty.

References

Malmqvist, Göran. "Six Poems on a Painting of Peonies." *The Museum of Far Eastern Antiquities (Östasiatiska Museet).* Bulletin no. 44. (Stockholm, 1972). pp. 75–93.

Newton, Isaac. "Chinese Ceramic Wares from Hunan." *Far Eastern Ceramic Bulletin,* serial no 40. (Ann Arbor, September-December 1958). pp. 9–12.

Wirgin, Jan. "Sung Ceramic Designs." *The Museum of Far Eastern Antiquities (Östasiatiska Museet).* Bulletin no. 42. (Stockholm, 1970). pp. 1–272, cf. pl. 44–j and k.

19
Vase

China, Northern Sung dynasty (960–1127)
Tz'u-chou ware, stoneware with green glaze and
sgraffito decoration
Height: 54.5 cm.

This vase illustrates the *sgraffito* (scratched on) technique, found among the extensive repertory of methods used to decorate Tz'u-chou ware. *Sgraffito* involved the application of two slips: a thick white slip and a dark brown slip (containing hematite). On this particular *mei-p'ing*, the white slip was applied first, covered with a dark iron wash, and the sumptuous designs of peony scrolls and decorative bands were then scratched through the dark slip to reveal the underlying white. The piece was then covered with a green glaze. The resulting effect provides an interesting contrast of dark and light areas tinged with the superimposed glaze. It is one of the finest examples of Tz'u-chou *sgraffito* craftsmanship known.

Scholars believe that Tz'u-chou wares decorated in the *sgraffito* technique were made from the tenth century to the end of the fourteenth century with predominant production centers in Hsiu-wu in Honan Province and in Hopei Province at Kuan-t'ai-chên.

In addition to the peony spray motif found on the *tou-lou-p'ing* vase (no. 18), the peony scroll was another popular design used during the Sung dynasty. Peony flowers and sinuous branches curl around the belly and neck of the ovoid-shaped neck with an everted lip. It is possible that this unusual type of vase was still produced as late as the Chin dynasty (1115–1234), but the Idemitsu example is earlier and is believed to have been made during the Northern Sung dynasty (960–1127). The use of the peony scrolls and the particular shape with the tall neck and trumpet-shaped mouth suggests this vase may have been made at the Hsiu-wu kilns in Honan Province.

Published
Hakutsuru Fine Art Museum. *Masterpieces of the Idemitsu Collection.* (Kobe, 1976). pl. 11.
Idemitsu Museum of Arts. *Special Exhibition Commemorating the Tenth Anniversary of the Idemitsu Collection.* (Tokyo, 1976). pl. 106.
Wirgin, Jan. "Sung Ceramic Designs." *The Museum of Far Eastern Antiquities (Östasiatiska Museet).* Bulletin no. 42. (Stockholm, 1970). pl. 49-f.

References
Lee, Sherman E. "Sung Ceramics in the Light of Recent Japanese Research." *Artibus Asiae,* Vol. XI, no. 3. (Ascona, 1948). pp. 164–175.
Wirgin, Jan. "Sung Ceramic Designs." *The Museum of Far Eastern Antiquities (Östasiatiska Museet).* Bulletin no. 42. (Stockholm, 1970). pp. 1–272, pl. 49-f.

20*
Vase

China, Southern Sung dynasty (1127–1279)
Kuan ware, porcelaneous stoneware with pale blue
celadon glaze
Height: 23.1 cm.
Important Cultural Property

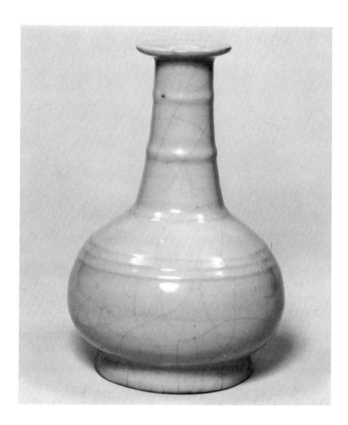

This vase is of the type classified as Kuan ware, or ware produced under official or imperial patronage at the kiln known as the Chiao-t'an kiln or Suburban Altar kiln at Hang-chou during the Southern Sung dynasty (1127–1279). The glaze and body on this piece both differ somewhat from pieces usually attributed to the Chiao-t'an kiln, and it might well come from another, still unidentified site; however, the vase represents a type of Kuan celadon ware.

The precise articulation of the parts—foot, body, neck, and lip—are characteristic of Sung dynasty taste. The bowstring decoration of three horizontal stripes about the body are a clear reference to early Shang dynasty bronze decoration, while the decorative quality of the vase and the form suggest a Chou dynasty decorative parallel, and a Sung dynasty prejudice in design.

Kuan ware is distinguished by a thin, dark-colored body with very thick, crackled glaze. The thick Kuan glaze was presumably created by successive applications. The resulting crackle is the intentional result of a disproportionate shrinking of the body and glaze, which produced the desired decorative and antique quality of the crackling.

The Idemitsu vase has unusual rectangular openings in the high foot ring, which are perhaps a reference to the unexplained openings found on some Shang bronzes.

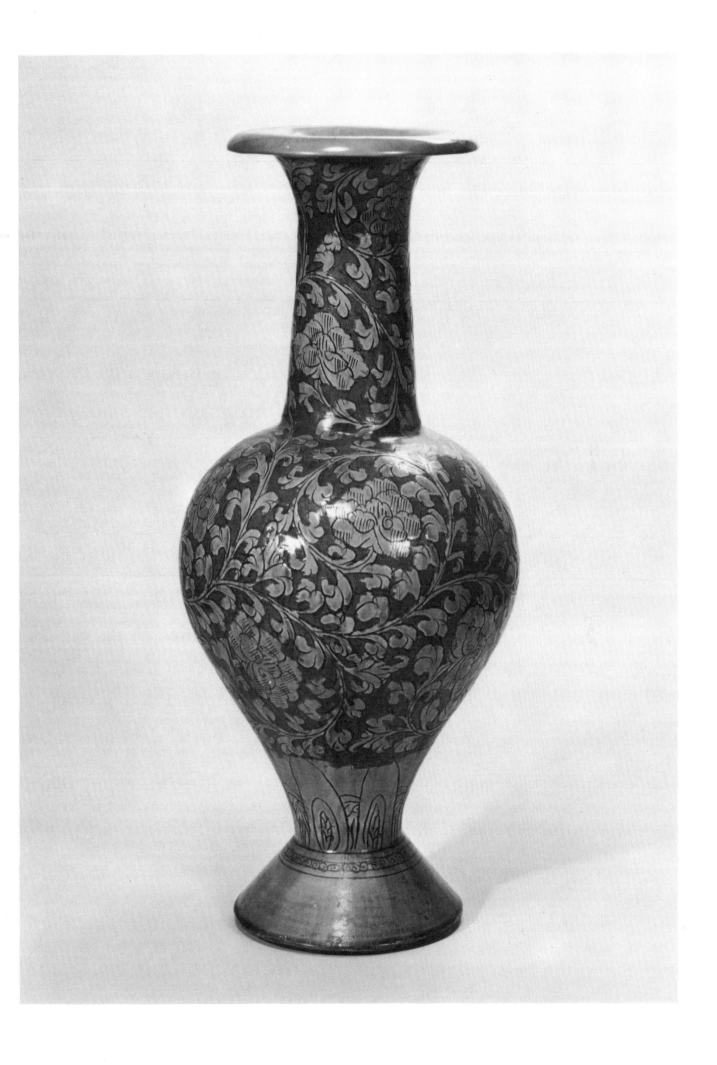

Unlike the Lung-ch'üan celadons (no. 21) which were exported in great numbers and were generally available in China, the so-called Kuan wares were apparently highly restricted. The simple lines and classical proportions of this bottle vase suggest that it was a type reserved for a special class of connoisseur.

This vase is thought to have been in Japanese collections for a long time, and ranks as what the Japanese call a *densei-hin*, a piece handed down for many generations. It is known to have been in the collection of the renowned Kōnoike family of Osaka. During the Muromachi period in Japan (1392–1568), the taste for Chinese art and decoration was the predominant standard of the age. Among the elite, Chinese antique bronzes were items of special interest, and they were often used to decorate a study or reception room. In place of these bronzes, gray-green glazed celadons in bronze forms were, however, an acceptable substitute, and among the cognoscenti were perhaps preferred to the actual object.

Published

Hasebe, Gaukuji and the Zauho Press. *Sō. Sekai Tōji Zenshū*, Vol. 12. (Tokyo, 1977). pl. 203.

Hayashiya, Seizō and Trubner, Henry et al. *Chinese Ceramics from Japanese Collections: T'ang Through Ming Dynasties.* (New York, 1977). pl. 19.

Idemitsu Museum of Arts. *Special Exhibition Commemorating the Tenth Anniversary of the Idemitsu Collection.* (Tokyo, 1976). pl. 94.

The Tokyo National Museum. *Exhibition of Chinese Arts of the Sung and Yüan Periods.* (Tokyo, 1961). pl. 180.

References

Chinese Ceramics: A Loan Exhibition of One Hundred Selected Masterpieces from Collections in Japan, England, France, and America. (Tokyo, 1960).

Koyama, Fujio. *Chūgoku Tōji*, Vol. 1. Idemitsu Art Gallery Series 2. (Tokyo, 1970). p. 232.

21
Incense Burner

China, Southern Sung dynasty (1127–1279)
Lung-ch'üan ware, porcelaneous stoneware with
celadon glaze
Height: 17.8 cm.

Among the most important ceramic wares of the Southern Sung dynasty were the Lung-ch'üan celadons. These wares were not only characterized by a beautiful unctuous green glaze, but they were also very sturdy and eminently suitable for export. Great quantities of plates, bowls, vases, and incense burners were exported to the Middle East, India, and Japan during the twelfth and thirteenth centuries.

The richness of the thick glaze and the rich, deep color gave the Lung-ch'üan celadons an almost universal acceptance, and great quantities were exported to Japan from the Southern Sung to the Ming dynasties, from the end of the twelfth through the fifteenth centuries.

This celadon incense burner emulates an archaic bronze form known as a *Li*. The intellectuals of the Sung dynasty in particular venerated the ancient periods, such as the Shang and the Chou dynasties, and collections were made of antiquarian objects, notably bronzes and jades. The gray-green celadon glaze color is derived from iron oxide fired in a reducing atmosphere and is probably a direct descendant of Yüeh wares (no. 11), which were produced from the Period of the Warring States (fifth-third centuries B.C.) through the Five Dynasties period in the tenth century. The green glaze is said to emulate the color of jade. The taste for the rich green color, however, perhaps derives also from a desire to reproduce the green of the patina that appears on archaic bronzes. This unusually large *Li* tripod incense burner has an especially rich and lustrous celadon glaze representing the finest quality of Southern Sung dynasty ceramic production.

The *Li* tripod is a popular incense burner shape. In Japan, this form with its spreading thick legs accentuated by a sharp crease, is reminiscent of the *hakama* (divided skirt) which men wore in another age. This designation, *hakama-goshi*, has been accorded this type of piece.

References

Hasebe, Gakuji and the Zauho Press. *Sō. Sekai Tōji Zenshū*, Vol. 12. (Tokyo, 1977). pp. 216–217, fig. 66.

Hayashiya, Seizō and Trubner, Henry et al. *Chinese Ceramics from Japanese Collections: T'ang Through Ming Dynasties.* (New York, 1977). cat. no. 25.

Medley, Margaret. *The Chinese Potter: A Practical History of Chinese Ceramics.* (New York, 1976).

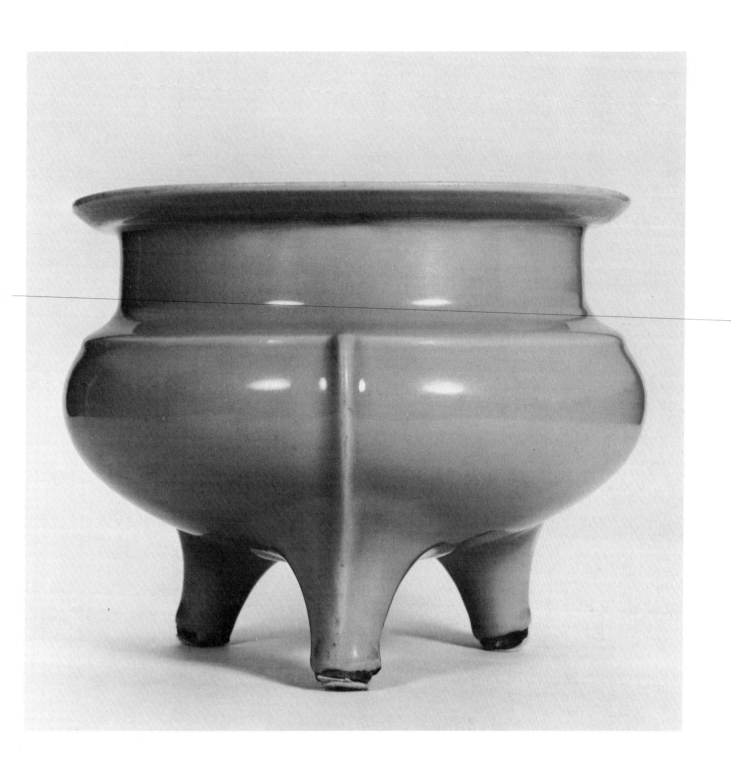

22*

Dish with Design of Dragon Chasing Flaming Pearl

China, Yüan dynasty (1280–1368)
Ching-tê-chên ware, porcelain with design reserved in
white on underglaze cobalt blue ground
Diameter: 16.0 cm.

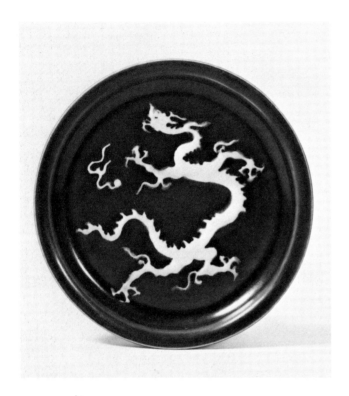

The Yüan dynasty potters at Ching-tê-chên displayed a great willingness to experiment with new techniques and materials in creating their unique wares. It was this experimentation which led not only to the mastery of the techniques of underglaze decoration, but to the invention of new shapes (no. 24) and the creation of new decorative themes (no. 23). This small plate is part of a distinctive group of blue-and-white wares that are generally accepted to date from the second quarter of the fourteenth century. The type represents an experimental technique which, while striking in appearance, must have proved too unprofitable or difficult to manage, for it was soon abandoned and never revived.

On this small, but boldly decorated plate, the figure of a rearing dragon is reserved in white against the smooth, dark blue ground. The sinuous form, edged with licking flames, breaks the expanse of rich, deep-colored glaze, as he claws eagerly for the flaming pearl in the distance. The body of the dragon reveals delicately incised detail in the *an-hua* (secret decoration) technique. Typical of many of the Yüan dynasty wares, the flat underside of the base is left unglazed.

Other examples of this type are found in several collections around the world. Similar plates are in the Percival David Foundation and the British Museum,

London, and in the Ataka Collection, Tokyo. There is a *mei-p'ing* vase in the Guimet Museum, Paris, and a pouring bowl in the Victoria and Albert Museum, London. Plates with foliate rims are in the Archaeological Museum, Teheran, and in the Topkapi Sarayi Museum, Istanbul; the latter has a brown rather than a blue glaze. John Ayers of the Victoria and Albert Museum has termed this group the 'white slip reserved' class of fourteenth-century porcelains. It is possible that other examples will appear, perhaps from archaeological excavations in China.

References
Ayers, John. "Some Chinese Wares of the Yüan Period." *Transactions of the Oriental Ceramics Society*, Vol. 29. (London, 1954, 1955). pp. 69–86.
Medley, Margaret. *Yüan Porcelain and Stoneware.* (London, 1974).
Yabe, Yoshiaki. *Gen no Sometsuke.* Tōji Taikei, Vol. 41. (Tokyo, 1974).

Fig. 16. Detail of base (no. 22)

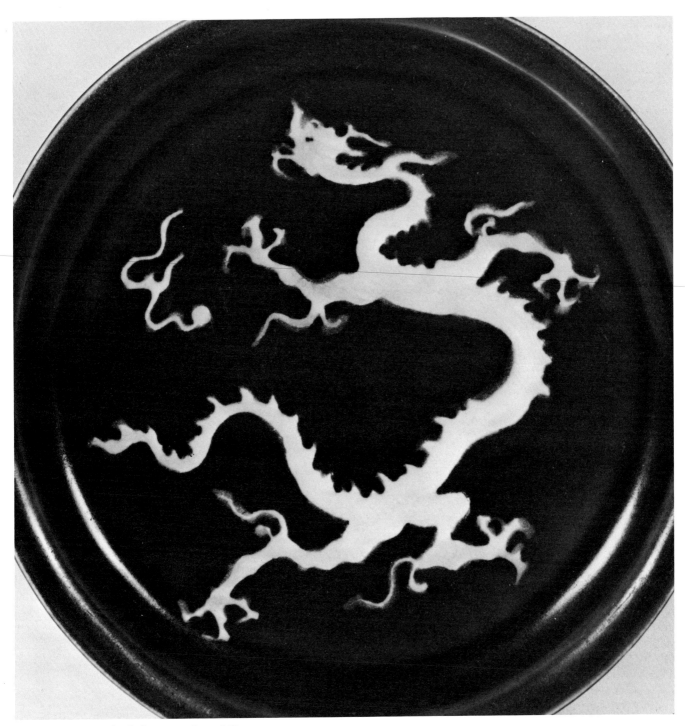

Fig. 17. Detail of dragon (no. 22)

23*

Jar with Design of Figures on Horseback
China, Yüan dynasty (1280–1368)
Ching-tê-chên ware, porcelain with underglaze cobalt blue decoration
Height: 34.0 cm.

During the Yüan dynasty, under Mongol domination, a new style of romantic literature, particularly for the theater, developed in China. This literary taste is reflected in the narrative designs decorating certain ceramics of this period. Once the potters had achieved a stable cobalt blue, they were free to treat the broad, white porcelain surfaces with painted designs. The only notable painted wares from earlier times were the Tz'u-chou wares. With the introduction of cobalt blue, the enhancement of ceramic surfaces had been given an entirely new language of design.

The Idemitsu jar, a *Kuan* or wine jar, is a pre-eminent example of this Yüan dynasty narrative decoration. The neck and shoulder of the jar are decorated with vigorous bands of curling waves and lotus scrolls; around the base of the jar is a band of lotus panels. The broad midsection of the jar, however, is reserved for a highly realistic depiction of scenes from a popular play of the day. The play has been identified as the *Han Kung Ch'iu*, a tragic drama, set in the Han dynasty. The heroine is shown riding the white horse. She is the Lady Wang Chao-chün from the Han court who was sent as wife to the king of the Huns. The scene seems to catch her with two attendants at the melancholy moment of departure for her new home among the barbarians. The bearded horsemen with their plumed hats, one sporting a hunting hawk on his wrist, are no doubt intended to represent the exotic and terrifying Huns.

The richness of the blue, the purity of the white body, and the lustrous glaze are finely balanced with the elaborate and highly refined painting style, complete with subtle nuances of shading and compositional movement. The delicacy of the pliant willows framing the saddened Lady Wang contrasts smartly with the ruggedness of the rock forms and spiky bamboo and pines associated with the forbidding horsemen. The result is a superlative expression of ceramic and painting skills to create an unrivaled example of fourteenth-century blue-and-white porcelain.

A pair of blue-and-white vases in the Percival David Foundation, London, bears an underglaze blue inscription with a date corresponding to 1351. These vases are irrefutable proof that highly developed underglaze cobalt blue-decorated porcelain was produced at the Ching-tê-chên kilns by the mid-fourteenth century. The strong connections between China and Persia during the Yüan dynasty (1280–1368) perhaps promoted the introduction to China of this type of decoration from the Near East where it was already in use on soft earthenware. The exact time and the method of the introduction to China of cobalt for decoration are, as yet, uncertain. It must have required several if not many generations of experimentation at the kilns to perfect the technique to the stage which could produce the massive and handsome vases of 1351.

At this time, the kiln center of Ching-tê-chên in Kiangsi Province became the focus of white porcelain production, much of which was created for export purposes. The exports were destined particularly for the Near East, but were also shipped to all of South Asia, Indonesia, and the Philippines. Almost inexplicably, little blue-and-white porcelain reached Japan until the early seventeenth century. It was then that the late Ming *Shonzui* ware (no. 34) began arriving in Japan, along with a ware known in Japan as *ko-sometsuke*, which was produced on order for the Japanese tea ceremony.

Published
Idemitsu Museum of Arts. *Special Exhibition Commemorating the Tenth Anniversary of the Idemitsu Collection.* (Tokyo, 1976). pl. 112.
Osaka Municipal Museum of Fine Arts. *Sō, Gen no Bijutsu.* (Osaka, 1980). pl. 42.
The Tokyo National Museum. *Exhibition of Far Eastern Blue-and-White Porcelain.* (Tokyo, 1977). pl. 8.

Reference
Medley, Margaret. *Yüan Porcelain and Stoneware.* (London, 1974).

Fig. 18. Central design (no. 23), photo by Heibonsha

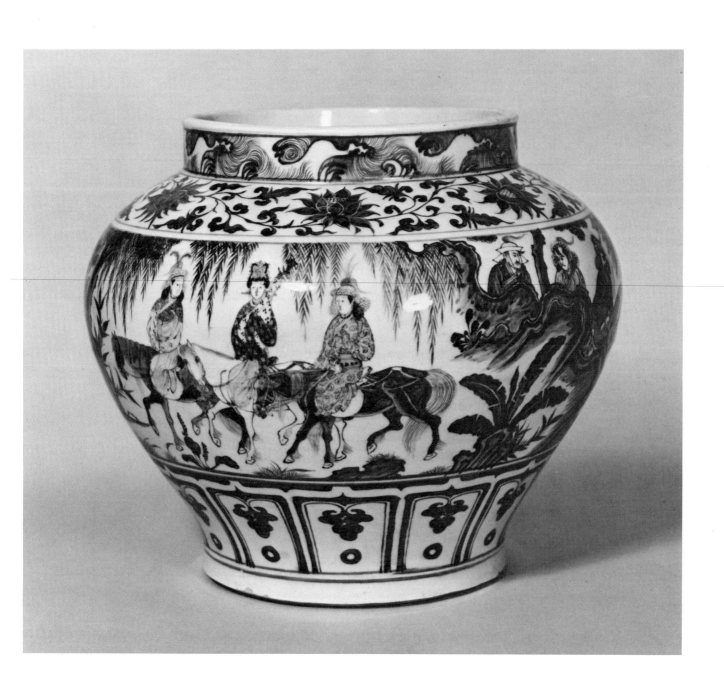

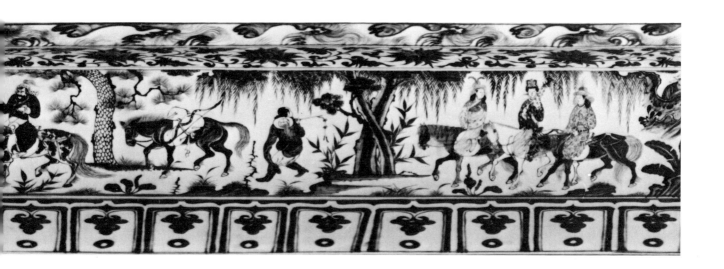

24*
Pilgrim Bottle with Design of
Dragons and Phoenixes

China, Yüan dynasty (1280–1368)
*Ching-tê-chên ware, porcelain with underglaze cobalt
blue decoration*
Height: 38.9 cm.

Like many other pieces recognized as dating from the second half of the fourteenth century, this blue-and-white pilgrim flask is exceptional among Chinese ceramics for its size, rich color, and brilliant decoration.

The shape—virtually rectangular in section, with almost vertical sides rising from a flat base and ending in rounded shoulders—is altogether foreign to Chinese ceramics. It probably reflects a Near Eastern metal prototype, as did other export-oriented, fourteenth-century porcelains. A more typically Chinese motif, however, is the pair of dragons on the shoulder, who arch their bodies to form loops, while their tails, curling along the outer edges of the shoulder, recall a scrolling meander pattern. The principal painted decorations is formed by a pair of dragons rising among clouds and chasing a flaming pearl. Below, a line of frothing waves is seen billowing above the base. The two painted dragons alternate, one ascending, one descending. They exchange positions on the opposite face of the flask. Their serpentine bodies coil and twist in a fascinating and exciting manner, with every detail sharply and richly portayed in an even sky blue. On both sides of the vessel, near the shoulder of the flask, a prominent cloud-collar pattern is depicted. The principal motif within the pattern consists of a pair of phoenixes. As in the case of the dragons, one is ascending, the other, descending; on one side, the dragons appear among peonies, on the other, they are shown among chrysanthemums. Lotus scrolls within a shaped border fill the narrow end faces of the flask on the left and right.

Unlike the Sung dynasty practice of imperial supervision and encouragement, the Ching-tê-chên kiln center, while controlled by the government under the Mongols, was developed commercially by merchants and traders. The government meanwhile extracted large sums through taxation from the production and export of porcelain. The unusual shape of the Idemitsu flask is probably the response to a special order either from a Near East trader or from one of the foreign traders living in China. Such accommodation by the kiln managers and potters for commercial gain was apparently viewed as desirable during this period and, as a result, shapes like the flask and the large dishes especially fashioned after Near Eastern examples in metal appeared. The type of flask represented by the present example never appeared again after the fourteenth century, but the platter or large plate form was continued into the eighteenth century, and later.

Flasks like the Idemitsu piece were probably very limited in production. Today only six related examples are known and the Idemitsu flask is the only one in perfect condition. Two flasks are in Iran, one is in Turkey, one in London, and one in the United States. In addition, an example in underglaze red has been reported in China. All are superb examples of one of the greatest achievements in Yüan dynasty ceramic design and decoration.

Published
Idemitsu Museum of Arts. *Special Exhibition Commemorating the Tenth Anniversary of the Idemitsu Collection.* (Tokyo, 1976). pl. 113.
Osaka Municipal Museum of Arts. *Sō, Gen no Bijutsu.* (Osaka, 1980). pl. 39.
Satō, Masahiko. *Chūgoku Tōjishi.* (Tokyo, 1978). pl. 61.
The Tokyo National Museum. *Exhibition of Far Eastern Blue-and-White Porcelain.* (Tokyo, 1977). pl. 7.

References
Medley, Margaret. *Yüan Porcelain and Stoneware.* (London, 1974).
Yabe, Yoshiaki. *Gen no Sometsuke.* Tōji Taikei, Vol. 41. (Tokyo, 1974). p. 141.

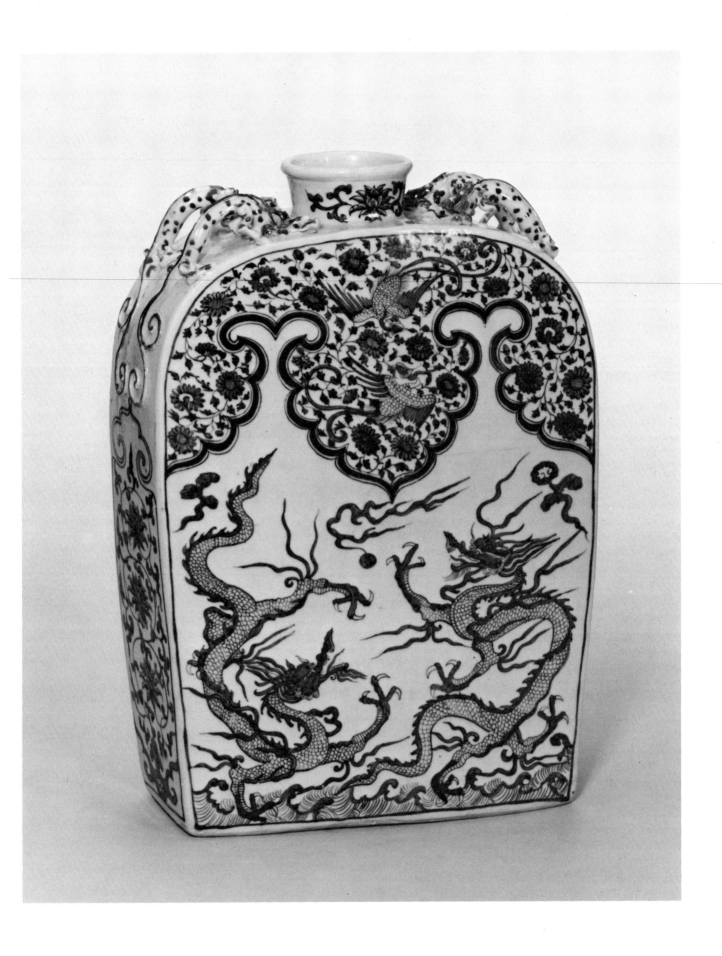

25*

Ewer with Design of Banana Trees

China, Yüan dynasty (1280–1368)
Ching-tê-chên ware, porcelain with underglaze
copper red decoration
Height: 33.8 cm.

The question of the origin of underglaze copper red decoration for porcelain is less clear than the origin of underglaze blue (nos. 22–24). The possibility of a cross-fertilization with Islamic ceramics does not exist, as in the case of underglaze blue, for the copper red was not in use in the Near East. There exist, however, a considerable number of examples dating from the fourteenth century. The use of underglaze red persisted into the early reigns of the Ming dynasty, but seems to have been eclipsed in popularity once the technique of overglaze enameling was developed. Copper red glazes and underglaze decoration were revived in the late Ming and Ch'ing dynasties, but the effect is quite different from the Yüan and early Ming types. The so-called *sang de boeuf* or *lang-yao* of the K'ang-hsi reign (1662–1722) is of this latter type.

The shapes of the early underglaze red wares were similar to those used for blue-and-white, and consisted of deep bowls, large plates and jars, tall footed bowls, cup stands, covered *mei-p'ing*, *kendi* water vessels, and pear-shaped vases and ewers. The pear-shaped ewer type (*yü-hu-ch'un-p'ing*) to which the Idemitsu example belongs, appeared rather late in the development of the Yüan style, suggesting that the group of known examples represents a transitional phase from the taste of the Yüan period to that of early Ming. The ewer (*hsien-chan-p'ing*) especially follows the form of the pear-shaped vase of the late Yüan dynasty, with the addition of a curved handle and long spout, which is given stability by the cloud-form bar running between the neck and the spout.

On the Idemitsu ewer, the main motif of plantain or banana trees with a tall, angular rock fills the central portion of the ewer. On either side appear spiky bamboo plants. A row of plantain leaves and a band of coupled key fret pattern encircle the neck above a band of lotus scrolls, bordered below by miniature cloud-collar pendants. Above the foot there is a band of false gadroons, or lotus panels, with a second band of key fret pattern around the footring. The spout and handle are decorated with scrolling vines, and the bar joining the spout and neck is carefully painted with realistic clouds.

Based on Margaret Medley's arguments ("The Blue and Red Decorated Porcelains of China," *Ars Orientalis*, Vol. IX. [New York, 1973].), the coupled key fret pattern stylistically establishes a date in the latter part of the fourteenth century for pieces bearing this type of design. The move away from a scattered, all-over design to a definite scene—in this case a Chinese garden, with a unified ground line from which plants rise and on which rests the fantastic rock—suggests even more strongly than the appearance of the coupled key fret, a transition phase from the export style of the Yüan dynasty to a native Chinese taste. The Chinese scholar class, ignored by the Yüan court, had essentially no influence on the development of underglaze porcelain decoration. Rather, the designs had developed in response to the taste of foreign markets, especially the Near East. The fantastic rocks, from Lake T'ai between Soochow and Nanking, were a favorite in the Chinese scholar's garden design. The plantain and bamboo are peculiarly Chinese motifs prominent in both literature and painting. The choice of these motifs set in a well-spaced design within the given area suggests a move towards conciliation with the Chinese scholar's taste.

The copper base from which the red color is obtained is very unstable in firing, and often the color misfires to a muddy brown. A fresh, bright crimson as on the Idemitsu piece is extremely difficult to obtain and is very rare. Even this piece with its excellent color exhibits a slightly different tone between one side and the other. The white body, almost a pure white, and the glaze, which has a high lustre almost as though it were moist, differs somewhat from the usual body and glaze of blue-and-white of the period.

Published
Hasebe, Gakuji and Hayashiya, Seizō. *Chūgoku Ko-tōji*, Vol. 2. (Tokyo, 1971). pl. 21.
Hakutsuru Fine Art Museum. *Masterpieces of the Idemitsu Collection.* (Kobe, 1976). pl. 20.
Idemitsu Museum of Arts. *Special Exhibition Commemorating the Tenth Anniversary of the Idemitsu Collection.* (Tokyo, 1976). pl. 117.
Koyama, Fujio et al. *Gen, Min.* Sekai Tōji Zenshū, Vol. 11. (Tokyo, 1961). fig. 93.
Koyama, Fujio and Mikami, Tsugio. *Tōji.* Tōyō Bijutsu, Vol. 4. (Tokyo, 1967). pl. 49.
T.O.C.S. *The Art of the Ming Dynasty.* (London, 1955–56, 1956–7). pl. 151.
The Tokyo National Museum. *Exhibition of Eastern Art Celebrating the Opening of the Gallery of Eastern Antiquities.* (Tokyo, 1968). pl. 442.
The Tokyo National Museum. *Exhibition of Far Eastern Ceramics.* (Tokyo, 1970). pl. 88.
Yabe, Yoshiaki. *Gen no Sometsuke.* Tōji Taikei, Vol. 41. (Tokyo, 1974). pl. 17.

References
Hasebe, Gakuji and Hayashiya, Seizō *Chūgoku Ko-tōji*, Vol. 2. (Tokyo, 1971).
Koyama, Fujio et al. *Gen, Min.* Sekai Tōji Zenshū, Vol. 11. (Tokyo, 1961).
Koyama, Fujio and Mikami, Tsugio. *Tōji.* Tōyō Bijutsu, Vol. 4. (Tokyo, 1967).
Medley, Margaret. "The Blue and Red Decorated Porcelains of China." *Ars Orientalis*, Vol. IX. (New York, 1973). pp. 89–107.
Medley, Margaret. *Pottery and Porcelain of the Yüan Dynasty.* (London, 1974).
T.O.C.S. *The Art of the Ming Dynasty.* (London, 1955–56, 1956–57).
Yabe, Yoshiaki. *Gen no Sometsuke.* Tōji Taikei, Vol. 41. (Tokyo, 1974).

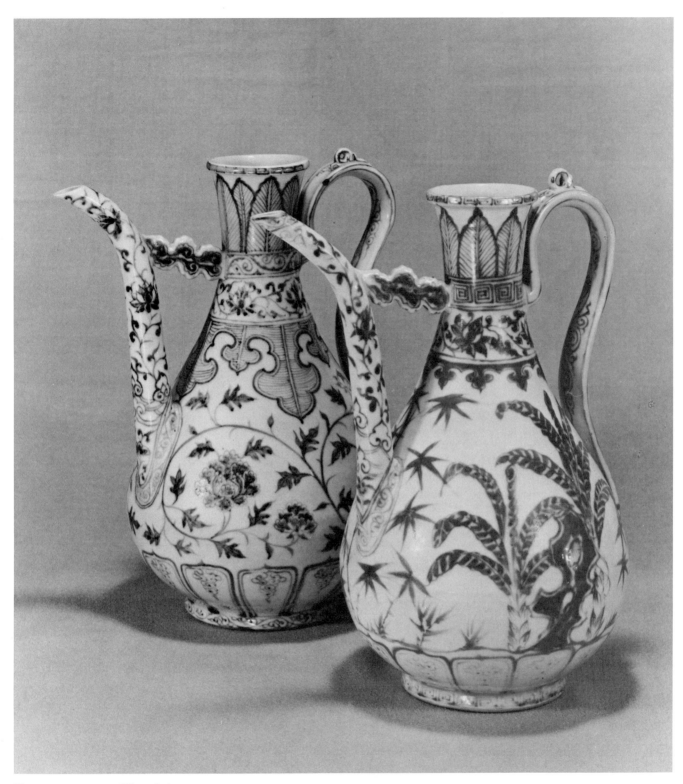

Two ewers nos. 25 and 26

26
Ewer with Design of Peony Scrolls

China, Ming dynasty (1368–1644)
Ching-tê-chên ware, porcelain with underglaze
cobalt blue decoration
Height: 33.0 cm.

The shape of this ewer is similar to the example in underglaze red (no. 25); some differences, however, suggest that the underglaze blue-decorated ewer is slightly later in date. The shape and size of the blue-and-white and red-and-white ewers are comparable, although the blue-and-white ewer is somewhat squat, and is shorter and slightly fatter than the former. Reminiscent of other examples of this shape is the decoration about the neck with a band of upright leaves and a border of classic scroll separating it from a band of peony scrolls. The lotus panels about the lower body and classic scroll motif on the footring also recall other Yüan period types.

The major changes that would suggest a more transitional date are the handling of the decoration and the quality of the blue. The peony scroll on the body has been reduced in scale as the pendant cloud-collar motif has become enlarged. The two motifs have simultaneously become more integrated and yet allow for more open, undecorated space than before. There is an attempt at greater balance and poise than in the more energetic examples of the Yüan period. The color, too, is significant. The rather thin color, dotted irregularly with saturated pigment and occasional impurities, indicates it was painted at a time when the supply of imported cobalt was interrupted, after the fall of the Yüan dynasty in 1368, and before an adequate substitute could be discovered. The thinness of the color is accentuated by the delicately restrained, narrow line of the painting. The difference in color and handling is quite apparent in comparison with the *Kuan* shape jar (no. 23) and the pilgrim flask (no. 24).

The group of late fourteenth- and early fifteenth-century wares is difficult to date. There was no officially designated imperial kiln specifically supplying the palace during the late fourteenth century. Assigning these transitional, late fourteenth- and early fifteenth-century ceramics to a definite reign, whether Hung-wu (1368–1398) or Yung-lo (1403–1424), is further complicated because the practice of inscribing the reign mark did not come into common use until sometime in the Hsüan-tê reign (1426–1435) (cf. no. 29).

This ewer definitely belongs in the late fourteenth century and recognizing it as a transitional piece, moving it closer to Ming rather than Yüan, gives it special importance. A growing number of scholars and collectors accept a specific date in the reign of Hung-wu, the first Ming emperor, as more information regarding early Ming developments comes to light, especially through new archaeological discoveries in China. The historical importance of this ewer will be considerably heightened if in the end it can be definitely assigned to this reign.

Published
Fujioka, Ryōichi *Min no Sometsuke.* Tōji Taikei, Vol. 42. (Tokyo, 1975). pl. 28.
Fujioka, Ryōichi and Hasebe, Gakuji. *Min.* Sekai Tōji Zenshū, Vol. 14. (Tokyo, 1976). pl. 1.
Idemitsu Museum of Arts. *Special Exhibition Commemorating the Tenth Anniversary of the Idemitsu Collection.* (Tokyo, 1976). pl. 118.
Koyama, Fujio et al., editors. *Gen, Min.* Sekai Tōji Zenshū, Vol. 11. (Tokyo, 1961). fig. 66.
The Tokyo National Museum. *Exhibition of Chinese Arts of the Sung and Yüan Period.* (Tokyo, 1961). pl. 296.
Yabe, Yoshiaki. *Gen no Sometsuke.* Tōji Taikei, Vol. 41. (Tokyo, 1974). pl. 16.

References
Fujioka, Ryōichi. *Min no Sometsuke.* Tōji Taikei, Vol. 42. (Tokyo, 1975).
Fujioka, Ryōichi and Hasebe, Gakuji. *Min.* Sekai Tōji Zenshū, Vol. 14. (Tokyo, 1976).
Koyama, Fujio et al., editors. *Gen, Min.* Sekai Tōji Zenshū, Vol. 11. (Tokyo, 1961).
Yabe, Yoshiaki. *Gen no Sometsuke.* Tōji Taikei, Vol. 41. (Tokyo, 1974).

Fig. 19. Detail of underside (no. 26)

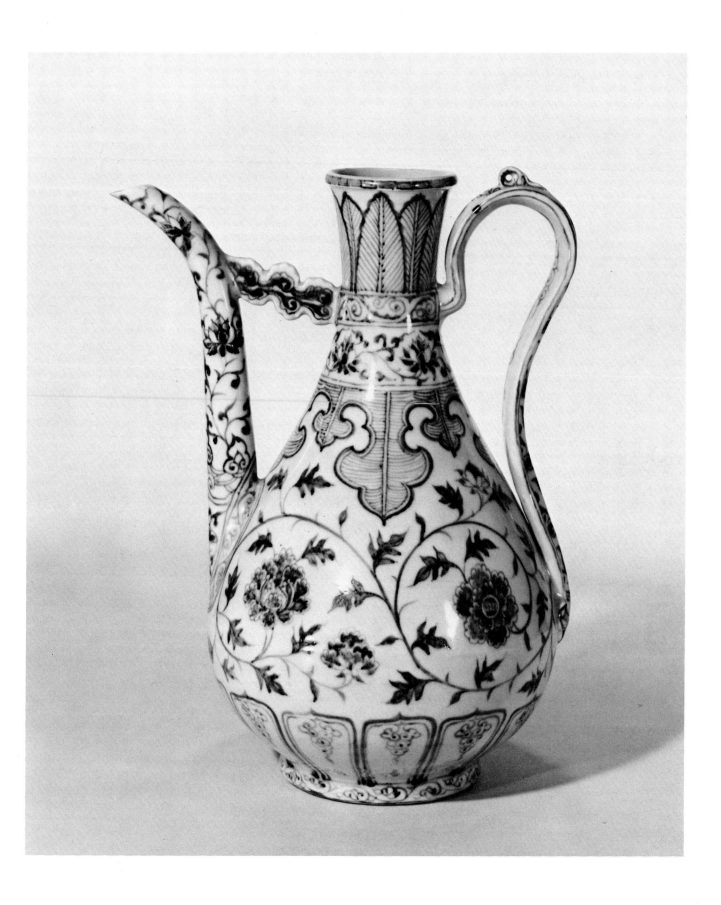

27*

Large Dish with Design of Flowers and Rocks

China, Ming dynasty, Yung-lo period (1403–1424)
Ching-tê-chên ware, porcelain with underglaze
blue decoration
Diameter: 67.6 cm.

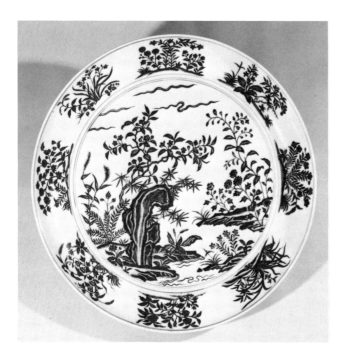

A series of large blue-and-white plates like the Idemitsu piece are believed to have been produced in the early Ming dynasty for export to the Near East. Almost identical examples are found in the two most famous collections of the Near East, the Topkapi Sarayi Museum, Istanbul, formerly the palace of the Sultans of Turkey, and the Ardebil Shrine Collection, Teheran, formerly in the mortuary mosque of Shah Abbas the Great (ruled 1587–1629). These large plates can be seen as the logical successors to the large export porcelain plates of the Yüan dynasty. The painted design, however, has moved toward a much more recognizably Chinese taste than that found on the earlier types. Also, the throwing techniques of the potter's art, as found in Sung dynasty ceramics, were once more gaining prominence. These large plates of the Ming dynasty were thrown by hand on the potters' wheel, while the large Yüan dynasty plates were made in elaborate molds.

The close similarity in motif and layout of the central design among the various examples argues for the presence of copy books at this time. The standardization of recognized themes came to be increasingly important in the development of ceramic styles at Ching-tê-chên, replacing the heterogeneous style based on foreign influence during the Yüan dynasty. The geometric, overall patterns and elaborate mixtures of decorative motifs so prevalent on fourteenth-century wares were replaced by calm, contemplative scenes like this garden of plants of the four seasons blooming in profusion beside a meander-

ing stream, a scene derived from a purely Chinese taste. At the center of the design is one of the Lake T'ai fantastic rocks, which appeared in the design on the underglaze red ewer (no. 25). Above the central motif on the cavetto wall are painted eight groups of blossoming plants, each rising from a clearly marked ground line. Identical groups in the same order appear on the various other examples; however, the positioning around the cavetto varies slightly. A series of eight groups of different flowering plants decorates the underside of the rim as well. The base is unglazed, as is common in large dishes of this type.

The dish does not have a reign mark, for the Yung-lo mark was not used on blue-and-white porcelain of the period. The attribution to this reign is, however, supported not only by the characteristic glaze and color, but by the decorative motifs, the potter's technique of throwing and painting, and by the appearance of almost identical examples in the Topkapi Sarayi and Ardebil Collections mentioned above. The modulated qualities of the 'heaped and piled' effect are less pronounced in the color of this large plate than in the globular vase (no. 28).

Published
Fujioka, Ryōichi. *Min no Sometsuke.* Tōji Taikei, Vol. 42. (Tokyo, 1975). pl. 39.
Fujioka, Ryōichi and Hasebe, Gakuji. *Min.* Sekai Tōji Zenshū, Vol. 14. (Tokyo, 1976). pl. 11.
Idemitsu Museum of Arts. *Special Exhibition Commemorating the Tenth Anniversary of the Idemitsu Collection.* (Tokyo, 1976). pl. 119.

Reference
Medley, Margaret. *The Chinese Potter: A Practical History of Chinese Ceramics.* (New York, 1976).

Fig. 20. Detail of base (no. 27)

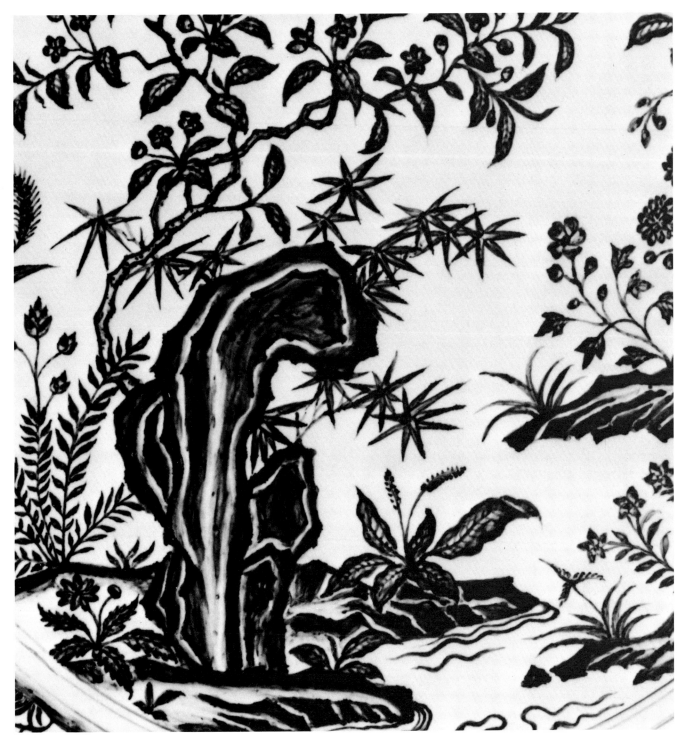

Fig. 21. Detail of inside (no. 27)

28

Vase with Design of Dragons and Waves

China, Ming dynasty, Yung-lo period (1403–1424)
Ching-tê-chên ware, porcelain with underglaze blue
decoration
Height: 42.7 cm.

Among the most attractive of the early Ming shapes is this large globular vase. This type of bottle or vase was a new form introduced during the Yung-lo (1403–1424) and Hsüan-tê (1426–1435) periods. Its strength and vitality, tempered by a flowing elegance, are among the new hallmarks of the period. The profile sweeps elegantly upward from the unglazed flat base, swinging freely outward and then in again to end in a subtle curve at the shoulder where the body joins the tall neck. The neck is not perfectly straight, but reverses the curve at its base, flaring slightly at the lip. The suppleness of the profile is echoed in the writhing of the dragon as it encircles the massive body of the vase. The entire surface of the vase, except for the small band of scrolling vines at the lip, is devoted to the motif of the dragon among churning waves.

The dragon, reserved in white against the blue waves, has only its eyes painted in underglaze blue; the details of scales and other features are incised into the white porcelain body of the vase. Dragons painted in blue on the white porcelain ground, or reserved in white against

a blue background, were an important decorative element of Yüan dynasty porcelain. The use of white reserve designs was usually limited to subsidiary motifs, with the exception of a few examples related to the small plate in the Idemitsu Collection (no. 22); however, the treatment of the dragon motif on the globular vase demonstrates a new sense of harmony of painted designs and ceramic form, which here brings the reserved design into prominence.

The blue on this vase is not uniform in color, but shows variations in intensity. This modulation gives a rhythmical energy to the wave pattern, which makes the impact of the design all the more striking. This 'heaped and piled' effect is very characteristic of early fifteenth-century Ming blue-and-white porcelain.

Several examples of this shape and similar size are known. A particularly fine example in the Hatakeyama Memorial Museum, Tokyo, is registered as an Important Cultural Property. One example in the Topkapi Sarayi Museum, Istanbul, has been fitted with a spigot and domed metal cover. Examples of this type of vase with decoration of dragon in blue-and-white amid lotus scrolls or clouds are also known, dating from the same period.

References
Fujioka, Ryōichi. *Min no Sometsuke*. Tōji Taikei, Vol. 42. (Tokyo, 1975).
Fujioka, Ryōichi and Hasebe, Gakuji. *Min*. Sekai Tōji Zenshū, Vol. 14. (Tokyo, 1976).
Medley, Margaret. *The Chinese Potter: A Practical History of Chinese Ceramics*. (New York, 1976).

Fig. 22. Detail of design (no. 28)

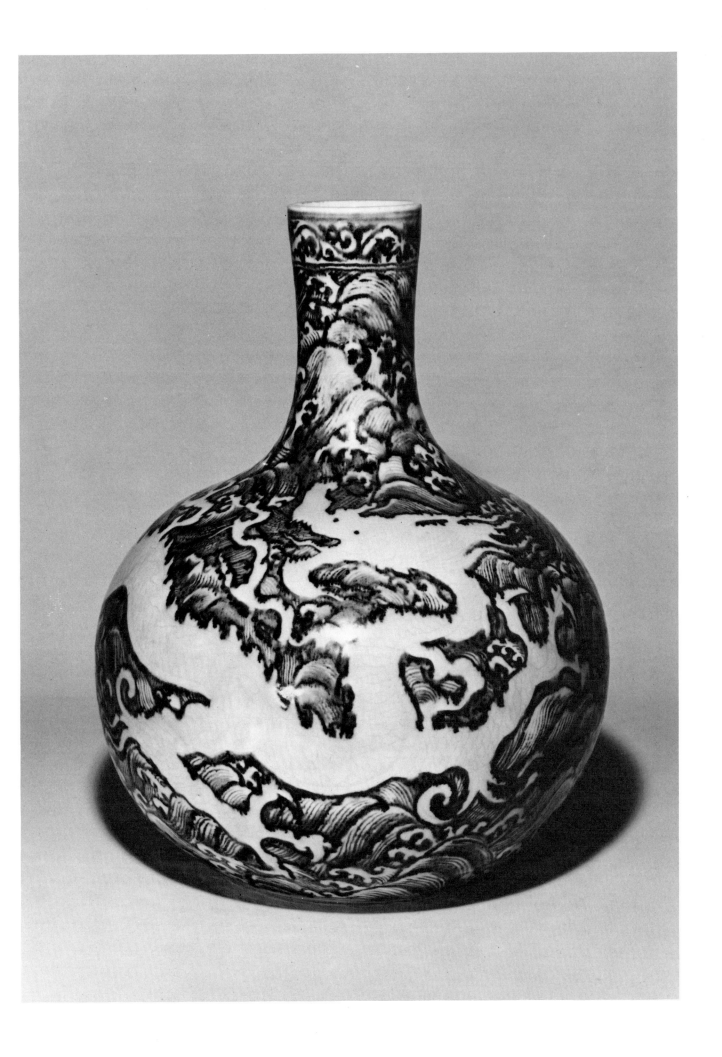

29
Dish with Design of Loquat Sprays

China, Ming dynasty, Hsüan-tê period (1426–1435)
Ching-tê-chên ware, porcelain with underglaze blue
decoration
Diameter: 45.5 cm.

Fig. 23. Inscription on underside of rim (no. 29)

Fig. 24. Detail of underside (no. 29)

The emperor Hsüan-tê (ruled 1426–1435) was a scholar and an artist. He enjoyed the art of painting, and exquisite renditions of furry cats and dogs bearing his signature are well known. The emperor seems also to have taken considerable interest in the ceramics in use at the palace, and no doubt the excellence of material and execution, and the rich visual beauty of the porcelains produced during his reign are the direct result of his particular interest in the production of the imperial porcelains. It was during this reign that the inscribing of the imperial reign mark became common practice. A six-character reign mark of Hsüan-tê appears below the lip on the outside of this Idemitsu dish.

Blue-and-white porcelains of the Hsüan-tê period combined the best qualities of ceramics of earlier reigns. They incorporated the richness of the cobalt color and the elegance of shape and profile. The designs, too, were not unrelated to earlier types, and evolved naturally out of the Yung-lo (1403–1424) and late fourteenth-century examples (nos. 26–28). The tendency toward stabilizing and standardization of motifs, scale, and shapes noted in earlier examples resulted in the production of imperial wares that included highly decorated plates of various sizes, bowls, jars, vases, cups, and pilgrim flasks. The list of decorative motifs was expanded to include many examples of blossoming and fruiting branches, as seen in this piece from the Idemitsu Collection, as well as designs of plants, birds, and dragons. The increasing restraint noted in earlier examples, such as the large Yung-lo period plate (no. 27) and the vibrancy of the Yung-lo globular vase (no. 28) were harmonized in this beautiful plate into a mature aesthetic formula. The form and decorative motifs are now balanced in a finished product that reflects superb craftsmanship and great technical perfection.

The beauty of the wares of this reign became legendary among Chinese collectors and connoisseurs, and for centuries to follow, the forms and decorative motifs popular during this reign were continued at Ching-tê-chên. The reign mark, itself, was often added to pieces, partly out of custom and partly out of respect for what was one of the most important artistic moments in the history of the Ching-tê-chên kilns.

References

Fujioka, Ryōichi. *Min no Sometsuke.* Tōji Taikei, Vol. 42. (Tokyo, 1975).

Fujioka, Ryōichi and Hasebe, Gakuji. *Min.* Sekai Tōji Zenshū, Vol. 14. (Tokyo, 1976).

Medley, Margaret. *The Chinese Potter: A Practical History of Chinese Ceramics.* (New York, 1976).

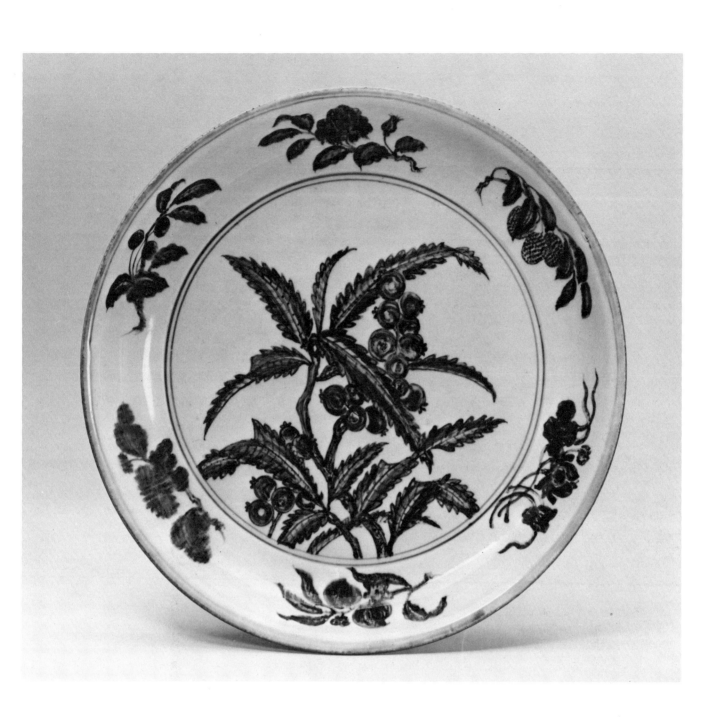

30*
Ewer with Design of Peacock and Peonies

China, Ming dynasty, Chia-ching period (1522–1566)
Ching-tê-chên ware, kinran-de type, porcelain with over-glaze red enamel and gold decoration
Height: 21.1 cm.
Important Art Object

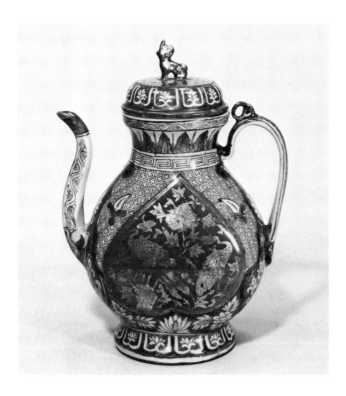

This handsome ewer belongs to a class of enameled and gilt Chinese porcelains known as *kinran-de* (gilt brocade design) in Japan. The ware is typified by the rich overglaze red enamel that covers large areas of the white porcelain body and on which have been painted rich designs and patterns in gold. In addition to the red and gold, overglaze green or yellow, and sometimes blue enamels were also used in the decoration of these pieces. Examples with green, blue, or yellow ground rather than red are also known. *Kinran-de* wares were made at private kilns in the area of Ching-tê-chên primarily for export purposes. The greatest concentration of *kinran-de* wares today is in Japan, and it is perhaps for this reason that the Japanese name has become the standard term for this type. The ware must have been imported in considerable numbers, and many pieces have been treasured for centuries, especially in connection with the tea ceremony food service, the *kaiseki ryōri*. Items for the scholar's desk were also produced.

The enameled and gilt *kinran-de* wares are generally related to the *wu-ts'ai* or five-color enameled porcelains that developed in the Ming dynasty (nos. 32, 33); however, the *kinran-de* ware displayed special characteristics, particularly in shapes. The main production period for *kinran-de* seems to have been during the Chêng-tê (1506–1521) and especially during the Chia-ching (1522–1566) reigns. These porcelains were manu-

factured at private kilns for the most part, and do not always bear a reign mark. Mock seal marks or wishes for long life and happiness are, however, frequently painted in underglaze blue within the footring. This ewer bears the four-character inscription *Fu Kuei Chia Ch'i* (vessel of beauty, wealth, and honor). The ewer can, however, be dated to the Chia-ching reign, for there is a blue-and-white ewer of similar shape in the Idemitsu Collection which bears a Chia-ching reign mark (*Special Exhibition Commemorating the Tenth Anniversary of the Idemitsu Collection.* [Tokyo, 1976] pl. 129). Other blue-and-white examples with the same reign mark are in the Tokugawa Museum, Nagoya, and the Percival David Foundation, London.

Among surviving examples, the *kinran-de* wares include sets of round food bowls, tall footed bowls, tea bowls, tall vases, incense burners, bottles—some in faceted or double gourd shape—covered jars, and ewers. The Idemitsu ewer is a type called *hsien-chan-p'ing* (Japanese: *sen-san-bin*). This type can be traced to Yüan dynasty examples (nos. 25, 26), but the taste for this ewer shape continued well into the Ming dynasty. Sixteenth-century examples usually have flattened or faceted sides, elaborate spouts, wide curving handles, and elaborate covers. This ewer is more compact in shape than is common, but its pleasing proportions and splendidly adapted decoration provide it with a sense of reassuring stability. The heart-shaped panels, which occupy each side of the flattened body, carry a design of peacocks and tree peonies.

During the Edo period in Japan (1615–1868), Japanese porcelain kilns at Arita and Kyoto produced their own versions of *kinran-de* ware. These wares are called *nishiki-de*, or brocaded wares.

Published
Idemitsu Museum of Arts. *Special Exhibition Commemorating the Tenth Anniversary of the Idemitsu Collection.* (Tokyo, 1976). pl. 128.

References
Fujioka, Ryōichi. *Min no Akae.* Tōji Taikei, Vol. 43. (Tokyo, 1972). pl. 11.
Fujioka, Ryōichi and Hasebe, Gakuji. *Min.* Sekai Tōji Zenshū, Vol. 14. (Tokyo, 1976). fig. 124.
Hayashiya, Seizō and Trubner, Henry et al. *Chinese Ceramics from Japanese Collections: T'ang through Ming Dynasties.* (New York, 1977). p. 29.

Fig. 25. Mark on base (no. 30)

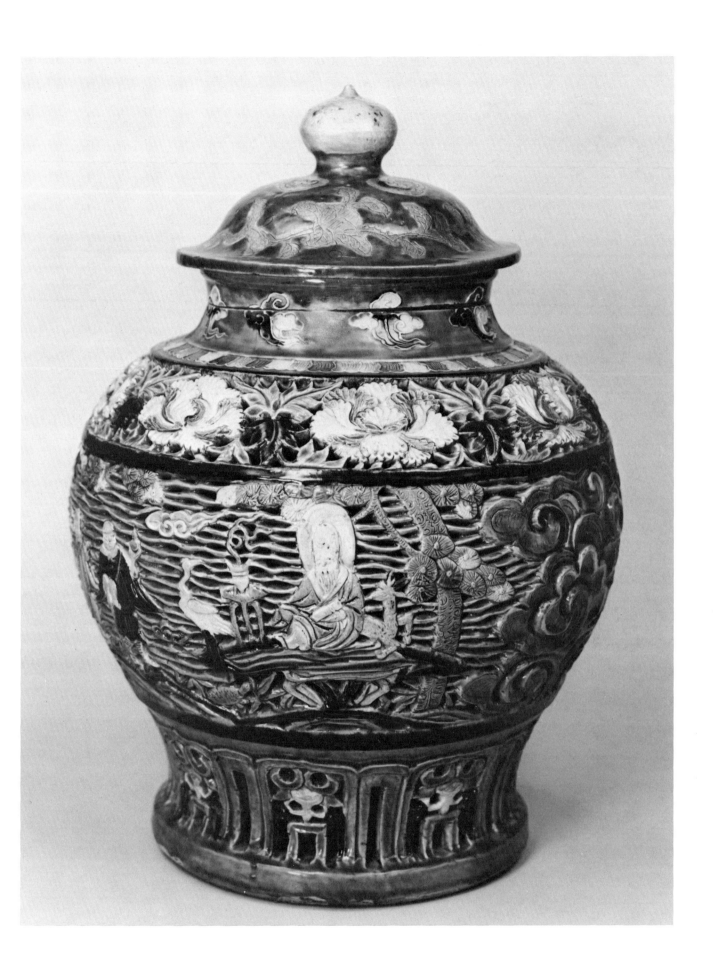

31
Covered Jar with Design of Figures on
Openwork Background

China, Ming dynasty (1368–1644)
San-ts'ai *(three color)* ware, fa-hua *type*
Height: 47.5 cm.

The term *fa-hua* refers to a technique of applying clay threads, or cloisons, in relief to divide the areas of colored enamels. This ware is a type of Ming dynasty three-color or *san-ts'ai* ware, distinguished not only by the appliqué threads dividing the colors, but also by the range of colors—usually white, purple, dark blue, and turquoise blue. The peak period of production was during the late fifteenth and early sixteenth centuries and most of the outstanding examples, like this Idemitsu jar, date from about 1500. These wares were made in the north of China, probably in Shansi, or possibly Honan Province.

A large proportion of the extant pieces reflect Buddhist themes of lotus and sacred jewel patterns; however, the Idemitsu jar bears a design of Taoist figures, featuring the popular God of Longevity accompanied by a deer and a crane. These two creatures are symbolic of long life and are associated with the pure in spirit who possess the ability to communicate with nature's most noble creatures.

The Idemitsu jar is unusual for the double-walled character of construction. The principal jar is covered by an overlay of openwork design that not only differs from the more common Buddhist-inspired motifs, but also represents a rare example of openwork design. The inner and outer jars were executed separately, but from the beginning were created with the idea of combining the two into one.

Other large jars of this size exist, but few still retain the original cover, as does the Idemitsu example. From the yellow knob of the cover to the base line, the jar exhibits a rich array of decoration, incorporating cloud forms, peony scrolls, Taoist Immortals, and stylized lotus panels, all represented in the cloisonné, or *fa-hua* technique, and combined with openwork decoration. The interior of the cover and jar are glazed a rich green.

Published

Hakutsuru Fine Art Museum. *Masterpieces of the Idemitsu Collection.* (Kobe, 1976). pl. 21.

32*

Jar with Design of Fish and Water Plants

China, Ming dynasty, Chia-ching period (1522–1566)
Ching-tê-chên ware, porcelain with underglaze blue and overglaze enamel decoration
Height: 35.4 cm.

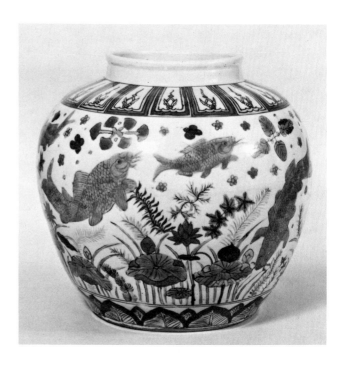

The earliest overglaze enamels known are found on Tz'u-chou ware bowls of the Southern Sung and Yüan dynasties. Early Ming experiments are cited; however, it was not until the Hsüan-tê period (1426–1435) that examples were produced combining underglaze blue with overglaze enamel colors. During subsequent reigns, the enameling process was further developed until, in the Ch'êng-hua period (1465–1487), a unified harmony of color, shape, and design was achieved by the potters of Ching-tê-chên.

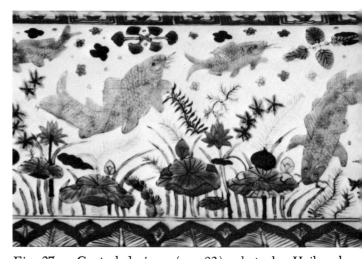

Fig. 27. Central design (no. 32), photo by Heibonsha

The family of porcelains known as *wu-ts'ai*, or five colors, combines underglaze blue with overglaze red, green, yellow, and purple enamels. It is a term generally denoting polychrome decoration, rather than specifically five colors. The technique represented the full development of the overglaze enamel technique. The earlier *tou-ts'ai* wares of the Ch'êng-hua period (1465–1487) are characterized by an elegant delicacy featuring gentle coloring in pale greens, soft yellows, and muted purples and reds applied to graceful and usually small pieces. The small cups are particularly notable for their thin potting.

During the reign of the emperor Chia-ching (1522–1566) a dramatic shift in taste occurred, and the kilns at Ching-tê-chên readily adapted the techniques of enamel decoration. The delicacy of Ch'êng-hua *tou-ts'ai* enameled wares was replaced by brilliant coloring and the use of a deep underglaze blue made from imported cobalt, known as Mohammedan blue. This jar, one of a small group of similar jars known in collections around the world, clearly testifies to the power and energy which characterized the new taste at the Ming court.

The motif of a lotus pond with carp and duck weed fills the surface of the entire jar, except for a band of decorative panels about the neck, and a narrow band of upright broad leaves about the foot. The vibrancy of the coloration is achieved by a selective combination of colors. The orange color of the fish, twisting and turning around the jar, is a special hue achieved by painting details in red over a wash of yellow on the body of the fish to create a color differing from and brighter than either the red or the yellow. A six-character mark of the Chia-ching reign is written in underglaze blue on the base of the jar.

In addition to the *wu-ts'ai* type of the Idemitsu jar, several other prominent types were developed during the late fifteenth and early sixteenth centuries. The *kinran-de* type (no. 30) and an overglaze type called *ko-aka-e* in Japan, featuring bold pictorial designs in overglaze red, green, and yellow, are especially notable. Both the *kinran-de* and *ko-aka-e* were imported to Japan in some quantity and have played an important role there in the development of tea taste and in the growth of ceramic production.

Published
Idemitsu Museum of Arts. *Special Exhibition Commemorating the Tenth Anniversary of the Idemitsu Collection.* (Tokyo, 1976). pl. 127.

References
Fujioka, Ryōichi. *Min no Akae.* Tōji Taikei, Vol. 43. (Tokyo, 1972). p. 118.
Fujioka, Ryōichi and Hasebe, Gakuji. *Min.* Sekai Tōji Zenshū, Vol. 14. (Tokyo, 1976). p. 75.

Fig. 26. Mark on base (no. 32)

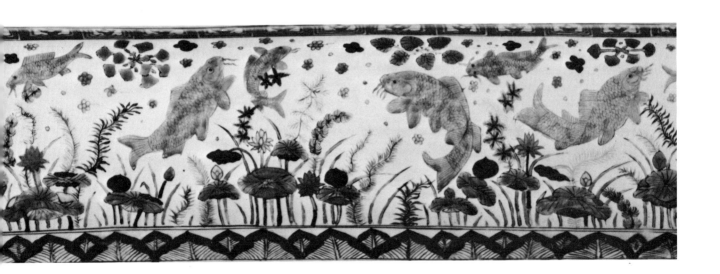

33
Vase in Shape of Bronze *Tsun*, with Design of Dragons and Phoenixes

China, Ming dynasty, Wan-li period (1573–1619)
Ching-tê-chên ware, porcelain with underglaze blue and
overglaze enamel decoration
Height: 74.0 cm.

The Chia-ching period (1522–1566) saw the beginning of full scale production of enamel-decorated wares. Once mastered, these wares continued to be produced through the succeeding Lung-ch'ing period (1567–1572) into the Wan-li period (1573–1619). The Wan-li period brought to its culmination all previous generations of enamel design that had begun during the Hsüan-tê period (1426–1435). For all its dynamic power, the designs on the *wu-ts'ai* porcelains produced during the Chia-ching reign (no. 32) maintained a sense of balance and sophistication. During the Wan-li period, however, potters were encouraged to generate more striking shapes decorated with ever more complex designs, further heightened by the use of intense overglaze enamel colors in combination with deep underglaze blue.

In the early part of the reign, the design control and potting skills reflected the standards of Chia-ching wares. After the middle of the reign, however, shapes seemed to become increasingly irregular, while the potting became rougher and less finished. The agitated designs are frequently jumbled and even sometimes poorly executed with blurred details and confused patterns in underglaze blue. This condition at the kilns might be partly explained by the prodigious production at Ching-tê-chên under the Wan-li court. As the reign progressed and the kilns were pressed with urgent orders for production, the materials often grew rough and the colors were frequently less delicately handled. The style of the wares became increasingly different from the self-assured dignity of the Chia-ching *wu-ts'ai* wares.

During the Ming dynasty, as in the Sung dynasty, there was a decided interest in the arts of earlier times, especially in the ancient bronze and jade forms. Archaistic designs recalling Shang and Chou bronzes were, therefore, not uncommon. This large vase is in the shape of a *Tsun*, or ceremonial wine vessel. During the Sung dynasty, the interest in archaic bronzes and jades would have been expressed in celadons (no. 20), but under the expansive mood of the Wan-li reign, this interest was expressed in brightly colored porcelains, as in this massive piece.

The principal motif represents a dragon and phoenix amid floral sprays, chasing a flaming pearl. The motif is repeated not only in the main sections, above and below, but on each of the faces of the octagonal midsection. Bands of scrolling vine and floral sprays border the mid-section, while a colorful lappet design decorates the underside of the lip. A series of churning waves and blossoms rings the foot. A lion mask designed to hold a loose ring handle is placed on either side near the neck.

In contrast to many other examples remaining from the Wan-li period, this vase is especially well proportioned, with the upper and lower sections almost equal, and separated by the bulging mid-section. The spreading lower section is somewhat larger in diameter than the upper part and imparts a comfortable visual balance to the slightly taller upper section with its grotesque applied masks and flaring mouth. This form of *Tsun* vase is known in Japan as a *nakakabura* shape, a term derived from the bulging mid-section which suggests a *kabura* (turnip) shape.

A six-character Wan-li reign mark is painted in underglaze blue within a decorative border near the rim. In the Idemitsu Collection, there is also a very similar *Tsun* of the Wan-li period, decorated only in underglaze blue, without the addition of enamel colors.

Published
Idemitsu Museum of Arts. *Special Exhibition Commemorating the Tenth Anniversary of the Idemitsu Collection.* (Tokyo, 1976). pl. 132.

References
Fujioka, Ryōichi. *Min no Akae.* Tōji Taikei, Vol. 43. (Tokyo, 1972).
Fujioka, Ryōichi and Hasebe, Gakuji. *Min.* Sekai Tōji Zenshū, Vol. 14. (Tokyo, 1976).
Medley, Margaret. *The Chinese Potter: A Practical History of Chinese Ceramics.* (New York, 1976).

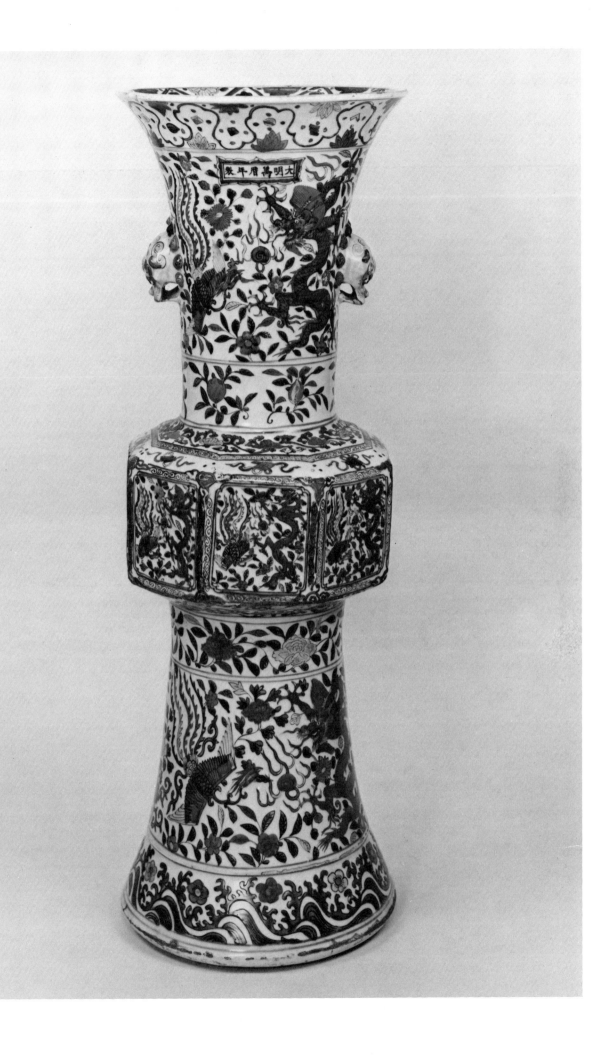

34*

Covered Water Jar in Shape of Mandarin Orange with Design of Flowers and Birds

China, Ming dynasty, Ch'ung-chêng period (1628–1644)
Ching-tê-chên ware, Shonzui type porcelain with
underglaze cobalt blue decoration
Height: 17.4 cm.

The style of this covered vessel is known in Japan as *Shonzui* ware. It was once believed that such pieces were created in Japan by a potter named Gorō Daiyū Shonzui,¹ the Japanese reading of the inscription *Wu liang t'ai fu wu hsiang jui* found on many pieces of this ware. According to the story, Shonzui went to China where he learned the secrets of porcelain making. After his return to Japan, he created these wares, now known by the name *Shonzui*. There is no documentation to support this theory and scholars today usually discount the story.

The so-called *Shonzui* wares are characterized by a brilliant cobalt blue coloring on a sumptuous white body that rivals the best imperial Chinese wares of the period. This rich coloring and fine potting allude to its production at the imperial kiln center of Ching-tê-chên, in Kiangsi Province. The designs and shapes of *Shonzui* ware differ from traditional Chinese styles, and since no references are found in the literature and no objects have been found in China, scholars conclude that the *Shonzui* types were especially designed and decorated, probably on order, for export to Japan.

The usual design elements, normally in blue and white, include bands of roundels bearing geometric designs or miniature landscape or figure motifs, combined with bird-and-flower designs or diaper patterns with shoulder lappets and sometimes calligraphic inscriptions. Occasionally landscape designs or animal themes were incorporated. The shapes alone would suggest that the *Shonzui* wares were created for the Japanese market: double-gourd shaped bottles, broad, flat shallow bowls, unusual tea bowls, or covered jars, like the Idemitsu piece, which was executed to resemble the *mikan*, or mandarin orange. This covered jar was probably intentionally designed as a *mizusashi*, or water jar, for the tea ceremony in Japan. The *Shonzui* wares sometimes incorporated unusual design elements. This piece has painted on the underside of the lid a very unusual scene of men washing an elephant.

Published
"The Art of the Ming Dynasty." *Transactions of the Oriental Ceramic Society.* (London, 1969–1971). pl. 184.
Hayashiya, Seizō and Trubner, Henry et al. *Chinese Ceramics from Japanese Collections: T'ang through Ming Dynasties.* (New York, 1977). pl. 71.
Idemitsu Museum of Arts. *Special Exhibition Commemorating the Tenth Anniversary of the Idemitsu Collection.* (Tokyo, 1976). pl. 194.
Koyama, Fujio and Mikami, Tsugio. *Tōji.* Tōyō Bijutsu, Vol. 4. (Tokyo, 1967). pl. 63.

Fig. 28. Detail of underside (no. 34)

Fig. 29. Detail of inside of cover (no. 34)

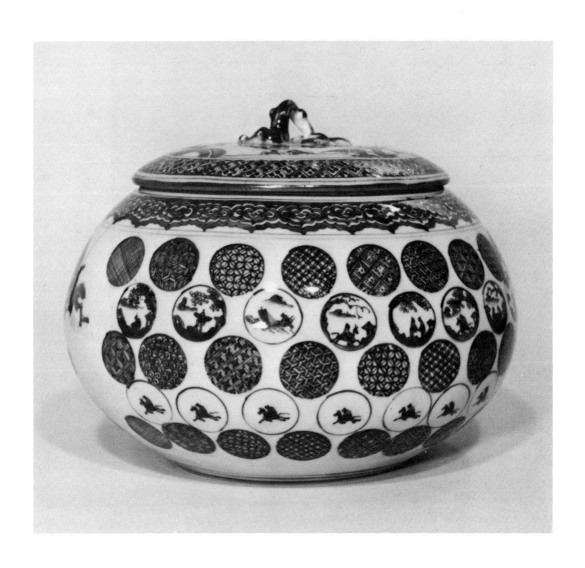

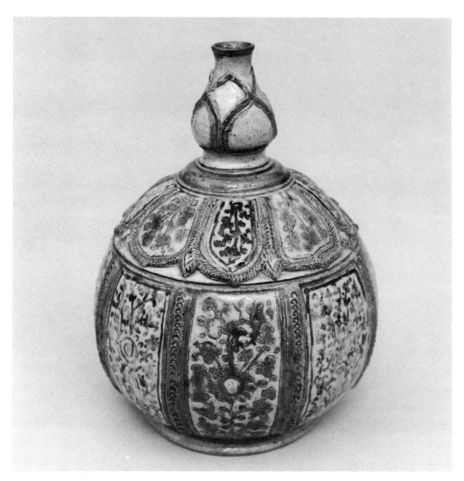

SOUTH EAST ASIAN CERAMICS

35
Vase in Shape of Gourd

Thailand, Sukhothai Kingdom (1220, or 1250–1512)
Sawankhalok ware, stoneware with decoration in
underglaze brown and blue
Height: 22.5 cm.

36
Storage Jar

Thialand, Sukhothai Kingdom (1220, or 1250–1512)
Sukhothai ware, stoneware with iron brown decoration
on white slip
Height: 18.5 cm.

During the rule of the Thai Kingdom of Sukhothai in Northern Thailand (1220, or 1250–1512), two major ceramic manufacturing centers appeared in the twin cities of Sukhothai and Sri Sachanalai. One group of kilns, the Sukhothai, was located inside the walls of the city, while the Sawankhalok kilns were grouped about sixty kilometers north of Sri Sachanalai. The dates of Sukhothai pottery production are vague, but Sukhothai ware is generally thought to predate Sawankhalok ware, with kilns becoming active at least as early as the fourteenth century. Sawankhalok production is believed to have begun around the end of the fourteenth century.

The origins of Sukhothai pottery (no. 36) are obscure;

yet, recent archaeological investigations have unearthed kilns constructed somctimc between the fourteenth and sixteenth centuries. However, Thai legends compiled in the eighteenth and nineteenth centuries in the *Phonsaawadaan Nya* (Annals of the North), and the *Culajudthakaarawan* (Lesser Dynastic Wars), attributed the beginnings of Thai ceramics to a group of 500 potters received as a gift from the Mongol Emperor. The Thai King traditionally credited with this event is the third and most illustrious Sukhothai King, Rama Khamhaeng (ruled 1283–1299, or 1317). If this tradition is true, it would place the origins of Sukhothai pottery in the thirteenth century. According to another theory, the Sukhothai ceramic industry was started by refugee potters accompanying Ch'ên I-chung, the former prime minister of the defeated Sung dynasty (960–1279), who sought refuge in Sukhothai in 1283. The demise of the Sukhothai and Sawankhalok wares is as enigmatic as their origin; however it is speculated that production continued until 1512 when the area became a battlefield in a struggle between the kingdoms of Ayudhya and Chieng-mai.

In contrast to Sawankhalok ware, Sukhothai ware was made from a rough and coarse clay which, when potted, produced heavy pieces. A thick layer of slip was applied before any initial underglaze decoration. Underglaze black and brown, like that of the Idemitsu example, monochrome white, and unglazed types were typical of Sukhothai pottery production. The repertory of motifs included *cakra* (solar whorls), sun bursts, stylized fern-

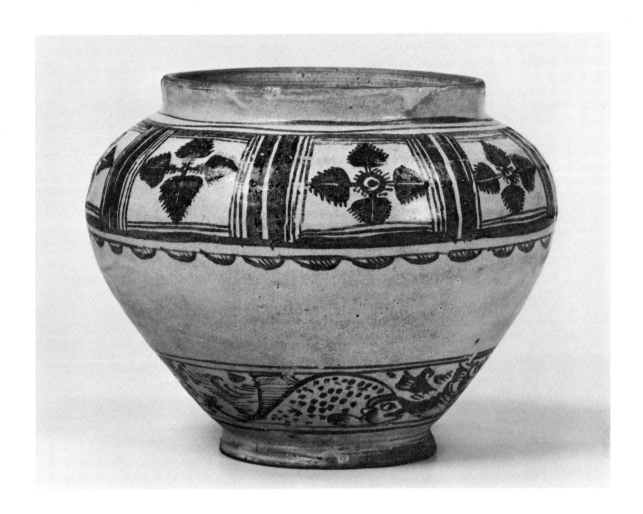

like sprays, floral patterns, chevron bands, scrolls, and zoomorphic designs of fish.

Sawankhalok pottery (no. 35) was technically superior to Sukhothai ware. Its fine grained clay body was easier to manipulate and shape into the desired forms. A diversity of glazes and shapes characterizes Sawankhalok ware, and scholars believe the availability of finer clay at Sri Sachanalai drew many potters there from Sukhothai. Nevertheless, the shapes and glazes are thought too diverse for only one migrant group to have introduced and scholars postulate that it may have developed from an influx of Chinese potters or from a mixture of Thai (Sukhothai), Chinese, and Vietnamese influences. Production techniques, shapes and decorative motifs—the underglaze black on this gourd-shaped bottle, for instance—can be traced to Sukhothai sources.

Underglaze black was among the most common types of Sawankhalok decoration. The Sawankhalok artist was concerned with filling the entire surface with detail. Underglaze patterns on Sawankhalok ware, unlike the free-flowing quality of Sukhothai motifs, is generally compartmentalized into vertical panels, medallions, and cartouches.

Sawankhalok and Sukhothai ware consisted of utilitarian pieces, such as dishes, bowls, and bottles, as well as architectural ornaments.

Published

Frasché, Dean F. *Southeast Asian Ceramics: Ninth Through Seventeenth Centuries*. (New York, 1976). pl. 46, p. 92.

Hakutsuru Fine Art Museum. *Masterpieces of the Idemitsu Collection*. (Kobe, 1976). pl. 70.

Koyama, Fujio and Mikami, Tsugio. *Tōji*. Tōyō Bijutsu, Vol. 4. (Tokyo, 1967). pl. 85.

The Tokyo National Museum. *Exhibition of Eastern Art Celebrating the Opening of the Gallery of Eastern Antiquities*. (Tokyo, 1968). pl. 218.

Yabe, Yoshiaki. *Thai Vietnam no Tōji*. Tōji Taikei, Vol. 47. (Tokyo, 1978). pl. 9.

References

Brown, Roxanna M. *The Ceramics of Southeast Asia: Their Dating and Identification*. (London, 1977).

Flood, Thadeus. "The Sukhothai-Mongol Relations: A Note of Relevant Chinese and Thai Sources." *Journal of the Siam Society*. (Bangkok, 1969). pl. 218.

Frasché, Dean F. *Southeast Asian Ceramics: Ninth Through Seventeenth Centuries*. (New York, 1976).

Goepper, Dr. Roger. *Legend and Reality: Early Ceramics from Southeast Asia*. (Tokyo, 1977).

Idemitsu Museum of Arts. *Special Exhibition Commemorating the Fifth Anniversary of the Idemitsu Collection*. (Tokyo, 1971).

Yabe, Yoshiaki. *Thai Vietnam no Tōji*. Tōji Taikei, Vol. 47. (Tokyo, 1978).

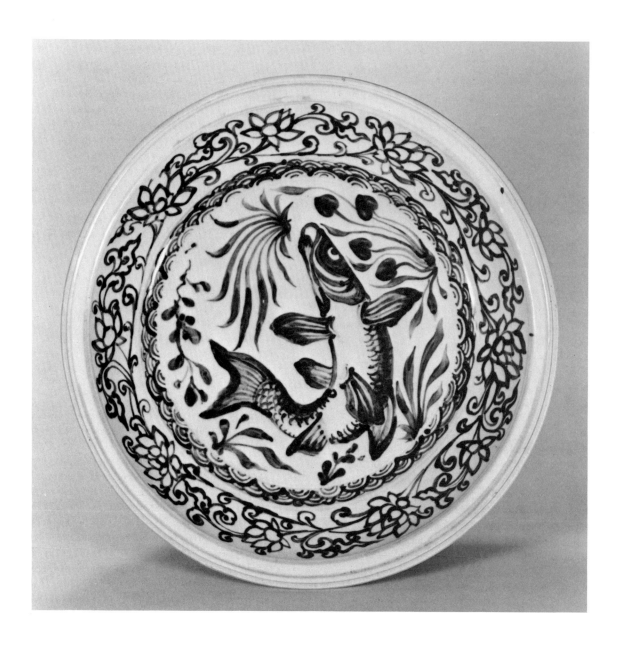

37

Dish with Fish Design

Vietnam, fifteenth-sixteenth centuries
Porcelain with underglaze blue decoration
Diameter: 37.0 cm.

Prior to the eighth century, Vietnamese ceramics (also referred to as Annamese, Sino-Annamese, and Tonkinese) were primarily indigenous designs in earthenware. Between the ninth and thirteenth centuries the native ceramics absorbed foreign, often Chinese, influences and were based on T'ang (618–906) and Sung (960–1279) dynasty prototypes. It seems probable that during the brief rule of the Ming dynasty (1368–1644) Chinese in Vietnam (1407–1428), Vietnamese pottery, under the exposure to the cultural influences of Chinese civilization, broke with past traditions. The new shapes and decorative motifs came to be inspired by the Chinese blue-and-white style of the Yüan (1280–1368) and Ming dynasties; however, Vietnamese potters, instead of

merely copying Chinese antecedents, assimilated Chinese designs and created a vital, independent blue-and-white style. For example, the Vietnamese potter borrowed Chinese motifs but arranged them differently. Floral patterns are a common central motif on Vietnamese plates, but generally when these same floral motifs are used by the Chinese they appear in horizontal registers on vases.

Similar to the problems surrounding the origins of Sukhothai and Sawankhalok ware, accurate dating of Vietnamese blue-and-white ware is difficult because of scanty archaeological records; however, it is believed that production commenced during the first quarter of the fifteenth century and continued at least until the end of the sixteenth century. The style, judging from the finest examples, seemingly reached its apogee around the mid-fifteenth century.

Technically, the body of the Vietnamese blue-and-white ware remained unchanged from earlier examples, but was fired to a porcelaneous hardness. This proto-porcelain paste did not take on the same translucency of its Chinese prototypes, but rather took on a grayish-

white or buff color. Transparent white glaze was then thinly applied over the cobalt blue designs. Recent flourescent spectrometry tests show the percentage of manganese in the cobalt and are helpful in dating the pieces. Cobalt imported from Persia had a lower manganese content than cobalt found locally or in China. Because of the presence of manganese, the glazes would not always fuse completely with the underlying paste, and pieces with such glazes have chipped easily.

Vietnamese potters employed a variety of Chinese decorative motifs including the lotus scroll, trailing vine patterns, peonies, and zoomorphic designs of fish in aquatic surroundings, as in this example. The central theme of a carp among aquatic plants bordered by a wave pattern displays a vitality and fluidity of line representative of superior Vietnamese compositions. The depiction of the carp with its body twisted to form an arc and encircled by diverse plant life is an inventive arrangement that represents a departure from the more formal style of Chinese examples (cf. nos. 27, 29). On the cavetto are freely brushed lotus scrolls. The exterior is decorated with a band of lotus panels.

Published
Frasché, Dean F. *Southeast Asian Ceramics: Ninth Through Seventeenth Centuries.* (New York, 1976). pl. 101.
Yabe, Yoshiaki. *Thai Vietnam no Tōji.* Tōji Taikei, Vol. 47. (Tokyo, 1978). pl. 79.

References
Brown, Roxanna M. *The Ceramics of Southeast Asia: Their Dating and Identification.* (London, 1977).
Garner, Sir Harry. *Oriental Blue and White.* (New York, 1970).
Idemitsu Museum of Arts. *Special Exhibition Commemorating the Fifth Anniversary of the Idemitsu Collection.* (Tokyo, 1971).
Joseph, Adrian M. *Chinese and Annamese Ceramics Found in the Philippines and Indonesia.* (London, 1973).
Koyama, Fujio and Figgess, Sir John. *Two Thousand Years of Oriental Ceramics.* (New York, 1961).
Okuda, Seiichi. *Annan Tōji Zukan (Annamese Ceramics).* (Tokyo, 1954).

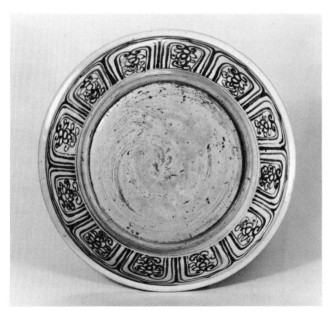

Fig. 30. Detail of underside (no. 37)

38*
Footed Dish with Design of Flowers

Vietnam, fifteenth-sixteenth centuries
Porcelain with underglaze blue and
overglaze enamels and gold
Diameter: 28.5 cm.

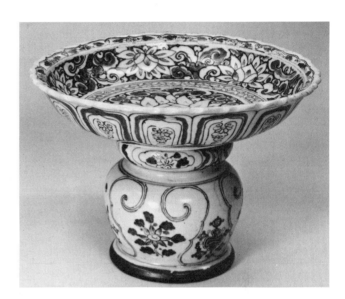

In addition to the use of underglaze blue as embellishment, the Vietnamese potters followed Chinese prototypes in employing overglaze red, green, and occasionally yellow enamels, as well as gold, on ceramics. Enamels were either painted on the plain glazed surfaces or, as in this example, were used to add ornamental detail to designs previously executed in underglaze blue. This piece is representative of a Vietnamese arrangement of a Chinese motif: the centrally placed lotus blossom is outlined in underglaze blue and overglaze enamels and set against a tripartite decoration of green and red enamels, and underglaze blue. Similar to the blue-and-white carp dish (no. 37), the central subject is encircled by a decorative border; in this case it is a diaper motif in red. The cavetto decoration is composed of lotus blossoms set off by red enamels and underglaze blue. The high foot is decorated with an alternating design of red lotuses and ingot-shaped crosses in red, green, and underglaze blue.

The chocolate brown base is a feature frequently found on Vietnamese pieces made between the fourteenth and sixteenth centuries. This element first appeared on late Thanh-hoa pottery of the twelfth century. It resulted from the brushing on of a brown or purplish-brown iron oxide wash. Later, during the fifteenth and sixteenth centuries, the wash was stroked on in a counter-clockwise motion and this has raised questions among scholars as to whether the Vietnamese potter's wheel rotated in the opposite direction from the Chinese wheel. It has also been speculated that perhaps these counter-clockwise brush markings designated the piece for a special use of unknown purpose.

Published

Frasché, Dean F. *Southeast Asian Ceramics: Ninth Through Seventeenth Centuries.* (New York, 1976). pl. 92, pp. 123, 140.

Hakutsuru Fine Art Museum. *Masterpieces of the Idemitsu Collection.* (Kobe, 1976). pl. 69.

Yabe, Yoshiaki. *Thai Vietnam no Tōji,* Tōji Taikei, Vol. 47. (Tokyo, 1978). pls. 21, 22.

References

Brown, Roxanna M. *The Ceramics of Southeast Asia: Their Dating and Identification.* (London, 1977).

Frasché, Dean F. *Southeast Asian Ceramics: Ninth Through Seventeenth Centuries.* (New York, 1976).

Garner, Sir Harry. *Oriental Blue and White.* (New York, 1970).

Joseph, Adrian M. *Chinese and Annamese Ceramics Found in the Philippines and Indonesia.* (London, 1973).

Koyama, Fujio and Figgess, Sir John. *Two Thousand Years of Oriental Ceramics.* (New York, 1961).

Okuda, Seiichi. *Annan Tōji Zukan (Annamese Ceramics).* (Tokyo, 1954).

Yabe, Yoshiaki. *Thai Vietnam no Tōji.* Tōji Taikei, Vol. 47. (Tokyo, 1978).

Fig. 31. Detail of inside (no. 38)

KOREAN CERAMICS

39
Covered Jar with Four Handles

Korea, Yi dynasty (1392–1910)
Punch'ong ware, stoneware with white slip and
sgraffito decoration
Height: 32.7 cm.

Within the early years of Yi dynasty (1392–1910), the Korean government, under the leadership of Yi-Songye, was revamped according to the model of Ming dynasty (1368–1644) China. Under Yi-Songye's leadership, the state policy shifted from Buddhism to Confucianism, and cultural and artistic achievements were expanded, particularly painting and ceramics. The delicately refined and subtle forms of inlaid celadons from the preceding Koryo period (918–1392) were replaced by the austere, utilitarian forms of *punch'ong* (Japanese: *mishima*) ware and a white porcelain produced under the auspices of government kilns. *Punch'ong* ware, although considered a continuation of late Koryo inlaid work was, in contrast to the regal quality of Koryo ware, heavy, sturdy, and characterized by incised, carved, *sgraffito*, and stamped or brushed-on motifs. The simplicity of form and decoration associated with *punch'ong* ware resulted partly from the necessity of applying white slip thickly so that it would adhere to the rough clay body before glazing. Particular pieces were characterized by a pale bluish-green glaze, and such *punch'ong* ware is regarded as a Korean rendering of the Chinese *fên-ch'ing* (pale blue or green).

Transitional pieces and early *punch'ong* designs are represented by a formal use of decorative patterns, while later pieces exhibit a freer, less inhibited approach to design. The Idemitsu piece is an example of *punch'ong* ware using the *sgraffito* technique in which the ceramic body was covered with slip, then incised to reveal the gray stoneware body underneath. This type of *punch'ong* ware was formerly classified by Japanese scholars as *hori mishima* (carved mishima, or carved *punch'ong*) because of its carved design; however, since the decoration is actually a carved slip motif, it is more appropriately referred to in Japanese as *hori hakeme* (carved slip). Although technically different, both methods are classified under the broader Korean term of *punch'ong* ware.

Production of *punch'ong* ware was extensive during the fifteenth century with kiln sites scattered throughout southern and central Korea. With the invasions of the armies of Toyotomi Hideyoshi (ruled Japan 1586–1598) in 1592 and 1597, the country was devastated. Kiln sites were shut down and groups of Korean potters were forcibly transplanted to Japan where they would later have a profound impact on the development of Edo period ceramics, particularly porcelains. The influence continued into the twentieth century through the interest

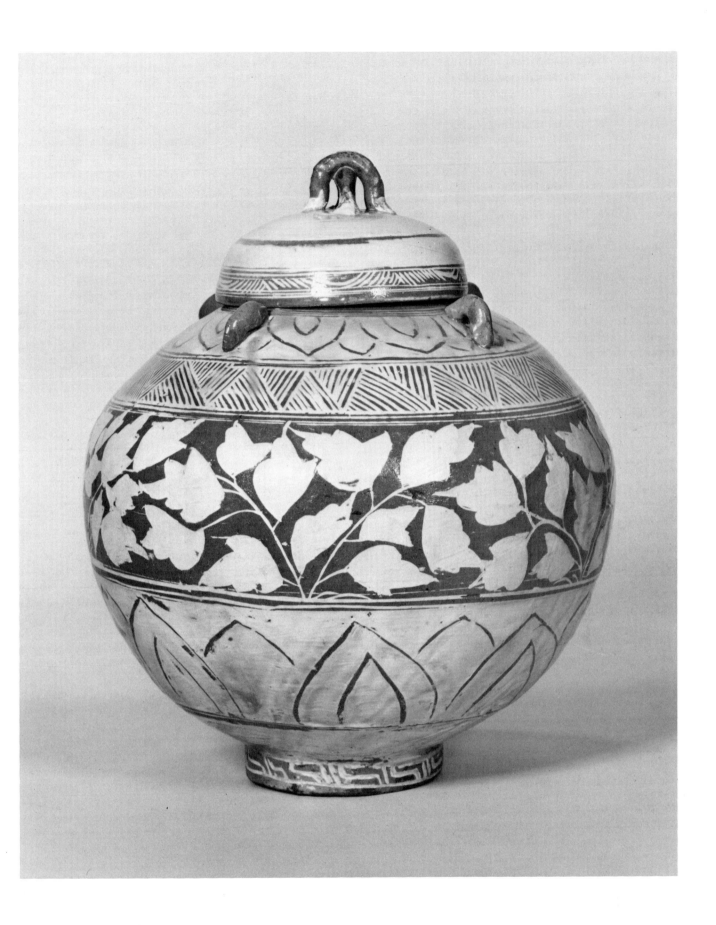

of men like Sōetsu Yanagi (1889–1961), Kanjiro Kawai (1890–1966), and Shōji Hamada (1894–1977) who generated the *mingei* (folk art) movement. As part of their folk art ethics, the aethetics of the Yi dynasty wares were greatly admired.

Published
Hakutsuru Fine Art Museum. *Masterpieces of the Idemitsu Collection.* (Kobe, 1976). pl. 72.
Idemitsu Museum of Arts. *Special Exhibition Commemorating the Tenth Anniversary of the Idemitsu Collection.* (Tokyo, 1976). pl. 139.
The Tokyo National Museum. *Exhibition of Far Eastern Ceramics.* (Tokyo, 1970). pl. 27.
The Tokyo National Museum. *Tōyō no Tōji.* (Tokyo, 1971). pl. 162.

References
Gompertz, G. St. G.M. *Korean Pottery and Porcelain of the Yi Period.* (New York, 1968).
Idemitsu Museum of Arts. *Masterpieces of the Idemitsu Collection.* (Tokyo, 1969).
Kim, Chewon and Gompertz, G. St. G. M. *Ceramic Art of Korea.* (London, 1961).
Lefebvre d'Argencé, René-Yvon, editor. *5000 Years of Korean Art.* (San Francisco, 1979).

Fig. 32. Detail of underside (no. 39)

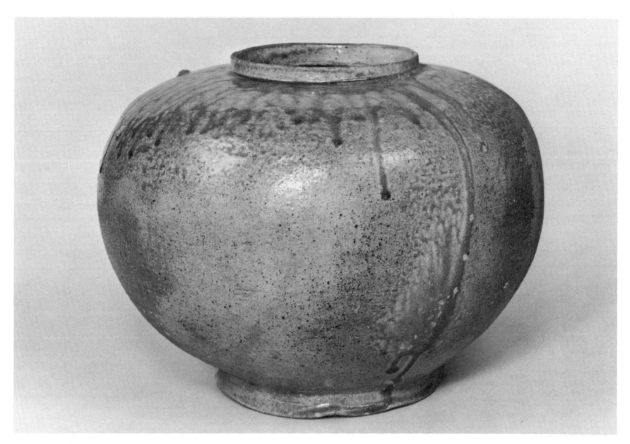

JAPANESE CERAMICS

40
Jar

Japan, Heian period (794–1185)
Sue ware, stoneware with ash glaze
Height: 26.5 cm.

During the fifth century new technological advances—the use of the potter's wheel and firing in *anagama*, (tunnel kilns)—were introduced to Japan from the Korean peninsula. These advances marked a departure from the previous low-temperature fired ceramics of the Jōmon (c. 4,500–200 B.C.) and Yayoi period (c. 200 B.C.–A.D. 250). This new type of ware, characterized by a high-fired clay body (1,200–1,300°C.) is called *sueki* (Sue ware). The word *sue* is thought to be derived from the Japanese verb *sueru* (to offer) since initially Sue wares were principally used as religious and ceremonial vessels.

Originally, potters were farmers who potted during the off-season. In contrast, Sue ware potters were thought to be professional craftsmen whose use of the potter's wheel and higher quality clay improved production and facilitated the control of the shapes. The use of the wood-fueled *anagama*, a one-chambered semi-subterranean kiln built parallel to a hillside or over a ditch, enabled higher temperature firings than previously known. During the firing, ash was produced from the burning wood and, when deposited on the clay body, it acted as a flux in fusing the silica found in the surface of the clay body. When these areas cooled, a semi-transparent glaze was formed, as seen on the shoulders

and body of this rotund jar. Consequently, Sue ware is recognized as among the first of the naturally glazed wares in Japanese ceramics history.

Sue ware manufacture originated by the Sue-mura (Sue village) kilns south of Osaka and, by the end of the fifth century, Sue were had spread as far north as Tōhoku and the island of Shikoku in the south. In the south, production waned during the Nara period (645–794), and had virtually ceased with the advent of the Heian period (794–1185). However, in the northern regions of Kantō and Tōhoku, kilns became more numerous during this time. This prompted a shift in production from the original site of Sue village to the Sanage mountains (modern Aichi Prefecture); this piece is thought to have come from a kiln in this area during the early Heian period.

Published
Idemitsu Museum of Arts. *Special Exhibition Commemorating the Tenth Anniversary of the Idemitsu Collection.* (Tokyo, 1976). pl. 141.
Musée du Petit Palais. *L'Art du Japon Eternel dans la Collection Idemitsu.* (Paris, 1981). pl. 148.

References
Jenyns, Soame. *Japanese Pottery.* (London, 1971).
Kidder, J.E. *Japan Before Buddhism.* (London, 1959).
Mikami, Tsugio. *The Art of Japanese Ceramics.* (New York and Tokyo, 1972).
Narazaki, Shōichi. "Recent Studies on Ancient and Medieval Ceramics of Japan." *International Symposium on Japanese Ceramics.* (Seattle, 1973). pp. 31–35.
Narazaki, Shōichi et al., editors. *Hajiki, Sueki.* Nihon no Tōji, Vol. 1. (Tokyo, 1976).
Okuda, Seiichi et al., editors. *Japanese Ceramics.* Translated by Roy Andrew Miller. (Tokyo and Vermont, 1960).

41*
Covered Jar with Incised Peony Design

Japan, Kamakura period (1185–1333)
Ko Seto ware, stoneware with celadon-type glaze
Height: 30.0 cm.

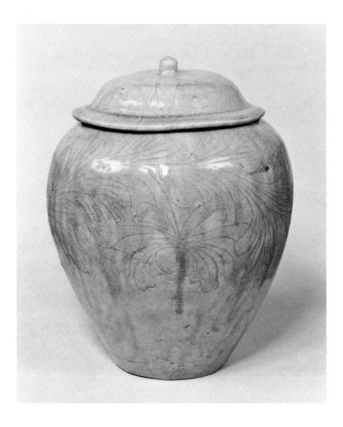

A significant turning point in Japanese ceramics, away from the earlier Sue ware (no. 40), was the formation of pottery centers between the twelfth and sixteenth centuries. Medieval ceramics were formerly considered to have been focused around six major centers collectively known as the 'Six Ancient Kilns' (Bizen, Tokoname, Shigaraki, Tamba, Echizen, and Seto), but recent archaeological excavations have shown these medieval kilns to be much more widely distributed. The prevailing image of medieval ceramics is one of large, sturdy, naturally glazed, utilitarian forms (no. 42). The one exception is the intentionally glazed Seto ware. The production of ceramics at Seto became so important that in time the term *setomono* (Seto objects) came to be used as a general term for all ceramics in Japan. Recent research has shown that Seto wares, which were formerly thought to be descendants of Sue ware, were more likely developed from the ash-glazed ware of the Sanage kilns in the vicinity of nearby Nagoya.

The beginnings of Seto ware, as it is known today, are generally dated from the thirteenth century when, according to tradition, Katō Shirozaemon Kagemasa, also known as Tōshirō, journeyed to China in the retinue of the Zen Buddhist priest Dōgen in 1223. While Dōgen studied in the T'ien-tai monastery in Chekiang Province, Tōshirō pursued the study of Chinese ceramic techniques. After his return to Japan in 1228, he settled in Owari Province (modern Aichi Prefecture), where

he built a kiln and started to make pottery following Chinese models. As many as 500 kiln sites existed in the Seto-producing areas of Aichi Prefecture and since, at any given time, any number of kilns could have been making similar wares, the process of tracing a piece to its original kiln site is difficult. The Idemitsu piece, excavated at Kamakura in 1935, is believed to be from the Motoyashiki kiln, one of the principal and largest Seto kilns.

During the medieval period, there was a shift from the use of reduction firing, in which air supply inside the kiln is limited, to oxidation firing, which allowed free admission of air into the kiln. Oxidized firing yields a color spectrum that includes a yellowish green called 'autumn leaf,' greens, browns, yellowish browns, and black.

Early Seto ware potters attempted to capture the beauty of imported Chinese prototypes such as the *ch'ing-pai* wares (no. 15) of Ching-tê-chên, and Lung ch'üan celadons produced in Chekiang Province. However, they lacked the technical means to equal Chinese standards and never quite approached the mastery of the Southern Sung wares. In the process, Seto potters developed their own aesthetic by combining native tastes with foreign influence. The shapes, for instance, were often taken from Chinese models, but the design motifs were peculiar to Seto. The great amount of wood ash used in the glaze produced a pale yellow-brown or yellowish-green color and introduced a high lye content, which frequently caused the glaze to crack and splinter off the clay body.

During the middle to late Kamakura period (1185–1333), Seto ware reached a stylistic maturity, and pieces from this time are generally referred to as Ko Seto, or Old Seto. The repertory of Ko Seto shapes ranges from wide-mouthed jars to bottles and vases. A distinguishing feature is the incised decoration of floral motifs—usually peonies or lotus—and foliage, as in the Idemitsu piece. The incised motif is strikingly juxtaposed to the yellow-brown glaze that characteristically runs down the surface in rivulets. This piece also has the original lid, which is extremely rare.

Published
Hakutsuru Fine Art Museum. *Masterpieces of the Idemitsu Collection.* (Kobe, 1976). pl. 37.
Idemitsu Museum of Arts. *Special Exhibition Commemorating the Tenth Anniversary of the Idemitsu Collection.* (Tokyo, 1976). pl. 142.
Musée du Petit Palais. *L'Art du Japon Eternel dans la Collection Idemitsu.* (Paris, 1981). pl. 149.

References
Cort, Louise Allison. *Shigaraki, Potter's Valley.* (Tokyo, 1979).
Figgess, Sir John. "Ko Seto." *International Symposium on Japanese Ceramics.* (Seattle, 1973). pp. 42–49.
Munsterberg, Hugo. *The Ceramic Art of Japan: Handbook for Collectors.* (Vermont and Tokyo, 1969).

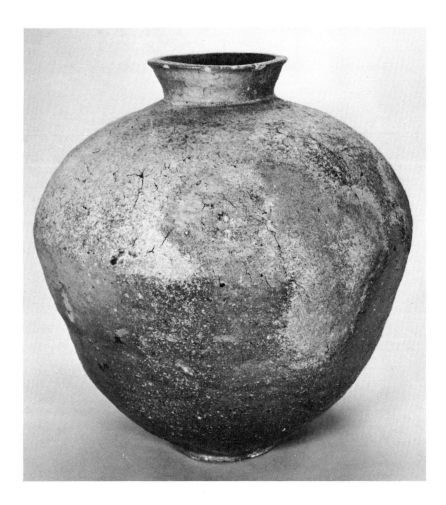

42
Jar

Japan, Muromachi period (1392–1568)
Shigaraki ware, stoneware with natural ash glaze
Height: 43.4 cm.

Shigaraki ware is a collective designation for a type of medieval pottery produced at a group of kilns scattered over southern Shiga Prefecture. The emergence of these regional kilns was influenced by agricultural advances at the end of the Heian period and the subsequent demands for storage vessels. The firing of the Shigaraki kilns is thought to have begun around 1250. Like the majority of medieval ceramics, Shigaraki appeared in three forms in its early stages: *tsubo* (narrow-necked jars), *kame* (wide-mouthed vats), and *suribachi* (mortar or grating dishes). Shigaraki, typical of medieval pottery, was produced in only these three shapes until the early sixteenth century when, primarily under the influence of the tea masters, smaller shapes were introduced. *Tsubo,* such as this example, and *kame* are referred to as 'seed jars', a misleading term since they were not necessarily used for the transport of harvested rice; instead *tawara* (woven rice straw bales) were used for this purpose. These seed jars were principally used as agricultural and kitchen storage vessels, ritual vessels, burial urns, and storage containers for indigo dyes.

Shigaraki ware can be identified by its gritty texture, which consists of sand, feldspar, and trace materials in the clay body. When fired to high temperatures of about 1,300°c., the unfused feldspar melts and leaves pitted areas called *ishihaze* (stone bursts). The glaze color would be determined by the reaction of the iron content in the wood ash with the clay body; since it is a naturally occurring reaction, the resulting glaze is referred to as *shizen-yū* (natural glaze). The nature of the glaze also depends on such factors as the position of the piece in the kiln, the type of fuel used, and the amount of ash circulating in the kiln.

Hand-building, primarily coiling, was the basis of Shigaraki construction until the fifteenth and sixteenth centuries when thrown sections were used in combination with hand-built portions. A piece was built in sections and, depending on the size, could consist of as many as six or seven parts.

This rustic example dates from the Muromachi period (1392–1568). Due to an extremely hot firing, *ishihaze* patterns dot the entire surface. The everted neck, typical of Muromachi wares, is slightly deformed due to the pressure exerted in smoothing the thin rim. The rounded, yet distorted, contour suggests that the Shigaraki potter was not consciously trying to execute a beautiful piece, but one that bespoke both stability and strength.

Reference
Cort, Louise Allison. *Shigaraki, Potter's Valley.* (Tokyo, 1979). cf. color pls. 2, 3, 4.

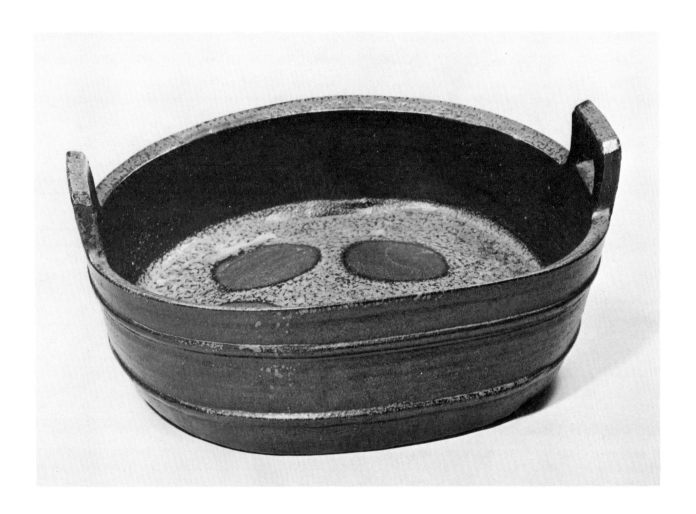

43
Flat Bowl with Handles

Japan, Momoyama period (1568–1615)
Ko Bizen ware, stoneware with natural glaze
Diameter: 40.4 cm.

Unlike Seto ware, which was shaped by the refined standards of Sung dynasty (960–1279) wares, the tradition of Bizen ware was largely determined by domestic demands, which called for a durable utilitarian product. Shapes were also influenced by the local materials which, while durable when fired, were not conducive to shaping elegant forms. Bizen ware, also called Imbe ware, was made in Bizen Province (modern Okayama Prefecture). Pottery making has an ancient tradition in this area, and the remains of Sue kilns dating from the Kofun period (c. 250–552) have been excavated. Between the time of the last production of Sue ware in the Heian period and the beginning of Bizen production in the twelfth century, there was a transitional period during which soft-bodied, light gray unglazed earthenware, known as *chukan-doki* (transitional ware) was made.

Production of Bizen ware, as we know it, is believed to have begun toward the end of the Heian (794–1185) or early Kamakura (1185–1333) periods. The height of Bizen ware operation is considered to have been during the late sixteenth and early seventeenth centuries; the impetus for Bizen production was fostered

by the needs and aesthetics of the tea masters. The work from this period is generally designated as Ko Bizen (Old Bizen). Ko—referring to old or early, as in Ko Bizen and Ko Seto—was a term frequently used by tea masters to distinguish work made before the time of Sen-no-Rikyū (1522–1591), tea master to the military rulers Oda Nobunaga (1534–1582) and Toyotomi Hideyoshi (1536–1598).

Bizen ware is recognizable by its distinctive hardfired, dark red stoneware body. The clay, which has a high ferruginous content with a low heat tolerance, was fired in sloping *anagama* kilns at low temperatures over a long period of time. In the Muromachi period (1392–1568) one of the great kilns at Ura-Imbe is said to have been fired for sixty days to allow the pottery to reach maturity.

Typically, Bizen ware was fired unglazed. Ash deposited on the clay surface produced a glossy finish called *gomayū* (sesame seed glaze). Japanese connoisseurs often compare *gomayū* with the bark of the *enoki* (Chinese nettle or hackberry tree). The golden yellow of the interior and the edges of the Idemitsu example display *gomayū* patterning. Reddish brown areas appeared as a result of oxidation and the absence of ash glaze.

An additional element of ornamental detail characteristic of Bizen ware involved the wrapping of unfired green ware in straw prior to stacking inside the kiln. Depending on the position in the kiln relative to the flame, the straw would burn, leaving on the clay body

streaks called *hidasuki* (fire stripes) or ornamental sunburst designs called *botamochi*. *Botamochi* are round rice cakes covered with thin bean paste. When the Bizen potter stacked small bowls or sake bottles inside larger pieces, small round areas would be protected from the heat of the kiln, leaving circular areas unglazed. These reserves resembled the round shapes of *botamochi*.

In the communal use of the kilns, various marks were used to identify the different potters' work. Bizen ware often carried marks such as circles, squares, lozenges, or numerals to identify the pieces after firing. On the Idemitsu piece, the character 力 is thought to be the identification of a particular kiln.

Originally, Bizen ware, similar to the majority of medieval stonewares, was created to supply the demand for storage vessels for agricultural products. The strong, unaffected, and slightly irregular shapes offer a striking contrast to their natural ash decoration, resulting in an aesthetic that attracted the attention of the tea masters. With the advent of the tea ceremony specialized forms were brought into existence.

Published

Idemitsu Museum of Arts. *Special Exhibition Commemorating the Tenth Anniversary of the Idemitsu Collection.* (Tokyo, 1976). pl. 146.
Mitsuoka, Naoshige; Okuda, Tadanari and the Zauho Press. *Momoyama Period I.* Sekai Tōji Zenshū, Vol. 4. (Tokyo, 1977). pl. 179.
Musée du Petit Palais. *L'Art du Japon Eternel dans la Collection Idemitsu.* (Paris, 1981). pl. 151.

References

Hayashiya, Seizō and Trubner, Henry et al. *Ceramic Art of Japan: One Hundred Masterpieces from Japanese Collections.* (Seattle, 1972).
Koyama, Fujio. *The Heritage of Japanese Ceramics.* Translated by John Figgess. (New York, 1973).
Mitsuoka, Naoshige; Okuda, Tadanari and the Zauho Press. *Momoyama Period I.* Sekai Tōji Zenshū, Vol. 4. (Tokyo, 1977).

44
Flower Vase with Two Handles

Japan, Momoyama period (1568–1615)
Iga ware, stoneware with natural ash glaze
Height: 26.7 cm.

The history of Iga wares before the end of the Momoyama period (1568–1615) is enigmatic. Like other medieval folk pottery centers of the period, Iga, located south of Shigaraki (modern Mie Prefecture), was probably a production center of utilitarian wares. Some early Iga and Shigaraki potters used a similar clay dug from the beds of Lake Biwa, and differences between these early wares are hard to discern. It is generally agreed that the bodies of Shigaraki wares tend to be lighter and more peach-colored than the cooler pinkish tones characteristic of Iga wares.

Iga emerged as a distinctive form of ceramic expression in the late Momoyama (1568–1615) and early Edo (1615–1868) periods. It was promoted by the celebrated tea master, Furuta Oribe (1544–1615)—the successor of Sen-no-Rikyū (1522–1591)—who is believed to have designed Iga tea wares for Tsutsui Sadatsugu (1562–1615), lord of Ueno Castle. Iga ware was later influenced by Kobori Enshū (1577–1647), a student of Oribe, and the official tea master of Tokugawa government during the Kanei era (1624–1644). Iga ware produced for Sadatsugu was subsequently called Tsutsui Iga, a type that represents quintessential tea wares. The Idemitsu piece may be an example of Tsutsui Iga. These Iga wares are characterized by the individualistic and inventive use of handles, knobs, and stamped decoration, such as the stamped geometric pattern on this paddled flower vase.

An irregularity and imperfection of form epitomized Iga wares. The beauty inherent in such imperfection was esteemed by tea masters of this period. As Sōetsu Yanagi (1889–1961), co-founder of the modern *mingei* (folk art) movement states: "the beauty of irregularity—which in its true form is actually liberated from both regularity and irregularity—the asymmetric principle contains the seed of the highest beauty known to man." This concept is parallel to the Buddhist idea of *musō*, a state of unchanging formlessness behind all phenomena in which there is no rejection and no acceptance. Thus, behind the eruptive asymmetrical surface of an Iga vase, such as this one, exists a perpetual state of formlessness and quietude, which is what tea masters refer to as *wabi*.

▷

References

Vollmer, John and Webb, Glenn T. *Japanese Art at the Art Gallery of Greater Victoria.* (Victoria, 1972).
Yanagi, Sōetsu. *The Unknown Craftsman: A Japanese Insight into Beauty.* (Tokyo, 1978).

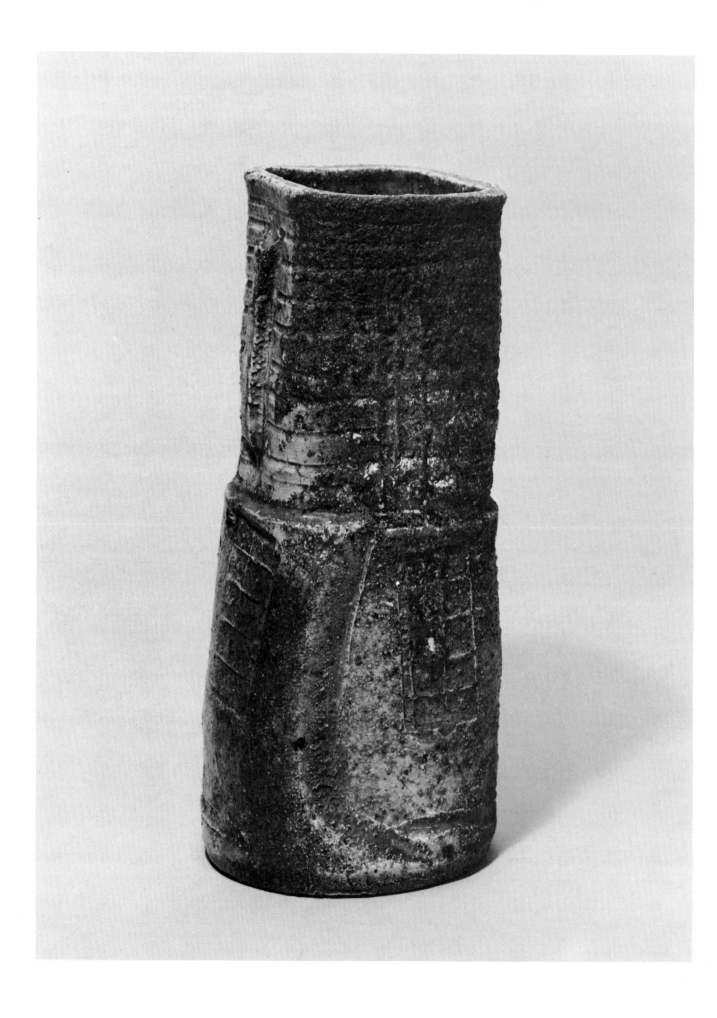

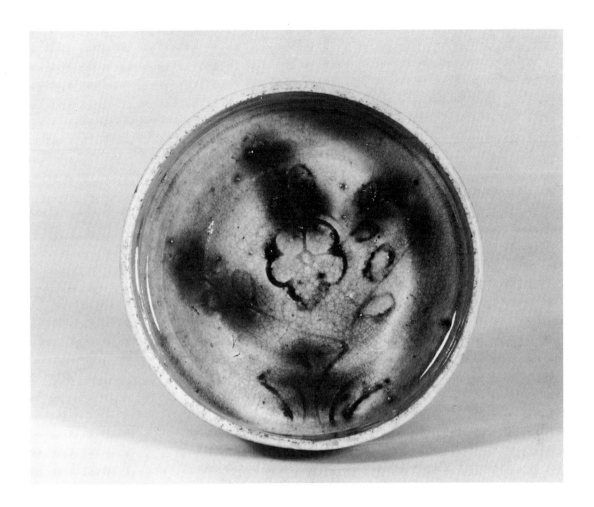

45
Bowl with Design of Plum Blossoms

Japan, Momoyama period (1568–1615)
Mino ware, Ki Seto type, stoneware with copper
coloring under feldspathic glaze
Diameter: 15.0 cm.

From the Muromachi period (1392–1568) onward, the Mino kilns continued production of Ko Seto wares with the characteristic 'autumn leaf' glaze; however, during the Momoyama period (1568–1615) these kilns underwent changes in materials and firing techniques. The ware that resulted, Ki Seto (Yellow Seto), is believed to have been successfully introduced and made at a number of kilns in the areas of Okaya, Ohira, and Kujiri after the late Momoyama period. However, scholars such as the late Fujio Koyama suggested that Ki Seto ware may have predated activity at the Mino kilns with production beginning as early as the Eiroku (1558–1570) and Genki (1570–1573) eras.

Ki Seto wares differed from their Ko Seto precursors and were characterized by a white clay body covered by a buff or yellow glaze that was fired to a glossy or matte finish, depending upon the position and degree of oxidation in the kiln. The more efficient the oxidation atmosphere in the kiln—generally at the rear of the kiln—the more matte the appearance of the glaze surface. Using these glaze surfaces as a stylistic guide,

historians and tea cultists broadly place Ki Seto wares into two groups. The first group are those pieces with a matte finish referred to as *abura-age-de* (fried bean curd type), which describes the yellow glaze, or *ayame-de* (iris type) named after a famous bowl with this design. The *ayame-de* ware is distinguished by *tambun-gusuri* (the green glaze derived from copper sulfate). The green tonality of this glaze was particularly prized by contemporary tea masters. The second group of wares, typified by a glossy finish, is called *kikuzara-de* (chrysanthemum dish type). The Idemitsu piece appears to be a stylistic variant of these types, and is inside and floral designs on the outside, both covered represented by an incised cherry blossom motif on the with a green glaze known from *ayame-de* style pieces.

Ki Seto shapes responded to the needs of the tea masters by producing small pieces for the tea ceremony—vases, tea bowls, plates, and *kashibachi* (cake dishes).

Published
Musée du Petit Palais. *L'Art du Japon Eternel dans la Collection Idemitsu.* (Paris, 1981). pl. 152.

References
Hayashiya, Seizō, editor. *Seto guro, Ki Seto.* Nihon no Tōji, Vol. 3. (Tokyo, 1973).
Hayashiya, Seizō and the Zauho Press. *Momoyama (II).* Sekai Tōji Zenshū, Vol. 5. (Tokyo, 1976).
Koyama, Fujio. *The Heritage of Japanese Ceramics.* Translated by John Figgess. (New York, 1973).

46

Bowl with Bail Handle

Japan, Momoyama period (1568–1615)
Mino ware, Ao Oribe type, stoneware with iron brown
decoration, copper green and transparent glazes, seven-
teenth century
Diameter: 24.0 cm.

At the turn of the seventeenth century, the *nobori-gama* (climbing kiln), a new type of kiln, was introduced to the Mino area from Kyushu. The *noborigama*, which superseded the less efficient *anagama* (tunnel kiln), in which Shino ware had been produced, is a single-barrel, vaulted kiln divided into a number of chambers by walls with portals through which flames pass. They were built to climb steep slopes, which created a natural updraft to pull the heat from the fire-box in the lower chamber. This arrangement facilitated complete and efficient firing. As the use of this kiln and the new style of pottery produced in it spread, the production of Shino ware declined considerably.

At the time, this new ware was referred to as *imayaki* (recently fired) or *seto*, but towards the end of the seventeenth century it began to be called by the name we use today—Oribe. The term Oribe ware is taken from the name of the tea master Furuta Oribe (1544–1615); however, to what extent its designs were influenced by him is unclear. It seems that the emergence of Oribe ware coincides with the period when Furuta Oribe was most influential as a tea master, late in his life. Furthermore, Oribe wares served as a foundation for a new style of tea ceramics influenced by the tea master's preferences. Unlike the elegant and restrained tastes of his teacher, Sen-no-Rikyū (1522–1591), Furuta Oribe preferred dynamic, expressive, and irregular forms.

A distinguishing trait of Oribe ware is the use of areas of solid glaze as a counterpoint to areas of painted decoration. Decoration in this manner was influenced by the contemporary patterns used on *tsujigahana* textiles manufactured in the districts of Okaya and Ohira, where the major Mino kilns were also located. *Tsujigahana* dyeing was popular among the military at the beginning of the Muromachi period (1392–1568) and involved the process of dyeing two contrasting areas; portions of the cloth were first tied so that the dye would not penetrate them, and on these areas designs would later be drawn by hand. It is not surprising that the popularity of one artistic form would influence the design process of another.

Mino area potters did not necessarily imitate the creations of *tsujigahana* weavers and dyers, but rather adapted similar compositional formats. The results are lively patterns, as in the Idemitsu example, in which areas of carefully applied green glaze contrast with the patterns of flowers and stripes freely drawn in iron brown wash. Oribe ware on which this copper green glaze is used is called Ao Oribe (green Oribe). Square or faceted shapes, typical of Oribe ware, were created by molding or shaping by hand rather than by using the potter's wheel.

Historical documents record that Katō Kagenobu, a Mino potter, traveled from Mino to Karatsu pottery centers in Hizen Province (modern Saga Prefecture) in Kyushu, where he became familiar with *noborigama*. Compared to other Mino kilns, the Motoyashiki kiln enjoyed a long period of popularity and the Oribe style ware produced there was unrivaled in its quality and beauty. The Idemitsu piece is thought to have come from this kiln.

Published
Idemitsu Museum of Arts. *Special Exhibition Commemorating the Tenth Anniversary of the Idemitsu Collection.* (Tokyo, 1976). pl. 145.
Musée du Petit Palais. *L'Art du Japon Eternel dans la Collection Idemitsu.* (Paris, 1981). pl. 157.

References
Fujioka, Ryōichi. *Shino and Oribe Ceramics.* Translated by Samuel Crowell Morse. (Tokyo, 1977).

47

Bowl with Landscape

Japan, Momoyama period (1568–1615)
Mino ware, E Shino type, stoneware with iron oxide
decoration under feldspathic glaze
Diameter: 27.5 cm.

In the sixteenth century, the Seto potters migrated from Owari Province (modern Aichi Prefecture) to Mino Province (modern Gifu Prefecture) to escape civil disturbances. Oda Nobunaga (1543–1582), then ruler of Japan, extended personal protection to these potters, enabling them to continue their work uninterrupted. Until 1930, when Toyozō Arakawa unearthed the Shino kiln in Mutabora in the Mino area, Shino and Oribe wares were thought to have been fired at Seto kilns. The finest products of Shino and Oribe ware were fired between 1575 and the early 1600s, and are now thought to have been produced at Mino, not Seto, kilns.

The development of Shino ware was largely due to the demands of the tea masters, and tradition suggests that the tea master Furuta Oribe (1544–1615) was instrumental in the designs of Shino ware. This influence may have come about by means of his descent from the Toki family of Mino that had ties with the daimyo who controlled the Mino kiln. However, it is unknown if he participated as a designer of Shino or only placed orders at the kilns.

With the move to Mino, the Shino potters brought with them the Seto techniques and also developed new techniques. Clay dug at Mino locations, primarily in the Okaya and Ohira areas, was of high quality. The potters also augmented the use of Seto glaze with local feldspar. These innovations resulted in the production of a white-glazed ware, considered the first among Japanese ceramics. Shino wares were unique in the generous application of a milky-white, semitranslucent glaze and the resultant quality appealed to the tastes of the tea masters

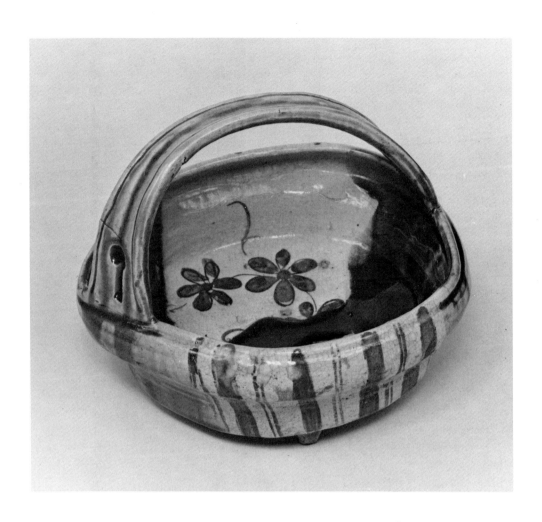

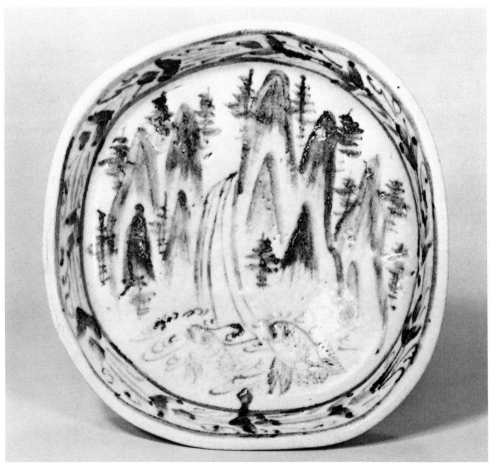

of the time.

The spontaneity and inventiveness of the Shino potters is also mirrored in the characteristic iron wash decoration. This type of decorated ware is called E Shino (decorated or pictured Shino). Designs were sketched directly on the piece with the iron wash and then covered with a feldspathic glaze and fired. When high temperatures were attained, the iron oxide would bleed into the glaze and, depending on the thickness of the glaze, would yield colors ranging from pinks to reds and browns. Since complicated and sophisticated designs would bleed into the white glaze, the Shino potters adapted simple and abbreviated motifs.

The Shino potters lived in the mountainous region of the modern Gifu Prefecture and, as was the custom of the time, they were required to cultivate the land that made up their environment. It was this environment that was reflected in their work. The lively and freely drawn designs of mountains and trees in the Idemitsu example are characteristic of the freedom of E Shino decoration, although this particular landscape motif is rarely found. Tall, pinched mountains are crowded with short staccato strokes representing pine trees. The depiction of fish, also rare in Shino designs, conveys a feeling of unaffected simplicity.

The Idemitsu piece is from the Ohira kilns, located in Kukuri village, one mile southwest of Okaya (in Gifu Prefecture). Here, the Yuemon kiln fired Shino ware in large quantities and is recognized for its superb examples of E Shino.

Published
Musée du Petit Palais. *L'Art du Japon Eternel dans la Collection Idemitsu.* (Paris, 1981). pl. 158.

Reference
Fujioka, Ryōichi. *Shino and Oribe Ceramics.* Translated by Samuel Crowell Morse. (Tokyo, 1977).

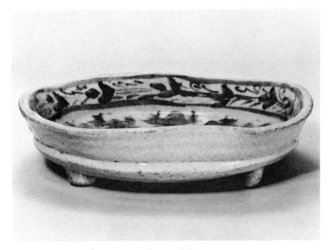

Fig. 33. Side view (no. 47)

48
Jar with Persimmon Tree Design
Japan, early Edo period (1615–1868)
Karatsu ware, E-garatsu type, stoneware with iron oxide decoration under feldspathic glaze, seventeenth century
Height: 17.1 cm.

The influx of Korean potters toward the end of the sixteenth century resulted in major changes in the development of Japanese ceramics, particularly during the so-called 'Pottery Wars' when the armies of Toyotomi Hideyoshi (1536–1588) invaded Korea in the Bunroku and Keichō campaigns of 1592 and 1597. These invasions did little to increase the material wealth of Japan, but the participating daimyo from western Japan returned with numerous trophies, including Korean potters and examples of ceramics.

These potters, under the patronage and protection of the daimyo, settled in northern Kyushu and western Honshu and began the production of Korean-inspired ceramics. The preeminent kilns were located in Hizen Province (modern Saga and Nagasaki Prefectures), near the port town of Karatsu, from which their wares were distributed to surrounding areas. As a result, this pottery came to be called Karatsu ware. Centers in Hagi, Agano, Takatori, and Satsuma also sprang up.

The immigrant potters brought with them innovations that increased the production and improved the quality of ceramics; these innovations included the kickwheel for throwing, and the *takewarigama* (vaulted or split bamboo kiln) for firing. This kiln was fashioned with a laterally arching roof divided at intervals into a series of chambers which, as indicated by its name, resembled the node-segmented shaft of split bamboo. The average size of an early Hizen kiln was of six to eight chambers. The light-weight kickwheel, constructed of wood, was kicked in a clockwise direction. This direction of the wheel was unique to Korean and Japanese potters.

The development of the Karatsu kilns arose from the need to supply utensils for the tea ceremony. The relationship between Karatsu ware and the popularity of Korean wares and the Korean potting techniques also made mass production commercially profitable. From the latter half of the Muromachi period (end of the sixteenth century) Japanese tastes in ceramics were shaped by the tea masters. They were aesthetes who moved away from the orthodoxy of pure form and design to ceramics imbued with a freedom derived from the simple beauty inherent in Karatsu pieces. As a result, the production of Karatsu ware flourished as its popularity and value in the tea ceremony grew. One early anecdote tells of an Osaka tea man, Tsuda Sōbon, son of the tea master Sōkyū, who hosted a tea ceremony in 1601 for a noted merchant and tea personality, Kamiya Sōtan (1550–1635). Sōtan was an influential tea expert and was the author of the *Sōtan nikki,* a tea journal. At this event Sōbon displayed a Karatsu

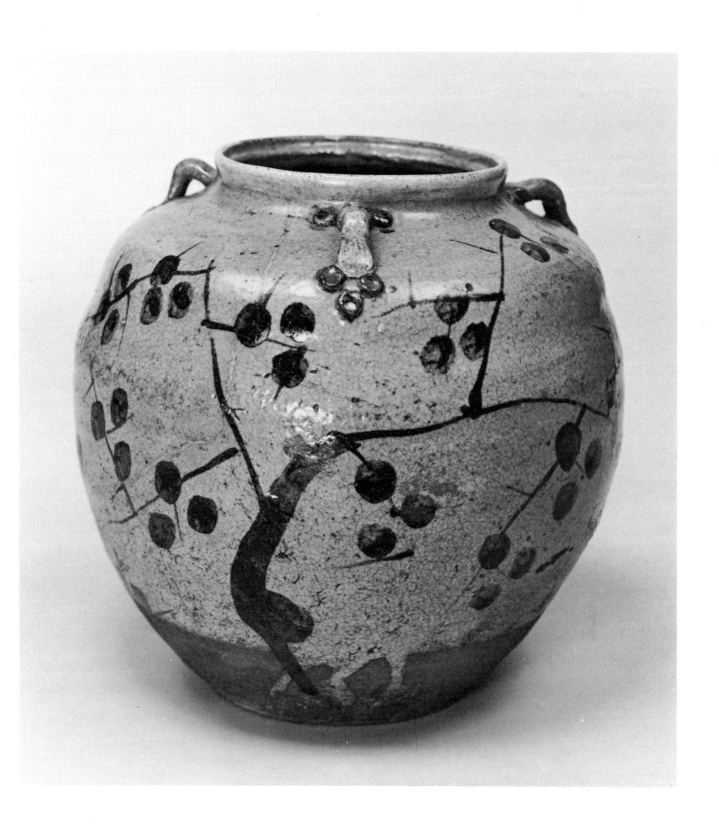

katatsuki (broad-shouldered tea container) in a gold brocade bag. The special coverings were an indication that the piece was something extraordinary.

It was also during the late Momoyama period that Katō Kagenobu (no. 46) came from Mino to observe the activity at the Karatsu kilns. Karatsu ware not only influenced Kagenobu, but his presence also influenced the stylistic elements of Karatsu. Iron pigment—originally inspired by the simple motifs of Korean Yi dynasty (1392–1910) ceramics and a distinguishing characteristic of the majority of Karatsu ware—also began to be employed in the more precise and calculated manner of Oribe ware (no. 46). These two types existed simultaneously.

In the early seventeenth century, the discovery of *kaolin* by Korean potters near Arita in Hizen Province (modern Saga Prefecture) altered the course of Karatsu history. The production of porcelain that ensued generated a new market among the Japanese. Consequently, the demand for Karatsu pottery declined, and only *hakeme* (brush-grain or brushed-slip decorated pieces) were manufactured.

Tea ceremony wares comprised a small proportion of Karatsu production; the Idemitsu jar is an example from the early Edo period (1615–1868) and was probably used as a *chatsubo* (tea jar). This heavily potted piece, fired in an oxidizing atmosphere in which the clay has matured to a reddish-brown color, is accented by the freely painted design of a persimmon tree. Karatsu of this type is commonly referred to as E-garatsu (decorated or pictured Karatsu).

The spine-like branches, executed with a swiftness and brevity of line, are dotted with stylized persimmons, and express the simplicity and spontaneity sought by early tea masters. The muted quality of such pieces carries none of the brilliance and boldness of the Mino designs, but rather adheres closely to the ideal of *wabi* (lonely seclusion or unpretentious beauty), an aesthetic attitude prompted by the tea master, Murata Jukō (1442–1502).

The most active kiln where E-garatsu is believed to have been produced was the Dozono kiln, which specialized primarily in smaller pieces: plates, bowls, sake cups, and tea caddies.

Published
Idemitsu Museum of Arts. *Special Exhibition Commemorating the Tenth Anniversary of the Idemitsu Collection.* (Tokyo, 1976). pl. 148.
Karatsu. Nihon Tōji Zenshū, Vol. 17. (Tokyo, 1976). pl. 1.
Koyama, Fujio et al., editors. *Edo Period.* Sekai Tōji Zenshū, Vol. 5. (Tokyo, 1980). pl. 8.
Nakazato, Taroemon. *Karatsu.* Tōji Taikei, Vol. 13. (Tokyo, 1972). pl. 4.
The Tokyo National Museum. *Exhibition of Far Eastern Ceramics.* (Tokyo, 1970). pl. 64.

References
Becker, Sister Johanna. "Karatsu Techniques: Fabrication and Firing." *International Symposium on Japanese Ceramics.* (Seattle, 1973). pp. 66–71.
Karatsu. Nihon Tōji Zenshū, Vol. 17. (Tokyo, 1976).
Koyama, Fujio et al., editors. *Edo Period.* Sekai Tōji Zenshū, Vol. 5. (Tokyo, 1980).
The Metropolitan Museum of Art. *Momoyama, Japanese Art in the Age of Grandeur.* (New York, 1975). pp. 112, 113.
Okuda, Seiichi. *Japanese Ceramics.* Translated by Roy Andrew Miller. (Tokyo and Vermont, 1960).
Satō, Masahiko. "The History and Variety of Karatsu Ceramics." *Chanoyu Quarterly: Tea and The Arts of Japan,* no. 24. (Kyoto, 1980). pp. 12–34.
Vollmer, John and Webb, Glenn T. *Japanese Art at the Art Gallery of Greater Victoria.* (Victoria, 1972).

Fig. 34. Detail of underside (no. 48)

49*
Dish with Design of Pine Trees

Japan, Momoyama period (1568–1615)
Karatsu ware, E-garatsu type, stoneware with iron oxide
decoration under feldspathic glaze
Diameter: 36.3 cm.

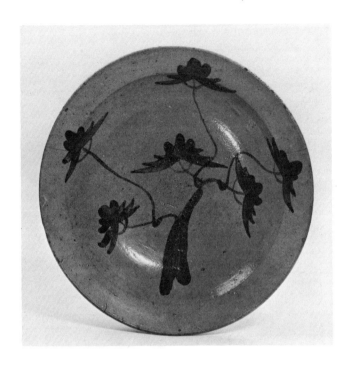

The Kameya-no-tani (Valley of the Urn Sellers) kiln, located in Hizen in the vicinity of Shōzan Mountain, is particularly noted for the production of stoneware bowls. These pieces exhibit a variety of designs drawn from the surrounding environment. The potters chose for their designs such motifs as persimmons, pines, willows, various vines, wisteria and reeds, and bird and shrimp motifs. Set on a small trimmed foot, this shallow dish is covered with a feldspathic glaze with a slightly green tinge. The stylized pine, with attenuated limbs and bud-like foliage, extends outward to the edges of the dish; it reflects the skill of the artist in adapting the design to the shape of the piece.

Published
Hayashiya Seizō, Editor. *Karatsu*. Nihon no Tōji, Vol. 5. (Tokyo, 1974). pl. 139.
Idemitsu Museum of Arts. *Special Exhibition Commemorating the Tenth Anniversary of the Idemitsu Collection*. (Tokyo, 1976). pl. 147.
Koyama, Fujio et al. *Edo*. Sekai Tōji Zenshū, Vol. 4. (Tokyo, 1956). pl. 38.
Mizumachi, Wasaburo. *Ko Karatsu*. Idemitsu Museum of Arts 6, Vols. 1 and 2. (Tokyo, 1973). Vol. 1, p. 124; Vol. 2, pl. 91, p. 158.
Nakazato, Taroemon. *Karatsu*. Tōji Taikei, Vol. 13. (Tokyo, 1972). pl. 22.

50
Jar with Reed Design

Japan, early Edo period (1615–1868)
Karatsu ware, E-garatsu type, stoneware with iron oxide
decoration under feldspathic glaze, seventeenth century
Height: 16.1 cm.

The Karatsu potters often drew from their Korean heritage a fondness for natural motifs, such as flowering grasses. On this utilitarian jar, reeds and flowering grasses were executed in a free and relaxed style, distinguished by a simple, direct manner of painting. The art historian Masahiko Satō describes this style as ceramics done in a 'minor key', as opposed to the 'major key' of the vibrant Mino wares (no. 46).

During the height of Karatsu production, pottery centers were distributed throughout northern Kyushu, a factor that contributed to the diversity of Karatsu styles. Examples such as this jar, in which a coarse hard clay was decorated with iron oxide-painted designs and covered with a thin olive green glaze, are mostly from the potting village of Ichinose-Kōraijin. Due to the highly highly ferruginous nature of the clay, the body turned a reddish brown in firing and the high percentage of feldspar in the glaze materials caused the glaze to crawl over the lower portion of the piece and form blotchy areas of glaze.

▷

Published
Hayashiya Seizō, Editor. *Karatsu*. Nihon no Tōji, Vol. 5. (Tokyo, 1974). pl. 17.
Hayashiya, Seizō and Trubner, Henry et al. *Ceramic Art of Japan: One Hundred Masterpieces from Japanese Collections*. (Seattle, 1972). cat. no. 48.
Idemitsu Museum of Arts. *Special Exhibition Commemorating the Tenth Anniversary of the Idemitsu Collection*. (Tokyo, 1976). pl. 150.
Mizumachi, Wasaburo. *Ko Karatsu*. Idemitsu Museum of Arts 6, Vols. 1 and 2. (Tokyo, 1977). Vol. 1, p. 159, Vol. 2, pl. 67, p. 110.
Satō, Masahiko. *Karatsu*. Nihon Tōji Zenshū, Vol. 17. (Tokyo, 1976). pl. 6.
The Tokyo National Museum. *Exhibition of Far Eastern Ceramics*. (Tokyo, 1970). pl. 66.

References
Hayashiya Seizō, Editor. *Karatsu*. Nihon no Tōji, Vol. 5. (Tokyo, 1974).
Mizumachi, Wasaburo. *Ko Karatsu*. Idemitsu Museum of Arts 6, Vols. 1 and 2. (Tokyo, 1977).

51
Water Jar with Handles and
Incised Decoration

Japan, Edo period (1615–1868)
Chōsen Karatsu ware, stoneware with splashed glazes
Height: 20.3 cm.

Karatsu ware was not limited stylistically to E-garatsu (nos. 48–50) (decorated or pictured Karatsu), but produced a range of styles based on diverse techniques employed at the various Karatsu kilns. Types such as Kuro-garatsu (black Karatsu), Mishima Karatsu (Karatsu with slip-inlaid designs), or Bizen Karatsu and Seto Karatsu (following the style of Bizen and Seto wares), Hōri Karatsu (carved Karatsu), and Chōsen Karatsu, (Korean Karatsu) were among the typical products from the Karatsu kilns. The Idemitsu water jar is an example of Chōsen Karatsu.

Chōsen Karatsu ware takes its name from the fact it resembled contemporary Korean ceramics and was frequently formed by the *tataki* (coiled and paddled) methods in use in Korea. The majority of Chōsen Karatsu pieces are decorated with a combination of two glazes: an amber glaze, formed by the iron in the ash glaze, and a milky-white glaze, formed by a straw-ash glaze. The use of straw-ash and amber glazes is also credited to Korean potters.

This water jar with its bulging heavy shoulder and a paddled central area that supports two handles, is decorated with a flowing pattern of dripping amber and white glazes. This kind of jar, now used as a storage jar, was used by tea masters as a *mizusashi* (water jar). In the tea ceremony, the *mizusashi* was traditionally placed adjacent to the *kama*, the container in which water was boiled. The *mizusashi* contained the cool water which is ladled into the *kama* to be boiled and used for tea.

The incised comb decoration was probably done on the wheel at the time of throwing. Due to the direction that the Korean, and consequently Japanese, wheel spun, a shell-like pattern resulted from the string marks left from cutting and removing the piece from the wheel. This pattern is called *ito-kiri* (string cuts).

The Fuji no Kōchi kiln, to which this piece is attributed, is located in a mountain village of the same name. The main products of this kiln were tea wares such as *chaire* (tea containers), tea bowls and jars, water jars, and flower vases. Utilitarian wares were also manufactured. And, judging from the surviving pieces, Chōsen Karatsu ware was a major product of this site.

Published
Idemitsu Museum of Arts. *Special Exhibition Commemorating the Tenth Anniversary of the Idemitsu Collection.* (Tokyo, 1976). pl. 153.

References
Becker, Sister Johanna. "Karatsu Techniques: Fabrication and Firing." *International Symposium on Japanese Ceramics.* (Seattle, 1973). pp. 66–71.

Satō, Masahiko. "The History and Variety of Karatsu Ceramics." *Chanoyu Quarterly: Tea and the Arts of Japan*, no. 24. (Kyoto, 1980).

52

Dish with Floral Design

Japan, Edo period (1615–1868)
Ko Imari ware, porcelain with underglaze cobalt blue and overglaze enamel decoration, second half of seventeenth century
Diameter: 54.0 cm.

The decline of stoneware such as Karatsu (nos. 48–51) and Mino (nos. 45–47) was accelerated by the discovery of porcelaneous *kaolin* in the early seventeenth century. Legend states that Ri Sampei, a Korean potter who arrived in Japan after the Pottery Wars in the late sixteenth century, discovered *kaolin* deposits in the vicinity of Mount Izumi in the Arita district of Hizen Province (modern Saga Prefecture). Following his discovery, Ri Sampei, also known as Kanegae Sambei and in Korean as Yi Sam-p'yong, built a kiln with other Korean potters at Tengudani (Valley of Tengu, or long-nosed goblins) along the Shirakawa River in 1616. Ri Sampei's existence was questioned until 1967 when his death register was found at the small Buddhist temple Ryūsen-ji, in the western part of Arita. According to the register, he was buried fifty meters north of the Tengudani kiln site. This record confirms the existence of Ri Sampei, but whether or not he was the first porcelain potter is unclear. Recent archaeological studies have shown that although instrumental in the establishment of the porcelain industry, Ri Sampei may not have been its actual founder. Magnetic dating shows that kilns at Tengudani may have commenced earlier than the 1616 date traditionally assigned to Ri Sampei and possibly as early as 1610.

The early porcelains that Ri Sampei and his followers produced were *sometsuke*, (blue-and-white) and white wares familiar to them from earlier Korean models of the Yi dynasty (1392–1910). The popularity of blue-and white porcelain spread throughout Japan, and as these wares were shipped from the port of Imari in northwestern Kyushu, they came to be called 'Imari.' The early wares were more specifically referred to as Shoki Imari (early Imari). It was only later in the seventeenth century that Chinese shapes and decorations replaced Korean models.

Arita *sometsuke* production continued into the seventeenth century, but once the secret of overglaze enameling—originally introduced by the Kakiemon potters about 1643—became generally known to the Arita potters, overglaze enamel wares superseded blue-and-white in popularity.

From the mid-seventeenth century on, many potters gradually came to prefer the more flamboyantly colored enamel wares known as Ko Imari (old Imari). Porcelains of this period, namely Ko Imari and Kakiemon, were produced to supply the demands of the European export market. As a result, many of the fine extant examples have been preserved in European collections.

According to the daily record books of the Dutch East India Trading Company, European contact with China declined after 1662 due to internal disturbances there, and for twenty years Japanese porcelain supplanted the Chinese porcelain market. The great demand for these pieces also heightened their development; the roughness typical of Shoki Imari evolved into smoother and more carefully executed designs. Due to technical advances, the shapes became more regulated and often followed Chinese prototypes.

The production of Ko Imari enameled porcelain began in the mid-seventeenth century, reached its height in the Genroku era (1688–1703), and gradually declined toward the end of the Kyōhō era (1716–1736). It seems likely that with the decline in the export trade, the quality of Ko Imari also declined. In contrast to the work formerly produced, the designs in these later wares often became more stylized and stereotyped.

The Ko Imari potters were strongly influenced by Chinese designs and decorative motifs familiar to them from imported Chinese porcelains of the seventeenth century. This example is reminiscent of Chinese designs found on late Ming and early Ch'ing porcelains of the Wan-li (1573–1619) and K'ang-hsi (1662–1772) periods. With a propensity toward the crowding of the design and a certain lack of cohesion in the composition, the Ko Imari potters have filled the entire surface of the Idemitsu piece with floral and vegetal patterns. The central circular medallion is filled with sketchy floral designs of arabesque *karahana* (Chinese flowers) and is enclosed by a band of diaper patterns. Alternating large and small cartouches filled with peony sprays encircle the central medallion and the surrounding background is a profusion of decorative floral and vegetal sprays.

Numerous tiny marks, called *meato* (spur marks)—the remains of saggers used to stack the pieces inside the kiln—are found on the base. There is also a double concentric circle in underglaze blue.

References
Beurdeley, Cécile and Michel. *A Connoisseur's Guide to Chinese Ceramics*. Translated by Katherine Watson. (New York, 1974). cf. pl. 81, p. 222.
Koyama, Fujio. *The Heritage of Japanese Ceramics*. Translated by John Figgess. (New York, 1973).
Lion-Goldschmidt, Daisy and Moreau-Gobard, Jean-Claude. *Chinese Art: Bronze, Jade, Sculpture, Ceramics*. Translated by Diana Imber. (New York, 1960). pl. 61, p. 356.
Mikami, Tsugio. "Arita Blue-and-White and the Excavations of the Tengudani Kiln." *International Symposium on Japanese Ceramics*. (Seattle, 1973). pp. 189–195.
——. *The Art of Japanese Ceramics*. (New York and Tokyo, 1972).
Nagatake, Takeshi. "Iro Nabeshima Ware: Style and Techniques." *International Symposium on Japanese Ceramics*. (Seattle, 1973). pp. 91–98.

53*
Bowl with Carp Design

Japan, middle Edo period, Genroku era (1688–1703)
Ko Imari ware, porcelain with underglaze blue and
overglaze enamel decoration
Height: 25.1 cm.

During the Genroku era (1688–1703) of the Edo period (1615–1868) the middle classes advanced commercially as learning and literacy spread to all classes of society. This period of economic prosperity fostered the flourishing of the arts, particularly the development of Ukiyo-e woodblock prints, Kabuki and Bunraku (puppet) theater, and in the literary circles, *haiku*, the seventeen-syllable poems.

The Ko Imari wares produced during this period represented the finest achievements of this ware, and pieces such as the Idemitsu example generate the lively and colorful mood representative of the times. Although reflective of the tastes of the day, Ko Imari ware still

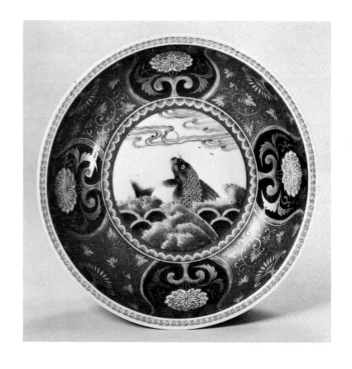

retained the borrowed Chinese motifs and color schemes. The use of the enclosed *karahana* (Chinese flowers) and the surrounding grasses in green and red overglaze enamels are identifiable with many examples from the Ch'ing dynasty in China (1644–1912). The light green gold brocade on the interior of the piece is similar to some of the designs on Ming dynasty (1368–1644) textiles.

The central motif exhibits an *ara-iso* (windswept sea-shore) design, in which a fish leaping from the turbulant ocean is boldly painted in underglaze blue. *Ara-iso* patterns commonly occurred on both ceramics and textiles.

On the exterior of the piece is an alternating band of chrysanthemums and other flowers. The base of the bowl has a double blue mark in underglaze blue as in no. 52, a mark also found on porcelain of the K'ang-hsi period in China (1662–1722). A single *meato* (spur mark) is centered on the base of the piece.

Published
Hayashiya, Seizō, editor. *Ko Imari and Ko Kutani.* Nihon no Tōji, Vol. 5. (Tokyo, 1972). pl. 241, pp. 190–191.
Idemitsu Museum of Arts. *Special Exhibition Commemorating the Tenth Anniversary of the Idemitsu Collection.* (Tokyo, 1976). pl. 155.
Musée du Petit Palais. *L'Art du Japon Eternel dans la Collection Idemitsu.* (Paris, 1981). pl. 167.

References
Hakutsuru Fine Art Museum. *Masterpieces of the Idemitsu Collection.* (Kobe, 1976).
Hayashiya, Seizō, editor. *Ko Imari and Ko Kutani.* Nihon no Tōji, Vol. 5. (Tokyo, 1972).
Varley, H. Paul. *Japanese Culture: A Short History.* (New York, 1973).

Fig. 35. Detail of underside (no. 53)

54
Octagonal Jar with Hydrangea Design

Japan, middle Edo period, Genroku era (1688–1703)
Ko Imari ware, porcelain with underglaze blue and
overglaze enamel decoration
Height: 58.5 cm.

A large quantity of Ko Imari ware exported during the Genroku era included large eight-sided jars, or *tsubo*, such as the Idemitsu example. These jars, termed *jinko tsubo* (aloeswood jars) referred to their resemblance to containers in which aloeswood, a source of incense, was shipped to Southeast Asia.

Although similar in many respects to certain Chinese prototypes, these Japanese examples had a distinctive foot called *takefushi* (bamboo-noded foot) recognizable as a slightly bulging base said to resemble a bamboo node. This element is commonly associated with Ko Imari and Kakiemon porcelain, often with examples of a slightly later date.

The Idemitsu jar is decorated by a central band of colorful, sprawling *ajisai* (hydrangea) in red, yellow, and green overglaze enamels. The artist, in attempting to fill the entire surface with design, has covered the remaining surface area with bands of diaper patterns, floral and vegetal motifs. This example still retains its lid, which is rare.

Published
Hayashiya, Seizō, editor. *Ko Imari and Ko Kutani.* Nihon no Tōji, Vol. 5. (Tokyo, 1972). pl. 410.
Musée du Petit Palais. *L'Art du Japon Eternel dans la Collection Idemitsu.* (Paris, 1981). pl. 166.
Nagatake, Takeshi; Hayashiya, Seizō and the Zauho Press. *Edo.* Sekai Tōji Zenshū, Vol. 8. (Tokyo, 1978). pl. 71, pp. 78–79.

References
Hayashiya, Seizō, editor. *Ko Imari and Ko Kutani.* Nihon no Tōji, Vol. 5. (Tokyo, 1972).
Hayashiya, Seizō and Trubner, Henry et al. *Ceramic Art of Japan: One Hundred Masterpieces from Japanese Collections.* (Seattle, 1972).
Idemitsu Museum of Arts. *Special Exhibition Commemorating the First Anniversary of the Idemitsu Collection: "Nihon no Iro-e."* (Tokyo, 1967). pl. 3.
Nagatake, Takeshi; Hayashiya, Seizō and the Zauho Press. *Edo.* Sekai Tōji Zenshū, Vol. 8. (Tokyo, 1978).
The Tokyo National Museum. *Edo Bijutsu Zuroku.* (Tokyo, 1967).

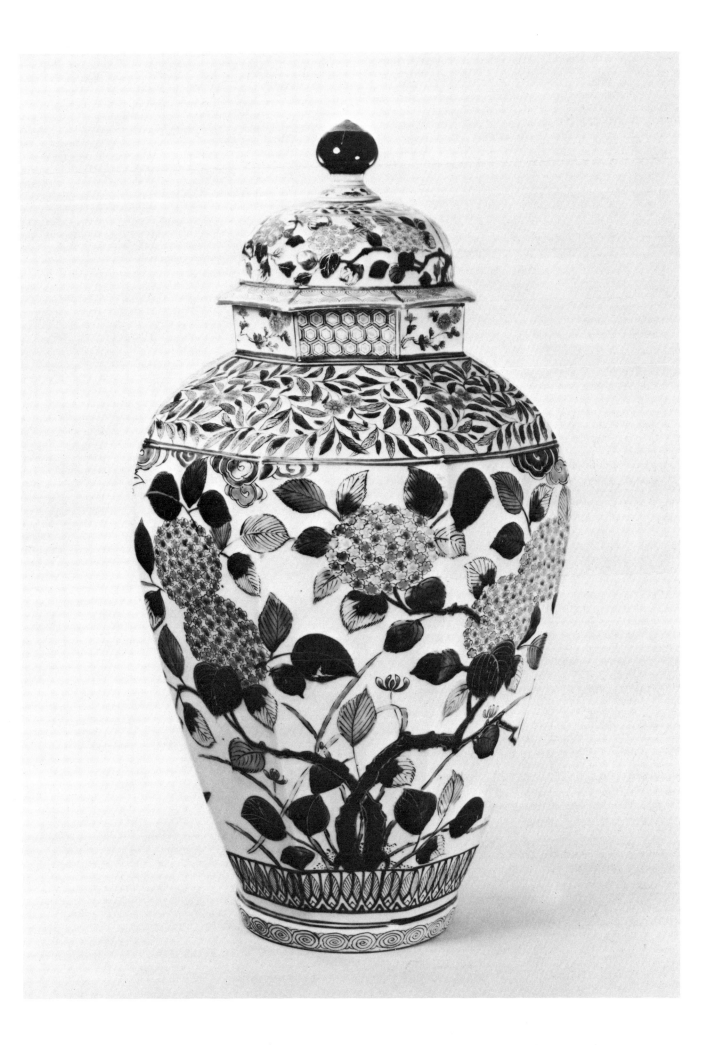

55

Covered Bowl with Flower-and-Bird Design

Japan, middle Edo period (1615–1868)
Kakiemon ware, porcelain with molded and overglaze
enamel decoration, eighteenth century
Height: 13.2 cm.

The origin of Kakiemon ware is traditionally associated with Sakaida Kakiemon, who lived at Arita in Hizen Province (modern Saga Prefecture). Kakiemon genealogical records state that the first Kakiemon, originally known as Sakaida Kizaemon (1596–1666), learned the technique of overglaze enameling from Tōshima Tokuemon, an Arita pottery merchant. Tokuemon is said to have learned the technique from a Chinese potter who resided on the island of Dejima in the bustling port of Nagasaki. At the time, Nagasaki was the principal port to which junks from the mainland brought their goods, possibly including enamel paints. It was not until the 1640s that Sakaida Kakiemon first succeeded in firing overglaze enamels on porcelains.

The derivation of the name Kakiemon traditionally has two sources. First, these overglaze enamels have an orange-red color resembling *kaki* (persimmon) and thus the name Kakiemon. Another account states that Sakaida Kizaemon made an *okimono* (ornament for the alcove) for Lord Nabeshima Katsushige in the form of two *kaki*, and the Lord, grateful to Kizaemon, conferred upon him the name of Kakiemon.

Scholars now question whether Sakaida Kakiemon was the first to successfully use overglaze enamels on porcelain. The genealogical records, thought to have been compiled in the Meiji period (1868–1912), show numerous chronological discrepancies. Based on recent research, it seems more likely that the breakthrough of overglaze enamels did not occur until the time of Kakiemon IV (1641–1679) and Kakiemon V (1660–1691).

Originally, the clay used by the Kakiemon potters was a coarse white clay from Izumiyama, near Arita, and by covering it with a thin layer of ash glaze, they produced a matte, grayish white ware. By the end of the seventeenth century, Kakiemon potters mixed porcelain stone from Iwayakawachi in Arita with their clay and were able to achieve a milky white body known as *nigoshi-de*. The excellent quality of the *nigoshi-de* body, as seen in the Idemitsu example, distinguishes Kakiemon ware as one of the most refined of Japanese porcelains.

Kakiemon designs, in contrast to the complicated decoration of Imari ware, were highly refined and at the time of its stylistic apogee, Kakiemon ware incorporated Japanese designs with Chinese taste. The designs were usually sparse to expose the milky-white quality of the underlying *nigoshi-de*. On this piece, floating chrysanthemum, sparrow, and flying plovers in red and green enamels are set against conventional wave patterns in molded relief. This use of floral designs against a wave pattern was also popular in eighteenth-century textile designs. Chinese motifs of jewels and phoenixes are painted in colored enamels on the interior of the

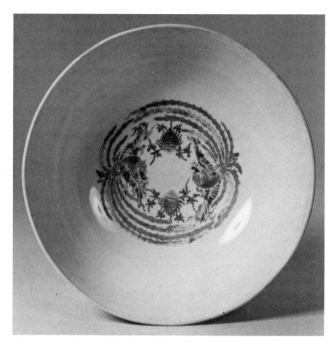

Fig. 36. Detail of inside of cover (no. 55)

bowl. On the base is a single *meato* (spur mark).

Published
Musée du Petit Palais. *L'Art du Japon Eternel dans la Collection Idemitsu.* (Paris, 1981). pl. 163.

References
Hayashiya Seizō. *Kakiemon and Nabeshima.* Nihon no Tōji, Vol. 6. (Tokyo, 1972).
Okuda, Seiichi et al. *Japanese Ceramics.* Translated by Roy Andrew Miller. (Tokyo and Vermont, 1960).
The Tokyo National Museum of Modern Art, editor. *Japanese Painted Porcelain: Modern Masterpieces in Overglaze Enamels.* Translated by Richard L. Gage. (New York, 1979).

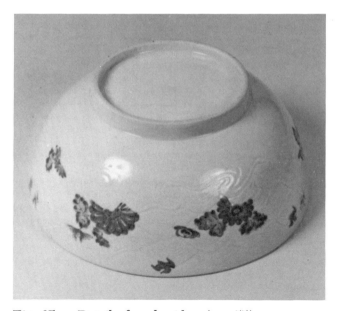

Fig. 37. Detail of underside (no. 55)

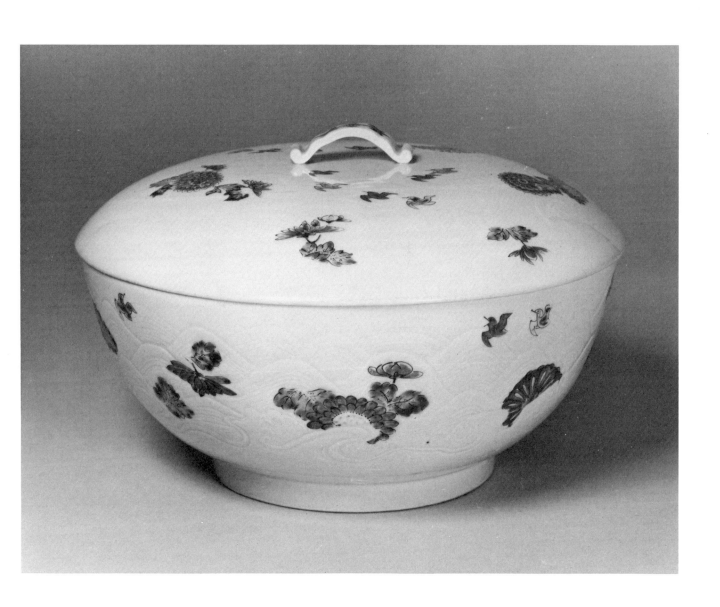

56*
Large Covered Bowl with Flower-and-Bird Design

Japan, middle Edo period (1615–1868)
Kakiemon ware, porcelain with overglaze enamel
decoration, late seventeenth century
Height: 36.6 cm.

Published
Koyama, Fujio. *The Heritage of Japanese Ceramics.* Translated by John Figgess. (New York, 1973). pl. 69, p. 145.

References
Hayashiya, Seizō, editor. *Nabeshima and Kakiemon.* Nihon no Tōji, Vol. 6. (Tokyo, 1972). pl. 8.
Koyama, Fujio. *The Heritage of Japanese Ceramics.* Translated by John Figgess. (New York, 1973).
The Tokyo National Museum of Modern Art, editor. *Japanese Painted Porcelain: Modern Masterpieces in Overglaze Enamel.* Translated by Richard L. Gage. (New York, 1980).

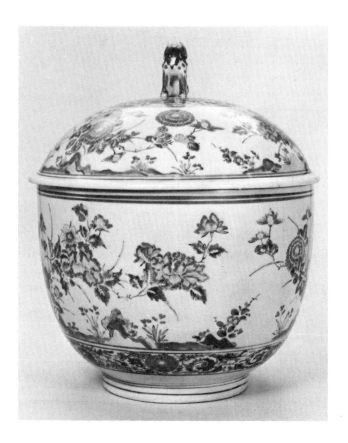

Deep bowls, such as this piece, exemplify the range of colors used by the Kakiemon potters. The multi-colored combination of azure blue, orange-red, primrose yellow, green, and black overglaze enamels was influenced by the style of the Chinese *wu-ts'ai* (five-color) enameled wares. *Wu-ts'ai* enameled wares were developed at the Ching-tê-chên kilns during the Ming dynasty and were later perfected during the Chia-ching (1522–1566) and Wan-li (1573–1619) periods.

In the Idemitsu piece, the overglaze enamels were meticulously applied to the glazed *nigoshi-de* body to create delicate and refined compositions such as the colorful lakeside scene with birds perched on rocks amidst a bright array of blossoming chrysanthemums and other flora. The painted designs were often outlined by a thin black line that merely suggested the form rather than defined it. Such gay compositions were fashionable between the Kambun (1661–1673) and the Genroku (1688–1703) eras and were sought after by the European trading companies.

A small molded ornamental knob in the shape of a *shishi* (Chinese lion), (cf. nos. 15 and 58), adorns the lid and was adapted from the Chinese porcelain of the Ming period.

57*
Dish with Design of Waves and Peonies

Japan, middle Edo period (1615–1868)
Nabeshima ware, porcelain with underglaze blue
and overglaze enamel decoration, late seventeenth-
early eighteenth centuries
Diameter: 20.0 cm.

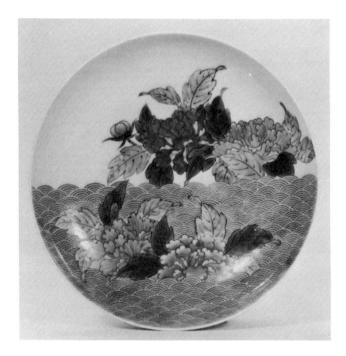

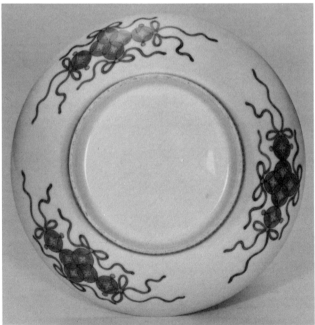

Fig. 38. Detail of underside (no. 57)

The three types of porcelain produced at Arita from the seventeenth century on, Ko Imari (nos. 52–54), Kakiemon (nos. 55 and 56), and Nabeshima, grew out of different national and international demands. Ko Imari production responded to the wide-spread demand for Chinese ceramics based on Ming and Ch'ing models; Kakiemon combined Japanese expression with Chinese models; and the last, Nabeshima, unlike either Ko Imari or Kakiemon, responded to the demands for a fine ware for use by the shogun and his family, the daimyo, and the nobility. The production of Nabeshima ware was carefully controlled and organized by the Nabeshima clan. They appointed *tokikata no yaku* (kiln governors) and established an office in Arita to control production of the ware.

The first examples of Nabeshima ware were made during the second quarter of the seventeenth century. These wares consisted principally of blue-and-white and celadon wares. While Ko Imari and Kakiemon production reached a peak stylistically during the prosperous Genroku period (1688–1703), the peak of Nabeshima ware production occurred during the Genroku and Kyōhō (1716–1736) eras. The ware of this period, such as the present example, is referred to as *Iro Nabeshima* (colored Nabeshima). By the time *Iro Nabeshima* emerged, the overglaze enamel process had been perfected and a full repertory of design motifs had been established.

During the Edo period (1615–1868), the textile industry reached a creative height with the invention of a starch-resist dyeing technique known as *yūzen*. The process of *yūzen* enabled decoration to be handled in a much freer manner than had previously been possible. Background patterns such as *seikai-ha* (overlapping wave pattern) and *higaki* (patterns resembling the texture of woven mats) were combined with complimentary designs. Nabeshima ware, influenced by the quality of these textile designs, assimilated many ideas from the pattern books of the mid-Edo period. As in this example, *seikai-ha* are combined with a *botan* (peony) and recall the sumptuous decorative textile patterns from the same period. The peony holds particular symbolic importance and is highly esteemed in China and Japan. In China, it was a symbol of riches and nobility and therefore it is not surprising that it would have been used on the exclusive Nabeshima wares.

Plates such as this one were probably produced in sets of ten or twenty. They were decorated with overglaze enamels and underglaze cobalt blue. Red, yellow, and green were the most frequently used colors in overglaze enamels. Underglaze blue was used to outline the overglaze designs which were similar to those used in the *tou-ts'ai* Chinese enameling techniques (see no. 32). In the case of Nabeshima porcelain, the techniques associated with stencil pattern dyeing and *maki-e* lacquering (see no. 71) were adapted for the purpose of standardizing the painted designs. After the piece was made, a paper with the desired design was placed over the surface of the piece to be painted. By rubbing the

paper, the design was transferred to the piece. Cobalt blue was then used to outline the areas to be completed later in over-glaze enamels, as in the *tou-ts'ai* enameling technique. The pieces were then dipped in clear glaze and fired. Overglaze enamels were applied after this firing.

On the exterior of the foot of many Nabeshima pieces is a design termed *kushi-kōdai* (comb marks). This feature was reserved by the Nabeshima family until feudal control over the kilns was lost in 1868. Subsequently, the *kushi-kōdai* began to be used by other potters.

Published
Hakutsuru Fine Art Museum. *Masterpieces of the Idemitsu Collection.* (Kobe, 1976). pl. 56.
Idemitsu Museum of Arts. *Special Exhibition Commemorating the Tenth Anniversary of the Idemitsu Collection.* (Tokyo, 1976). pl. 161.

References
The Japan Textile Color Design Center, compiler. *Textile Design of Japan: 1, Free Style Design.* (Tokyo, 1980).
Nagatake, Takeshi. "Iro Nabeshima Ware: Style and Techniques." *International Symposium on Japanese Ceramics.* (Seattle, 1973). pp. 91–98.

58*
Dish with Hexagonal Medallions

Japan, Edo period (1615–1868)
Ko Kutani ware, porcelain with overglaze enamel decoration, late seventeenth—early eighteenth centuries
Diameter: 34.1 cm.

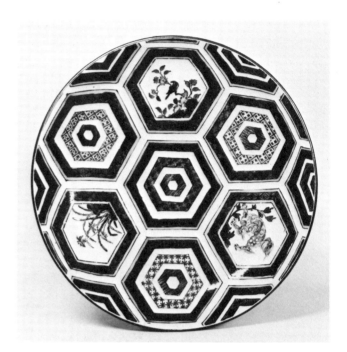

Fig. 39. Detail of underside (no. 58)

The most outstanding feature of Ko Kutani ware is the colorful and striking combination of decorated patterns and shapes. Among the extant examples is a large body of work that employs the decorative use of geometric patterns and pictorial motifs. Geometric shapes such as hexagons, as seen in this piece, squares, and diamond shapes are essential design elements on many Ko Kutani wares. The Ko Kutani potters used variations of basic patterns to form alternating decorative

bands. On this piece, bold and heavily applied yellow, brown, and green overglaze enamels and underglaze blue illustrate the complex nature of Ko Kutani design, a design unprecedented in contemporary ceramics. The composition is further embellished with the addition of pictorial elements within the medallions such as flower-and-bird, floral, and animal motifs. The interior of one medallion depicts a *shishi* (Chinese lion), a mythical animal, half deer, half dragon.

The dating of pieces such as this dish poses certain difficulties. According to the late Sensaku Nakagawa, the complex nature of the designs is not always an indicator of when the piece was produced since many different types of Ko Kutani ware were apparently made around the same time. Therefore, variables such as the nature of the composition, materials, and techniques of manufacture must be considered when dating pieces. The Idemitsu piece was made during the Edo period (1615–1868), probably in the late seventeenth or early eighteenth century.

The blossoming of the overglaze enameling process at Arita in the seventeenth century appealed to the ceramic tastes of the northern Maeda clan in Kaga Province (modern Ishikawa Prefecture). Members of the Maeda family were then the richest and most powerful retainers under the tutelage of the Tokugawa Shogunate. Legends state that during the mid-seventeenth century, Gōtō Saijirō, a loyal vassal to the Maeda clan, was sent by the feudal Lord, Toshiharu Maeda, to the Kakiemon kilns in Arita to uncover the secrets of overglaze enameling. The process of overglaze enameling, well-guarded by the Kakiemon family, was a barrier to Saijirō, and only after becoming a servant and marrying a Kakiemon daughter, is he said to have been able to learn the overglaze enamel technique. Once Saijirō learned the secrets of the technique, he left his family in Arita and returned to Kaga around 1655. Under the direction of the Lords of Kaga, he then began to produce porcelain at Kutani village (in modern Ishikawa Prefecture). The products of these efforts were called Ko Kutani (Old Kutani).

The truth surrounding this legend has been questioned by scholars in recent years, and efforts are being made to clarify the history of Ko Kutani. Although a number of white-glazed porcelains, celadons, ash-glazed, and iron-glazed shards were unearthed at Komatsu in 1969 and at Kaga in 1971, 1972, and 1973 no shards of what is properly called Ko Kutani were found. Many questions surrounding the place of production of Ko Kutani porcelain therefore remain unanswered. The majority of scholars now believe that, although a unique ware called Ko Kutani did exist, many examples, once thought to be Ko Kutani ware, are in fact from kilns at Arita, in Kyushu.

The ware known as Ko Kutani has a characteristically grayish body which is often described as having the appearance of old *mochi* (rice cakes). The surface of the non-lustrous glazed ware frequently shows cracks, pitting, or crazing. The matte glaze, a trademark of Ko Kutani ware, is set off by the brilliant and distinc-

tive polychrome overglaze enamel decoration with colors ranging from green, blue, matte yellow, and aubergine to cherry reds and browns.

For unknown reasons, the Ko Kutani kilns apparently closed down during the Genroku era (1688–1703) but later reopened in the Bunka era (1804–1817) when the Lord of Kaga invited the painter and potter, Aoki Mokubei (1767–1833) (no. 64) to supervise the new kiln at Kasugayama. The Kutani wares from this period onward are referred to as *Saikō Kutani* (Revived Kutani). In the succeeding generations, the principal sites were at Yoshidaya and Wakasugi, hence the names Yoshidaya ware and Wakasugi ware, which are also frequently used to describe these later types.

Published
Musée du Petit Palais. *L'Art du Japon Eternel dans la Collection Idemitsu.* (Paris, 1981). pl. 160.

References
Jenyns, Soame. "The Problem of the Ko Kutani and the Ao Kutani Enameled Wares." *International Symposium on Japanese Ceramics.* (Seattle, 1973). pp. 139–150.
Nakagawa, Sensaku. *Kutani Ware.* Translated by John Bester. (Tokyo and New York, 1979).
The Tokyo National Museum of Modern Art, editor. *Japanese Painted Porcelain: Modern Masterpieces in Overglaze Enamel.* Translated by Richard L. Gage. (New York, 1980).

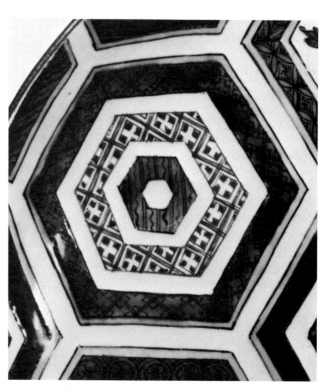

Fig. 40. Detail of geometric patterns (no. 58)

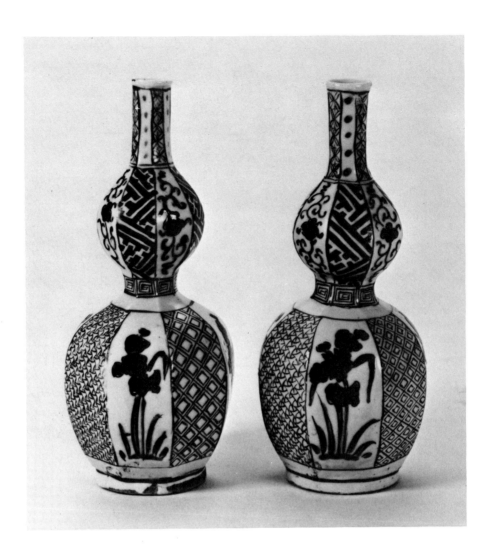

59
Pair of Gourd-Shaped Sake Bottles

Japan, early Edo period (1615–1868)
Ko Kutani ware, porcelain with overglaze
enamel decoration
Height: 20.1 cm.

Among the repertory of Ko Kutani forms were the gourd-shaped sake bottles that resemble *hyōtan* (calabash gourds). *Hyōtan* were originally dried and used as sake containers. The provenance of these gourd-shaped sake bottles poses a difficult problem for Ko Kutani ware scholars since similar forms are known to have been produced also at the Arita kilns. The shape may indicate an Arita origin instead of the long-held belief that shapes such as this, when found in Japanese porcelain, were products of the Ko Kutani kilns. Other sources indicate that the gourd shape was derived from *Shonzui* ware—named for the Japanese potter Gorodaiyū Shonzui—produced in Ming dynasty China (1368–1644). According to legend, Shonzui was sent to study at Arita in 1578, and to China in 1595 under the patronage of the Maeda family.

These double-sectioned bottles, divided into horizontal bands of geometric and naturalistic motifs, exemplify the Ko Kutani potters' love of detail. The lower portion of the bottle is an alternating pattern of iris, diagonal quadrangles, and *bishamon* patterns. *Bishamon* is taken from *Bishamon-ten* (Vaisravana), one of the four Guardian Kings, the Protector of the North, and this overlapping, scale-like motif traditionally appeared on his armor. *Sayagata* (key fret) patterns and floral designs ornament the upper portion of the two bottles while geometric bands encompass the neck.

Published
Idemitsu Museum of Arts. *Special Exhibition Commemorating the First Anniversary of the Idemitsu Collection: "Nihon no Iro-e."* (Tokyo, 1967). pl. 17.
Idemitsu Museum of Arts. *Special Exhibition Commemorating the Tenth Anniversary of the Idemitsu Collection.* (Tokyo, 1976). pl. 173.
Koyama, Fujio et al., editors. *Edo Period.* Sekai Tōji Zenshū, Vol. 6. (Tokyo, 1961). pl. 79.

References
Hayashiya, Seizō and Trubner, Henry, et al. *Ceramic Art of Japan: One Hundred Masterpieces from Japanese Collections.* (Seattle, 1972).
Jenyns, Soame. "The Problem of the Ko Kutani and Ao Kutani Enameled Wares." *International Symposium on Japanese Ceramics.* (Seattle, 1973). pp. 139–150.
Mikami, Tsugio. "Ko Kutani in the Light of Recent Research." *International Symposium on Japanese Ceramics.* (Seattle, 1973). pp. 135–139.
Nakagawa, Sensaku. *Kutani Ware.* Translated by John Bester. (Tokyo and New York, 1979).

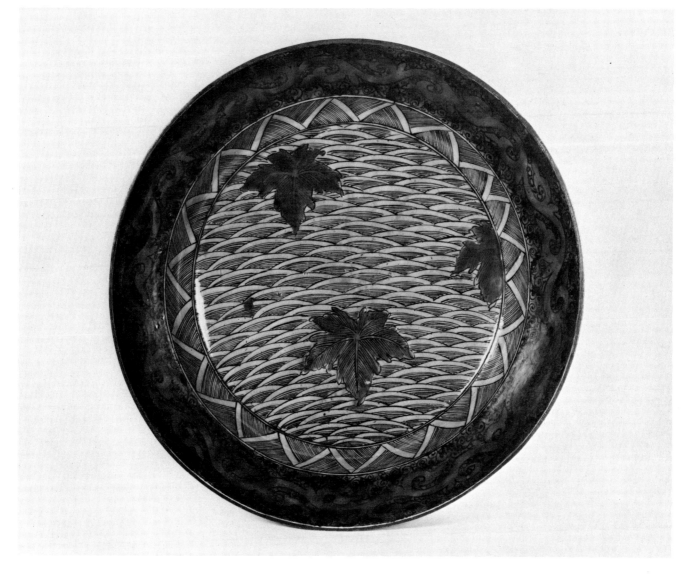

60
Dish with Ivy Leaves

Japan, early Edo period (1615–1868)
Ao Kutani ware, porcelain with overglaze enamel
decoration, second half of seventeenth century
Diameter: 43.7 cm.

Within the spectrum of known Ko Kutani wares, the origin and dating of Ao Kutani (green Kutani) or Ao-de Ko Kutani (green-style Ko Kutani) is the most problematic. Precisely when Ao-de Ko Kutani appeared is unclear: however, scholars generally believe that it was produced sometime after the demise of the Ko Kutani kilns in the Genroku era (1688–1703) and that it was not produced at official kilns.

Ao-de Ko Kutani is distinct from the orthodox designs of Ko Kutani and Arita wares, for as the term Ao-de Ko Kutani implies, green is the predominant color to which yellow or aubergine were added. These overglaze enamels were applied over designs sketched on the body in black. Although only two colors, yellow and green, are used on the Idemitsu piece, the *seikai-ha* (overlapping wave pattern) designs in yellow overglaze enamel enhance the contrasting and decorative motif of the floating ivy leaves, and effectively create a dynamic color composition. Designs drawn from the natural world—flowers, plants, and animals—were predominant themes in Ao-de Ko Kutani. In addition to the ivy leaf motif on this dish, bamboo, camellia, lotus blossoms, and birds were among the recurring themes of Ko Kutani ware.

The underside of this dish is decorated with chrysanthemum arabesques; on the base is inscribed an undecipherable character.

Published
Hakutsuru Fine Arts Museum. *Masterpieces of the Idemitsu Collection.* (Kobe, 1976). pl. 47.
Idemitsu Museum of Arts. *Special Exhibition Commemorating the First Anniversary of the Idemitsu Collection: "Nihon no Iro-e".* (Tokyo, 1967). pl. 1.
Idemitsu Museum of Arts. *Special Exhibition Commemorating the Tenth Anniversary of the Idemitsu Collection.* (Tokyo, 1976). pl. 171.
Musée du Petit Palais. *L'Art du Japon Eternel dans la Collection Idemitsu.* (Paris, 1981). pl. 162.

References
Jenyns, Soame. "The Problem of the Ko Kutani and the Ao Kutani Enameled Wares." *International Symposium on Japanese Ceramics.* (Seattle, 1973). pp. 139–150.
Nakagawa, Sensaku. *Kutani Ware.* Translated by John Bester. (Tokyo and New York, 1979).

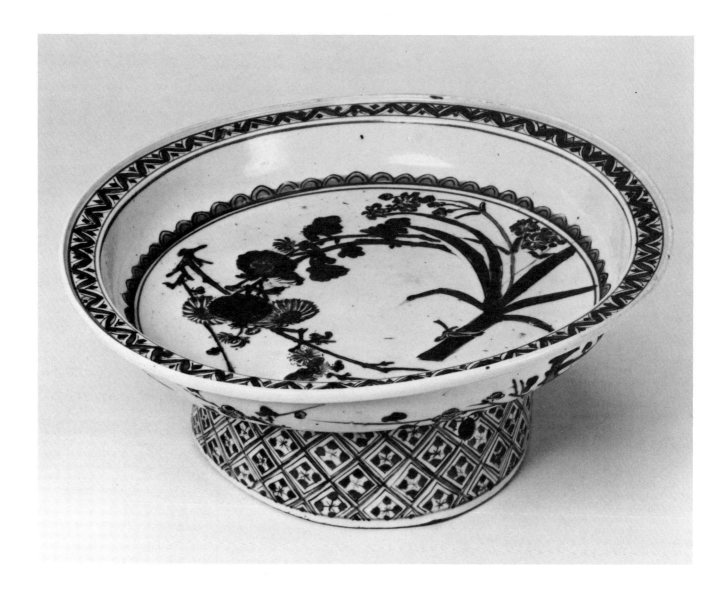

61
Footed Dish with Design of Flower Sprays

Japan, early Edo period (1615–1868)
Ko Kutani ware, porcelain with overglaze enamel
decoration, second half of seventeenth century
Diameter: 28.3 cm.

The variety of decorative themes used on Ko Kutani wares shows the diversity of traditions from which the Ko Kutani potters drew inspiration. Ko Kutani themes were influenced by the ceramics of the late Ming (1368–1644) and early Ch'ing (1644–1912) dynasties in China, as well as by imported paintings, textiles, and other designs. Contemporary Japanese painting styles such as the Kanō and Tosa schools were frequently assimilated by the Ko Kutani potters, and themes used on Japanese ceramic wares similar to Kakiemon and Ko Imari wares also appeared.

Large dishes are considered the masterpieces of Ko Kutani craftsmanship and this particular example recalls the treatment of floral and border compositions found on Ming dynasty wares of the Wan-li (1573–1619) and T'ien-ch'i (1621–1627) reigns. The interior of the dish and the border patterns are delicately decorated, using a splatter of light green, cherry reds, overglaze enamels, and underglaze blue. Blue, red, and green plum sprays decorate the exterior of the dish and the high foot is ornamented with diagonal lattice patterns in blue and red overglaze enamels.

Marks are frequently found on the bases of Ko Kutani wares, and the most common are variations of the Japanese character, *fuku* (good fortune). It is a mark frequently found on Edo period ceramics.

Published
Hayashiya, Seizō, editor. *Ko Imari and Ko Kutani.* Nihon no Tōji, Vol. 5. (Tokyo, 1977). pls. 113–114.
Idemitsu Museum of Arts. *Special Exhibition Commemorating the Fifth Anniversary of the Idemitsu Collection.* (Tokyo, 1971).
Idemitsu Museum of Arts. *Special Exhibition Commemorating the First Anniversary of the Idemitsu Collection: "Nihon no Iro-e."* (Tokyo, 1967). pl. 7.
Koyama, Fujio et al., editor. *Edo Period.* Sekai Tōji Zenshū, Vol. 6. (Tokyo, 1955). fig. 10.

Reference
Nakagawa, Sensaku. *Kutani Ware.* Translated by John Bester. (Tokyo and New York, 1979).

62*

Covered Jar with Phoenix Medallions

Nonomura Ninsei (active mid-seventeenth century)
Japan, Edo period (1615–1868)
Kyō-yaki ware, stoneware with overglaze enamel
decoration
Height: 37.0 cm.
Important Cultural Property

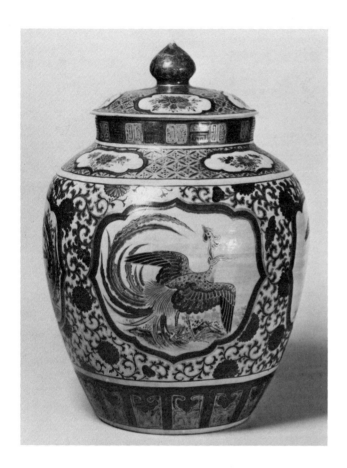

sumed the name Ninsei, using the first character in the name of Ninna-ji in reference to his connection with the temple.

Ninsei's work exhibits considerable variety and his search for creative ideas led him to explore the fields of lacquer, cloisonné, dyeing, and weaving as well as the synthesis of design concepts from the Kanō and *Yamato-e* schools of painting. Chinese porcelain designs were also a major influence on his work, particularly the porcelains from the Wan-li period (1573–1619), as illustrated by the Idemitsu example.

The most impressive examples of Ninsei's work are to be found in the designs and patterns of his large *chatsubo* (tea jars). The conception of *chatsubo* did not originate with Ninsei but came from Chinese prototypes; however, he broke with the traditional mode of subdued ornamentation by boldly and imaginatively decorating them with sumptuous stylized designs. The four panels on this *chatsubo* are embellished with phoenixes in overglaze enamels. The gold, blue, and red floral decoration surrounding the large panels and the *genjibishi* (lozenge design) ornamenting the shoulder and lid suggest origins from lacquer designs. Ninsei's mark appears on the base.

Published
Mitsuoka, Tadanari, editor. *Edo Period*. Sekai Tōji Zenshū, Vol. 6. (Tokyo, 1975). pls. 6, 7, and 8, pp. 18–19.
Musée du Petit Palais. *L'Art du Japon Eternel dans la Collection Idemitsu*. (Paris, 1981). pl. 170.
The Tokyo National Museum. *Edo Bijutsu Ten*. (Tokyo, 1966). pl. 398.

References
Hayashiya, Seizō and Trubner, Henry et al. *Ceramic Art of Japan: One Hundred Masterpieces from Japanese Collections*. (Seattle, 1972).
Satō, Masahiko. *Kyoto Ceramics*. Translated by Anne Ono Towle and Usher P. Coolidge. (Tokyo and New York, 1973).

Although the capital of Japan was transferred to Edo (modern Tokyo) in 1615, Kyoto still remained the artistic and cultural center of the country. During this period Kyoto rose to prominence in ceramic output with the manufacture of Raku ware, a low-fired pottery particularly prized by the tea masters. With the decline of Raku production, there was a need to supplant it with a newer, more innovative ceramic style. The work of Nonomura Ninsei, born Tsuboya Seiemon, came to fill this void, and established the tradition of *Kyō-yaki* (Kyoto ware). *Kyō-yaki* refers to thte ceramics made in the tradition of Ninsei and Kenzan (no. 63) which were produced in or near the capital city of Kyoto.

Ninsei's life is wrapped in obscurity; he was born in Nonomura village in Tamba Province northwest of Kyoto, and although little is known about his background, it seems that he was trained in lacquer techniques and designs and also had a knowledge of textile patterns and designs. The date of his arrival in Kyoto is also unknown; however, it is thought that he established a kiln at Ninna-ji, a temple in the Omuro district north of Kyoto, around 1647. Ten years later he as-

Fig. 41. Inscription on base
(no. 62)

63*
Jar with Design of Maple Leaves

Ogata Kenzan (1663–1743)
Japan, Edo period (1615–1868)
Kyō-yaki ware, stoneware with overglaze enamel
decoration
Height: 14.5 cm.

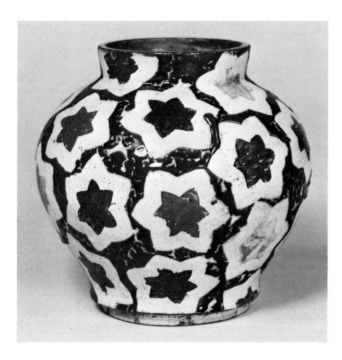

The tradition of *Kyō-yaki*, established by the sumptuous forms and colors of Ninsei's work (no. 62) took a different, yet equally innovative path under the influence of another artist potter, Gompei Ogata, more commonly known as Kenzan. Kenzan, destined to become a celebrated painter and potter, was born into a wealthy family of Kyoto clothiers in 1663. While renowned as a potter, Kenzan was also adept as a calligrapher, painter, poet, and lacquer artist.

As a quiet, studious, and meditative man involved in Buddhism, Kenzan, after his father's death in 1687, moved to Shū-sei-dō, the Zen Hermitage, near Ninsei's kiln in the Omuro district. During this period, he spent time in the art colony of Takagamine founded by the artist Honami Kōetsu (1567–1643). Kenzan also studied under the head of the fourth generation of Raku potters, Ichinyū. It is not clear whether contact with the noted Ninsei inspired Kenzan to undertake ceramic production; however, in 1699, he moved to Narutaki, located west of Omuro, and reproduced ceramics with the sons of Ninsei as his apprentices. It is believed that during this period, Kenzan received Ninsei's *denshō* from his sons: a *denshō* is a document passed down by a master to his successors and contains the working principles of his profession. In the case of potters, the *denshō* usually contains the recipes of clays and glazes.

During the early years at Narutaki, Kenzan's elder brother, Kōrin (1658–1716), then approaching fame as an artist in the Sōtatsu-Kōrin tradition of painting, also known as the Rimpa school, did the majority of the decoration on Kenzan's pottery. Later, when Kōrin became increasingly occupied with painting commissions, Kenzan turned to his creative genius for ceramic designs.

In 1712, Kenzan, fifty years old, left Narutaki and moved back to Kyoto where he decorated pottery fired in kilns at Awata and Kiyomizu. Much of his work from this period, however, lacks the spirit of the work made at Narutaki. The times grew increasingly difficult; the number of Kenzan's patrons gradually declined and, in 1716, his brother, Kōrin, died. Welcoming an offer to move to Edo in 1731, Kenzan was provided with a house by a friend at Iriya on land owned by the Kanei temple. After traveling to the Sano district near Edo in 1737 and 1738, he returned to Edo where he died, impoverished, in 1743 at the age of 80.

As a potter, Kenzan is best remembered for his innovative designs. He successfully combined Ninsei's overglaze enamel techniques with the decorative tastes of the Sōtatsu-Kōetsu school that he had learned from his brother Kōrin. His favorite motifs were drawn from nature, as in the bold and dynamically colored stenciled maple leaves on this jar, which are very contemporary in feeling. Such bold designs offer a contrast to the refined and pristine work of his esteemed predecessor, Ninsei. This jar has been decorated with multi-colored overglaze enamels, a process that had been perfected by his master, Ninsei. Kenzan apparently shortened the two-step process of overglaze enameling by directly painting the colors of the background and of the maple leaves onto the unfired clay body that had been coated with white slip. The overglaze enamels in this process do not fit the body perfectly and as a result crawl over the surface of the piece.

Fig. 42. Signature on base (no. 63)

Published
Idemitsu Museum of Arts. *Special Exhibition Commemorating the Tenth Anniversary of the Idemitsu Collection.* (Tokyo, 1976). pl. 165.
Mitsuoka, Tadanari. *Kenzan.* Tōji Taikei, Vol. 24. (Tokyo, 1973). pl. 31.

References
Leach, Bernard. *Kenzan and His Tradition: The Lives and Times of Koetsu, Sotatsu, Kōrin and Kenzan.* (London, 1966).
Satō, Masahiko. *Kyoto Ceramics.* Translated by Anne Ono Towle and Usher P. Coolidge. (Tokyo and New York, 1973).
——. "The Three Styles of Kenzan Ware." *International Symposium on Japanese Ceramics.* (Seattle, 1973). pp. 178–183.
Vollmer, John and Webb, Glenn T. *Japanese Art at the Art Gallery of Greater Victoria.* (Victoria, 1972).

64*
Flower-Shaped Bowl with Design of Lohans

Aoki Mokubei (1767–1833)
Japan, Edo period (1615–1868)
Kyō-yaki ware, porcelain with overglaze enamels and gold
Height: 9.5 cm.

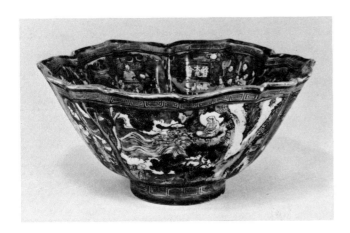

Aoki Mokubei (1767–1833), motivated by the prosperous and stable atmosphere of the Edo period (1615–1868) and an artistic development based on the ideals and doctrines of the Chinese literati artists, inspired the formation of intellectual and artistic coteries of *bunjin* (literati) in Kyoto. Among these artists, Mokubei was respected as a scholar, antiquarian, and painter. He was also reputed to be a student of the potter Okuda Eisen (1753–1811), and is included among the 'Three Great Masters' of the Kyoto school of pottery, together with the potters Ninsei (no. 62) and Kenzan (no. 63). Legend has it that Mokubei began to make ceramics in the 1780s, and later, during the Bunka era (1804–1818), accepted an invitation to go to Kanazawa to reactive the Kutani kilns. It was there that he worked at a new kiln at Kasugayama.

Mokubei was adept at a variety of ceramic forms. A prime factor for his versatility was the use of Chinese

prototypes; he copied Ming blue-and-white, *gosu-akae*, celadons and Kōchi ware. The most representative of Mokubei's style are bowls used for *sencha*, a tea ceremony using leaf tea rather than the *matcha* (powdered tea) more commonly used. This foliate bowl, brightly decorated in red, yellow, green, and brown enamels, recalls the *kinran-de* porcelain ware made in China during the Chia-ching period (1522–1566). On the interior and exterior of the bowl, a myriad of yellow and green clad Buddhist *Lohans* are crowded together against a deep red background. The composition is heightened by the contrasting bands of green diaper patterns circling the lip and foot.

Lohans (*Arhats* in Sanskrit) were 'worthies' or disciples and guardians of the Buddha and are personifications of the perfected Arya, a disciple who passed through the different stages of the Eightfold Way or Noble Path. In the Hinayana Buddhist pantheon, there are eighteen major *Lohans*, sixteen of which are derived from Hindu cosmology, and two from the Chinese. They are generally recognizable by individual attributes, such as a fan or staff. These eighteen *Lohans* are appointed to various stations in different locations in the world and are assigned a myriad of subordinate *Lohans*, as shown in this example.

Four Chinese characters, *Chen Chi-lin tsao*, are written on the base of the bowl and covered with a purple enamel; their exact meaning is unclear.

Published
Hayashiya, Seizō and Trubner, Henry et al. *Ceramic Art of Japan: One Hundred Masterpieces from Japanese Collections.* (Seattle, 1972).
Mitsuoka, Tadanari, editor. *Edo.* Sekai Tōji Zenshū, Vol. 6. (Tokyo, 1975). pls. 78 and 79, pp. 76–77.
Musée du Petit Palais. *L'Art du Japon Eternel dans la Collection Idemitsu.* (Paris, 1981). pl. 173.

Fig. 43. Inscription on base (no. 64)

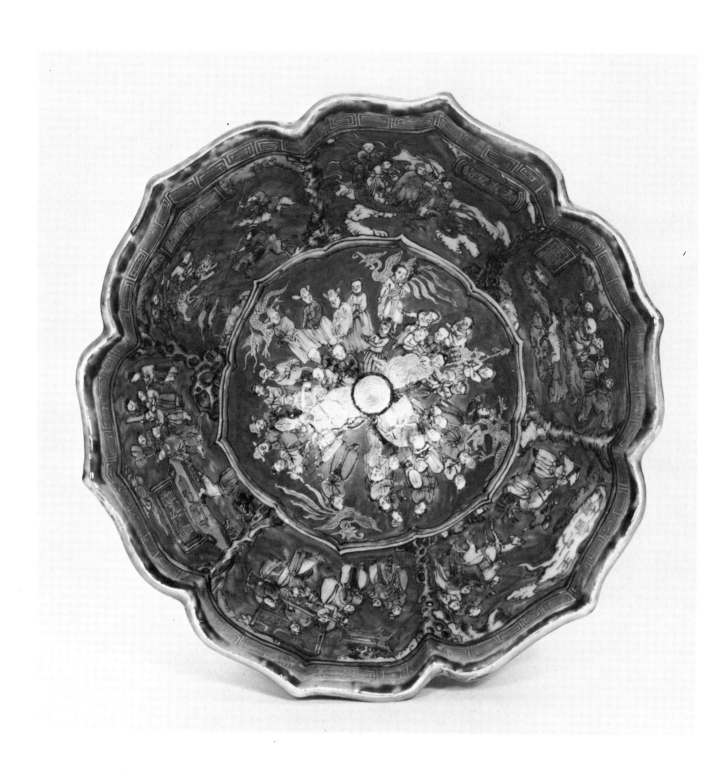

CHINESE LACQUER WARES

65
Six-Lobed Dish in Shape of Open Flower

China, Northern Sung dynasty (960–1127)
Black lacquer ware with silver rim
Diameter: 15.1 cm.

The dish is in the form of an open flower with six petals, formed by slight indentations in the rim, and radiating ridges on the side. The rim is fitted with a metal band, possibly copper. The dish is plain, with black lacquer applied directly to the wooden body. An undecipherable one-character mark in red lacquer is centered within the circular footring.

Plain dishes lacquered in black, or sometimes red, have been found in considerable numbers in Sung dynasty tombs, and reflect the period's taste for simple undecorated vessels, produced in ceramics as well as in lacquer.

Several black- and red-lacquered dishes similar to the Idemitsu piece were included in the large and definitive exhibition, "Oriental Lacquer Arts," held at the Tokyo National Museum from October 8 – November 23, 1977 (cat. nos. 423–428: see also no. 420, lobed stand for tea bowl, dated 1034 or 1097).

Published
Hakutsuru Fine Art Museum. *Masterpieces of the Idemitsu Collection.* (Kobe, 1976). pl. 82.
Idemitsu Museum of Arts. *Special Exhibition Commemorat-*

ing the Tenth Anniversary of the Idemitsu Collection. (Tokyo, 1976). pl. 70.

Reference
Idemitsu Museum of Arts. *Masterpieces of the Idemitsu Collection.* (Tokyo, 1969).

Fig. 45. Detail of underside (no. 65)

66
Square Tray with Design of Chrysanthemums and Grapevines

China, Yüan dynasty (1279–1368)
Red lacquer ware with ch'iang-chin designs
Width: 20.0 cm.

This square tray is decorated with chrysanthemums and grapevine designs in *ch'iang-chin*. In this technique, first introduced in the early Yüan dynasty, the designs were incised into the lacquer surface and then filled with gold.

The tray is decorated with a design of chrysanthemums and rocks in the central field, and the rim, both on the interior and on the underside, is decorated with a design of grapevines. The background of the principal decoration and the rim are filled with circles similarly rendered in the *ch'iang-chin* technique.

Although the *ch'iang-chin* technique goes back to the Yüan dynasty, only a few examples from this period have survived. The most notable examples of early *ch'iang-chin* lacquer are nine sutra boxes preserved in Japan. They were included in the 1977 exhibition of Oriental lacquer held at the Tokyo National Museum (*Oriental Lacquer Arts*. [Tokyo, 1977]. cat. nos. 469–477). Four of the sutra boxes preserved in Japan are inscribed "Yen-yu erh nien," a date corresponding to A.D. 1315, thus providing evidence that these sutra boxes

were produced very early in the fourteenth century.

The *ch'iang-chin* type is described in two Chinese texts, the *Cho-kêng* of 1366 and the *Ko-ku-yao-lun* of 1388. From lists preserved in Japan, we also know that pieces of *ch'iang-chin* lacquer, almost all of them furniture, were sent from China to Japan in 1406, 1407, and 1433. However, no known examples exist today.

The *ch'iang-chin* technique was employed to only limited extent in Japan, where other techniques are preferred, but it became highly popular in the Ryukyu Islands following its introduction there in the fifteenth century. Its popularity has continued there to the present day. In China, the *ch'iang-chin* technique never achieved a similar popularity and although it was still produced in the sixteenth century, it apparently never won the official approval of the court.

Published
Hakutsuru Fine Art Museum. *Masterpieces of the Idemitsu Collection.* (Kobe, 1976). pl. 83.
Idemitsu Museum of Arts. *Special Exhibition Commemorating the Tenth Anniversary of the Idemitsu Collection.* (Tokyo, 1976). pl. 71.
The Tokyo National Museum. *Ch'iang-chin, Chinkin and Zonsei.* (Tokyo, 1974). pl. 191.

Reference
Tokyo Bijutsu Club. *Chugoku no Shitsukogei.* (Tokyo, 1970).

67*

Covered Food Box Decorated with Garden Scenes and Floral Scrolls

China, Yüan-early Ming dynasties, fourteenth century
Lacquer ware with mother-of-pearl inlay
Diameter: 41.3 cm.
Important Cultural Property

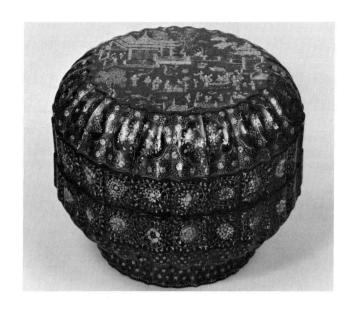

This foliate-shaped box and cover are elaborately decorated in mother-of-pearl inlay on a black lacquer ground. The sides of the box and cover are divided into twelve segments running from the top of the cover to the foot. The cover is decorated with a garden scene of pavilions and figures. The curved sides of the cover are ornamented with ogival panels filled with flowering

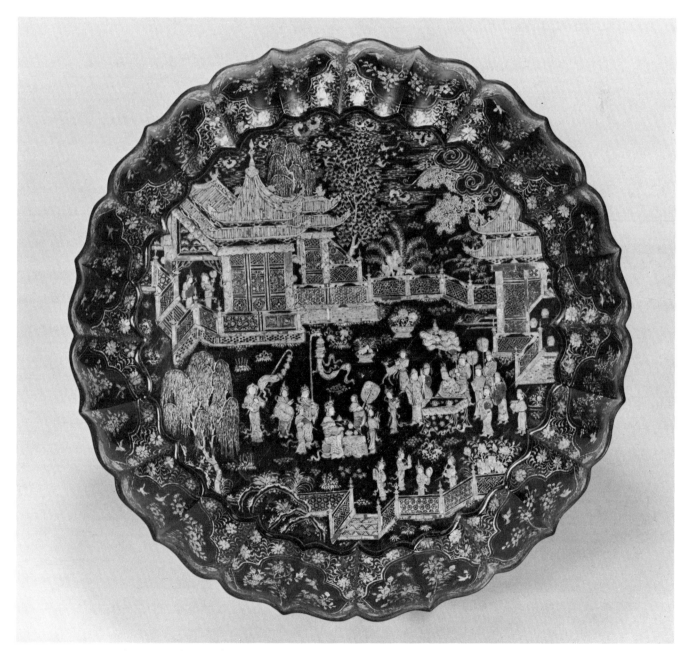

Fig. 46. View of cover (no. 67)

plants and birds. The panels are set against a background of floral scrolls. The vertical sides of the box and cover are decorated with a stylized, prominently curved floral scroll and small comma-shaped leaves, a design that suggests Korean lacquerwork of the twelfth and thirteenth centuries. Ogival panels with floral motifs are repeated on the underside of the body while a small pattern of floral scrolls above a band of small dots encircles the foot.

On top of the cover there is a six-character inscription: *Chi-shui t'ung-ming kung-fu*, indicating that the piece was made in Chi-an Fu in Chekiang Province. It is said that the piece was imported to Japan during the Muromachi period (1392–1568).

Decoration inlaid in mother-of-pearl against a lacquer ground had been popular in China since the T'ang dynasty (618–906), although the origins of this technique go back much further, to the pre-Christian era. Very little mother-of-pearl inlaid lacquer from the T'ang dynasty has survived in China, but superb examples exist in Japan, in the Shōsō-in and in various other temples, exported to Japan at the time of manufacture and carefully preserved there under ideal climatic conditions.

Most of the decoration of Yüan dynasty lacquer, with its landscape and floral motifs, is based on contemporary paintings of the Sung (960–1279) and Yüan (1280–1368) periods and represents the introduction of new motifs to the repertoire of Chinese lacquer ornament. The mother-of-pearl used in inlays were extremely thin, much thinner than their T'ang prototypes, but with a high degree of iridescence. Originally, pieces of inlay had to be selected with great care to provide the necessary variation of color; but later a new technique of tinting the undersurface of the shell was introduced, resulting in strong but subtle colors.

The technique of decorating lacquer with mother-of-pearl inlay was extremely popular and continued into the nineteenth century. Use of the technique also spread to the Ryukyu Islands, Korea and Japan.

A box and cover of similar type, its body and cover divided into twelve foliate-shaped segments and decorated with floral and figural subjects in mother-of-pearl inlay is in the Museum für Ostasiatische Kunst, Cologne, West Germany. In the catalogue of the museum, the Cologne box is given an early Ming date, second half of the fourteenth to first half of the fifteenth century. As in the case of the Idemitsu example, the Cologne box shows the use of twisted wire to give added strength to the mouth-rim and to the foliate contour of the cover and body. This, too, suggests the influence of earlier Korean lacquerwork.

Published

Hakutsuru Fine Art Museum. *Masterpieces of the Idemitsu Collection.* (Kobe, 1976). pl. 85.
Idemitsu Museum of Arts. *Special Exhibition Commemorating the Tenth Anniversary of the Idemitsu Collection.* (Tokyo, 1976). pl. 77.
Mostra D'arte Cinese. (Venice, 1954). cat. no. 748.
Okada, Jō, *A Study of the History of Far Eastern Lacquer Art.* (Tokyo, 1978). pl. 58.
The Tokyo National Museum. *Mother-of-Pearl Inlay in Chinese Lacquer Art.* (Tokyo, 1979). pl. 2.
The Tokyo National Museum. *Oriental Lacquer Arts.* (Tokyo, 1977). pls. 233, 489.

References

Low-Beer, Fritz. "Chinese Lacquer of the Early 15th Century." *Bulletin of the Museum of Far Eastern Antiquities,* vol. 22. (Stockholm, 1950). cf. pp. 145–167, pl. 25, fig. 36.
Museum für Ostasiatische Kunst der Stadt Köln, *Meisterwerke aus China, Korea und Japan.* 2nd edition. (Cologne, 1979). cf. pl. 50, p. 51.

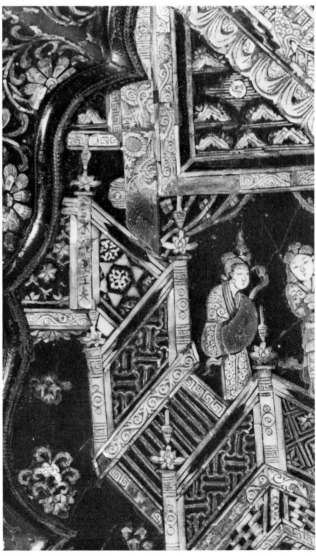

Fig. 47. Detail of cover (no. 67)

68
Dish with Design of Flowers and Birds

China, Ming dynasty, sixteenth century
Carved black lacquer ware
Diameter: 57.0 cm.

The lobed dish of black lacquer carved on a yellow ground is decorated with birds and floral designs in the center panel. The everted rim is in the form of eight lobes decorated with floral motifs in each of the panels. The ground is filled with hexagonal patterns, carved very deep, almost to the body, revealing the yellowish color and contrasting with the black lacquer surface of the dish. The reverse is decorated with a peony design. The area within the footring is plain.

Reference
Idemitsu Museum of Arts. *Oriental Art.* (Tokyo, 1978).

69
Octagonal Dish with Dragon Design

China, Ming dynasty, Wan-li period (1573–1619)
Lacquer ware with t'ien-ch'i design
Diameter: 26.2 cm.

The dish, decorated on yellowish-red ground, features a design of a five-clawed dragon chasing a pearl among clouds, and above rocks and waves. In the rim are eight ogival panels, each decorated with a floral design and a bird, or animal, such as bird or grapevine and squirrel. The underside of the dish is decorated with scrolls of flowering plants. Stylized dragon-like designs in colored lacquer inlay decorate the exterior of the footring. The base is lacquered black.

T'ien-ch'i (filled-in) lacquer, which became one of the most important types of the Imperial wares, was especially popular in the sixteenth century and was derived from the earlier *ch'iang-chin* (etched gold) technique. In *ch'iang-chin*, the designs were etched in the plain black or red ground and then filled in with gold. The *t'ien-ch'i* technique retains the use of incised gold outlines for precision of design, but in addition, plastic lacquer of different colors was inlaid to produce a polychrome design. The incised gold outlines alone are a survival from the true *ch'iang-chin* techniques, which relied solely on gold.

Ch'iang-chin lacquer and its derivative, *t'ien-ch'i* (called *zonsei* in Japanese, a term which refers to the inlaid and painted designs) were the two most important Chinese lacquer techniques relying on the use of gold outlines. The best of the *t'ien-ch'i* lacquers, represented by the Imperial wares of the Chia-ching (1522–1566), Wan-li (1573–1619), and Ch'ien-lung (1736–1795) reigns all seem distinguished by the use of lacquer half a millimeter thick and polished to a smooth, even surface. The *t'ien-ch'i* technique was greatly favored by the Ming court in the sixteenth century and nearly all the Ming pieces that have survived have either the Chia-ching or Wan-li reign mark.

Published
Idemitsu Museum of Arts. *Special Exhibition Commemorating the Tenth Anniversary of the Idemitsu Collection.* (Tokyo, 1976). pl. 74.

Reference
Garner, Sir Harry. *Chinese Lacquer.* (London, 1979). pp. 155, 179 ff.

70
Tiered Cake Box

_China, Ming dynasty, late fifteenth-early sixteenth
centuries
Carved red lacquer ware
Height: 36.5 cm._

This box, made in five sections with seven sides, is
decorated with carved designs of figures and floral
motifs. The cover is decorated with a design of figures
and pavilions in a garden setting surrounded by peony
and other floral motifs. Each of the seven sides of the
tiered box is decorated with oblong panels of groups
of figures in garden settings. Above the foot is a narrow
horizontal band decorated with peony and other floral
designs similar to the decoration encircling the cover.

A stylistically similar, but square-tiered box, is illus-
trated in _Chinese and Associated Lacquer from the
Garner Collection._ (London, 1973) cat. no. 48. The
Garner box is given a late fifteenth-century date.

Published
Hakutsuru Fine Art Museum. _Masterpieces of the Idemitsu
Collection._ (Kobe, 1976). pl. 86.
Idemitsu Museum of Arts. _Special Exhibition Commemorat-
ing the Tenth Anniversary of the Idemitsu Collection._
(Tokyo, 1976). pl. 75.

Reference
Idemitsu Museum of Arts. _Oriental Art._ (Tokyo, 1978).

Fig. 48. View of cover (no. 70)

JAPANESE LACQUER WARES

71*

Sutra Box with Butterfly Design

Japan, Muromachi period, second half of fourteenth century
Wood, lacquered with maki-e design
Length: 23.1 cm.

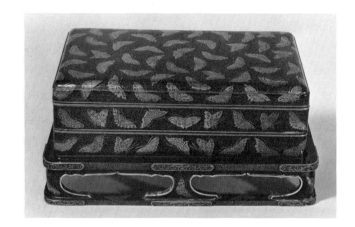

This sutra box is a superb example of *maki-e* lacquer decorated in the *togidashi* technique. In the *maki-e* style, the wooden body of the box was first covered with black lacquer on which silver dust was sprinkled to form a ground design. Later, lacquer mixed with gold dust was used to produce the overall design of butterflies on the cover and sides of the box. The design was subsequently finished in the *togidashi* technique, which required the application of several layers of black lacquer to completely cover the sprinkled decoration. Through careful polishing with charcoal, the top layers were gradually worn away until the sprinkled motifs reappeared. As a result of the overlacquering and subsequent polishing of the top layer, the final design appears in exactly the same plane as the surrounding lacquer ground. The entire surface was finished with a coat of transparent lacquer, like a protective skin, which was then polished, producing a flat, lustrous surface.

An inscription on the underside of the box indicates that it was dedicated to a temple in A.D. 1385.

Fig. 50. Inscription on underside
(no. 71)

Published
Musée du Petit Palais. *L'Art du Japon Eternel dans la Collection Idemitsu.* (Paris, 1981). pl. 119.

Reference
Idemitsu Museum of Arts. *Special Exhibition Commemorating the Tenth Anniversary of the Idemitsu Collection.* (Tokyo, 1976).

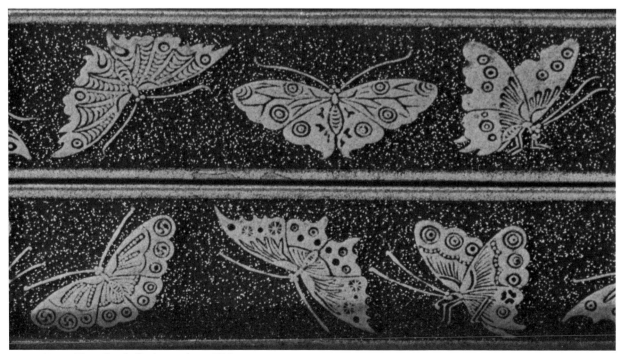

Fig. 49. Detail of design (no. 71)

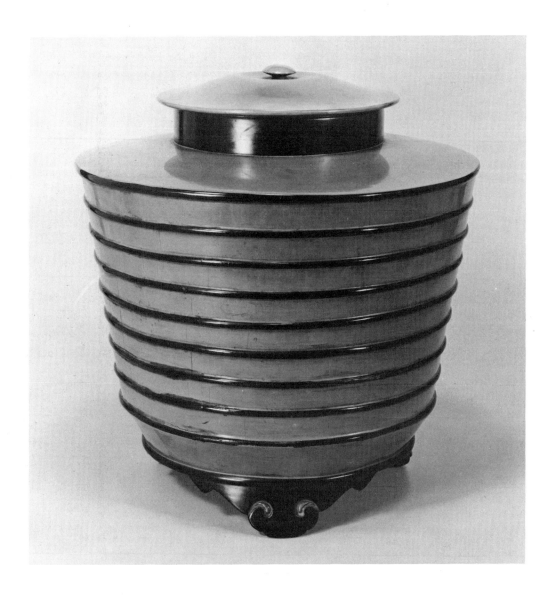

72
Medicine Container

Japan, Momoyama period, late sixteenth century
Negoro lacquer ware
Height: 31.0 cm.

The container, made to hold medicine, is of unusual shape with ten hoops encircling the body. The vessel has a dome-shaped cover and is supported on three *ju-i* shaped legs. The cover and body are lacquered in red; the neck, hoops, and legs in black.

The type of lacquerwork distinguishing this piece is called *negoro-nuri*, a term derived from the lacquer objects produced for daily use by the priests at Negoro-ji, a temple in Wakayama where the technique originated toward the end of the Kamakura period (the last decades of the thirteenth century). *Negoro* lacquer, however, did not really attain a place of prominence until the Muromachi period.

The term *negoro-nuri* became a generic term referring specifically to a group of undecorated lacquer wares distinguished by their red lacquer coating applied over a layer of black lacquer. In places where the red lacquer has been worn away by long use, irregular areas of the underlying black lacquer would be revealed, producing rich and very beautiful effects.

Negoro lacquer also includes objects in which red lacquer is used in direct combination with black lacquer, not as an undercoating, but as a second color, as in the Idemitsu piece. Yet another variant of *negoro-nuri* includes objects in which the red lacquer is used in combination with transparent lacquer on a natural wood base. The term, therefore, was used rather loosely. It is also imprecise from the point of view of dating, for it applies equally to lacquer objects produced prior to 1288, when the Negoro temple was founded, and objects produced after the destruction of the temple in 1585.

The container is similar in shape to a *negoro* lacquer pitcher in the Freer Gallery of Art, Washington, D.C., except for the addition of a handle and spout. The Freer piece also dates from the Momoyama period.

References
The Freer Gallery of Art. *The Freer Gallery of Art: II Japan.* (Tokyo, n.d.). pl. 110.
Idemitsu Museum of Arts. *Masterpieces of the Idemitsu Collection.* (Tokyo, 1969).
Von Ragué, Beatrix. *A History of Japanese Lacquerwork.* Translated by Annie R. de Wasserman. (Toronto and Buffalo, 1976). pp. 84–85.

73*

Suzuribako (writing box) with Deer Design

Honami Kōetsu (1558–1637)
Japan, early Edo period, first half of
seventeenth century
Black lacquer ware with designs in gold lacquer,
silver, and lead
Length: 24.0 cm.

The writing box and cover have a ground of black lacquer. The cover is decorated with autumnal grasses painted in gold lacquer with a deer in lead inlay standing on a silver inlaid ground. The box itself, with ink stone and water container on the left side, is decorated with a design of flowing waves in gold lacquer, a design repeated on the inside of the cover. The representation of the deer in a setting of autumnal grasses may be an allusion to the sacred deer of the Kasuga shrine in Nara.

Kōetsu was one of the most gifted and versatile artists of the Momoyama and early Edo periods. He was a member of the Honami family, long known as authorities on swords. Kōetsu was known as a man of great artistic talent, famous not only as a calligrapher, but also as a creative genius in lacquerwork and ceramics.

In 1615, he received a gift of land from the Tokugawa Shogun, Ieyasu, at the village of Takagamine, near Kyoto, where he gathered around him a large following of artists and artisans. He thus had a profound influence upon the art of the period, although it is possible that he perhaps never actually made a single piece of lacquer. However, Kōetsu's ideas and concepts dominated the production of lacquerwork, both in the design and in the materials used.

Kōetsu introduced a new arrangement for the interior of writing boxes. Up to this time, the ink stone had usually been in the center, with small brush trays on either side. However, as illustrated by the Idemitsu box, Kōetsu moved the ink stone and water container to the left half, leaving the right half free for the brushes. As the box was placed to the right of the paper during writing, the new arrangement shortened the distance between the brush and ink, and the paper. This more practical approach reflects the new functionalism that characterizes many of the products of the seventeenth century, including the present box.

Kōetsu's style and concepts often influenced the lacquerwork of Ogata Kōrin (1658–1716), famous painter and lacquer artist active in Kyoto in the middle Edo period. Kōrin, born into a family of wealthy Kyoto silk merchants, was related to Kōetsu. His grandfather Sōhaku had lived for a time in Takagamine, and his father, the wealthy owner of the Karigane-ya silk shop in Kyoto, was a well known calligrapher in the manner of Kōetsu. It is therefore no surprise that Kōetsu influenced the work of Kōrin. A writing box by Kōrin in the Seikado Collection, Tokyo, is similar to the Idemitsu box in the division of the interior, which follows Kōetsu's basic concept, and in the use of gold lacquer waves and lead inlay rocks. However, the earlier Idemitsu box features a more pictorial, less abstract design, generally characteristic of the earlier work associated with Kōetsu.

Published
Musée du Petit Palais. *L'Art du Japon Eternel dans la Collection Idemitsu.* (Paris, 1981). pl. 128.

References
Idemitsu Museum of Arts. *Oriental Art.* (Tokyo, 1978).
Von Ragué, Beatrix. *A History of Japanese Lacquerwork.* Translated by Annie R. de Wasserman. (Toronto and Buffalo, 1976). p. 203, pl. 163.

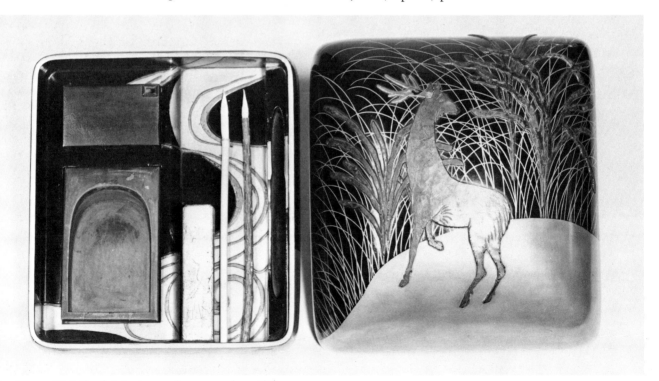

Fig. 51. Detail of interior and cover (no. 73)

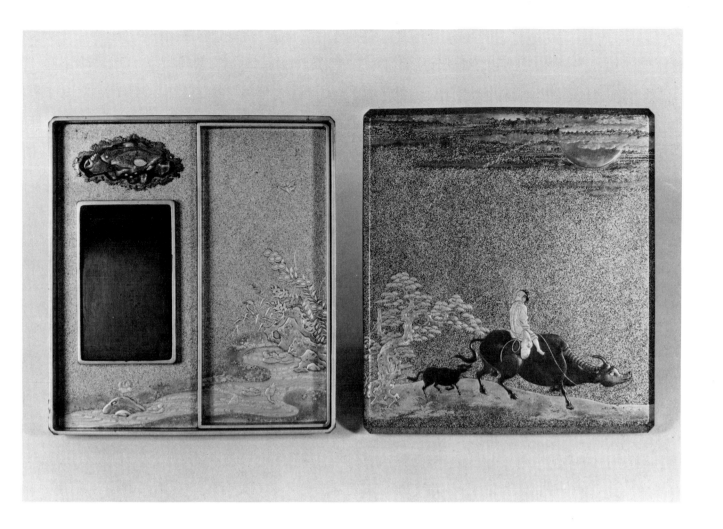

74

Suzuribako (writing box) with Design of Buffalo and Herdsboy

Japan, Edo period (1615–1868)
Wood, lacquered with maki-e design
Length: 23.5 cm.

The box is elaborately decorated in *maki-e* as a ground decoration, with silver inlay for the moon, and additional sprinkling of *okihirame* (large gold and silver flakes) for the ground, sky, and clouds. The pine tree, wild duck, herdsboy, and ox were painted in gold lacquer.

The inside of the cover and box depict a scene of *hikibune* (towing boat) on the river Yodo, in Osaka, with *maki-e* as ground decoration in combination with various other techniques, including mother-of-pearl inlay for the Chinese bellflowers, red lacquer for the maples, and gold lacquer for the chrysanthemums, kingfisher, and mandarin duck.

The representation of ox and herdsboy is probably a reference to one of "The Ten Ox-herding Songs," a famous series of Zen (Chinese: Ch'an) parables that recounted the various stages of understanding. The scene depicted here corresponds to the sixth ox-herding song, "Returning Home on the Back of the Ox."

In its original form in China, Ch'an Buddhism did

not regard enlightenment as the ultimate result of a gradual process. Rather, enlightenment was viewed as a sudden manifestation not preceeded by preliminary stages. According to Sung accounts, the T'ang masters attained enlightenment practically without any guidance. In later times, however, with the study of *koans* (paradoxes presented in anecdotal or aphoristic form by Ch'an and Zen masters to their disciples) there gradually evolved the belief that there are progressive stages in a person's ability to grasp the Ch'an truth, as well as definite degrees in the attainment of enlightenment.

To instruct their followers, the Ch'an masters relied on parables, symbols, and recorded acts of faith. One way to help in the process of "seeing into one's own nature" was to study the famous parable known as "The Ten Ox-herding Songs," symbolic of the ten separate stages of understanding.

There existed in China several sets of illustrations of "The Ten Ox-herding Songs" but only two became highly popular. One was the version of P'u-ming (c. 1050), which was most popular in China and continued to be reprinted for many centuries after his death. The other was the version written and illustrated by Kuo-an (Japanese: Kaku-an), dating from about 1150, which attained great popularity in Japan. The woodblock prints illustrating the books in which the songs were initially printed came to inspire artists in many media, as illustrated by the Idemitsu box (cf. Fontein and Hickman. *Zen Painting and Calligraphy*. [Boston,

1970]. pl. 114, fig. 6). Japanese monks brought back copies of Kuo-an's book, which was reproduced in many different editions.

In the lacquer techniques of the Heian period, and up to the end of the twelfth century, the gold used was not gold dust, but the so-called *yasuri-fun* (fine gold and silver filings). As a result of the irregular sizes and shapes of the filings, the outlines of Heian lacquer were sharp and clear, but always somewhat blurred when examined under a magnifying glass.

The technique was modified toward the end of the Kamakura period (1185–1333), when finer and more uniformly graded gold dust known as *hirame-fun* (flat-eye dust) was produced. From the Kamakura period onward, this *hirame-fun* was used. Eventually, as irregularities in the shape of the gold dust were further reduced, it came to be known as *nashiji-fun* (pear-skin powder).

References

Fontein, Jan and Hickman, Money L. *Zen Painting and Calligraphy.* (Boston, 1970). pp. 113–118.
Idemitsu Museum of Arts. *Special Exhibition Commemorating the Tenth Anniversary of the Idemitsu Collection.* (Tokyo, 1976).
Von Ragué, Beatrix. *A History of Japanese Lacquerwork.* Translated by Annie R. de Wasserman. (Toronto and Buffalo, 1976). p. 62.

75

Octagonal *Suzuribako* (writing box) with Design of Boats and Figures

Japan, Edo period (1615–1868)
Lacquer ware with mother-of-pearl inlay
Diameter: 24.0 cm.

The scene on the exterior of the cover—two boats and figures on a ground of waves—depicts the three deities of the Sumiyoshi shrine near Osaka, who supposedly helped the Empress Jingū on her Korean expedition in A.D. 200.

Jingū Kōgō, the Empress Jingū, was the consort of the Emperor Chuai who died while suppressing an insurrection in Kyushu. It was reported that the Koreans were the instigators of this revolt and the Empress Jingu therefore led an expedition to Korea which eventually is said to have resulted in the conquest of the kingdom of Shiragi. The son of Jingū Kōgō was later described as Hachiman, the God of War.

The inside of the cover shows the Sumiyoshi shrine itself, built by imperial order to enshrine the three deities and the Empress. The god Sumiyoshi, to whom the shrine was dedicated, was regarded as the patron saint of *waka* (Japanese indigenous thirty-six syllable poem). The three characters for Sumiyoshi (住吉 の), written in *Ashide* (reed writing) are embodied in the depiction of the shrine precinct and in a *waka*

dedicated to the shrine. The box itself is decorated with pine and bamboo surrounding the ink stone.

The design on the cover of the box corresponds to the theme depicted on a painted screen by Ogata Kōrin (1658–1716), in a private collection in Tokyo. The screen was included in the exhibition, "Exquisite Visions: Rimpa Paintings from Japan," shown at the Honolulu Academy of Arts and at Japan House Gallery, New York, during 1980–1981. The screen depicts the poet, Haku Rakuten (Chinese: Pai Chu-i), of the T'ang dynasty (618–906) crossing the sea to Japan and meeting a solitary fisherman. The theme, which was greatly favored by Kōrin and which is the subject of another screen in the Nezu Art Museum, depicts the storm-tossed boat of the poet in a sea of churning waves off the coast of Japan, as it comes across the boat of the fisherman. The composition is quite close to that on the lid of the lacquer box. According to the story, the poet is none other than Sumiyoshi Myōjin, the God of *waka* and, as the poet and the fisherman met, each composed a poem.

References

Honolulu Academy of Arts. *Exquisite Visions: Rimpa Paintings from Japan.* (Honolulu, 1980). cf. p. 81, cat. no 17, p. 94.
Meech-Pekarik, Julia. "Disguised Scripts and Hidden Poems in an Illustrated Heian Sutra: Ashide and Uta-e in the Heike Nōgyō." *Archives of Asian Art,* vol 31. (New York, 1977–1978). pp. 53–78.

76
Cabinet for *Inrō* (medicine containers)

Japan, Edo period, late seventeenth-early eighteenth centuries
Wood, lacquered with maki-e design and colored lacquer
Height: 28.0 cm.

The ground of this cabinet is decorated with gold *maki-e*, and the reserve panels with a design of wild ducks and reeds, in colored lacquer. It has the signature and seal of the artist, Yamamoto Kagemasa, who died in 1707. There are five drawers containing a total of twenty *inrō* (medicine containers)

The origin of *inrō*, small multi-cased medicine containers worn by men on their girdles, goes back to the Momoyama period, but none can with certainty be ascribed to this period, although *inrō* appear in Momoyama paintings. The best *inrō* were produced in the eighteenth and early nineteenth centuries.

Reference

Idemitsu Museum of Arts. *Special Exhibition Commemorating the Tenth Anniversary of the Idemitsu Collection.* (Tokyo, 1976). cf. pl. 209.

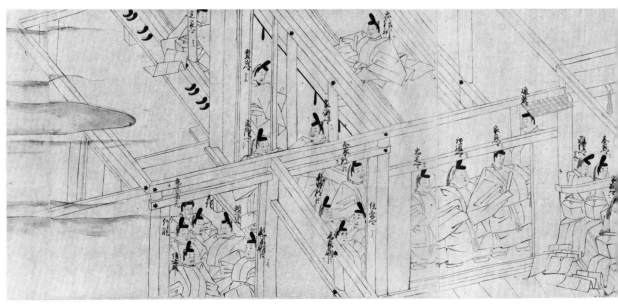

JAPANESE PAINTINGS

77
A Poetry Party at the Imperial Court

Artist unknown
Japan, Muromachi period (1392–1568)
Handscroll
Ink on paper
33.8 × 369.3 cm.
Important Art Object

In Japanese painting, the handscroll format is of very ancient origin. Buddhist sutra scrolls dating from the eighth century still exist, and in terms of secular painting, the handscroll, along with screens and fans, was the primary format for many centuries. The most famous example of handscroll painting, perhaps, was the set of scrolls painted in the early twelfth century depicting the *Genji Monogatari* (The Tale of Genji) written by Murasaki Shikibu (978–1016). These scrolls, in only

fragmentary form today, were produced in the usual format for the narrative scroll in which text and illustrations alternate.

The painting style followed in these scrolls set a standard for depicting court life and is termed *Yamato-e* (Japanese painting). This is distinguished from *Kara-e* (Chinese style paintings) which were popular in the Heian (794–1185) and Kamakura (1185–1333) periods. The *Yamato-e* developed characteristic expressive forms, such as the bird's eye view in which the roof of a building has been removed to reveal the interior where the narrative action is set. Another special characteristic is the description of facial features in a manner termed *hiki-me kagi-bana*. This term refers to the abbreviated forms for eye and nose in which little more than a single stroke for the eye and a hooked line for a nose are used. This was the typical convention for representing the nobility, and the *Yamato-e* style was used not only to illustrate court literature but to depict the annual rites or entertainments of the court, or events in the

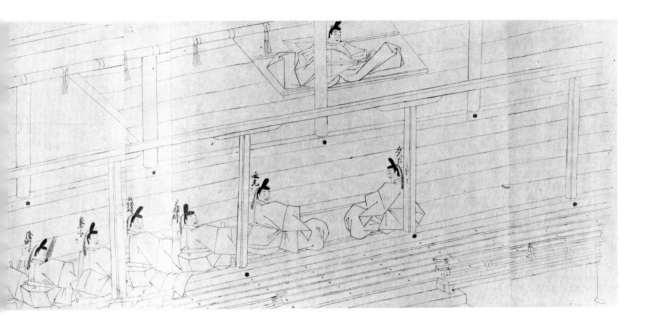

lives of courtiers.

The *Genji Monogatari* scrolls established standards for subsequent artists. Later versions of the *Genji Monogatari* and the *Makura no Sōshi* (Pillow Book) by Sei Shōnagon (tenth century), and scrolls of the diary, *Murasaki Shikibu Nikki*, by the author of the *Genji Monogatari*, were all painted in this *Yamato-e* style established through the original *Genji* scrolls of the Heian period.

During the Kamakura period (1185–1333) the rise of the military class brought an interest in portraiture. The Heian period aristocrats, whose positions were secured by hereditary privilege, felt no urge to develop a realistic portraiture in the sense of contemporary Chinese painting, or in any Western sense. In the Kamakura period, however, the newly powerful military felt a desire not only to record their accomplishments, but to preserve their own likenesses. The newly arrived Zen Buddhism was greatly in favor with the military, and the tradition of painting portraits of the Zen Buddhist

masters was only the latest evidence of a long-held interest in realistic portraiture in China.

This painting in the Idemitsu collection, by an anonymous fifteenth-century artist is after an original attributed to the Kamakura period artist, Fujiwara Nobuzane (born before 1185, died after 1265). Nobuzane with his father, Fujiwara Takanobu, both courtiers and recognized poets, established a new style of realistic portraiture, or *nise-e*. Among the paintings traditionally attributed to Nobuzane are portraits of the emperor Gotoba (reigned 1183–1198), scrolls depicting the history of the Kitano Shrine (*Kitano Tenjin Engi*), and *Chūden Gyokai Zukan* (Portrait of the Emperor and Courtiers Gathered in the Imperial Palace) of which the Idemitsu painting is a copy.

This painting interestingly combines earlier traditions with the newly emerging taste of the Kamakura period. The aristocratic Heian courtliness is preserved in the elaborate court robes and the nobles gathered in the company of the emperor at the aristocratic pastime of

composing poetry and playing music in the palace. The roof has been removed for more intimate observation in the *Yamato-e* style. Rather than the typical *Yamato-e* style *hiki-me kagi-bana* faces, however, there is clear individualization. Each man's name appears beside him, so that there would be no mistake in recognizing who was being recorded for posterity. The uniformity of the court robes, presented like the rest of the scene only in ink outline without color, heightens interest in the faces and gives importance to them.

This type of line depiction without color, or with only touches of color at the cheeks or lips, was in use in the Heian period but became popular during the Kamakura period and later. The style is termed *haku-byō* or *shira-e* which literally means 'white painting.'

There is an inscription at the end of the scroll that includes a reference to the Meiō era (1492–1500) of the Muromachi period which gives a late fifteenth-century date for this scroll. The inscription is followed by *waka* poems contributed by the emperor and each of the courtiers present at the original poetry gathering here depicted.

Published

Musée du Petit Palais. *L'Art du Japon Eternel dans la Collection Idemitsu.* (Paris, 1981). pl. 9.

References

Ienaga Saburō. *Painting in the Yamato Style.* (New York and Tokyo, 1973). p. 104 ff.

Okudaira, Hideo. *Narrative Picture Scrolls.* (New York and Tokyo, 1973). p.45 ff.

The Tokyo National Museum. *Emaki Special Exhibition.* (Tokyo, 1974). pp. 8, 9.

78

Kannon, Goddess of Mercy

Sōen Osei (active 1340–1375)
Japan, Nanbokucho period (1333–1392)
Hanging scroll
Ink on paper
97.2 × 32.5 cm.

One of the popular painting subjects in the pantheon of Buddhist deities is the figure of Kannon, the embodiment of benevolence. (The name is Kuan-yin in Chinese and Avalokitesvara in Sanskrit). Early interpretations of this Bodhisattva in China during the T'ang dynasty placed him in his habitat of Mount Potalaka on an island near Ningpo, off the Chinese coast. The Bodhisattva depicted in the Mount Potalaka landscape setting of water, rocks, and bamboo, later became the prototype of different aspects of Kannon, such as the *Takimi Kannon* (Waterfall-contemplating Kannon), *Yōryū Kannon* (Willow Kannon) and, as in this paintings, the *Byaku-e Kannon* (White-robed Kannon).

As a result of close ties between Japanese Zen priests and China, especially between the twelfth and fourteenth centuries, numerous Kannon paintings entered Japan.

By the fourteenth century, Japanese Zen priest-painters journeyed to Yüan dynasty China, and the Kannon figure was one of the favorite subjects. One artist known to have traveled to China in the 1340s was Sōen Osei. (The name can also be read Shūon Osei). There is a great lack of information concerning this priest's life; however, he is often mentioned in connection with the more renowned priest-painter Mokuan Rei-an. Mokuan made a pilgrimage to China around 1326 or 1328 and is thought to have died there around 1345. Subsequently, many of Mokuan's paintings reached temples in Japan. Mokuan is considered one of the earliest Japanese ink, or *suiboku*, Zen painters. He specialized particularly in the Kannon theme. It is recorded that Osei traveled in China from the 1340s to the early 1350s where he possibly came into contact with Mokuan, since both were known to have been associated with the Chinese priest, Ch'ing-yu Liao-an (Japanese: Seiyoku Ryō-an) who inscribed the Idemitsu painting on the upper left while Osei was visiting him. Ch'ing-yu Liao-an's seals appear in the upper left, and seals of the artist and of collectors appear in the lower left.

Kannon paintings such as this reflect contemporary ink paintings of Yüan dynasty China. The simply drawn figure shows the brush of a well-trained and skillful master of figure painting. Yet, the surrounding landscape setting would hardly be considered mature in comparison. The artist was apparently struggling to master the techniques of landscape design and, at the same time, to combine figure and landscape into a harmonious composition. His lack of strict control, reflected in a tightness and in somewhat monotonous brush strokes on rock and cliff, suggests his struggle toward a mature artistic style. Scholars now question whether some of Osei's work might be confused with Mokuan's. Future research, through inscriptions such as the one by Ch'ing-yu Liao-an on the Idemitsu painting, will perhaps lead to new criteria to help separate Osei's works from those of other priest-painters.

Published

Musée du Petit Palais. *L'Art du Japon Eternel dans la Collection Idemitsu.* (Paris, 1981). pl. 7.

References

Ebine, Toshio. "Sōen Ōsei hitsu Byaku-e Kannon zu." *Kobijutsu,* Vol. 53. (Tokyo, 1977). pp. 89–96, pl. p. 91.

Kanazawa, Hiroshi. *Japanese Ink Painting: Early Zen Masterpieces.* Translated by Barbara Ford. (Tokyo, 1979).

Shimizu, Yoshiaki and Wheelwright, Carolyn. *Japanese Ink Paintings.* (Princeton, 1976).

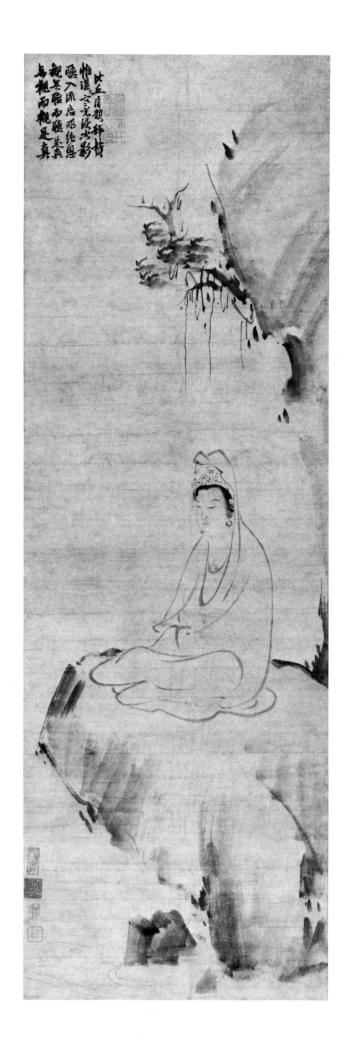

79

Landscape

Shūbun (active 1414–1463)
Japan, Muromachi period (1392–1568)
Hanging scroll
Ink and light color on paper
90.4 × 35.1 cm.
Important Art Object

By the end of the fourteenth century, the center of Zen religious thought began to shift from Kamakura to Kyoto. Many of the disciples of the noted Zen master, Musō Soseki (1275–1351) assumed important positions at significant Kyoto temples. The Sōkoku Temple, one of the *Gozan* (Five Great Temples) was established in 1382 with the aid of Yoshimitsu, the third Ashikaga shogun. During the late fourteenth century, when ink painting was flourishing, three noted priest-painters were affiliated with the Sōkoku monastery: Josetsu, Shūbun, and Sesshū.

Furthermore, this period witnessed both the decline of the old established *Edokoro*, the Bureau of Painting at the Imperial Court, and the formation of a new art academy under the auspices of the Ashikaga shoguns. This development marked a change in emphasis from a focus on religious art among the monasteries, which had continued since the Heian period (794–1185), and provided new artistic avenues for the rise of *suiboku-ga* (ink painting).

Similar to his teacher, Josetsu, Shūbun must have also been affiliated with this Muromachi academy because of his association with the high-ranking Sōkoku monastery, which enjoyed shogunal patronage. Muromachi temples such as Sōkoku were large monastic centers. This atmosphere of continued activity was sometimes distracting, if not stifling, for the priest-painters. As a result, in an attempt to escape this temporal activity, many paintings done by the priests of this period were *shosai-zu*, or studies viewing arcadian landscapes clearly isolated from the bustling world of real life. *Shosai-zu* were paintings of a mental attitude, an expression of an ideal landscape that was not to be hindered by the literal description of non-ideal realities. Almost certainly, the Idemitsu painting served as a *shosai-zu*.

Details of Shūbun's life are obscure, but it is known that he visited Korea from 1423 to 1424 where he became familiar with the Korean schools of painting. Shūbun was employed at the Sōkoku temple as a *Tokan* (head of the executive office). At the temple, Shūbun acted as an *ebusshi* (professional Buddhist painter). He also accepted outside commissions. There is conflicting information concerning his painting style but presumably his experiences in Korea as well as his training at the monastery influenced his development. There are few works that scholars have universally agreed upon as authentic works by Shūbun. It seems that Shūbun was adept at a diversity of artistic styles, and this painting, like a score of others, is merely attributed to his brush. Because there is no signature and, more importantly, no inscription on this piece, the attribution is further complicated. It is not known whether this painting originally had an inscription, for it was common for later Edo-period collectors to trim such paintings to adapt them for use in the *tokonoma* (alcove for the display of valued objects).

Like many of the landscapes attributed to Shūbun, this painting is arranged on a vertical axis. Such vertical landscape compositions were based on the thirteenth- and fourteenth-century paintings of the Chinese Imperial Academy. Japanese painters of this period were particularly influenced by the artists of the Southern Sung Academy, Hsia Kuei (c. 1180–1230), Ma Yüan (c. 1190–1224), and their Yüan dynasty follower, Sun Chün-tsê (c. 1300). By the fifteenth century, evidence of the Ma-Hsia academic style became apparent in the works of Japanese artists. Characteristic elements such as clusters of foreground trees and rocks, pinnacled mountains, distant lakes, and pavilions recall the traditions of Sung academic painting.

Brushwork derived from the Ma-Hsia school, as seen in the 'axe-cut' strokes, is distinguishable on the rocks in the foreground of this and other Shūbun paintings. Perhaps the special flavor in Shūbun's style is partially the result of influences not only from Chinese but from Korean adaptations of Chinese painting. Shūbun successfully assimilated these traits to create a distinctly Japanese style of painting.

Published
Musée du Petit Palais. *L'Art du Japon Eternel dans la Collection Idemitsu.* (Paris, 1981). pl. 16.

References
Akiyama, Terukazu. *Japanese Painting.* (Lausanne, 1961).
Satō, Miyako. *Nihon Meigakaden.* (Tokyo, 1967).
Shimizu, Yoshiaki and Wheelwright, Carolyn. *Japanese Ink Paintings.* (Princeton, 1976).
Tanaka, Ichimatsu. *Japanese Ink Painting: Shūbun to Sesshū.* Translated by Bruce Darling. (New York and Tokyo, 1972).
Vollmer, John and Webb, Glenn T. *Japanese Art at the Art Gallery of Greater Victoria.* (Victoria, 1972).

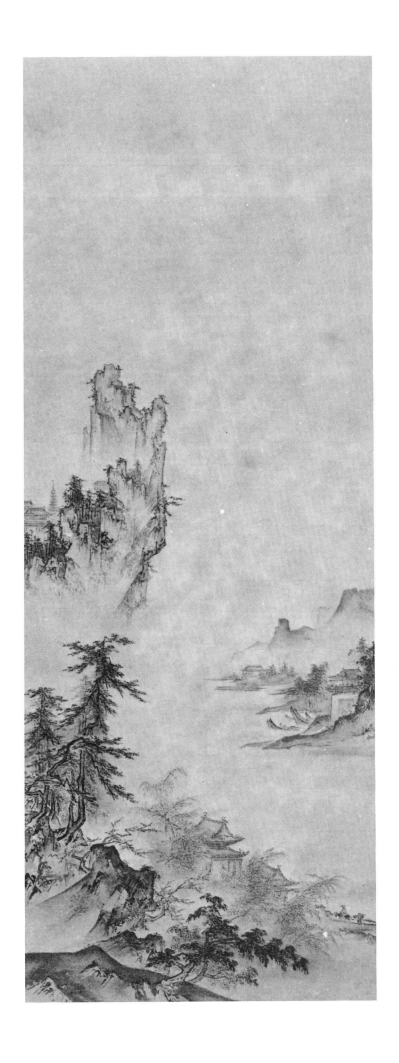

80*
Flowers and Birds of the Four Seasons

Sesshū Tōyō (1420–1506)
Japan, Muromachi period (1392–1568)
Six-panel screen
Ink and light color on paper
158.8 × 348.7 cm.

Sesshū Tōyō was the third of the three great priest-painters affiliated with the Sōkoku monastery during the fourteenth century (see no. 79). Sesshū was born in the rural Inland Sea village of Akahama in Bitchū Province (modern Okayama Prefecture). At age eleven he entered a Zen temple near his native home. Later, he moved to the Sōkoku monastery in Kyoto where he is thought to have practiced Zen under the priest Shunrin Shūto, and where he became a student of the master priest-painter Shūbun. During this period he also attained the important rank of *Shika* a 'Chief of Protocol'. It seems that after the deaths of Josetsu and Shūbun, Sesshū left the monastery and around 1465 established a painting studio called Unkoku-an in Suwo (or Suo) Province (modern Yamaguchi Prefecture) where he enjoyed the patronage of the Ouchi family, the local feudal lords. In 1467, the Ouchi family dispatched a trading expedition to China and Sesshū was invited to accompany the group.

During the sojourn in China, Sesshū pursued both his religious and artistic training; he underwent further training at T'ien-tung, one of the Five Great Temples of China, and traveled extensively throughout the country making sketches from the landscape, and eventually even reached Peking. This journey enabled him to go directly to the source of Chinese art, as opposed to many of his Japanese contemporaries, who made paintings only from imported models.

After his return to Japan in 1469, he continued his study of Sung and Yüan dynasty painting models, and he established another painting studio called the Tenkai Toga-ro or Heaven-created Painting Pavilion's in Bungo Province (modern Oita Prefecture). Later, in the 1470s, he returned to the Yamaguchi area. After a life of wandering and traveling through both Japan and China, Sesshū died at the age of 85.

As an artist, Sesshū's uniqueness lay in his ability to synthesize the art of Sung and Yüan models, filtered through the Japanese heritage from his teachers Josetsu and Shūbun, and through elements drawn from his own experiences. The result is a style that broke the strict bonds of Chinese ink paintings which had been the standard followed by Zen priest-painters and which became thoroughly Japanized in mood. His work represents a transition from the purely religious subject matter of this earlier painting to an essentially aesthetic format such as this *kachō-ga* (flower-and-bird) screen. Depicted are pine and bamboo and other traditional elements such as the chrysanthemum, crane, and stylized wave patterns. As is evident from the elements of this screen, Sesshū

has looked to Chinese sources such as the gnarled pine and rocks in the manner of the Ma-Hsia school (cf. no. 79). However, Sesshū's works differ from his Chinese antecedents in that he has destroyed any illusion of deep space by pulling the compositional elements to the picture surface, thereby creating a more purely two-dimensional composition. This format heralded the later decorative style perfected by the Kanō school of painting. Already present in this painting can be seen such Kanō school characteristics as the patterns of the bamboo, in particular, and the emphatic horizontal movement of line describing the pine branches and tree trunk. The strength and vigor of brushwork with which he executed this piece and the brilliance in handling the ink distinguishes Sesshū as one of the finest Muromachi *suiboku-ga* painters.

This screen is signed by Sesshū in the upper right. During the Muromachi period, the practice of signing a work was still rare; Sesshū was one of the first artists to do it. This act again signals the movement toward artistic independence, as painting evolved from purely religious to more purely secular aesthetic forms, and as the artist gradually came to be recognized as an individual in his own right.

Published
Tanaka, Ichimatsu and Yonezawa, Yoshiho. "Sesshū no Kachō ga." *Kokka* 970. (Tokyo, 1974). p. 27, pl. 10.

References
Shimizu, Yoshiaki and Wheelwright, Carolyn. *Japanese Ink*

Paintings. (Princeton, 1976).

Tanaka, Ichimatsu. *Japanese Ink Painting: Shūbun to Sesshū.* Translated by Bruce Darling. (New York and Tokyo, 1972).

Fig. 52. Signature
(no. 80)

81
Namban Byōbu

Artist unknown
Japan, Momoyama period (1568–1615)
Pair of two-panel screens
Ink and color on paper
168.0 × 180.0 cm. each

Namban is the Japanese name coined in the late Muromachi period (1392–1568) to denote the Portuguese and Spanish traders, and Catholic missionaries living in Japan. The Portuguese, the first Europeans to reach Japan, and later the Spanish, arrived from the south, a region considered inhabited by barbarian types; thus, they were dubbed *Namban* (Southern Barbarians).

The Portuguese had established a colony at Goa in India in 1510 and by 1543 a group had landed at Tanegashima, a tiny island off the southern coast of Japan. Portuguese ships began making visits to ports in Kyushu, the southern main island, within a year following this visit.

Catholic missionaries customarily followed closely on the heals of the traders, and by 1549 Saint Francis Xavier had landed at Kagoshima on Kyushu where he began his efforts to bring Christianity to Japan. He traveled as far as Kyoto, where he hoped to have an interview with the emperor. He failed, and finally returned to Kyushu; he was later permitted to establish a church in the fief of the powerful Ouchi family in western Honshu.

Many daimyo felt favorably inclined to the missionaries, partly in respect for their religious discipline and strength of character, and partly because they hoped the presence of the priests would attract the foreign merchants and commercial gain. Within a few years of the initial contact, several hundred Japanese had converted to Christianity. Most of them were in Kyushu and western Honshu, and many were of the samurai class.

Aside from a curiosity about the new religion, the physical appearance of the foreigners proved an irresistable source of interest to the Japanese. There was a veritable craze for foreign things, and new words entered the language. Men of fashion might wear capes or ballooning trousers or wide brimmed hats in emulation of tall, dark-skinned foreigners. In the Japanese language, the word for bread, "pan," from the Portuguese "pao" remains as a testimony to the foreign contact.

These screens belong to a type of genre painting developed in the Momoyama period, which recorded the activities of these foreign visitors. Some paintings, like this pair of screens, were painted on paper in the traditional Japanese ink and pigments. Artists, however, also studied European techniques with the priests, or adapted traditional methods to the new styles. Among the themes they painted were elaborate landscape scenes of Europeans in their homeland, and folding screens with maps of Japan, or even the world. Religious paintings and engravings copying European originals were other very distinct types. Paintings recording secular activities have survived in some number, but religious paintings were largely destroyed in the early seventeenth century when the Edo period shogun, Tokugawa Ieyasu, began a policy of anti-Christian persecution.

The Idemitsu collection's two-panel screens are unusual in format and theme. The known screens are usually pairs of the six-panel type. The theme, in particular, is unusual in that it focuses on a group of foreigners making purchases from Japanese shopkeepers; in general, little direct interaction between foreigners and the Japanese appears in this type of painting. More often the artist views his subjects with strict detachment, recording the foreigners in their activities and pastimes as a group apart from the local populace. In the Idemitsu screens, a trader perched at a shopfront engages the shopkeeper in a discussion regarding some possible purchase; others stand about observing; in the foreground stands a man with rolls of cloth under his arm; at the left, a well-dressed Japanese, perhaps an interpreter, stands with a foreigner, and at the right, three more foreigners appear—one probably a black-robed priest. A bearer loaded with a pack moves out of the picture, and another waits to add new purchases to his load.

In the other screen, a gentleman gingerly examines a teapot, while a shopkeeper gestures at something at the rear of the shop. Other gentlemen look on, their long noses and mustaches clearly identifying them as foreign types. A mother and child peek out from behind a curtained doorway, eager to catch a glimpse of these curious creatures. At the left, a Japanese gentleman is shown wearing a pair of foreign-style trousers.

The artists who provided these views of the visitors from across the seas, or created the religious paintings, or painted portraits were, with few exceptions, commercial artists. The flavor of the Kanō school is, however, often present in *Namban* painting, and perhaps the prototypes after which commercial painters created their own versions were provided by artists of the stature of Kanō Eitoku (1543–1590), Kanō Sanraku (1559–1635), or their close followers.

The patrons commissioning these works were the wealthy daimyo and samurai who wanted to have a sample of this exotic experience. There was, however, a growing awareness and interest in genre painting among the emerging merchant classes, and it was their support of this anonymous genre painting that provided an impetus for the development of the art which culminated in the ukiyo-e traditions of the Momoyama and Edo periods.

Published
Sakamoto, Mitsuru. *Fzōkuga—Namban Fūzoku.* Nihon Byōbu-e Shūsei, Vol. 15. (Tokyo, 1979), p. 86.

References
Cooper, Michael, S.J. et al. *The Southern Barbarian.* (Tokyo, 1971).
Okamoto, Yoshitomo. *The Namban Art of Japan.* (New York and Tokyo, 1972).

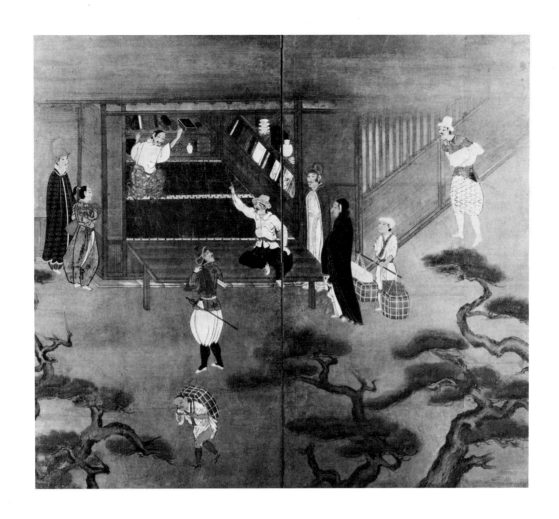

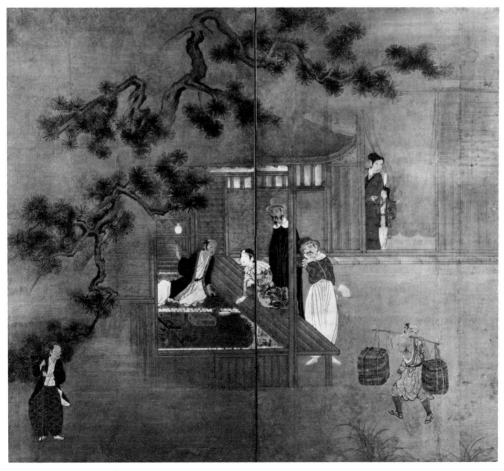

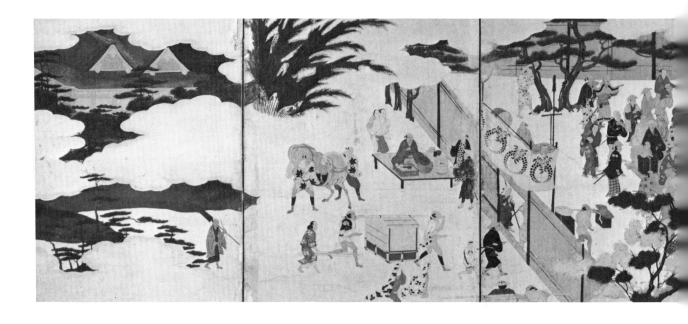

Tani, Shinichi and Sugase, Tadashi. *Namban Art.* (Wash-Yamane, Yūzō. *Momoyama Genre Painting.* Translated by ington D.C., 1973).
John M. Shields. (New York and Tokyo, 1973).

82
Okuni Kabuki

Artist unknown
Japan, late Momoyama–early Edo period,
seventeenth century
Six-panel screen
Color on paper
56.8 × 273.0 cm.

This single six-panel screen shows a scene of the celebrated actress, Izumo Okuni, in a performance of one of the theatrical skits she originated. She stands jauntily posing, attired in her role as a young samurai, with a long sword slung across her shoulders. Beside her, in search of pleasure, is her companion Saruwaka, a comic character whose name means, literally, 'young monkey.' At the front corner of the stage sits a young woman, a member of the pleasure quarter, and the object of Okuni's and Saruwaka's search.

Okuni arrived in Kyoto about 1603 when she is said to have begun giving public performances to raise funds for the restoration of Izumo Taisha, the important Shinto shrine on the Japan Sea coast where she served as a *miko* (shrine maiden). The original site of her performances is thought to have been Kitano Temman-gu, one of the largest and most important Shinto shrines of Kyoto. In this screen, at the left, the double-peaked roof of the main building of the shrine is clearly presented to identify the scene.

Okuni must have possessed rare talents, if not beauty, and her performances soon began to attract considerable attention. She moved her stage to the Shijō pleasure quarter where her skits gradually took on an increas-

ingly risqué quality as her popularity grew. The skits were termed *kabuki* (novel and curiously eccentric behavior). This sort of farcical comedy routine quickly spread throughout the country and gradually an *Onna Kabuki* (women's Kabuki) developed. The appearance of women on the stage, especially in bawdy skits, was not welcomed by the puritanical Confucian officials, and the fact that most of these performers were recruited from the pleasure quarters further complicated the issue. Finally, in 1629, the appearance of women on the stage was banned. The public demand for Kabuki continued, however, and soon men began appearing, taking both male and female roles. This was the origin of the Kabuki theater as it is known today.

In this painting, the stage and the performance served as the central focus of the scene, suggesting that the screen dates from a later time than the screens with a more diffuse overview, such as those produced by Kanō Naizen (1570–1616). On stage, on the other hand, the lack of a separation between dancers and musicians indicates a fairly early date in the development of the Kabuki. A further indication is the absence of the shamisen among the musical instruments. This three-stringed, long-necked instrument entered Japan from Okinawa, and in later Kabuki became a basic instrument accompanying the Kabuki performance. A probable date for this screen would seem to be about the middle of the Keichō era (1596–1615).

Published
The Suntory Museum of Art. *Kami to Keshō, Keichō kara Taishō made.* (Tokyo, 1970). pl. 34.

References
Idemitsu Museum of Arts. *Masterpieces of the Idemitsu Collection.* (Tokyo, 1968).
Kondo, Ichitarō. *Japanese Genre Painting: The Lively Art of Renaissance Japan.* (Rutland, Vermont and Tokyo, 1961).
Okada, Jō. *Genre Screens from the Suntory Museum of Art.* Translated by Emily J. Sano. (New York, 1978).
Yoshida, Eiji. "Keichō-ki Okuni Kabuki Fūzoku-zu." *Kokka* 694. (Tokyo, 1950). p. 20.

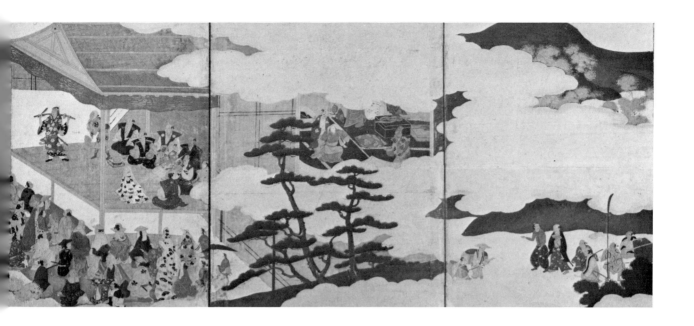

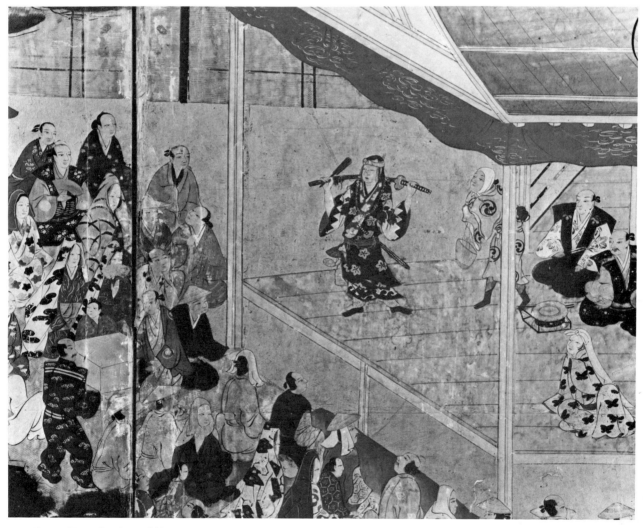

Fig. 53. Detail (no. 82)

83*
Gion Festival

Artist unknown
Japan, Momoyama period (1568–1615)
Pair of six-panel screens
Color on gold-covered paper
153.7 × 347.0 cm. each
Important Cultural Property

From the middle of the sixteenth century, there was a discernable interest in genre painting among the urban society of Japan. The growth of castle towns and cities promoted by the development of central fortification after the introduction of gun powder tended to concentrate society into urban organizations previously unknown in Japan. Commercial growth and prosperity was in the sixteenth century only a rudimentary foretaste of seventeenth-century developments; nevertheless it brought with it an increase in urban culture, especially among the commoners, and consequently an interest in art which newly affluent groups, such as the merchant class, could now afford.

One of the most popular and enduring themes which grew out of this interest was the *Rakuchū Rakugai* theme which depicted in panoramic views the busy life in and around the capital. Screens showing the various annual celebrations and popular outings—such as the viewing of cherry blossoms or autumn leaves—were also among the desired themes. Such paintings, usually by anonymous commercial artists, were made not only for sale to the citizens of Kyoto, but were taken back to the countryside as souvenirs by visitors to the capital to remind themselves and to demonstrate to others that the capital was a beautiful and exciting place, and perhaps more importantly, to demonstrate that the owner had been part of that excitement.

The tradition of this type of screen painting arose with the end of the Muromachi period (1392–1568), but almost all screens surviving today date from the Momoyama period (1568–1615) and later. Few screens can be assigned specific dates and very few were ever produced by established artists. A few examples exist, however, of special commissions by famous artists, such as the *Rakuchū Rakugai* screens by Kanō Eitoku in the Uesugi Collection, Yamagata Prefecture, or the Hōkoku Festival screens by Kanō Naizen, dated 1606, in the Hōkoku Shrine, Kyoto. The most popular themes of the early screens, like public festivals, seem to have been viewed in a broad expanse in a desire to include as much and as many different elements as possible. Later screens began to focus more definitely on a specific event or area such as the *Okuni Kabuki* (no. 82), and later still, the focus narrowed to a specific instance, and particular figures emerged as the element of primary interest, as in the *Kambun Bijin* (see no. 85).

Among the annual festivals in the capital, the Gion Festival was, and still remains, the most important. Held in mid-summer, it is the principal celebration of the Shinto shrine, *Yasaka Jinja*. The celebration originated

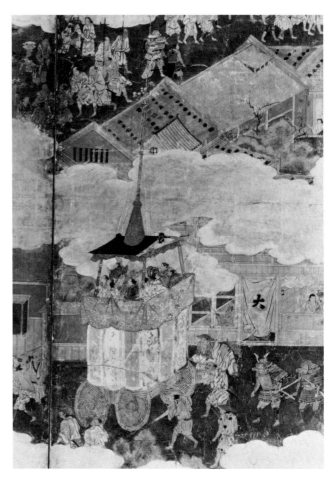

Fig. 54. Detail (no. 83)

in the ninth century when, during a severe epidemic, *hoko* (processional carts) representing each of the provinces were dragged through the streets to propitiate the deity of the Yasaka Shrine. Beginning in 970, the procession became an annual event and continued presumably without interruption until the disastrous Onin wars during the period 1467–1477. The next recorded instance of the celebration was in 1500 when the capital, destroyed during the Onin wars, was beginning to rebuild. It has apparently continued without interruption ever since. The most exciting part of the celebration today is a procession of *hoko*, some of which have musicians and performers in striking costume. The huge carts, colorfully draped and decorated, are pulled by specially attired groups of men through the streets, to the delight of the throngs who line the route and position themselves on every conceivable perch to gain a better view. Visitors to the festival today behave just as the paintings show visitors behaving in centuries past.

Yamane Yūzō (*Momoyama Genre Painting*, [New York and Tokyo, 1973] p. 163) considers these Idemitsu screens to be the oldest existing, screen-format version of the Gion Festival theme. The one screen shows the huge floats, or processional carts, which first appear before the public during the festival. These are the *hoko*, each surmounted by a tall *hoko* or *naginata* (long-handled pike), the *tsukuri-yama*, palanquins representing a mountain on which scenes from history are represented, or various other elaborate vessels sponsored by guilds and societies. These floats have taken

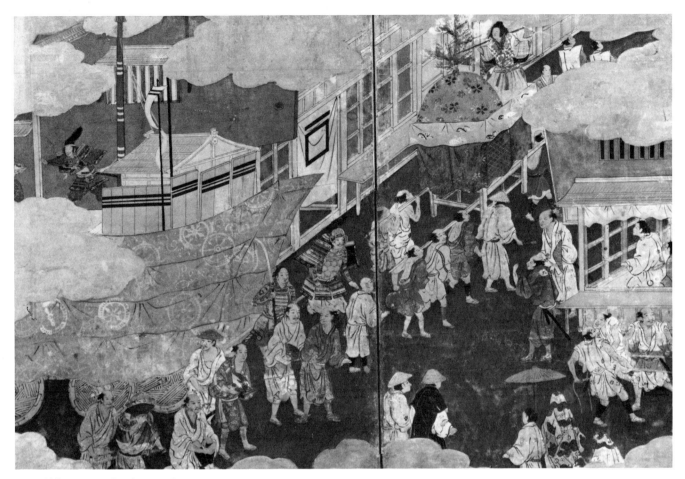

Fig. 55. Detail (no. 83)

on such importance over the centuries that this part of the Gion Festival has made it more important as an urban event than as a religious celebration.

The scenes on the screen are closely hemmed in by the Kamo River and by Sanjō and Shijō Avenues. The bridges are seen at the upper part of the painting, and the composition emphasizes the movement of the carts and the wonder and excitement of the populace. The homes, shops, and general urban setting are well described. In the other screen, the central theme is the transporting of the three *mikoshi* (shrine palanquins) for the gods. These are seen at the left, moving diagonally across the screen along the street. At the lower front are warriors in battle dress, some wearing the ballooning *horo*, originally a kind of protection against arrows. The helmet decorations, and especially the enormous folding fan are greatly exaggerated, lending a fanciful air to the scene and suggesting that, even in the Momoyama period, the festival was highly theatrical. Overall, however, the painter has captured a true feeling of emotional release and exuberant pleasure. The townspeople were in their element, enjoying a good performance in the name of a traditional sacred rite.

Stylistically, the screens are not really of either the Kanō or the Tosa school, the predominant artistic trends in the capital at the time. The Kanō element is strong, however, and there is a suggestion that the artist was perhaps one of the *Machi-Kanō*, artists trained in the Kanō style but operating independently. He may also have been one of the *machi-e-shi*, the purely commercial

painters. There is in these screens the sense of the extraordinary, a feeling of a peculiar Kyoto professional painting style heralding the rise of the ukiyo-e school.

Published
Idemitsu Museum of Arts. *Masterpieces of the Idemitsu Collection.* (Tokyo, 1968).
Idemitsu Museum of Arts. *Special Exhibition Commemorating the Fifth Anniversary of the Idemitsu Collection.* (Tokyo, 1971).
Idemitsu Museum of Arts. *Special Exhibition Commemorating the Tenth Anniversary of the Idemitsu Collection.* (Tokyo, 1976). pl. 20.
Kokka 829. (Tokyo, 1961). pls. 4–6.
Yamane, Yūzō. *Momoyama Genre Painting.* Translated by John M. Shields. (New York and Tokyo, 1973). pls. 96, 97, and 109.

References
Kokka 829. (Tokyo, 1961).
Narazaki, Muneshige. "Gion-sai Gion Ten." *Kokka* 829. (Tokyo, 1961). p. 165.
Okada, Jō. *Genre Screens from the Suntory Museum of Art.* Translated by Emliy J. Sano. (New York, 1978).
Takeda, Tsuneo. *Kimpeki Shōhei-ga.* Nihon no Bijutsu, Vol. 131. (Tokyo, 1977). p. 39.
Takeda, Tsuneo *Fūzokuga—Sairei, Kabuki.* Nihon Byōbu-e Shūsei, Vol. 13. (Tokyo, 1978). pls. 1–4, p. 93.
Yamane, Yūzō. *Momoyama Genre Painting.* Translated by John M. Shields. (New York and Tokyo, 1973).

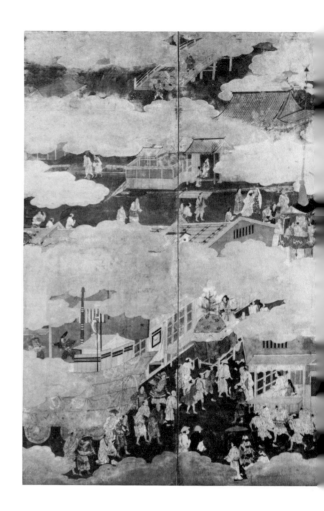

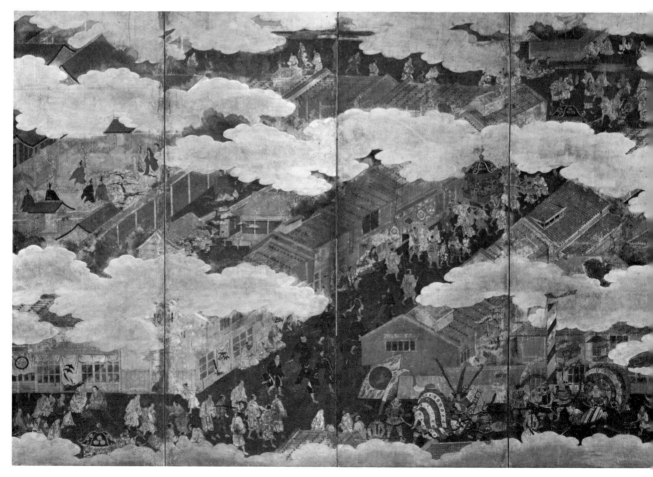

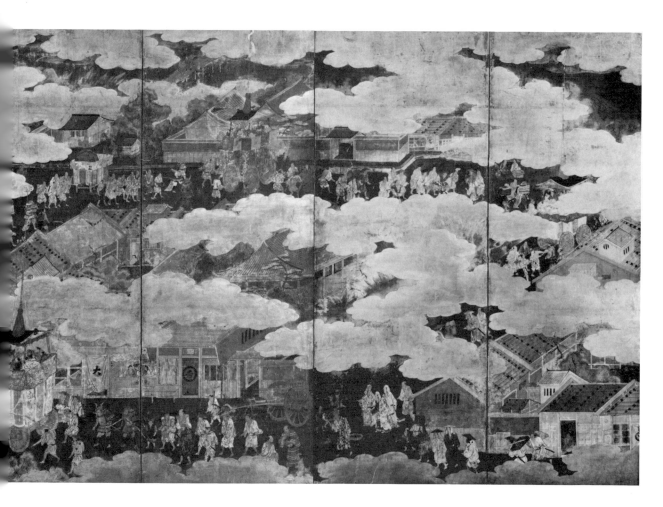

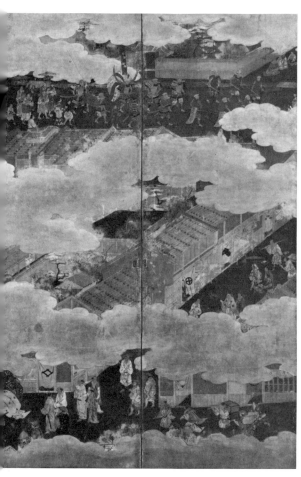

84
Thirty-six Master Poets

Iwasa Katsumochi (1578–1650)
Japan, late Momoyama–early Edo period
(sixteenth-seventeenth centuries)
Pair of six-panel screens
Ink and color on gold-covered paper
153.8 × 365.9 cm.

Iwasa Katsumochi, better known as Matabei, was once considered the originator of genre or ukiyo-e painting in Japan. How the tradition developed is not exactly clear; however, the misunderstanding caused many works for approximately three hundred years to be arbitrarily attributed to Matabei without any semblance of documentation. This mistake has resulted in a mixed understanding of his oeuvre. More recent scholarship has revealed a more definitive profile of Matabei, pointing especially to recorded paintings and works with appropriate seals or signatures.

Sources differ on the childhood history of Matabei, but tend to agree that he was born in 1578, the son of Araki Murashige, and that when he was very young he was taken from his birth place of Itami, near the modern site of the Osaka airport, to live in Kyoto. Possibly because he was separated from his parents, or orphaned, it is likely he was taken to the Nishi Honganji temple. He used his mother's family name of Iwasa. Some reports say he grew up as a page in the household of Oda Nobuo (1558–1630), the second son of Oda Nobunaga (1534–1582). Little is known for certain of his youth.

During the years when Matabei was growing up, Kyoto was the home of many fine artists. Moreover, the return to civil order and peace established in the capital in the late sixteenth century, first under Oda Nobunaga

and then under Toyotomi Hideyoshi (1536–1598), brought prosperity to the city, which became a center of commerce and cultural activities (nos. 81, 82). By the time the Tokugawa shogunate was established in the early seventeenth century, Kyoto was free from civil strife and was once again the center of culture. The new capital at Edo soon outstripped its rival, Kyoto, in political importance, but the old capital never entirely relinquished its title as the center of art and culture.

Considering the qualities revealed in his paintings, Matabei clearly pursued painting studies with a variety of masters, including those of the Kanō and Tosa schools. The genre painting that was gaining popularity could hardly have escaped his notice, especially since his economic circumstances probably made him eager for commissions from any quarter. In 1616, he traveled with a priest friend to the Echizen, or Fukui, fief where he eventually took a position working for the Lord Matsudaira Tadamasa (1597–1645).

Matabei's art became known for its decorative qualities, which blended the colorful traditional *Yamato-e* style of the Tosa school with the dramatic linear qualities of the Chinese-inspired Kanō tradition. He used his particular blend of painting styles to enliven contemporary portraits, or portraits of historical figures like Yang Kuei-fei, the mistress of the T'ang emperor Hsüan-tsung (reigned 713–755). To the new social elite of urban Edo-period Japan, he also made more accessible, if not more palatable, the traditional themes dealing with courtly traditions, such as the series of the "Thirty-six Master Poets," or the *Genji Monogatari* (cf. no. 77). He gave a fresh appearance to favorite subjects from literature and history and in the process created a special style of his own.

In 1637, he was summoned to Edo by the third Tokugawa shogun, Iemitsu (1604–1651). Iemitsu was anxious to dedicate a series of paintings of the "Thirty-six Master Poets" to the newly rebuilt Tōshōgu shrine

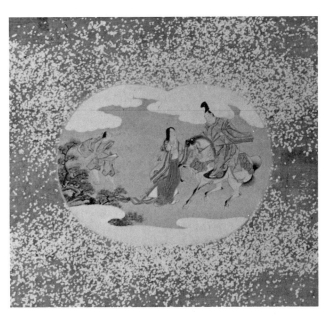

Fig. 56. Details (no. 84)

at Kawagoe, near Edo. (The shrine was dedicated to his grandfather, Ieyasu, the founder of the Tokugawa shogunate.) One of this set of paintings is dated on the reverse to the year 1640, and signed in Matabei's own hand. Each of the other paintings bears his alternate name, Katsumochi. His signature-inscription describes him as the last of the line of Tosa painters, suggesting that he considered himself a part of this family of traditional artists.

The list of the "Thirty-six Master Poets" originated in the Heian period (794–1185) when certain poets included in famous anthologies of the past were selected for special attention. Imaginary portraits of these poets, each usually accompanied by one of his or her poems, were painted as tribute to Shinto shrines, especially during the Kamakura period (1185–1333) and since. Thus, Iemitsu's choice of subject for a dedication to the shrine was entirely traditional and appropriate. Iemitsu might well have become aware of Matabei's talents, or his renown for this subject, during Matabei's visit to the capital as a member of Lord Matsudaira's household. Tokugawa retainers, like Lord Matsudaira, were required to maintain residence in Edo for six months each year and they often brought many of their own retainers with them. Matabei was, perhaps, known for this subject prior to the Tōshōgu set, but he certainly was asked to create many sets thereafter.

In the Idemitsu screens, Matabei has organized the poets evenly in a continuous band across the upper section, each attired in the traditional, Heian-period costume and set beneath a square containing an appropriate poem. Beneath the band of poets a group of twelve fan faces on each screen depicts legends and landscape scenes done in various and mixed painting styles. These are set between gold cloud borders with raised designs which give three-dimensionality and added interest. The device of the gold banks is borrowed from genre screens such as the *Rakuchū Rakugai*

screens of scenes of life in and around the capital, and the Gion Festival screens (no. 83) of this exhibition. The fan faces are placed in an asymmetrical composition between the borders on a dark ground sprinkled with gold dust.

Several points tie the Idemitsu poet-paintings to those at the Kawagoe Tōshōgu. The figures are comfortably posed, but not so relaxed either in execution of line or in posture as some examples. Also the figures of the poets are shown separated from the calligraphy. Further, the name Katsumochi appears in the Tōshōgu inscriptions and in the seals on the Idemitsu screens. The well-known Dōun seal also appears on the Idemitsu screens. There is no evidence the twelve fan faces set about the lower position of each screen are attributable to Matabei, and probably the screens were a combined production of several artists.

The theme and the quality of the paintings of the poets suggest these screens date from the late period of Matabei's life, perhaps from about the time he was summoned by the shogun in 1637, until his last years. He died in Edo in 1650 at age seventy-three.

Published
Idemitsu Museum of Arts. *Masterpieces of the Idemitsu Collection.* (Tokyo, 1968).
Musée du Petit Palais. *L'Art du Japon Eternel dans la Collection Idemitsu.* (Paris, 1981). pl. 21.

References
Fujikake, Shizuya. "On Paintings of Master Poets of Matabei Iwasa." *Kokka* 631. (Tokyo, 1943). pls. 1–3.
Kokka 104. (Tokyo, 1898). pp. 144–148.
Kokka 643. (Tokyo, 1944). pls. 1–3.
Kokka 846. (Tokyo, 1962). pl. 1–3.
Narazaki, Muneshige. "On Katsumochi Matabei Iwasa." *Kokka* 686. (Tokyo, 1949). pls. 1–7.

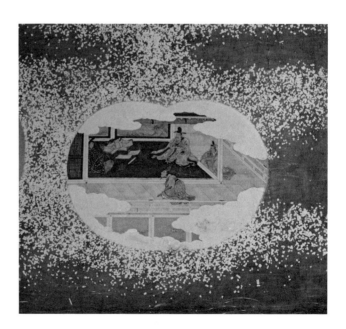

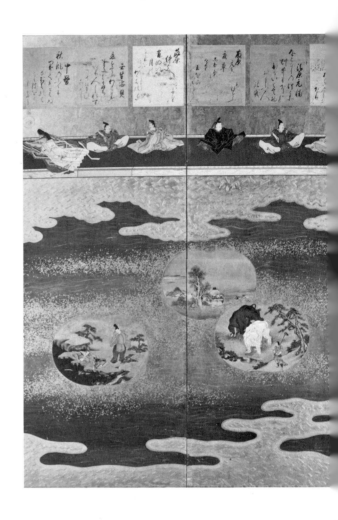

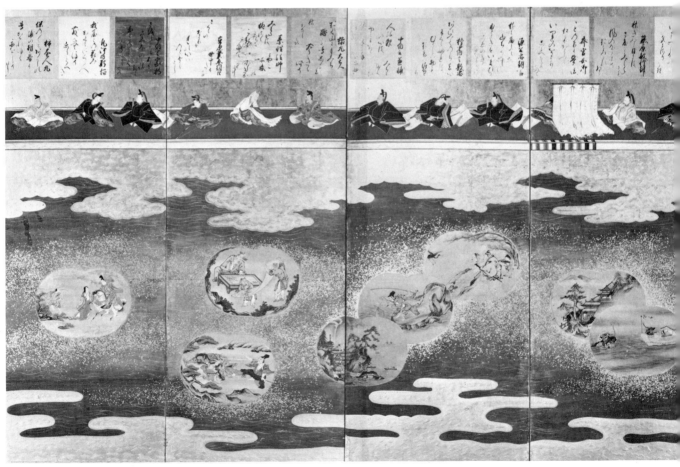

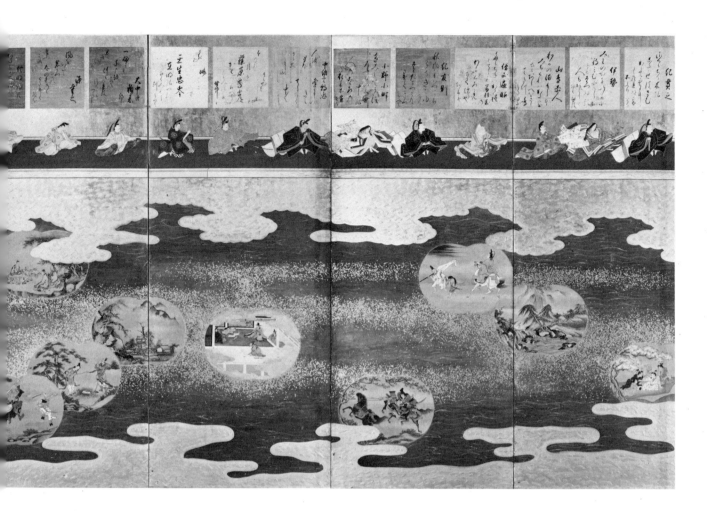

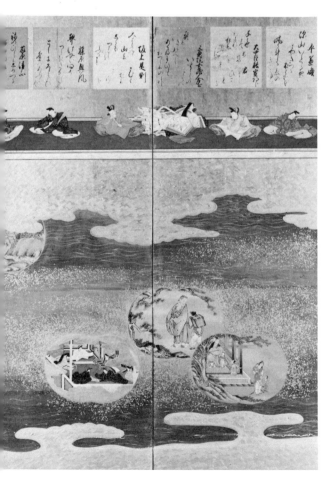

85*

A Beauty

Kaigetsudō Ando (active 1704–1714)
Japan, Edo period (1615–1868)
Hanging scroll
Color on silk
102.0 × 37.0 cm.

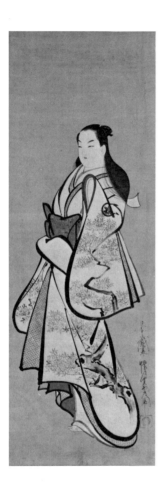

The traditional themes of *fūzoku-ga* (depictions of manners and customs) of the Momoyama and early Edo periods, such as the *Namban* scenes, the *Okuni Kabuki*, and the Gion Festival theme, emerged gradually in response to an increased standard of living and greater leisure time among urban society. By the early seventeenth century, however, the focus of *fūzoku-ga* centered increasingly on life in the entertainment quarters—the Yoshiwara in Edo and the Shimabara in Kyoto—and, in particular, on the reigning courtesans of these fabled realms of endless pleasure.

The *ukiyo* (floating world) derives ultimately from Buddhist doctrine which holds that the matters and feelings of this world are transient and fleeting, impermanent as the rising and ebbing foam on the surface of a rushing stream. This term *ukiyo* came to be applied, sometime during the early seventeenth century, to the life of the pleasure quarter, and in fact to anything modish or sensual. It referred to a lifestyle novelists and playwrights of the time liked to romanticize and turn into an adventure of ecstatic rapture.

Paintings of the life of the pleasure quarter are called ukiyo-e. Among this genre there grew up a commercial demand for portraits of the famous beauties of the quarter. A type of picture now called *Kambun Bijin* emerged, for it was during the Kambun era (1661–1672) that there appeared a specialized production of hanging scrolls with the figure of a woman whose form and attire represented the epitome of the fashion of the day. The lady was revealed alone without setting or props. This genre eventually lent its name to all such early paintings of beautiful women.

Edo was the capital of the Tokugawa shoguns who represented political and military power in the service of the emperor who resided in Kyoto. One of the laws enacted by the shogunate—which was to have a profound effect on life in the Edo period—required important retainers to maintain a household in Edo and to live there for six months each year. In consequence, not only did a large number of wealthy people live at leisure in the city for half a year at a time, but new arrivals appeared constantly. Naturally, this domestic activity required considerable maintenance, which assured commercial activity and prosperity for the merchants. The months of enforced inactivity for the feudal retainers produced a demand for diversions that was met by the creation of a pleasure quarter, the Yoshiwara, perhaps unrivaled in world history for excitement, luxury, and the promise of sensual gratification. The expense often offered a challenge equal to the promise of satisfaction. Merchants and artisans were by law the lowest of the feudal order, but in the Yoshiwara district the ability to pay the cost demanded guaranteed them an equality outside feudal regulations; the growing wealthy merchant class discovered an area of expression denied to them in feudal politics and society.

The Idemitsu painting of a courtesan is by the artist, Kaigetsudō Ando. The painting is typical of the Kaigetsudō style in which the figure, like the *Kambun Bijin* is presented alone and without setting. She is the center of attention and her robes are as important to the appreciation of the work as her countenance or pose. The figures of the Kaigetsudō school were usually shown either in three-quarter view, as in this painting, or in a contraposto pose, looking slyly back over their shoulders. There is a uniformly robust, not to say buxom, quality to these ladies which is emphasized by the full, round face. The highly detailed patterns of the kimono were obviously important in establishing the lady's position in the fashionable demi-monde. The profile of the figure and costume are characteristically outlined with bold, sweeping brush strokes that are a hallmark of the Kaigetsudō school. Her kimono bears a crest of a maple leaf within a circle, seen where her left arm bends, suggesting that the painting is a portrait of a specific entertainer from a well-known house. Her gown, with a pattern of blossoming cherry trees, might otherwise indicate that she is one of a set of calendar paintings representing one of the early months of the year.

Kaigetsudō Ando has as murky a history as any of the other early Edo-period ukiyo-e artists. Apparently

nothing is known for certain of his origins or early life. He established an atelier at Asakusa near the Yoshiwara, and was active as a painter during the Genroku-Hōei eras (1688–1710) until his banishment in 1714. A group of artists all shared the Kaigetsudō name, but Ando was the founder and his taste guided the fortunes of the school. He and his followers specialized in depicting beautiful women, the entertainers and courtesans of the Yoshiwara, and competed with the *Torii* school of print designers who specialized in Kabuki actor prints. Kaigetsudō artists occasionally painted subjects other than courtesan portraits, real or imaginary, and although Ando made only paintings, others of the group made designs for woodblock prints to satisfy the demand for the images.

For some reason, not completely understood, Kaigetsudō Ando was banished in 1714. It is suspected he was involved in the *Ejima Jiken* (Ejima Affair) of that year. Perhaps, he was only inadvertently caught up in the purge that followed the revelations of the notorious relationship of the Lady Ejima, a principal lady-in-waiting in the shogun's household, with an actor from the Yamamura Kabuki theater. Whatever Kaigetsudō Ando's involvement, he was banished to the island of Oshima and apparently died in exile. His school flourished for some years, but perhaps as a result of the Ejima Affair or merely because the group was deprived of Ando's leadership, the Kaigetsudō group seems to have disappeared soon after his arrest.

The Idemitsu painting is signed in a typical Kaigetsudō school fashion which reads *Nihon giga Kaigetsudō Ando kore o egaku.* The term *giga* (playfully painted) suggests that the ukiyo-e painters considered their art as *opéra comique* or *commedia dell' arte* in which there is a lighthearted, but professionally serious treatment of the subject.

Published
Idemitsu Museum of Arts. *Masterpieces of the Idemitsu Collection.* (Tokyo, 1968).
Narazaki, Muneshige. "Kaigetsudō Ando Hitsu, Bijin-zu Kaisetsu." *Kokka* 916. (Tokyo, 1968). pl. 6.

References
Narazaki, Muneshige. "Kaigetsudō Ando Hitsu, Bijin-zu Kaisetsu." *Kokka* 916. (Tokyo, 1968).
Narazaki, Muneshige. *Nikuhitsu Ukiyo-e.* Zaigai Hi Hō, Vol. III. (Tokyo, 1969).
Stern, Harold P. *Ukiyo-e Painting.* (Washington, D.C., 1973).

Fig. 57. Detail of signature and seal (no. 85)

86

A Beauty

Miyagawa Chōshun (1682–1752)
Japan, Edo period (1615–1868)
Hanging scroll
Color on silk
85.0 × 30.6 cm.

Chōshun came to Edo from his native village of Miyagawa (near modern Nagoya) to study paintings. His family name was Hasegawa, but he chose Miyagawa as his art name. He studied first the Tosa painting style, but was also attracted to the ukiyo-e style of the Kaigetsudō school (no. 85), and to the works of the older ukiyo-e painter and woodblock print designer, Hishikawa Moronobu (died 1694). Chōshun has presented the lady in the Idemitsu painting much in the manner of the Kaigetsudō school, with the full figure filling the foreground in a three-quarter pose. In contrast to the Kaigetsudō figures, which are assertive and bold both in execution and in psychological expression, Chōshun has imbued his courtesan with a softer, gentler quality. In this Idemitsu painting, the dramatic sweep of the profile found in the Kaigetsudō figures has been somewhat broadened and softened, and Chōshun has bound into a discreet bun the free-flowing tresses of the Kaigetsudō figures. The figure in the Idemitsu painting has not been given a setting, a characteristic of the Kaigetsudō school style. Although Chōshun was not interested in strict naturalism in the Western sense, he did often provide a realistic landscape or interior setting for his figures. This interest in providing a setting perhaps derives from his acquaintance with Moronobu book illustrations. Chōshun's color sense was unerring and he had a remarkable ability to balance tones and patterns with image shapes. His observation of detail was almost encyclopedic, whether describing a kimono pattern for a single figure, or developing a composition showing rows of houses with their residents and guests in the pleasure quarter.

Chōshun's ukiyo-e style avoided the sordid and noisy brashness that characterized much of the earlier ukiyo-e painting and woodblock print designs. He chose to portray his figures and scenes of the pleasure quarter in a sedate and polished manner. This attitude clearly reflects his early training in Tosa school painting with its *Yamato-e* courtly associations and traditions of muted, but gorgeous coloring. His typical signature reads *Nihon-e Miyagawa Chōshun zu*, (a Japanese picture painted by Miyagawa Chōshun), which suggests his strong personal association with Japanese traditions in painting.

Chōshun's softening of the emphasis on the more vulgar aspects of ukiyo-e signaled a change in taste among his clientele, which was perhaps the result of official pressure regarding public morals, a subject never far from the thoughts of the puritanical Confucian authorities. In taming the exuberant spirit of an earlier age, Chōshun established new standards for ukiyo-e painting, and a great number of students were attracted to his side. Chōshun never made designs for woodblock prints; however, his many followers became well-known, not only for their ukiyo-e paintings, but for their beautiful print designs.

Chōshun, like Kaigetsudō Ando before him, was sent into exile as punishment for an offence. The details of Chōshun's problem are confused; however, at the height of his career he had been invited to join an academy painter, Kanō Shunga, to work on the restoration of the Tōshō-gu at Nikko. There was an argument over some matter between the two and the result of the altercation was that Chōshun was banished to Niijima, an island off the Pacific coast, in 1751. He was released the following year and returned to Edo, where he died.

Published
Idemitsu Museum of Arts. *Special Exhibition Commemorating the Fifth Anniversary of the Idemitsu Collection.* (Tokyo, 1971).
Idemitsu Museum of Arts. *Special Exhibition Commemorating the Tenth Anniversary of the Idemitsu Collection.* (Tokyo, 1976). pl. 31.
Mainichi Shimbunsha, editor. *Nikuhitsu Ukiyo-e Shūsei,* Vol. 2. (Tokyo, 1977). pl. 70.

References
Narazaki, Muneshige. *Masterworks of Ukiyo-e: Early Paintings.* (Tokyo and Palo Alto, 1968).
Stern Harold P. *Ukiyo-e Painting.* (Washington D.C., 1973).
Young, Martie and Smith, Robert. *Japanese Painters of the Floating World.* (Ithaca, 1966).

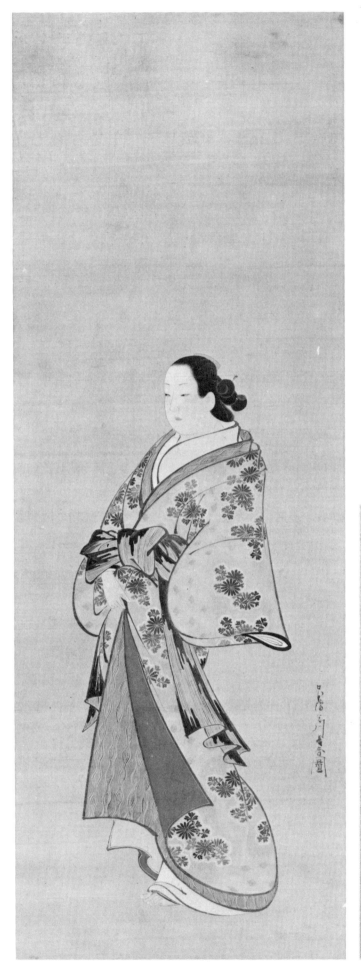

Fig. 58. Detail of signature
and seal (no. 86)

87
A Beauty

Nishikawa Sukenobu (1671–1751)
Japan, Edo period (1615–1868)
Hanging scroll
Color on paper
89.6 × 26.1 cm.

Ukiyo-e painting and woodblock print design were important art forms in both Edo and Kyoto, and among the ukiyo-e artists active in Kyoto, Nishikawa Sukenobu (1671–1751) was perhaps one of the most influential in establishing the direction of ukiyo-e art. His style, like Chōshun's (no. 86), exhibits a softening of the boldness of the Kaigetsudō style (no. 85) or the frankness of the Hishikawa Moronobu school, and Sukenobu chose to present his figures with an open, gentle, and quiet mystery. His paintings are still considered *bijin-ga* (paintings of beautiful ladies) and certainly he did depict courtesans and execute designs for erotic prints. There is, however, a tender, almost naive innocence emanating from his figures that clearly distinguishes his style. The shy and almost reluctant mood of the figure in the Idemitsu painting harmonizes beautifully with the subdued and delicate design and colors of her elegant kimono. Perhaps, as suggested with regard to Chōshun's work, the authorities were pressing for less explicit depictions of the activities of the pleasure quarters; however, by masking the obvious behind a facade of gentle manners and delicate attire, Sukenobu was making the suggestion of sensual pleasures all the more intriguing.

In addition to scenes of courtesans or lovers, Sukenobu also chose scenes from the lives of the Kyoto citizens he saw about him. Some of his seemingly innocent scenes, however, have hidden suggestions of love and longing. In a painting in the Freer Gallery of Art, Washington, D.C., (Stern. *Ukiyo-e Painting.* [Washington, D.C., 1973) No. 45) a young maiden kneels beside her bed, holding a writing box on her lap while grinding ink with which to write, undoubtedly to some absent lover; paper and brushes are at hand. She stares dreamily at the lamp set on the tatami before her as she moves the ink stick slowly back and forth on the inkstone. A folding screen behind her shows a willow with its branches gracefully echoing the curve of her tilted head and shoulders. A curving stream passes beneath the willow branches. On the surface, it is a simple interior setting with a lady preparing to write, but it is loaded with erotic suggestions. As Japanese urban society was growing more sophisticated in its tastes in art, the blatantly sensuous became less satisfying and gave way to the suggestive and symbolic.

Sukenobu's particular figure style was popularized throughout the country in the more than two hundred books for which he designed illustrations. The ladies in these illustrations have a supple delicacy, with tiny hands and wrists. The smooth flowing rhythms of the profile figure in the Idemitsu painting are carried through into the tiny fingers barely visible where she catches up her kimono in front, and are carried further to the delicately curved toes that appear at the hem of her under-kimono. The late figure style of the important Edo print designer, Suzuki Harunobu (1725–1770), was strongly influenced by Sukenobu's lithe and delicate creatures. The compositions of several known prints by Harunobu were borrowed from Sukenobu sources (Waterhouse. *Harunobu and His Age.* p. 28, fn. 100).

Sukenobu was born in Kyoto and stayed there all his life. As other ukiyo-e painters before him, he studied the established art styles, exemplified by the Kanō and Tosa schools of painting. He is thought to have studied with the artist Kanō Eino (1634–1700). Michener states, however, that Sukenobu was outspoken in his appreciation of Japanese, rather than Chinese, themes and styles, and it seems unlikely that with this attitude he would have studied long with the Chinese-inspired Kanō school. (Michener. *The Floating World.* p. 60.) His landscape style, also, seems more clearly based on Tosa traditions, and in the Tosa school his name is often associated with the artist, Tosa Mitsusuke (1675–1710). The ukiyo-e school could hardly have escaped his attention, and rather like other professional artists of the time, he generated his own style out of a general association with all three major styles. In his art, he brought the ukiyo-e school closer to its earlier traditions of the true *fūzoku-ga,* which depicted scenes taken from the life of the urban dweller. He preferred this form of expression to one which would focus narrowly on the activities of the pleasure quarters. Sukenobu died in 1751.

Published
Mainichi Shimbunsha, editor. *Nikuhitsu Ukiyo-e Shūsei,* Vol. 2. (Tokyo, 1977). pl. 73.

References
Hillier, Jack. *Suzuki Harunobu.* (Philadelphia, 1970).
Kyusei Hakone Art Museum and Kyusei Atami Art Museum. *Selected Catalogue.* Vol. III. (Atami, 1977).
Link, Howard A. *Primitive Ukiyo-e.* (Honolulu, 1980).
Michener, James A. *The Floating World.* (New York, 1954).
Narazaki, Muneshige. *Masterworks of Ukiyo-e: Early Paintings.* (Tokyo and Palo Alto, 1967).
Stern, Harold P. *Ukiyo-e Paintings.* (Washington, D.C., 1973).
Young, Martie and Smith, Robert J. *Japanese Painters of the Floating World.* (Ithaca, 1966).

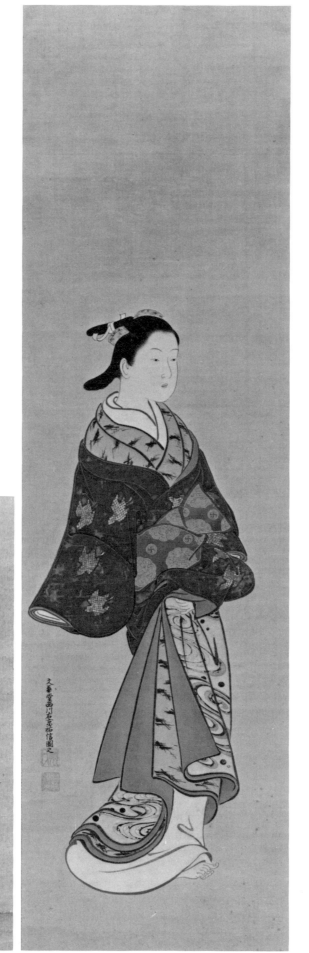

Fig. 59. Detail of signature
and seals (no. 87)

88
Three Beauties under the Cherry Blossoms

Katsukawa Shunshō (1726–1792)
Japan, Edo period (1615–1868)
Hanging scroll
Color on silk
97.2 × 34.7 cm.

Katsukawa Shunshō (1726–1792) was a prominent ukiyo-e artist living in Edo. He belonged to the artistic lineage that began with Miyagawa Chōshun (no. 86). Shunshō's teacher was Miyagawa Shunsui (flourished 1741–1770), a pupil of Chōshun and possibly one of his sons. Traditionally it is said that Shunsui changed his name to Katsukawa at the time Chōshun was sent into exile. Shunshō, as Shunsui's student, thus inherited the Miyagawa traditions but the Katsukawa name. In keeping with those traditions of gentle *fūzoku-ga*, Shunshō in his painting featured light and airy genre scenes in which the ladies he depicted were more likely to be socially respectable and refined than queens of the demi-monde. He was particularly adept at composition, and used landscape and interior settings with great ease and in a charming and convincing manner. His interest in landscape perhaps resulted from his supposed association with an artist named Kō Sūkoku (1730–1804), who is said to have studied the style of Kanō Tanyū (1602–1674), a popular and influential academy artist.

Miyagawa Chōshun, founder of the line, had never made designs for woodblock prints, but a few prints with Shunsui's name are known. It is not certain, however, whether these are prints by the teacher of Shunshō. Shunshō, nevertheless, became fascinated with actor portraits and, as a master print designer, specialized in representing Kabuki actors, particularly Danjūrō V. Many of his portraits are of compelling interest, and he injected into ukiyo-e a new sense of realism and elegant stylishness. Shunshō was an immensely popular artist and established a school that attracted many talented students. Among them was a certain Shunro who soon bolted from the school and took a new name for himself, Hokusai.

The three statuesque beauties in the Idemitsu painting are shown as they stroll in a park-like setting, viewing the blossoming cherry trees. Chōshun had been an avid observer of objects and actions involved in everyday life, but his interest in detail did not reach the levels of Shunshō's compulsion for observation. Shunshō's interest in the realistic treatment of the landscape setting is also seen in his obvious pleasure in the qualities of draped fabric and in the sense of movement of garments, as in the swing of the long graceful sleeve of the young lady as she moves along the path.

The ladies do not have the adolescent innocence of a Sukenobu courtesan (no. 87). Rather, they are sophisticated and urbane. Their bearing, attire, and coiffure all identify them as ladies of respectable, high fashion. The strictness of Shunshō's meticulous observation reaches to the elaborate hairstyles popular at the time. The hair was swept out into wide wings at either side and piled high at the crown. These stiffened arrangements required various pins and combs to support the fanciful treatments. These pins and combs, too, opened new avenues for decoration and adornment. Shunshō delighted in the flared and high-crowned hairstyles which, like the obi and sleeve and kimono profiles, became abstract forms worthy of special attention in the composition of the painting. Beyond the extravagant detailing of a simple outing, Shunshō imparted a relaxed sense of sympathetic intimacy that transformed his paintings of everyday events into a powerful personal style that affected the future direction of ukiyo-e. The early prints of Kitagawa Utamaro (no. 89), for example, owe a debt to Shunshō's figure style.

Beneath the artist's signature, *Katsu Shunshō ga*, appears his distinctive cipher, or *kaō*. The painting is not dated, but the characteristic hairstyles of the Temmei era (1781–1798) suggest a date late in the artist's career. He died in 1792.

Published
Musée du Petit Palais. *L'Art du Japon Eternel dans la Collection Idemitsu.* (Paris, 1981). pl. 52.

References
Kyusei Hakone Art Museum and Kyusei Atami Art Museum. *Selected Catalogue,* Vol. III. t(A ami, 1977).
Michener, James A. *The Floating World.* (New York, 1954).
Stern, Harold P. *Ukiyo-e Paintings.* (Washington, D.C., 1973).
Young, Martie and Smith, Robert J. *Japanese Painters of the Floating World.* (Ithaca, 1966).

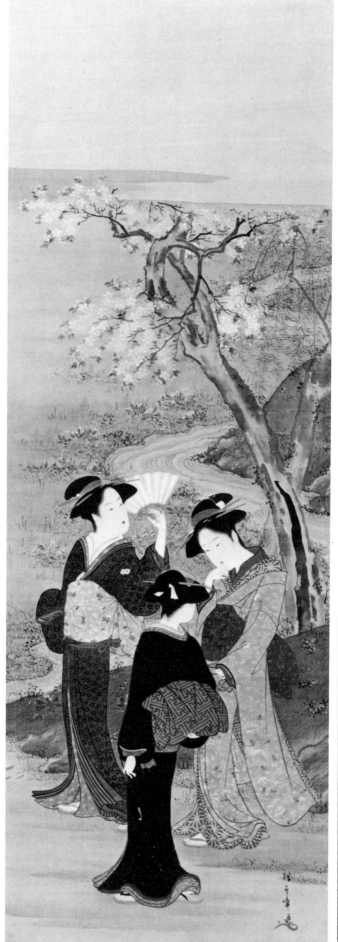

Fig. 60. Detail of signature
(no. 88)

89
A Beauty Changing Clothes

Kitagawa Utamaro (1753–1806)
Japan, Edo period (1615–1868)
Hanging scroll
Color on silk
117.0 × 53.3 cm.
Important Art Object

This exhibition includes examples of the development of ukiyo-e from the *fūzoku-ga* of the Momoyama and early Edo periods (nos. 81–83) to the robust Kaigetsudō style of courtesan figure painting (no. 85), through the modifying influences of artists like Miyagawa Chōshun (no. 86) and Nishikawa Sukenobu (no. 87). The collection includes many rare and exceptional examples of ukiyo-e paintings. One of the most important of these is this portrait of a courtesan by the master print designer, Kitagawa Utamaro (1753–1806), one of the preeminent artists of the later phase of Edo-period ukiyo-e. Utamaro was primarily renowned for his woodblock print designs; however, a number of original paintings by him are known, and the Idemitsu painting of a beauty disrobing is among the finest. The painting is registered by the Japanese government as an Important Art Object.

Utamaro became prominent as an artist in the last two decades of the eighteenth century. Although he had begun to make prints slightly earlier, it was not until about 1780 that his artistic promise was fully developed under the influence of the publisher, Tsutaya Jūzaburō. He began using the name Utamaro about 1781. During the 1780s, he made some exceptional designs for a book of humorous verses, and a superb example of his observation of nature appears in the book of insects and other creatures, the *Ehon Mushi Erami*, of 1788. Also during the 1780s, he produced an erotic album, the *Uta Makura* (Pillow Songs). Utamaro was at first influenced by the elongated forms of the ladies created by a contemporary print master, Torii Kiyonaga (1752–

1815); however, he soon developed his own distinctive perception of feminine proportions. Utamaro's major contribution to the field of ukiyo-e print design came in the 1790s when he developed the *ōkubi-e* (close-up view) in which the head or half-figure almost filled the entire field. It was a device which forced him to explore the compositional possibilities of the human figure, or groups of figures, within a very limited space and to exploit handsomely the new printing techniques of novel effects. The close-up view also allowed him to concentrate on the figure's emotions, to which he imparted a unique psychological realism. The realism which Katsukawa Shunshō (no. 88) had injected into ukiyo-e grew in Utamaro's handling of the *ōkubi-e* into an expression of femininity, profoundly sympathetic and affectionate.

In spite of Utamaro's importance in the history of ukiyo-e art, there is very little knowledge concerning his personal history or personality. He is known to have studied with an artist named Toriyama Sekien (1710–1788), a painter now perhaps best remembered as Utamaro's teacher. It is thought, however, that Utamaro was part of a circle of writers and intellectuals prominent in the cultural life in Edo. In his early career he lodged at his publisher's establishment near the gate to the Yoshiwara, where the novelist Takizawa Bakin (1767–1848) also stayed. Utamaro is said to have spent nights making the rounds of the pleasure quarter with friends like Santō Kyōden (1761–1816) and Jippensha Ikku (1765–1831), authors of popular literature. Kyōden was himself an ukiyo-e artist using the name Kitao Masanobu. Utamaro's prints reveal a familiarity with the activities of the entertainers, whether bathing, dressing or applying make-up, which clearly indicates his considerable first-hand knowledge of their private lives. Early in his career he depicted ladies of the merchant class and even low-class prostitutes, but eventually the courtesan and life in the Yoshiwara dominated his work.

In the Idemitsu painting, Utamaro has placed the monumental figure against a neutral background. He frequently used the neutral ground in his prints to maximize attention on the subject. The scene is set on a hot summer day and the lady wears a lightweight *kasuri* weave kimono which she is slipping off her shoulder with one hand; in the other, she holds a fan to cool herself. She has already discarded the heavy, bulky obi which lies encircling her like a wreath. Her face reveals the relief she feels at her release from this encasing garment. Her pleasure at finding privacy and relaxation conveys a source of pleasure to the viewer. The act of disrobing, however, has strongly erotic overtones, and like most of Utamaro's work, the sensual is never far below the surface. He brought back to ukiyo-e art an interest in the courtesans, which was earlier personified in the courtesans of the Kaigetsudō school, and he reveled in the frankly erotic qualities of the Yoshiwara district.

The authorities were always suspicious of the ukiyo-e print makers for their strong ties with the pleasure quarter. Censorship was instituted from 1790 onward

and every print was required to bear a censor's seal of approval. Utamaro, like others, flouted the censor's edicts whenever possible in his designs. An example is a set of three prints depicting the former ruler, Toyotomi Hideyoshi, with his wife and four mistresses, that carried identifying *mon* (crests) and other indications of identification. This act ran counter to the regulations banning the representation of historic warriors. Censured for this, Utamaro proceeded to design several other prints, equally as easily identifiable and lacking the censor's seals. For this he was finally jailed in 1805. Some reports mention a year's imprisonment, but it was probably only a few days. He was, however, kept under house-arrest and in handcuffs for fifty days. This humiliation is sometimes cited as the beginning of his physical decline, for he died within the year after the incident.

This portrait of a courtesan disrobing is thought to come from the late period of his life. The line of his brush is perhaps losing some of the bright polish seen in his best prints; however, the change of the medium to brush and ink on silk might account for some differences in feeling of the line. Nevertheless, Utamaro's skill in portraying the simple, direct, and unguarded manners of a body so totally relaxed ranks this work as one of Utamaro's most compelling portraits.

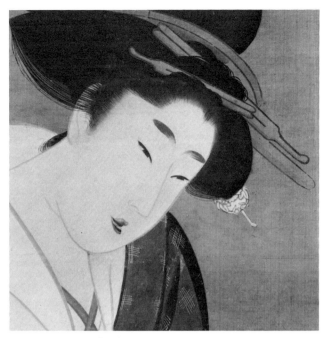

Fig. 61. Detail (no. 89)

Published

Idemitsu Museum of Arts. *Special Exhibition Commemorating the Tenth Anniversary of the Idemitsu Collection.* (Tokyo, 1976). p. 27.

Kikuchi, Sadao. *Utamaro.* Ukiyo-e Taikei, Vol. 5. (Tokyo, 1973). pl. 72.

Mainichi Shimbunsha, editor. *Nikuhitsu Ukiyo-e Shūsei,* Vol. 1. (Tokyo, 1977). pl. 206.

Musée du Petit Palais. *L'Art du Japon Eternel dans la Collection Idemitsu.* (Paris, 1981). pl. 55.

Narazaki, Muneshige. *Utamaro.* Nihon no Bijutsu, Vol. 134. (Tokyo, 1977). p. 15.

References

Binyon, Laurence and Sexton J.J. O'Brien. *Japanese Colour Prints.* (New York, 1923).

Hillier, J. *Japanese Prints and Drawings from the Vever Collection,* Vol. II. (London, 1976).

Hiller, J. *Utamaro.* (Greenwich, 1961).

Kyusei Hakone Art Museum and Kyusei Atami Art Museum. *Selected Catalogue,* Vol. III. (Atami, 1977).

Michener, James A. *The Floating World.* (New York, 1954).

Neuer, Roni and Yoshido, Susugu. *Ukiyo-e: 250 Years of Japanese Art.* (New York, 1978).

Stern, Harold P. *Ukiyo-e Painting.* (Washington, D.C., 1973).

Young, Martie and Smith, Robert J. *Japanese Painters of the Floating World.* (Ithaca, 1966).

Fig. 62. Detail of signature
and seal (no. 89)

90*

Two Landscapes

Ikeno Taiga (1723–1776) and
Ikeno Gyokuran (1728–1784)
Japan, Edo period (1615–1868)
Hanging scrolls
Ink and light color on paper
99.6 × 29.0 cm. each

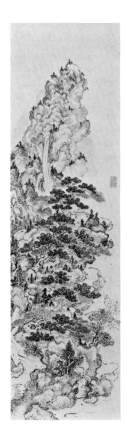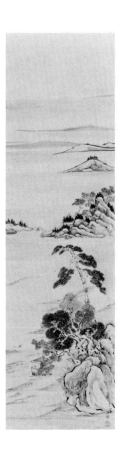

Ikeno Taiga was one of the most important painters to emerge during the Edo period. Despite his humble origins, Taiga showed exceptional talent. There is a story that at a very young age his skill at calligraphy astounded even the learned priests of the Obaku Zen monastery at Mampuku-ji, and that by the age of seven he was receiving formal training in Chinese classics and calligraphy.

Taiga, along with Yosa Buson (no. 91), in the mid-eighteenth century, brought the Chinese Nanga (Southern school) into full development as a uniquely Japanese artistic form. He began his professional painting career as a teenager operating a fan shop, painting fans with compositions he found in the books of the *Hasshu Gafu* (Albums of Eight Types of Paintings) a recently arrived, woodblock-printed book from China. These volumes recorded various painting styles, in particular the amateur or literati painters. These books along with another woodblock-printed set, the *Kaishien Gaden* (Mustard Seed Garden Painting Manual) served as the training manuals and sources of inspiration for such pioneer Nanga artists as Yanagisawa Kien (1706–1758), Gion Nankai (1676–1751), and Sakaki Hyakusen (1697–

1752). Kien and Nankai were both known to Taiga, and Kien in particular seems to have played an important role in shaping Taiga's future ideals.

Taiga was too energetic to be limited by the Chinese standards as they were understood. He was virtually insatiable in his appreciation of painting and referred on his paintings to various artists and Japanese artistic traditions. He also used techniques associated with schools other than Nanga, such as the gold ground screens of the Kanō and Rimpa schools, and the *tarashikomi*, the technique of dropping color or ink onto moist areas of wash to achieve special effects.

The Idemitsu painting is undated, but stylistically it can be placed in the period of his late forties or early fifties, about 1770. He was taking command of the brilliant style he had launched and was bringing forth a uniquely personal statement. In this he combined dramatic line with decorative color and composition to produce a powerful expressionism which has recommended his paintings so strongly to modern viewers.

In this landscape he builds with rhythmical arcs, a taut organic mass punctuating the surfaces with staccato texture dots or short, curved lines. The power of his vision builds as he mounds shapes, which rise to a remote climax of a luxuriant growth of trees and ground cover. The upward motion of the pine-clad mountain is countered by the downward movement of the waterfall and the coursing stream. The stream flows out of the picture space to return and sweep below the rocky promontory where the scholar-recluse and his attendant stand surrounded by the majesty of nature, the ideal of literati existence. Taiga's work is filled with colorful energy and excitement and this painting represents his landscape art at its point of fullest development.

There are no inscriptions or titles on the paintings to indicate whether these two landscape paintings by husband and wife were originally intended to be a pair; however, they have been skillfully chosen to complement each other. Where the Taiga painting is massive, densely structured, exuberant, the Gyokuran landscape is sparce, open, and retiring. The one—pulsing and eager—the *yang*, and the other—quiet and reserved—the *yin*, together present a pleasing and reassuring aesthetic balance.

Gyokuran's history can be only sketched from certain records of the period. Diaries and commentaries of the day record her and Taiga's penchant for irregular, if not eccentric, behavior. It is known that her grandmother and mother before her ran a tea shop in the Gion district of Kyoto. Her mother, in particular, was noted for her abilities in the *waka* form of Japanese poetry, and even published a book of collected verses. Gyokuran herself gained a reputation for this kind of poetry, and when she inscribed a poem on one of her paintings, the springing, elegant line of her cursive script gave evidence of her proficiency as a calligrapher. Gyokuran's tea shop was frequented by such intellectuals as Yanagisawa Kien, and it is possible that Taiga first made Kien's acquaintance in this shop.

Taiga and Gyokuran were married about 1752, and

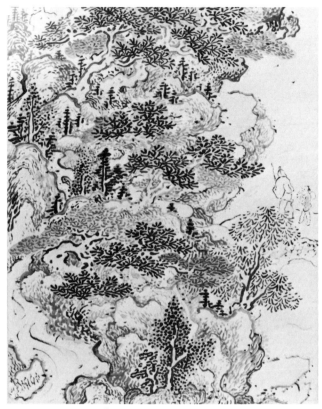

Fig. 63. Detail: Taiga (no. 90)

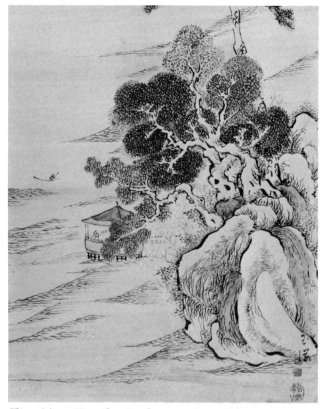

Fig. 64. Detail: Gyokuran (no. 90)

Taiga soon became Gyokuran's painting master. The style of her preserved works often reflects Taiga's own style of about 1760, not long after their marriage.

It is perhaps inevitable that Gyokuran's painting would be regarded in terms of her husband's work; however, her paintings display a personal expressiveness that distinguishes her work completely from his. Gyokuran has a strong tendency for regularizing forms and patternizing textures that lends a rather static quality to the overall composition. The touch of her brush, however, animates the composition with a compressed tension that seems just at the point of being released. There is a crisp clarity and almost naive delicacy about her scrolls, no matter how large the mountain or how complicated the scene.

Taiga's reputation has long overshadowed his wife's; however, as her work becomes more widely known, her skill and talent gain recognition and assure her place as an important figure in eighteenth-century Nanga painting.

References
Ikeno Taiga. Bunjinga Suihen, Vol. 12. (Tokyo, 1973). seal no. 56, pl. 144.
Rosenfield, John, editor. *Song of the Brush: Japanese Paintings from the Sansō Collection*. (Seattle, 1979).
Suzuki, Susumu. "Taiga and Gyokuran." *Kobijutsu*, Vol. 44. (Tokyo, 1974).

Fig. 65.
Signature and seal:
Taiga (no. 90)

Fig. 66.
Signature and seals:
Gyokuran (no. 90)

91
Solitary Deer in the Deserted Winter Forest

Yosa Buson (1716–1784)
Japan, Edo period (1615–1868), dated 1779
Hanging scroll
Dark and light colors on silk
111.3 × 48.9 cm.

The early history of Yosa Buson's career is somewhat unclear, but from his own seals and painting notations, and from references in his writings, it seems that he was born at Kema village on the Yodo River, a site now within the limits of the city of Osaka. Nothing is known for certain about his family, except that his original family name was Taniguchi. Buson's early interest was in poetry, in particular *haiku*, rather than in painting. These poems are a unique Japanese poetic form of only seventeen syllables. The *haiku* form was enjoying a special popularity during the time of Buson's youth, and while still in his teens, Buson traveled to Edo to study with Hayano Hajin (1617–1742), the preeminent *haiku* poet of the day.

In 1742, after the death of Hajin, Buson set out on a protracted tour of the north country, following the path of the *haiku* master, Matsuo Bashō (1644–1694), who popularized this area through his long poem, *Oku no Hosomichi*. Many students of Hajin lived in this area and they eased the way for Buson, virtually making possible his sojourn, which lasted over ten years.

In 1754, Buson settled in the village of Yosa in the province of Tango (modern Kyoto Prefecture) near the Japan Sea coast. It is said to be his mother's birth place, and the name by which he is known in history, Yosa Buson, is borrowed from this sleepy country town where he spent the years 1754 to 1757. In his early period of development as a painter Buson was open to various artistic influences, and his early works reflect a variety of experiments, some of which are more successful than others. Jōhei Sasaki (*Kokka* 971. [Tokyo, 1974].) has charted the early influence on Buson's painting of such diverse styles as Kanō, Otsu-e, and the *Kaishien Gaden* (Chinese: Chieh-tzu-yuan Hua-chüan), the woodblock-printed Chinese painting manual. Buson must also have been well acquainted with the works of Shên Ch'üan (Japanese: Chin Nan-p'in), a Chinese painter who visited Nagasaki from 1731 to 1733. Shên Ch'uan's paintings were popular for their exoticism, if not for their detailed, colorful realism.

By the time he settled in Kyoto, Buson had successfully embarked on the career of a painter-poet, the literati ideal combining the arts of poetry, painting, and calligraphy. He soon gathered an ardent and devoted group of followers. Many of his followers were attracted to his poetic genius, and he is known in literary history as second only to Matsuo Bashō among Japan's *haiku* poets. In 1770, he succeeded to his master's position as preeminent *haiku* poet of the day, and he assumed his master's art name of Yahantei. Buson successfully fused Japanese poetry with Nanga painting, and along with Ikeno Taiga (no. 90) brought literati painting to its most definitive development as a unique Japanese expression.

There is more than a little of the realism of Shên Ch'üan's style in this painting of a young deer from the Idemitsu Collection. The raw boned, adolescent deer wanders in romantic peace through the idyllic autumnal landscape. An overall effect of lighthearted elegance characterizes this type of developed landscape scene of Buson's later work. The appearance of the *Shaen* signature marked the beginning of Buson's mature period, and dates from 1778. This painting, dated in accordance with 1779, is an example from Buson's early mature period.

Published
The Tokyo National Museum, editor. *Nihon no Bunjin-ga.* (Tokyo, 1966). pl. 62.

References
Sasaki, Jōhei. "Buson in His Tango Period." Special Edition: Paintings by Yosa Buson During His Sojourn in Tango Province. *Kokka*, 971. (Tokyo, 1974).
The Tokyo National Museum, editor. *Nihon no Bunjin-ga.* (Tokyo, 1966).
Yosa Buson. Bunjinga Suihen, Vol. 13. (Tokyo, 1974).

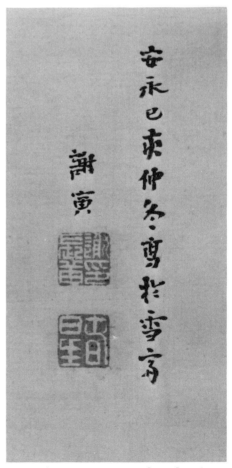

Fig. 67. Signature and seals (no. 91)

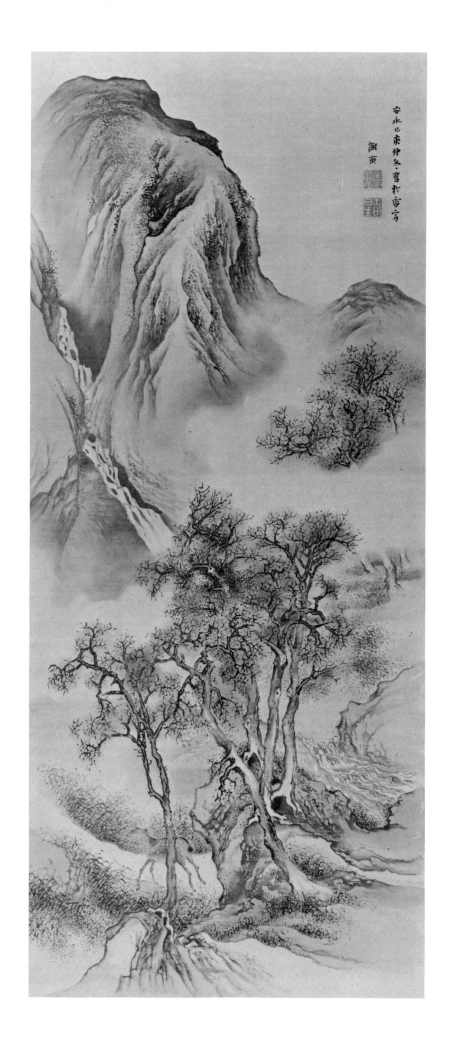

175

92*
Two Peaks Embraced by Clouds

Uragami Gyokudō (1745–1820)
Japan, Edo period (1615–1868)
Hanging scroll
Ink and light colors on paper
174.5 × 90.5 cm.
Important Cultural Property

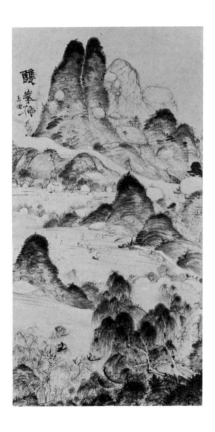

Fig. 68.　Title, signature and
seals　(no. 92)

Gyokudō was born in 1745 into a samurai family which served the Ikeda clan in Bizen Province, on the Inland Sea between Osaka and Hiroshima. From his youth he favored painting and Confucian classics. He also studied the Chinese *ch'in*, a seven-stringed lute somewhat reminiscent of the Japanese *koto*, but smaller. He served the clan with distinction as a teacher and advisor for many years. His interests in Confucianism and Chinese history and art led him to amass a huge library numbering thousands of volumes. He took his art name, Gyokudō (Jade Hall) or Gyokudō Kinshi (The Koto Master of the Jade Hall) from the *ch'in* he acquired in 1779, which was named Gyokudō Sei-in (The Pure Sounds of the Jade Hall).

In his studies, he was attracted to the theories of the Ming dynasty Confucian, Wang Yang-ming (1472–1529). The Wang Yang-ming theories were, however, disapproved by the Tokugawa authorities and in 1790, the study of these theories was banned. Gyokudō was censured and his library confiscated. Not long after the loss of his treasured library and the official censure, his wife sickened and died. These disappointments and frustrations seemed to engulf him in an inconsolable depression. Soon thereafter, he left on a trip with his two sons and sent word to the feudal lord that he intended to abandon his position. By cutting himself free from the feudal relationship of samurai and master, he was essentially making himself a social outcast and a penniless wanderer. With his two sons, he set out in 1794 on a journey that took them from the northernmost part of Honshu to Kyushu in the south. One son, Shūkin, settled in Aizu Province in northern Japan, but Gyokudō and his elder son, Shunkin, continued their meandering life-style until they finally settled in Kyoto in 1811.

Gyokudō's emphatic rejection of conventional society, his determined scholarship, his painting as the cultivation of self-expression exemplified the pure and uncompromising spirit of the literati. His emotional, though inventive, reaction to life and nature permeates his art and imbues it with a melancholy restlessness that is counter to the measured dignity expected of the ideal Chinese literati artist, exemplified by his friend and fellow artist Tanomura Chikuden (nos. 94, 95).

Gyokudō specialized in painting landscapes, usually executed in only black ink on paper. His landscapes were frequently composed after places he visited in his many travels and seldom was there more than a minute figure of a solitary traveler populating the vast expanse of nature he created. This painting is among the largest and best known of Gyokudō's many works. It varies from his usual landscape theme in that it represents the fabled West Lake at Hang-chou, the capital of the Southern Sung dynasty (1127–1279) and the spiritual home of poets and scholars following the literati traditions in art.

The wildness of much of Gyokudō's brush work and surprising reshaping of natural forms, such as his twisting mountains, wildly tilted plateaus, and dense patches of burnt black ink, emphasize the fantasy and romance of the expressionist quality of Nanga painting. There

is, however, in Gyokudō's work a carefully structured logic, as formal as a musical composition, yet as soaring and free as the music itself.

In the right foreground, Gyokudō has anchored his composition with anecdotal depictions of fishermen and a series of strongly detailed willow trees, some displaying dense foliage in the burnt black ink that was his unique technique. The small islands, points of land, and peculiar humped bridges at the West Lake emerge as diagonal elements and encircling arms, leading toward the middle ground and providing a foundation for the towering distant peaks. A band of low clouds rises through the valley, paralleling a foreground element and acting as a veil to separate the hermit-scholar and the remote peaks from the ordinary world below.

The figure of the hermit-scholar—perhaps Gyokudō himself—and the pavilion are not in proper scale for the supposed distance from the viewer; however, the artist has the freedom to move the viewpoint at will. Part of this caprice of scale and distance might have resulted from the artist's well known penchant for consuming quantities of sake. He would play music or paint furiously while intoxicated, sometimes signing a work as "painted by the drunken Gyokudō."

This work comes from the period of Gyokudō's full development as a painter, and while undated by inscription, belongs to a group of landscapes of the style of the last decade of his life.

Published

Cahill, James. *Scholar Painters of Japan: The Nanga School.* (New York, 1972). pl. 34.

Idemitsu Museum of Arts. *Masterpieces of the Idemitsu Collection.* (Tokyo, 1968).

Idemitsu Museum of Arts. *Special Exhibition Commemorating the Fifth Anniversary of the Idemitsu Collection.* (Tokyo, 1971).

Idemitsu Museum of Arts. *Speical Exhibition Commemorating the Tenth Anniversary of the Idemitsu Collection.* (Tokyo, 1976). pl. 40.

Musée du Petit Palais. *L'Art du Japon Eternel dans la Collection Idemitsu.* (Paris, 1981). pl. 67.

Suzuki, Susumu. *Kobijutsu,* Vol. 30. (Tokyo, 1970). pl. 3.

Suzuki, Susumu. *Uragami Gyokudō.* Nihon no Bijutsu, Vol. 148. (Tokyo, 1978). p. 12.

Suzuki, Susumu. *Uragami Gyokudō Gafu.* (Tokyo, 1980).

Suzuki, Susumu. *Uragami Gyokudō Gashū.* (Tokyo, 1956). pl. 18.

The Tokyo National Museum. *Exhibition of Japanese Literati Painting.* (Tokyo, 1965). pl. 216.

The Tokyo National Museum, editor. *Nihon no Bunjin-ga.* (Tokyo, 1966). pl. 84.

References

Cahill, James. *Scholar Painters of Japan: The Nanga School.* (New York, 1972). p. 71 ff.

Hasumi, Shigeyasu. "Uragami Gyokudō Hitsu, Sōhō Sōunzu, Kanrin Kankyo-zu." *Kokka* 716. (Tokyo, 1951). p. 397.

Suzuki, Susumu. *Kobijutsu,* Vol. 30. (Tokyo, 1970).

Suzuki, Susumu. *Uragami Gyokudō.* Nihon no Bijutsu, Vol. 148. (Tokyo, 1974).

The Tokyo National Museum, editor. *Nihon no Bunjin-ga.* (Tokyo, 1966).

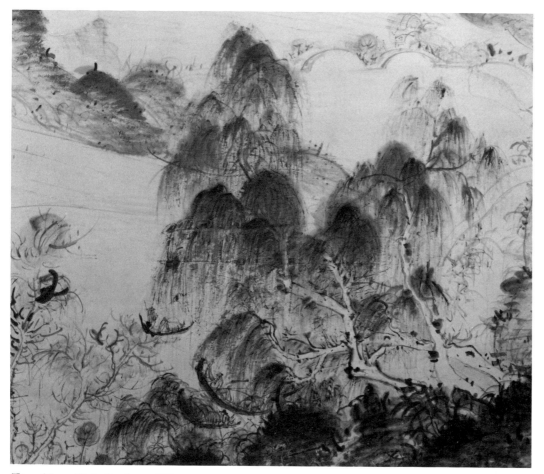

Fig. 69. Detail (no. 92)

93

Poem-composing Party of Wang Hsi-chih at the Lan-t'ing Pavilion

Okada Beisanjin (1744–1820)
Japan, Edo period (1615–1868), dated 1816
Hanging scroll
Ink and light color on paper
141.0 × 48.4 cm.

Humor and a lighthearted approach were often as much a part of the early Japanese Nanga painting tradition as was the earnest desire to emulate Chinese scholar painting. Ikeno Taiga (no. 90) and Yosa Buson (no. 91) both occasionally treated literati subjects in a humorous manner, sometimes presenting long-venerated subjects in a slightly irreverent way. Among these early Nanga painters was one in particular whose joy in painting often allowed him to project humor into his works and gave him a wide latitude of experimentation and self-expression. This was Okada Beisanjin, the artist of this painting. Beisanjin seems to have been a self-taught artist, and perhaps it was the lack of a definitive master that allowed him the freedom to explore directions that the influence of a strong teacher would have denied him.

Little is known about Beisanjin's early history. He was probably born in Osaka, but nothing is known of his early life until about the age of thirty when he began to work in Osaka as a rice merchant. The enterprise was rather small-scale and he apparently managed it by himself. He is said to have studied poetry as he operated the rice-polishing machine and, in his spare time, he studied painting and calligraphy. His name first appears in an Osaka city register in the section on artists in 1790, at age forty-six. Not long after this date he apparently moved into the Osaka residence of the Tōdō clan where he was employed in a minor position.

Beisanjin became part of the circle of scholars and literati painters who gathered about Kimura Kenkadō (1736–1802), the scion of a wealthy sake-brewing family, and an ardent scholar and literati artist. Beisanjin seems to have met Kenkadō first in 1783, during the period when he was developing his own painting style; Beisanjin's earliest dated painting is a folding fan of 1788. The Taiga influence was prevalent in Nanga painting of the time and, while perhaps encouraged by Kenkadō—said to have been an admirer of Taiga's work and a friend of several of Taiga's followers, and perhaps Taiga himself—the fan design of a blossoming plum branch bears no relation to a Taiga influence and only vaguely suggests the broad sweeping rhythms so characteristic of Beisanjin's later style.

It is doubtful that Nanga artists in late eighteenth-century Japan had an opportunity to study any authentic Sung or Yüan dynasty Chinese paintings, but they were aware of the general approach in brush work and the appearance of a typical composition of the style of such artists as Mi Fu (1051–1107) or Huang Kung-wang (1269–1354). Beisanjin shows in his own style the

'hemp-fiber' texture strokes for hills and mountains, derived from an acquaintance with Huang Kung-wang's style. Beisanjin also frequently worked with his own version of the horizontal 'Mi' dots, said to have been the favorite technique of the artist Mi Fu. Beisanjin also might have taken the Mi of Mi Fu's name as part of his own name, as Mi, the character for rice, is read Bei in Japanese. It is also possible that the name Beisanjin, literally Rice Hermit, is a reference to his years as a rice merchant.

The fantastic landscape in the Idemitsu Collection provides a setting for Beisanjin's interpretation of the theme of the poetry gathering at the Lan-t'ing, or Orchid Pavilion. The theme was one of the best known incidents in Chinese literary history and most representative of the literati life-style. Wang Hsi-chih (307–365) was China's most famous calligrapher and a figure long-venerated by Chinese literati. Naturally, the Japanese literati artists knew of him and his noted poetry party. In the spring of 353, Wang called together a group of forty-one friends, all poets and scholars, at his country estate, the Orchid Pavilion. The friends gathered in the garden of the estate, which bordered a winding stream on which wine cups were floated. The group sipped wine and composed verses as a pleasurable pastime. Wang, seen seated in the pavilion in the distance, immortalized the occasion when he made a collection of the poems of his guests and added his own introductory essay.

The theme of the poetry party at the Orchid Pavilion was one often employed by literati artists in their paintings. Beisanjin, himself, painted at least one other, more cursory version in 1799. In comparison with the earlier work, the Idemitsu version is elaborately detailed and awesome in its grand sweep, especially the striking feature of the fabulous rocks of Lake T'ai placed so prominently in the landscape. The strangely shaped rocks from Lake T'ai have for centuries been an important element in Chinese garden design and exceptional examples were sought as a focus for contemplation. Beisanjin has provided this garden scene with an assemblage of fantastic rocks, alluding not only to the wealth of the owner, but also to the accomplished design of the garden. The garden is perhaps better described as a park, and scattered throughout the landscape are writing tables with seating mats and rugs, and temporary enclosures furnished with tables laden with objects and refreshments suited to the literati taste. The entire scene is something of a dream fulfilled, not unrelated, perhaps, to the utopian vision of the *Kōban-zu* by Tanomura Chikuden (no. 94).

Beisanjin's paintings display a happy exuberance, sometimes mingled with a sly wit. One of his own self-portraits clearly reveals his sense of humor. Painted at the age of seventy-five, it shows him drunk and slipping beneath his writing desk, a beatific smile on his face. The poetic inscription specifically mentions drunken paradise. In this painting of the Orchid Pavilion, Beisanjin has bound together the space cells of his composition with the winding stream and a series of lacey

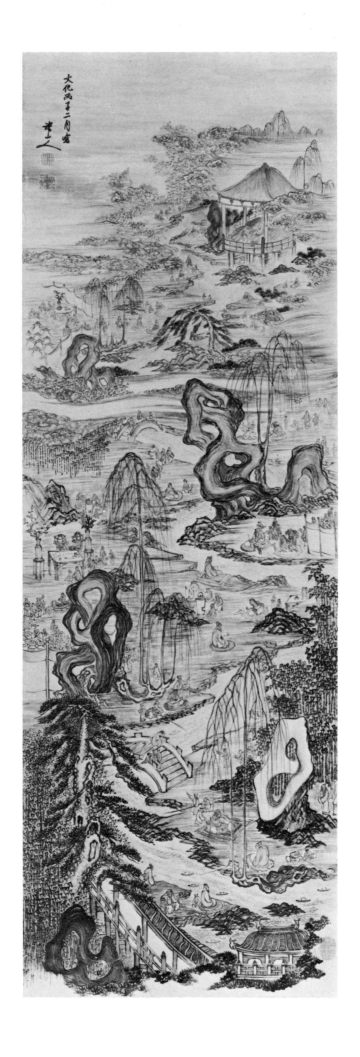

clouds, while linking the foreground, middle ground, and distant pavilion with the vertical forms of pines, bamboo thickets, and leafless willows. The figures of the assembled guests are suitably composed and dignified, while the army of attendants pursues the various tasks supporting this relaxed life of the scholars. The impression of a holiday mood is deftly conveyed in the openness of the composition and in the light color with its pleasant sense of freshness and comfort.

Published
Musée du Petit Palais. *L'Art du Japon Eternel dans la Collection Idemitsp.* (Paris, 1981). pl. 69.
Okada Beisanjin, Bunjinga Suihen, Vol. 15. (Tokyo, 1978). pl. 39.

References
Okada Beisanjin. Bunjinga Suihen, Vol. 15. (Tokyo, 1978).
Special Edition on Beisanjin and Hankō Okada. *Kobijutsu,* Vol. 53. (Tokyo, 1977).
Yoshizawa, Tadashi and Yamakawa, Takeshi. *Nanga to Shaseiga.* Genshoku Nihon no Bijutsu, Vol. 18. (Tokyo, 1969). p. 82.

Fig. 70. Signature and seals (no. 93)

94
Kōban-zu (Utopia) and Calligraphy

Tanomura Chikuden (1777–1835)
Japan, Edo period (1615–1868),
datable to about 1832
Hanging scroll
Ink and light color on paper
166.5 × 47.5 cm.

Tanomura Chikuden was born into a family of physicians to the feudal lords of Bungo Province (modern Oita Prefecture) in northern Kyushu. Chikuden, himself, studied to follow his father as a clan physician, but early declared his preference for Confucian studies and ancient Chinese poetry and literature. His abilities impressed his superiors sufficiently and he received permission to leave the position of physician to serve as a teacher at the clan school. Later he was asked to write the clan history. In addition to Confucian classics, Chikuden also studed poetry and calligraphy, and he was always conscious of poetry and poetic images. He had a talent for painting, which he developed initially by studying with local artists. At one point, he corresponded with Tani Bunchō, the great Edo artist, gaining advice and instruction. Eventually Chikuden visited him at the shogunal capital.

Chikuden was of samurai stock and the stereotyped discipline and rigorous self-control of samurai status are qualities reflected in his paintings. His strong sense of samurai duty, however, led him to an act of defiance against clan superiors in 1812, regarding what he considered the mismanagement of the affairs of the peasants during a time of drought. Consequently, he resigned his position. In contrast to Gyokudō's passive retreat from clan society (no. 92), Chikuden made his resignation an assertive act of social protest.

Chikuden traveled frequently, and in addition to a trip to Edo, he made visits to Nagasaki and to the Kyoto-Osaka area where he met other scholars and intellectuals, such as Rai Sanyō (1780–1832) and Uragami Gyokudō. His visits outside the clan fief were important to the development of his painting skills and the formulation of his deep artistic understanding. He was able, for instance, to meet Chinese painters resident in Nagasaki and to examine contemporary Chinese works. His mature style, as expressed in this painting entitled *Kōban-zu* clearly reflects a history of such contacts.

After leaving the clan, he became a restless traveler, spending time with various friends and fellow literati. The *Kōban-zu* theme, a sort of literati utopian view, is an appropriate theme for Chikuden, for he was perhaps closer to achieving in his life and art the ideal existence of the Chinese literati than any other Nanga painter of the Edo period. He clearly expressed his profound grasp of Chinese painting history and theories in his own writings, such as the *Sanchūjin Jozetsu,* but it is in the paintings of his mature period, especially from the decade before his death, that he reveals his indisputable achievement in aesthetic vision and technical

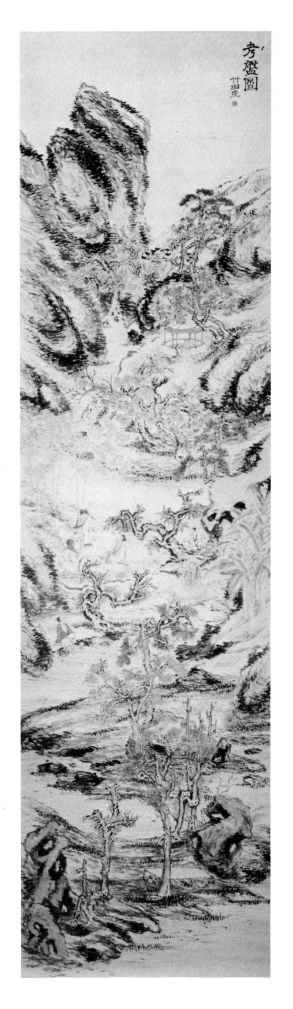

brilliance. Chikuden's style is sometimes considered better suited to small-scale works, like album leaves, rather than large-format painting, such as *Kōban-zu*. In his larger works, however, he is also capable of translating the qualities that shine so charmingly from his album paintings. He can make clear his particular interest in detailed textural finish and subtlety of tonal shifts, his sensitivity to compositional structure and poetic mood, so that the entire surface of a large painting like *Kōban-zu* is a veritable shimmer of brush work and elegantly sophisticated color.

The text of the calligraphy panel reveals that this painting and the poem were executed for his friend, Andō Shundai, whose home he was visiting during the summer of 1832. The poem is Chikuden's own composition, and like his paintings, reveals his mastery of the Chinese standards. His words describe the idyllic life sought by the scholar-hermit who wishes only for a humble hut in a bamboo thicket, the opportunity to enjoy flowers in their season, to sip properly aged tea and to know the fragrance of delicate incense. The painting is a romantic transcription of a secluded, enchanted valley where all the literati dreams might come true.

Published

Expo Museum of Fine Arts. *Catalogue of Expo Museum of Fine Arts.* (Osaka, 1970). pl. 153.
Idemitsu Museum of Arts. *Masterpieces of the Idemitsu Collection.* (Tokyo, 1968).
Idemitsu Museum of Arts. *Special Exhibition Commemorating the Fifth Anniversary of the Idemitsu Collection.* (Tokyo, 1971).
Idemitsu Museum of Arts. *Special Exhibition Commemorating the Tenth Anniversary of the Idemitsu Collection.* (Tokyo, 1976). pl. 46.
Mokubei, Chikuden. Nihon Bijutsu Kaiga Zenshū, Vol. 21. (Tokyo, 1977). pl. 34.
Musée du Petit Palais. *L'Art du Japon Eternel dans la Collection Idemitsu.* (Paris, 1981). pl. 76.
Sasaki, Kōzō. *Chikuden.* (Tokyo, 1970). pl. 28.
Tanomura Chikuden. Bunjinga Suihen, Vol. 17. (Tokyo, 1975). p. 28.
The Tokyo National Museum. *Exhibition of Japanese Literati Painting.* (Tokyo, 1965). pl. 363.
The Tokyo National Museum, editor. *Nihon no Bunjin-ga.* (Tokyo, 1966). pl. 139.

References

Cahill, James. *Scholar Painters of Japan: The Nanga School.* (New York, 1972).
Sasaki, Kōzō. *Chikuden.* (Tokyo, 1970).
Suzuki, Susumu, editor. *Chikuden.* (Tokyo, 1963). pl. 50.
Tanomura Chikuden. Bunjinga Suihen, Vol. 17. (Tokyo, 1975).
The Tokyo National Museum, editor. *Nihon no Bunjin-ga.* (Tokyo, 1966).

95
Early Morning in a Hamlet

Tanomura Chikuden (1777–1835)
Japan, Edo period (1615–1868), dated 1833
Hanging scroll
Color on silk
129.0 × 37.0 cm.

This painting, like *Kōban-zu* (no. 94), was painted for a friend of the artist. The *Early Morning in a Hamlet* is dated to the year 1833 in the inscription that Chikuden has provided in the upper left corner. In it he tells us that he has composed this painting at the request of his poet friend, Rangetsu. In the blending of poetry, calligraphy, and painting—where there is poetry in the painting and painting in the poetry—a work like this can be composed in the manner of a poem. Chikuden often provided inscriptions and poems on his works, and this poem, like the inscription panel with the painting *Kōban-zu*, was prepared by Chikuden himself. The quatrain, like Chikuden's paintings, is firmly and strictly formulated. He describes the glowing beauty of a fresh dawn and the crackling sounds of a crowing cock, as though seated at a window observing the view. In a personal comment, he remarks on how much time he has spent refining the poem.

Compositionally, the painting is almost the *Kōban-zu* turned inside out. Where the *Kōban-zu* was sheltered like a secret hideaway, nestled between forgotten peaks, this painting is open and free, inviting and sparkling as a new day dawns. The scholar-hermit's abode, however, is securely locked behind walls and gates to insure privacy and to protect integrity. Chikuden's consummate constructionist nature as an artist is again revealed in this painting. The powerful thrust of the mountain slopes, the assuring separations of water and land, bring together his peculiar type of personal projection and emotional restraint that characterize much of his painting.

As the inscription on the painting testifies, Chikuden traveled widely and made his paintings for friends, or friends of friends. He frequently visited along the Inland Sea and around the Kyoto-Osaka area. He has left an album of paintings, dated 1829, made up of views from the window of a ship he had taken down the Inland Sea. These paintings are a subtle combination of poetic feeling with an appreciation of everyday life, and the paintings in this album, *Senso Shogi-jō*, are often humorously presented. Chikuden lived a free and uncluttered life, dedicated to the principles of literati detachment that bordered on a 'counter-cultural' existence in defiance of the established order. For all his freedom, his was a strict and disciplined life, elegantly sophisticated, but with a respect for high standards of moral behavior.

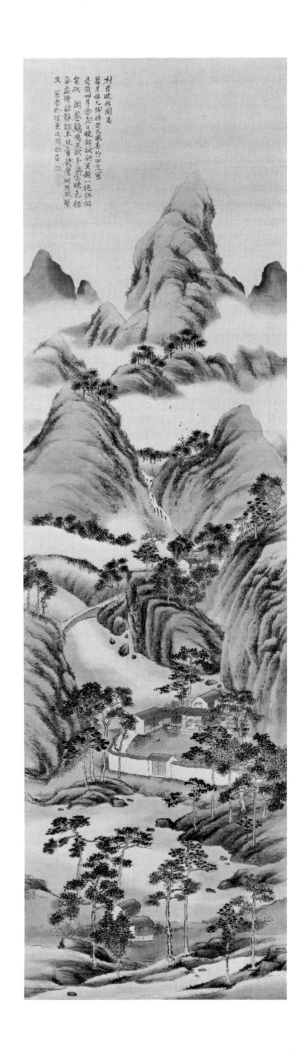

Fig. 71. Inscription, signature and seals (no. 95)

References
Cahill, James. *Scholar Painters of Japan: The Nanga School.*
(New York, 1972).
Idemitsu Museum of Arts. *Special Exhibition Commemo-rating the Fifth Anniversary of the Idemitsu Collection.*
(Tokyo, 1971).
The Tokyo National Museum. *Exhibition of Japanese Literati Painting.* (Tokyo, 1965).
The Tokyo National Museum. editor. *Nihon no Bunjin-ga.*
(Tokyo, 1966).

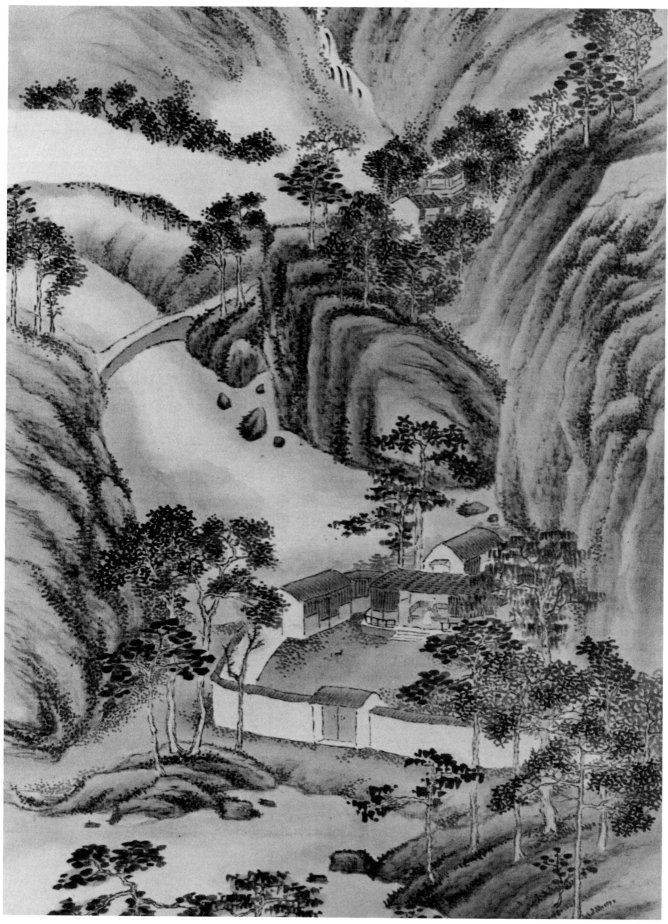

Fig. 72. Detail (no. 95)

A Hermit on a Boat Admiring Plum Blossoms

Takahashi Sōhei (1802–1834)
Japan, Edo period (1615–1868)
Hanging scroll
Color on silk
113.6 × 35.5 cm.
Important Art Object

Takahashi Sōhei is today perhaps the best known of the students of Tanomura Chikuden (nos. 94, 95). Sōhei came from Bungo Province (modern Oita Prefecture) in northern Kyushu. This is near the area where Chikuden grew up and where he served the feudal lords of Bungo Province. Sōhei joined Chikuden as a disciple at age nineteen, and followed him on his many travels to Kyoto, Osaka, and through the countryside. Sōhei's special talents in painting were early recognized not only by Chikuden but by such people as the renowned Confucian scholar, Shinozaki Shōchiku (1781–1851) and others of the Rai Sanyō circle. Rai Sanyō (1780–1832), a calligrapher and painter, was the most influential Confucian scholar of early nineteenth-century Japan. His circle of friends was thoroughly cosmopolitan and included not only Confucianists and intellectuals from all fields, but priests and artists such as Tanomura Chikuden, Aoki Mokubei (1767–1833) and Uragami Gyokudō and his elder son, Shunkin (1779–1813).

Sōhei's talent in painting seemed to assure him a prominent place in the art world; yet an unexplained illness overtook him and he died at a very young age. Accounts differ on the dates of his birth and death, but it seems that he died in either 1833 or 1834 at the age of 31. The daughter of Shinozaki Shōchiku had been betrothed to Sōhei, but he died before they could be married. Chikuden, who had regarded Sōhei almost as a son, was particularly grief-stricken.

In his painting style, Sōhei initially followed Chikuden's work with its meticulous detail and rich textural surfaces. He eventually developed a more individual mode, after studying Chinese painting styles. But his work suggests that, had he lived, he would have perhaps surpassed even his teacher in his painting abilities. The Idemitsu Collection painting is close in feeling and composition to Chikuden's works of about 1830, in particular to the style reflected in the painting *Kōban-zu* (no. 94). Sōhei injects here a broadness of composition, however, which Chikuden seemed always to avoid in his delicately detailed paintings of gem-like brilliance. The broken dark profiles added to tree trunks by Chikuden, for instance, were avoided by Sōhei in favor of gnarled, but clearly delineated elements. The overall spacing and arrangements of elements might reflect the one artist in the other, but Sōhei's personal vision is without doubt fully revealed in this painting, executed in 1831, just two years before his death.

The painting is signed *Sōhei Genichi* and the poem, by his own hand, tells of the pleasures of idly drifting in the boat, enjoying the sight of plum blossoms "soaked in the fragrance of the flowers while composing poems." His interest in Chinese-style poetry is an obvious extension of Chikuden's interest, and Sōhei's skill at composing further indicates his bright future had he lived. This painting, harmoniously uniting elegant Chinese poetry with the delicacy of the theme and the strength of execution, epitomizes much of the ideal Edo period Nanga painting.

Published
Idemitsu Museum of Arts. *Special Exhibition Commemorating the Tenth Anniversary of the Idemitsu Collection.* (Tokyo, 1976). pl. 52.
"Takahashi Sōhei Hitsu, Keijō Tambai-zu Kaisetsu." *Kokka* 397. (Tokyo, 1923). p. 399.

References
Idemitsu Museum of Arts. *Masterpieces of the Idemitsu Collection.* (Tokyo, 1968).
Idemitsu Museum of Arts. *Special Exhibition Commemorating the Fifth Anniversary of the Idemitsu Collection.* (Tokyo, 1971).
Iijima, Isamu, editor. *Bunjinga.* Nihon no Bijutsu, Vol. 4. (Tokyo, 1967).
"Takahashi Sōhei Hitsu, Keijō Tambai-zu Kaisetsu." *Kokka* 397. (Tokyo, 1923).
Yonezawa, Yoshiho and Yoshizawa, Tadashi. *Japanese Painting in the Literati Style.* (New York and Tokyo, 1974).

Fig. 73. Inscription, signature and seals (no. 96)

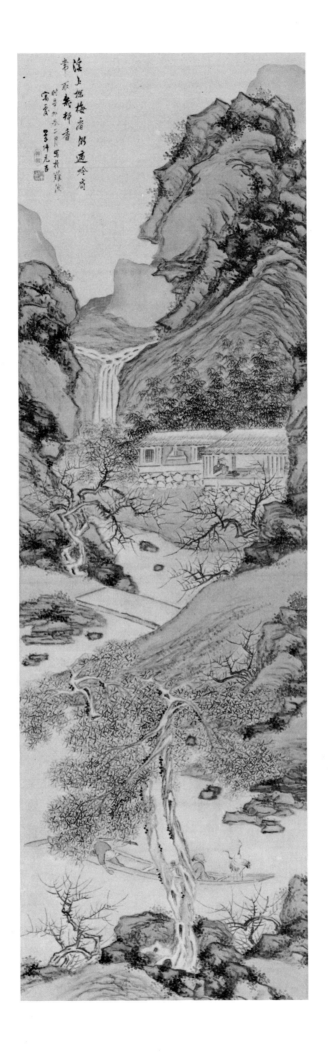

97*

Spider and Sparrow

Watanabe Kazan (1793–1841)
Japan, Edo period (1615–1868)
Hanging scroll
Color on silk
39.8 × 55.8 cm.

As a painter, Watanabe Kazan followed a variety of schools; yet in the course of his career he eluded clear identification with any particular style. His independence in examining and mastering many approaches to art was a reflection of his scientific curiosity and intellectual energy. He was fascinated by Western science and technology and sometimes included Western shading in his paintings, effects he learned from examining Western engravings and book illustrations. He used this shading especially in the realistic portraits for which he is perhaps best known.

Kazan was also highly skilled in other types of painting, particularly Nanga or literati painting, and in bird-and-flower themes. His early training had been with Tani Bunchō (1763–1840), the great Edo painter and probably the most influential artistic leader of the time. Kazan's talents, like Bunchō's, transcended any single school, but both were inevitably drawn to the relative freedom of movement of the literati tradition. This delicate nature study of a sparrow eyeing a spider, however, is a product of Kazan's acquaintance with Chinese paintings of the late Ming (1368–1644) and early Ch'ing (1644–1912) dynasties, in particular the work of artists such as Yün Shou-p'ing (1633–1690) whose style Kazan is known to have admired. His interest in scientific accuracy, too, perhaps influenced his choice of subject matter and certainly his manner of depiction. In this simple incident from nature, Kazan reveals for the viewer an array of natural forms and textures. His willingness to experiment allowed him to mix various techniques. He has combined the 'boneless' method, that is, painting without outlines, with the outline-and-wash technique. In the tender leaves and blossom of the morning glory vine and in the soft feathers of the

bird and the down of the spider, he has followed a 'boneless' manner, suited to expressing pliant, furry, and soft textures and surfaces. The crisp bamboo, with its tensile strength and crackling, stiff leaves is rendered in a sharp, thin outline with colored wash, lending structural as well as compositional strength to the work.

In the inscription, Kazan alludes to Sung dynasty (960–1279) poetry. He also records the date for the year 1837. The accuracy of dating Kazan's later works, such as this one, however, is clouded. Together with some friends, he had been arrested in 1839 and charged with studying proscribed European texts. Influential friends prevailed on the authorities to reduce the death sentence to house-arrest, and he was eventually removed to a remote area of the fief of his feudal master. He is thought to have dated works produced there to an earlier time to avoid conflict with the authorities. This painting is very much in the vein of a series of studies and album leaves he painted, all of which are dated to 1837. It is impossible to say with certainty whether this series, along with this painting, comes from the period of confinement, but his letters suggest that this is a group of paintings he did while imprisoned.

Kazan was born in Edo, modern Tokyo, into a samurai family who were impoverished, though of important rank. Samurai families were expected to live on their annual stipends, which by the late Edo period were often not adequate, and Kazan lived in dire poverty all his life. His samurai status brought him into government service, and he soon recognized the weakness of the late Edo period military government in the face of rapidly approaching contact with European powers. He wrote regarding the state of coastal defenses and, in defiance of the government's seclusionist policy, urged international trade. He was censured for his vision, and as an unsanctioned scholar of Western learning, he was finally arrested. The ignominy of arrest and confinement weighed heavily on Kazan's proud and noble spirit, and after continued difficulty over letters sent from exile, he at last committed suicide in the autumn of 1841. He is remembered as a patriot and tragic hero of the late Edo period.

Published
Musée du Petit Palais. *L'Art du Japon Eternel dans la Collection Idemitsu.* (Paris, 1981). pl. 82.
Suzuki, Susumu. "Kazan no Kachō-ga ni Tsuite." *Kokka* 708 (Tokyo, 1951). p. 133.

References
Suganuma, Teizo, editor. *Kazan.* (Tokyo, 1962).
Suzuki, Susumu. "Kazan no Kachō-ga ni Tsuite." *Kokka* 708. (Tokyo, 1951).
Yonezawa, Yoshiho and Yoshizawa, Tadashi. *Japanese Painting in the Literati Style.* (New York and Tokyo, 1974).

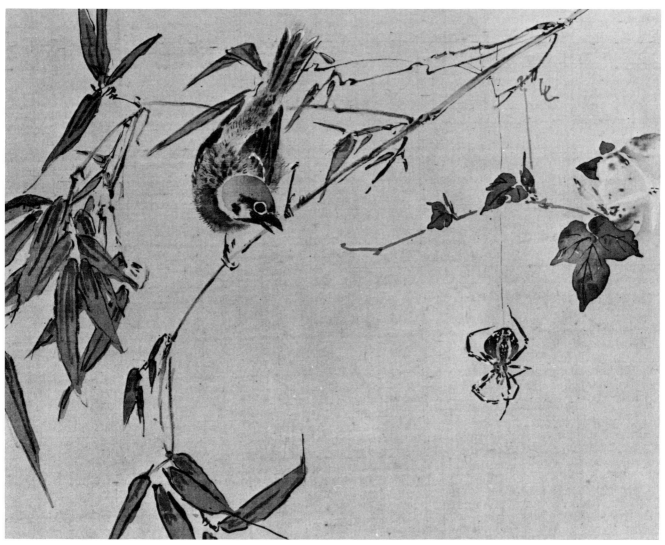

Fig. 74. Detail (no. 97)

Fig. 75. Inscription, signature and seals
(no. 97)

98*
Flowers and Birds

Yamamoto Baiitsu (1783–1856)
Japan, Edo period (1615–1868), dated 1845
Pair of six-panel screens
Ink and color on paper
156.0 × 361.0 cm. each

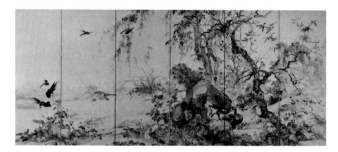

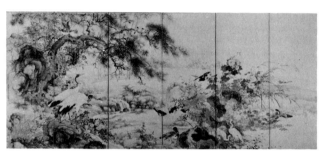

Baiitsu came from an artisan family of Nagoya, and from childhood was well acquainted with the sculptures and wood carvings produced by his father. Nagoya was the site of Owari castle of the Tokugawa family and, as the seat of local feudal government, was a prosperous and active urban center. From early youth, Baiitsu's almost constant companion was Nakabayashi Chikutō (1776–1853), and both Chikutō and Baiitsu began to study paintings while under the tutelage of a local collector and enthusiastic connoisseur of Chinese paintings, Kamiya Tenyū. The two also studied the techniques of painting with local artists, but it was not until they traveled to Kyoto in 1804 that their talents were given focus. There is a tradition that Baiitsu worked with Tani Bunchō, the great painting master from Edo, when he visited Nagoya on a commission and that Baiitsu later traveled to Edo to study with Bunchō.

Earlier generations of Nanga artists, such as Ikeno Taiga (no. 90), Yosa Buson (no. 91), and Okada Beisanjin (no. 93), had little knowledge of actual Chinese paintings and imperfectly understood or ignored the Chinese standards and history of the literati ideal. By the time Baiitsu was growing up, however, collections of Chinese paintings and books about Chinese art were more readily available and the young artists were better informed. Moreover, they were aware of contemporary developments in Chinese painting in a way earlier Japanese artists had not been. In addition, the influence of the Nagasaki school artists, who had absorbed Ming dynasty realistic bird-and-flower painting

through the works of Shên Ch'üan (active 1725–1778), and the paintings of Maruyama Okyo (1733–1795) and his followers in Kyoto with their strong realism, might very well have been irresistable influences on Baiitsu when he was working in Kyoto.

This pair of screens is a supreme example of the realistic bird-and-flower paintings for which Baiitsu is primarily known. The 'boneless' style of painting with its washes of color without outlines was one of Baiitsu's most accomplished techniques, and he has used it to great effect in this large-scale work. The elegant, delightful coloring, for which he is justly famous, glows from across the massive composition of birds and blossoms of the various seasons. He has combined into a grand scheme themes that often are separated out for individual treatment, such as cranes and pine trees, or herons and lotus, or peafowl with peonies and rocks. It is almost as though Baiitsu wanted to engulf the viewer with his bright and sensitive touch by massing delicate textures of feathers and foliage amid delightfully posed and graceful creatures.

Baiitsu also painted landscapes, and even in a somewhat shallow spatial format such as these screens, he has preserved the sense of traversable space which is a hallmark of his developed landscape style. His real fame as an artist, however, was based on his bird-and-flower paintings, like the Idemitsu screens. They are dated by inscription to the year 1845. It was a time when he was still living and working in Kyoto, perhaps at the peak of his career. He had many students and achieved considerable financial success during his long career. In 1854, near the end of his career, he returned to Nagoya where he was given patronage by the local daimyo. He died two years later. Baiitsu is remembered as one of the greatest Nanga painters of Nagoya. His friend Chikutō was no doubt a more typical Nanga painter, but Baiitsu is generally recognized as the more skillful artist.

Published
Musée du Petit Palais. *L'Art du Japon Eternel dans la Collection Idemitsu.* (Paris, 1981). pl. 85.
Yoshizawa, Tadashi. *Sansuiga—Nanga Sansui.* Nihon Byobu-e Shūsei, Vol. 3. (Tokyo, 1979). pls. 104, 105, p. 144.

References
Cahill, James. *Scholar Painters of Japan: The Nanga School.* (New York, 1972).
Iijima, Isamu. *Bunjinga.* Nihon no Bijutsu. Vol. 4. (Tokyo, 1967).
Rosenfield, John, editor. *Song of the Brush: Japanese Paintings from the Sansō Collection.* (Seattle, 1979).
Yonezawa, Yoshiho and Yoshizawa, Tadashi. *Japanese Painting in the Literati Style.* (Tokyo and New York, 1974).

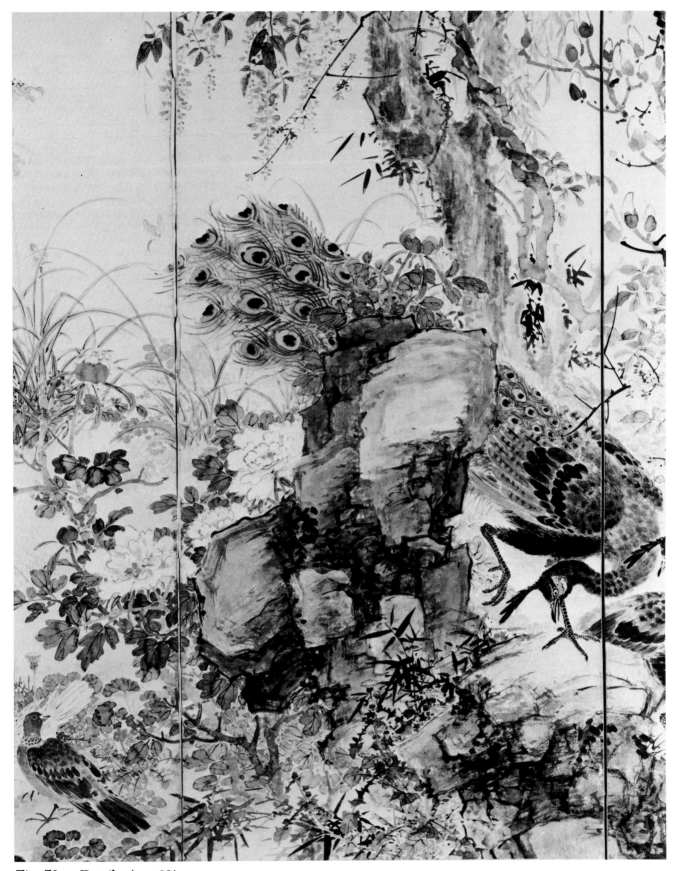

Fig. 76. Detail (no. 98)

99
Tiger and Dragon

Sengai Gibon (1750–1837)
Japan, Edo period (1615–1868)
Pair of hanging scrolls
Ink on paper
128.9 × 55.5 cm. each

Sengai, one of the most influential Zen priests during the late eighteenth and early nineteenth centuries, was twice abbot of Shōfuku-ji at Hakata in northern Kyushu, the oldest Zen temple in Japan. After his retirement in 1811, he devoted himself to painting and calligraphy and, even though virtually untrained as an artist, he became well known for his abilities with the brush. In time he was virtually bombarded with requests from pilgrims and disciples for examples of his work. Among his favorite themes were Kannon, the Bodhisattva of Compassion, and other sacred figures. Many of his renderings of other subjects, however, are richly humorous or satirical images imbued with a Zen connotation.

Sengai's style is characterized by a naive brevity and directness, derived partly from his lack of formal training, but also arising from his forceful and rugged, though kindly, spirit. He reduced forms to their basic elemental shapes and infused these paintings with a charming bravura by means of a pungent, stabbing line. The tiger peers up with a bemused, wide-eyed gaze, unperturbed by the dragon who seems about to fall head first from the sky. The animals and their setting are depicted in fleeting and abbreviated form, yet the physical presence of the tiger and dragon are undeniable.

The calligraphic inscriptions echo the economy of Sengai's artistic vision and their seemingly scattered and broken appearance belies the true brilliance of his brush.

The poem on the painting of the tiger in the bamboo thicket reads:

> House cat or tiger?
> Or [is it] Watōnai?

In Japan, Watōnai was a semi-legendary character often associated with the tiger. His exploits were popularized through an Edo period play entitled *The Battles of Coxigna* by the renowned dramatist, Chikamatsu Monzaemon (1653–1724). It was perhaps Chikamatsu's most successful play, and the relationship of Watōnai with the tiger became deeply rooted in the public mind. Chikamatsu's play is loosely based on the historical figure of Chên Ch'êng-kung, known as Coxigna, who worked to restore the Ming dynasty at the time of the Manchu invasion of China. Watōnai was his childhood name and Chikamatsu made him a fisherman living on an island off Kyushu. His father, who was Chinese, his mother, and Watōnai, traveled to China, where in a bamboo forest, they were attacked by a ferocious tiger. Watōnai subdued rather than killed the beast. Watōnai's act of generosity and kindness was rewarded by the tiger's allegiance and they subsequently joined together to defeat a force of attacking soldiers. From this grew the popular association between the two and Sengai's reference suggests that the face of the tiger somehow resembled Watōnai.

The inscription on the painting of the dragon reads:

> This, what is it?
> Call it a dragon.
> [But] people give a big laugh.
> I, too, laugh heartily.

It is perhaps true that Sengai's dragon, rather than a fabulous creature descending in wrath from the heavens, is more a humorous, stumbling parody expressing a Zen spirit of humility and compassion.

Neither painting is signed, but each carries the impressed seal reading "Sengai."

Published
Daisetz, Suzuki. *Sengai, the Zen Master.* (London, 1971). pl. 44.

References
Furuta, Shōkin. *Sengai.* Idemitsu Art Gallery Series, Vol. 3. (Tokyo, 1966). pp. 118–119.
Idemitsu Museum of Arts. *Special Exhibition Commemorating the Tenth Anniversary of the Idemitsu Collection.* (Tokyo, 1976).
Keene, Donald. *World Within Walls, Japanese Literature of the Pre-Modern Era, 1600-1867.* (New York, 1980). pp. 263–265.

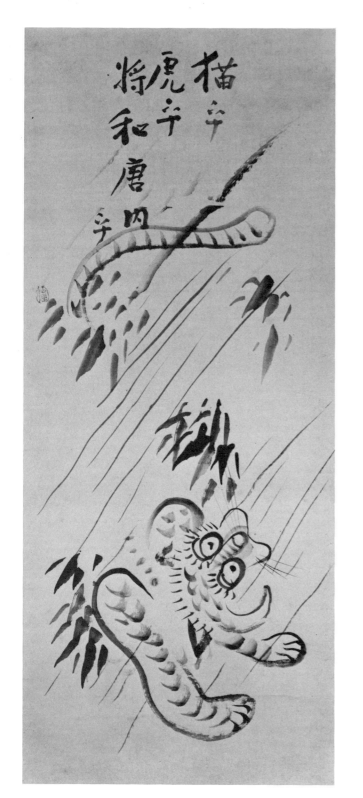

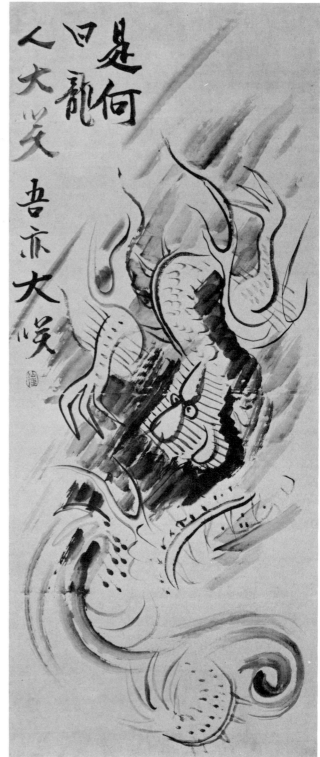

100
Hotei Singing

Sengai Gibon (1750–1837)
Japan, Edo period (1615–1868)
Hanging scroll
Ink on paper
54.3 × 60.4 cm.

A rotund, bearded Hotei skips along, clutching his bag of treasures and gaily pointing at the moon, while his chubby little companion follows his lead, laughingly mimicking Hotei's actions. Sengai has written out part of the song they shout as they frolic. It is a traditional children's song, a *warabe uta*, a nonsensical, rhythmical tune, learned generation after generation. The song was as familiar to Sengai's public as "London Bridge is Falling Down" is to an English-speaking audience, and probably as little understood by children. Because of its general familiarity, Sengai needed only to indicate the first few words in order to trigger the desired response in his viewer and establish clearly the presence of the moon overhead without actually showing it. Japanese even today smile when recollecting moments from childhood, and when reading the first few words of the song, they automatically repeat the rest to themselves.

The short quote Sengai includes goes as follows:

> Honorable moon,
> How old are you?
> Thirteen [and] seven . . .

Of course, thirteen and seven equal twenty and as the song suggests, this is an appropriate age for bearing first one baby, and then another. But, the song then asks who will hold and caress the babies, and suggests that Oman, the housemaid, be pressed into service. But where has she gone? The song continues in a silly way, typical of children's songs.

With its rhythmical curving lines, dance-like poses, and smiling countenances, the painting communicates an infectious joy. Sengai has captured in a few deft strokes the lighthearted innocence and happy humor which are the essense of the character of Hotei.

Hotei (Chinese: Pu-tai) was a historical figure who lived during the late T'ang dynasty (618–906). He was a monk of prodigious proportions with an especially large stomach. Seemingly without aim or guile, he roamed the Chinese countryside, carrying only a staff and a large cloth bag. His gentle ways and innocent humor charmed people wherever he traveled; however, such unconventional behavior gave rise to many fanciful impressions of him, and much of the traditional lore surrounding Hotei is purely legendary.

The contrast of Hotei's spiritual wealth with his material poverty gave him special distinction, and over the centuries he has been a favorite subject of Zen paintings. A set of standardized themes developed, such as "Hotei Asleep," "Hotei Dancing," "Hotei Gazing at the Moon," "Hotei Astride a Buffalo," or "Hotei at Play with Children." It is with children that Hotei is most strongly associated, for, although, asking nothing for himself, he is regarded as the jolly, unselfish provider of bounty and favors which he keeps in his bottomless bag. Sengai, with his usual artistic economy, seems to have combined a number of these themes into this one painting.

In addition to his role as a Zen paradigm of selfless innocence and artless simplicity, Hotei also appeared in Japan, as one of the *Shichifuku-jin*, the traditional Seven Gods of Good Fortune.

The painting is unsigned, but carries the impressed seal reading "Sengai."

Published
Daisetz, Suzuki. *Sengai, the Zen Master*. (London, 1971). pp. 180–181.
Furuta, Shōkin. *Sengai*. Idemitsu Art Gallery Series, Vol. 3. (Tokyo, 1966). p. 50.
Idemitsu Museum of Arts. *Special Exhibition Commemorating the Fifth Anniversary of the Idemitsu Collection*. (Tokyo, 1971).

References
Daisetz, Suzuki. *Sengai, the Zen Master*. (London, 1971).
Furuta, Shōkin. *Sengai*. Idemitsu Art Gallery Series, Vol. 3. (Tokyo, 1966).

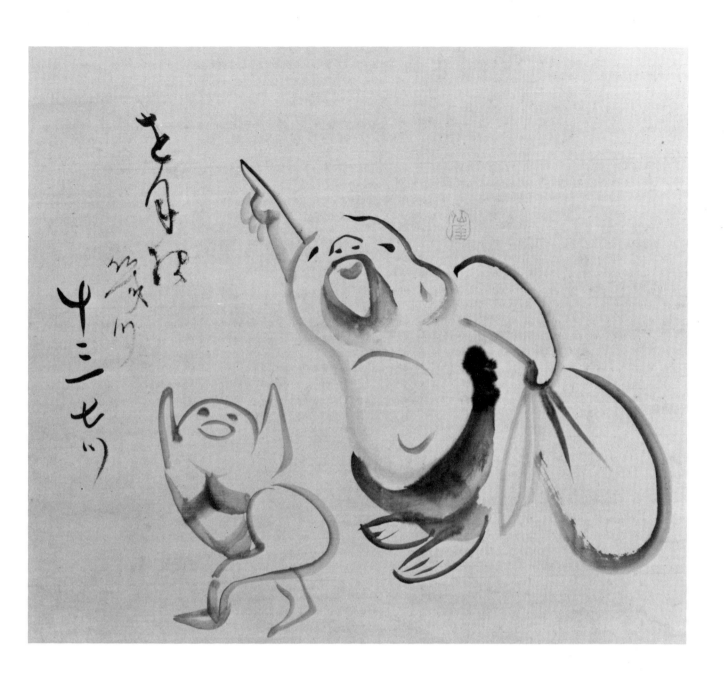

Selected Bibliography

Addiss, Stephen. *Zenga and Nanga.* New Orleans: 1976.

Akiyama, Terukazu. *Japanese Painting.* Lausanne: 1961.

Asaoka, Okisada. *Koga Bikō.* 4 volumes. Tokyo: 1912.

Becker, Sister Johanna. "Karatsu Techniques: Fabrication and Firing." *International Symposium on Japanese Ceramics.* Seattle: 1973.

Beurdeley, Cecile and Michel. *A Connoisseur's Guide to Chinese Ceramics.* Translated by Katherine Watson. New York: 1974.

Brown, Roxanna M. *The Ceramics of Southeast Asia: Their Dating and Identification.* London: 1977.

Cahill, James. *Scholar Painters of Japan: The Nanga School.* New York: 1972.

Cort, Louise Allison. *Shigaraki, Potter's Valley.* Tokyo: 1979.

D'Argencé, René-Yvon Lefebvre, editor. *5,000 Years of Korean Art.* San Francisco: 1979

Figgess, Sir John. "Ko-Seto." *International Symposium on Japanese Ceramics.* Seattle: 1973.

Fong, Wen. editor. *The Great Bronze Age of China: An Exhibition from the People's Republic of China.* New York: 1980.

Fontein, Jan and Hickman, Money. *Zen Painting and Calligraphy.* Boston: 1970.

Frasché, Dean F. *Southeast Asian Ceramics: Ninth Through Seventeenth Centuries.* New York: 1976.

Fujioka, Ryōichi. *Shino and Oribe Ceramics.* Translated by Samuel Crowell Morse. Tokyo: 1977.

Furuta, Shōkin. *Sengai.* Idemitsu Museum of Arts Series, vol. 1. Tokyo: 1966.

Garner, Sir Harry. *Chinese Lacquer.* London and Boston: 1979.

—————— . *Oriental Blue and White.* New York: 1970.

Gompertz, G. St. G. M. *Chinese Celadon Wares.* London: 1958.

—————— . *Korean Pottery and Porcelain of the Yi Period.* New York: 1968.

Gunsaulus, Helen C. *The Clarence Buckingham Collection of Japanese Prints.* 2 volumes. Chicago: 1955.

Hayashiya, Seizo, editor. *Nihon no Tōji*, vols. 1–7. Tokyo: 1974–1975.

Hayashiya, Seizo and Trubner, Henry et al. *Chinese Ceramics from Japanese Collections: T'ang Through Ming Dynasties.* New York: 1977.

Hucker, Charles O. *China's Imperial Past.* London: 1975.

Idemitsu Museum of Arts. *Ancient Chinese Works of Art.* Tokyo: 1978.

—————— . *The Fifteenth Anniversary Catalogue.* Tokyo: 1981.

—————— , *Special Exhibition Commemorating the Tenth Anniversary of the Idemitsu Collection.* Tokyo: 1976.

Jenyns, Soame. *Chinese Art: The Minor Arts II.* New York: 1965.

—————— . *Japanese Pottery.* London: 1971.

—————— . *Ming Pottery and Porcelain.* New York: n.d.

The Japan Textiles Color Design Center, compiler. *Textile Design of Japan: 1, Free Style Design.* Tokyo: 1980.

Kanazawa, Hiroshi. *Japanese Ink Painting: Early Zen Masterpieces.* Translated by Barbara Ford. Tokyo: 1979.

Kanda, Kiichiro et al., editors. *Bunjinga Suihen.* Tokyo: 1972-present.

Karlgren, Bernhard. *A Catalogue of the Chinese Bronzes in the Alfred F. Pillsbury Collection.* Minneapolis: 1952.

Kidder, J. E. *Japan Before Buddhism.* London: 1959.

Kim, Chewon and Gompertz, G. St. G. M. *Ceramic Art of Korea.* London: 1961.

Koyama, Fujio. *Chūgoku Tōji*, Idemitsu Museum of Arts Series, vol. 2. Tokyo: 1970.

——————. *The Heritage of Japanese Ceramics.* Translated by John Figgess. New York, Tokyo and Kyoto: 1973.

Koyama, Fujio and Figgess, John. *Two Thousand Years of Oriental Ceramics.* New York: 1961.

Koyama, Fujio et al. *Tōji Taikei.* Tokyo: 1974-present.

Lee, George F. "Numbered Chün Ware." *Transactions of the Oriental Ceramics Society.* London: 1945–1946.

Lee, Yu-Kuan. *Oriental Lacquer Art.* Tokyo and New York: 1972.

Link, Howard A. and Shimbo, Toru. *Exquisite Visions: Rimpa Paintings from Japan.* Honolulu: 1980.

Lion-Goldschmidt, Daisy. *Ming Porcelain.* Translated by Katherine Watson. New York: 1978.

Lion-Goldschmidt, Daisy and Moreau-Gobard, Jean-Claude. *Chinese Art: Bronze, Jade Sculpture, Ceramics.* Translated by Diana Imber. New York: 1960.

Loehr, Max. *Ritual Vessels of Bronze Age China.* New York: 1968.

Matsushita, Takaaki. *Muromachi Suibokuga (Suiboku Painting of the Muromachi Period).* Tokyo: 1960.

Medley, Margaret. *The Chinese Potter: A Practical History of Chinese Ceramics.* New York: 1976.

——————. *Yüan Porcelain and Stoneware.* New York: 1976.

Mikami, Tsugio. "Arita Blue-and-White and the Excavations of the Tengudani Kiln." *International Symposium on Japanese Ceramics.* Seattle: 1973.

——————. *The Art of Japanese Ceramics.* Translated by Ann Herring. New York and Tokyo: 1972.

Mitsuoka, Tadanari. *Kenzan.* Tōji Taikei, vol. 24. Tokyo: 1973.

Mizumachi, Wasaburo. *Ko Karatsu.* Idemitsu Museum of Arts Series, vols. 6 and 7. Tokyo: 1973.

Mizuno, Seiichi. *Bronzes and Jades of Ancient China.* Translated by J. O. Gauntlett. Tokyo: 1957.

——————. *Tō san ts'ai.* Tōji Taikei, vol. 35. Tokyo: 1977.

Murase, Miyeko. *Japanese Art: Selections from the Mary and Jackson Burke Collection.* New York: 1975.

Nagatake, Takeshi. "Iro Nabeshima Ware: Style and Techniques." *International Symposium on Japanese Ceramics.* Seattle: 1973.

Nakagawa, Sensaku. *Kutani Ware.* Translated by John Bester. Tokyo and New York: 1979.

Nakazato, Tarōemon. *Karatsu.* Tōji Taikei, vol. 13. Tokyo: 1972.

Narasaki, Shoichi. "Recent Studies on Ancient and Medieval Ceramics of Japan." *International Symposium on Japanese Ceramics.* Seattle: 1973.

Narazaki, Muneshige and Kikuchi, Sadao. *Utamaro.* Translated by John Bester. Tokyo and Palo Alto: 1968.

The National Museum of Modern, Art. *Japanese Painted Porcelain: Modern Masterpieces in Overglaze Enamel.* Translated by Richard L. Gage. Tokyo and New York: 1980.

Noma, Seiroku. *The Arts of Japan.* Translated by Glenn T. Webb and John Rosenfield. 2 volumes. Tokyo: 1976–1978.

Okuda, Seiichi. *Annan Tōji Zukan (Annamese Ceramics).* Tokyo: 1954.

——————. *Thai Vietnam no Tōji.* Tōji Taikei, vol. 47. Tokyo: 1978.

Okuda, Seiichi et al. *Japanese Ceramics.* Translated by Roy Andrew Miller, Tokyo: 1960.

Papinot, E. *Historical and Geographical Dictionary of Japan.* New York: 1910.

Pekarik, Andrew J. *Japanese Lacquer, 1600–1900.* Selection from the Charles A.

Greenfield Collection. New York: 1980.

Pope, John A. *Chinese Porcelains from the Ardebil Shrine.* Washington, D.C.: 1956.

Pope, John A. et al. *The Freer Chinese Bronzes,* vols. 1 and 2. The Freer Gallery of Art Oriental Studies, no. 7. Washington, D.C.: 1967–1969.

Roberts, Laurence. *A Dictionary of Japanese Artists.* Tokyo and New York: 1976.

Rosenfield, John and Shimada, Shūjirō. *Traditions of Japanese Art: Selections from the Kimiko and John Powers Collection.* Cambridge: 1970.

Ross, Nancy Wilson. *Buddhism: A Way of Life and Thought.* New York: 1980.

Satō, Masahiko. *Chūgoku no Tojiki.* Tokyo: 1977.

——————. *Hakuji.* Tōji Taikei, vol. 37. Tokyo: 1975.

——————. "The History and Variety of Karatsu Ceramics." *Chanoyu Quarterly: Tea and the Arts of Japan,* no. 24. Kyoto: 1980.

——————. *Kyoto Ceramics.* Translated by Anne Ono Towle and Usher P. Coolidge. Tokyo and New York: 1973.

——————. "The Three Styles of Kenzan Ware." *International Symposium on Japanese Ceramics.* Seattle: 1973.

Satō, Miyako. *Nihon Meigakaden.* Tokyo: 1967.

Seattle Art Museum. *Ceramic Art of Japan: One Hundred Masterpieces from Japanese Collections.* Seattle: 1972.

Sekai Tōji Zenshū. Tokyo: 1976–78.

Shimizu, Yoshiaki and Wheelwright, Carolyn, editors. *Japanese Ink Paintings.* Princeton, N.J.: 1976.

Shimonaka, Kunihiko, editor. *Aporo Hyakka Jiten.* Tokyo: 1969.

Speiser, Werner. *Lackkunst in Ostasien.* Baden-Baden: 1965.

Speiser, Werner; Goepper, Roger and Fribourg, Jean. *Chinese Art: Painting, Calligraphy, Stone Rubbing, Wood Engraving.* Translated by Diana Imber. New York: 1964.

Sugimura, Yūzō. *Chūgoku Ko-dōki.* Idemitsu Museum of Arts Series, vol. 3. Tokyo: 1966.

Tanaka, Ichimatsu. *Japanese Ink Painting: Shūbun to Sesshu.* Translated by Bruce Darling. New York and Tokyo: 1972.

Tokyo National Museum, editor. *Nihon no Bunjinga.* Tokyo: 1966.

Umehara, Sueji. *Kanan anyō ihō.* Kyoto: 1940.

——————. *Shina kodō seika. Obei shūcho,* 7 volumes. *Nihon shūcho,* 6 volumes. Osaka: 1933–1935, 1959–1964.

——————. *Shin-shū sen-oku sei-shō,* vol. 2. Kyoto: 1971.

Valenstein, Suzanne G. *A Handbook of Chinese Ceramics.* Boston: 1975.

Varley, H. Paul. *Japanese Culture: A Short History.* New York: 1973.

Vollmer, John and Webb, Glenn T. *Japanese Art at the Art Gallery of Greater Victoria.* Ontario: 1972.

Von Ragué, Beatrix. *A History of Japanese Lacquerwork.* Toronto and Buffalo: 1976.

Watson, William. *Ancient Chinese Bronzes.* London: 1962.

——————. "On T'ang Soft-Glazed Pottery." *Pottery and Metalwork in T'ang China,* Colloquies on Art and Archaeology in Asia, no. 1. London: 1970.

Wenley, A. G. "The Question of the Po-shan Hsiang-lu." *Archives of the Chinese Art Society of America,* no. III. New York: 1948–1949.

Williams, C. A. S. *Outlines of Chinese Symbolism and Art Motives.* Rutland and Tokyo: 1974.

Wirgin, Jan. "Sung Ceramic Designs." *The Museum of Far Eastern Antiquities (Ostasiatiska Museet).* Bulletin no. 42. Stockholm: 1970.

Yonemura, Ann. *Japanese Lacquer.* Washington, D.C.: 1979.

Yonezawa, Yoshiho and Yoshizawa, Tadashi. *Japanese Painting in the Literati Style.* New York and Tokyo: 1974.

Index